MODERN CHROMATICS

MODERN CHROMATICS

Students' Text-Book of Color with Applications to Art and Industry

By OGDEN N. ROOD (1831-1902)

Including a facsimile of the first American edition of 1879
Preface, introduction and commentary notes by
FABER BIRREN

VAN NOSTRAND REINHOLD COMPANY
NEW YORK CINCINNATI TORONTO LONDON MELBOURNE

Van Nostrand Reinhold Company Regional Offices:
New York Cincinnati Chicago Millbrae Dallas

Van Nostrand Reinhold Company International Offices:
London Toronto Melbourne

Copyright ©1973 by Litton Educational Publishing, Inc.

Library of Congress Catalog Card Number 73-1627

ISBN number 0-442-27028-3

Designed by Morris Karol

Color printed by Princeton Polychrome Press

Published by Van Nostrand Reinhold Company
450 West 33rd Street, New York, N.Y. 10001

The author and Van Nostrand Reinhold Company have taken all possible care
to trace the ownership of every work of art reproduced in this book and to
make full acknowledgment for its use. If any errors have accidentally occurred,
they will be corrected in subsequent editions, provided notification is sent
to the publisher.

16 15 14 13 12 11 10 9 8 7 6 5 4 3 2 1

Preface

This is a unique and important book in the literature of color. Ogden N. Rood was a professor of physics at Columbia College in New York during and after the American Civil War. Trained at Princeton and Yale colleges and at universities in Berlin and Munich, he won eminence as a physicist and became the first distinguished American to deal with the then new science of physiological optics.

What is remarkable about Ogden N. Rood is that he was both a leading scientist and an artist of capable talents, a combination seldom before encountered in the field of color. In writing *Modern Chromatics* he addressed both the scientist and the artist and was highly regarded by both.

Although France dominated the world of painting in the latter decades of the nineteenth century, Rood's book, published in French in 1881, became what can be fairly considered the most significant of all influences in the school of Neo-Impressionism. It was avidly read and studied by artists such as Camille Pissarro, Georges Seurat, Paul Signac.

Presented herewith is a well-deserved tribute to him and to the masterwork he wrote.

FABER BIRREN

Contents

PART I

Introduction

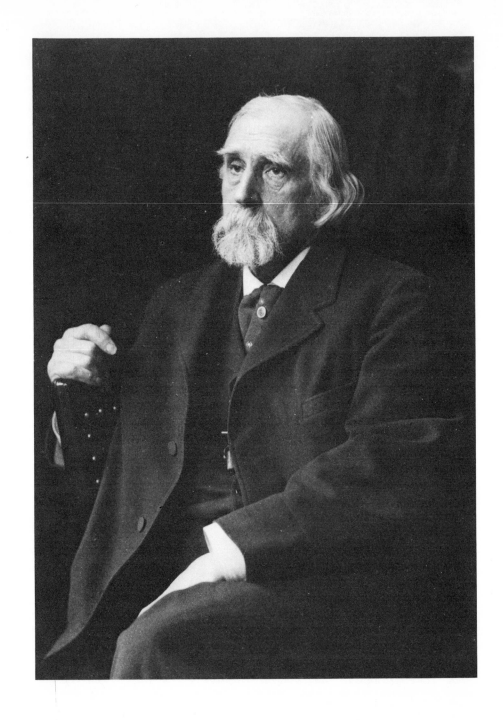

Ogden Nicholas Rood (1831-1902)
His Life

Ogden N. Rood was born in Danbury, Connecticut, on February 3, 1831. He was of Scottish descent. However, his immediate ancestors, both on his father's and his mother's side had settled in America during Colonial times before the Revolutionary War. Little is known of his early childhood. It can be assumed that he was well educated, his father, Anson Rood, being a Congregational minister.

In 1852 he was graduated from Princeton College. During following years he was a graduate student at Yale and an assistant professor at the University of Virginia. He prepared for a life of science, as a physicist, by studying four years (1854–58) at the Universities of Berlin and Munich. His teacher in science at Munich was Baron von Liebig, a well-known chemist. Also having a great interest in art, he took lessons in drawing and painting from Joseph Wilhelm Melchior, a Munich genre and animal painter. Rood bought a few of Melchior's canvases.

In 1858 he married a Miss Prunner of Munich and returned to the United States to begin his career as a teacher.

His first appointment was as Professor of Chemistry at the newly-organized but short-lived University of Troy, New York. In an inaugural address delivered on July 20, 1859, he said, in the best of Victorian eloquence, that natural philosophy came as a revelation from God and was to be pursued before a "mere desire of wealth." In anticipation of his coming role as an authority on color, he proclaimed, "But if you have not listened to His voice, speaking in His yellow sunbeam; in His banded rainbows and purple sunsets, in the violet flash of His lightning, and in the war of His tempests; or in His white crystalline snow with its blue shadows, and in His dark rivers congealed into transparent highways, solid as the rock; neither would you meditate on any crude thoughts that I might suggest."

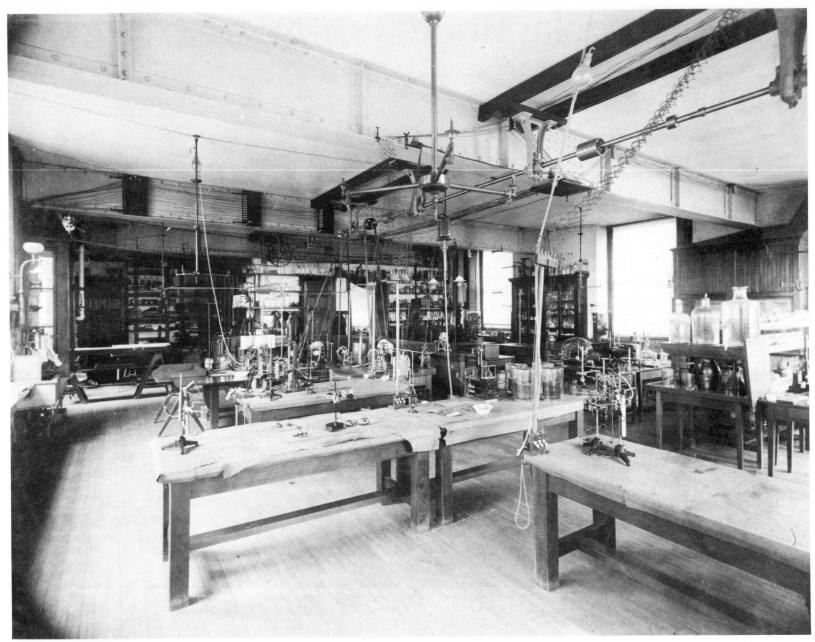

Rood's laboratory, Columbia University, about 1880.

Troy was a poor college. Rood had access to a meager library and little equipment, as compared with what he had experienced in Munich. Yet he remained there for five years.

Now he began his research in color and the writing of technical articles. (These articles would number over 65 before his death.) One of his first papers (1858) was devoted to polarized light. This was followed by further articles on such subjects as the solar spectrum, the compound microscope, optical experiments, theories of light, the perception of distance and color, the phenomenon of luster, the use of prisms, and "On certain appearances produced by revolving disks." A few were in German. His chief publisher was the *American Journal of Science*.

For relaxation he engaged in hunting and target shooting, which took him on walks into nature. He prepared a treatise on the American rifle. The infant science of photography occupied his attention, and he applied photography to the microscope.

It was during this time that he entered the realm of physiological optics, studied after-images, subjective colors, color mixtures noted in the spinning of disks. He constructed a spectrometer in 1862.

In 1863 the chair of physics at Columbia became vacant and he soon gained this appointment, holding it through 38 years. At first, equipment at Columbia was not much better than it had been at Troy. Although Columbia was one of the oldest of American colleges, it was then struggling to make its way into the new scientific age. Too, the Civil War was at its height, and this tended to emphasize the sciences over the humanities.

Under Rood's guidance, Columbia grew in stature as a scientific institution. The new professor of physics would become a world authority on physiological optics. He continued his writings, with particular attention to visual phenomena. He wrote on thermo-electric currents, electrical discharges, the photometer, the duration of lightning in nature.

In 1868 he visited Germany with his family, as a tourist, a scientific observer, an artist.

After this he gave concentrated attention to optics and color and began work on his *Modern Chromatics*. As will be re-peated later, in 1874 he delivered two lectures on *Modern Optics in Painting* before the National Academy of Design. This was five years before his book was published. Breaking with old Newtonian concepts, he wrote, "Color is a sensation existing merely in ourselves." His artist listeners must have been startled to have him tell of additive mixtures and to explain and demonstrate that yellow and blue formed, not green, but gray in optical blends.

In 1876 he wrote on *The Constants of Color* for *Popular Science Monthly* and the *Quarterly Journal of Science*. Here Rood featured the three constants of color—purity, luminosity, and hue—and broke ground for a radically different approach to color based on visual rather than physical phenomena.

In 1879 *Modern Chromatics* appeared and was to become a classic in its field—and the subject of this present tribute. Rood became a famous man both here and abroad almost at once, his masterpiece being printed again and again in America, in England, and in France and Germany.

In 1891, he wrote another highly significant article *On a Color System*, this being read before the National Academy of Sciences and published in the *American Journal of Science* in 1892. Rood, who had given thought to a systematic organization of color and who had devised a double pyramid (see pages 216, 217 in the facsimile of his book, which follows the commentary notes), perhaps hoped to leave the legacy of a well-balanced color solid. He prepared hundreds of carefully graded colors in paper disks, mixed them on color wheels, wrote mathematical notations and sought to put the complex world of visual color sensations into sensible order. During his lecture he agreed to give anyone in his audience a collection of color samples "without cost" for them to undertake experiments on their own.

It was in connection with this system that Rood some years later met with Albert H. Munsell. On July 26, 1899, Munsell wrote to Rood. (See letter reproduced on page 15.) This led to meetings at Rood's laboratory at Columbia on March 29 and November 2, 1900, and on May 17, 1901.

Munsell had read Rood's book and had learned much from it. (He also had studied Chevreul's work and had visited the Beaux Arts Library at Gobelins where Chevreul had been

Ap'l 18th/875.

D. APPLETON & CO.

549 & 551 BROADWAY, N.Y.

My dear Sir,

Will you please send me the full title of your book for the International Series & give me some idea when we may expect to begin printing.

Yours very truly

Wm. H. Appleton

Letter from Rood's publisher, D. Apple-
ton & Co., written in 1875, four years
before the book was issued in Appleton's
Scientific Series.

employed.) According to Munsell's diary, Rood admitted that "With all the desire in the world I have so far been unable to make a scientifically accurate color-system." (Also see pages 216, 217 of Rood's book, and this writer's comment ㉓.)

At the time, Munsell was developing what would become the most famous and widely-accepted of all color systems. What troubled Rood was well solved by Munsell. It is probably true that Rood inspired the idea of a decimal system of color notation. He concurred in the choice of five key hues. He educated Munsell to the technique of color-wheel measurements.

Munsell, in turn, asked for permission to quote and refer to Rood. He sent notes and diagrams to Rood, went into the details of his color "sphere." He built a photometer with Rood's advice. Much of his creative and inventive work was done during the latter years of Rood's life.

Munsell's *Color Notation* was published in 1905. His *Color Atlas* came later, in 1910. By this time Rood was dead (1902) and Munsell himself died in 1918.

In his more personal and artistic life, Ogden N. Rood kept active as a painter, without interruption. Sketchbooks and drawings on file in the Special Collections of Columbia University include sketches made in Dover, England, Calais, France, and in Germany. Over many years in America he spent summers at Stockbridge in Massachusetts, New London in Connecticut, and Narragansett in Rhode Island. Three of his Narragansett watercolors, the originals in full-color, are reproduced in black and white on following pages.

Let the reader bear in mind that these were horse-and-buggy days. While there were steam trains and steamboats—and thousands of bicycles—there were no automobiles or internal combustion engines.

Rood belonged to the New York Watercolor Society and often exhibited his paintings at the National Academy of Design. He knew many artists and corresponded with John Ruskin of England. In America he knew Albert Bierstadt, the German-born painter who enjoyed national popularity as a glorifier of Western scenery. Frederic E. Church, one of the most famous and prosperous of the artists of the Hudson River School, invited Rood to consider living along the wooded banks and palisades of the Hudson River.

Letter from Albert H. Munsell, 1899. He met with Rood on various occasions.

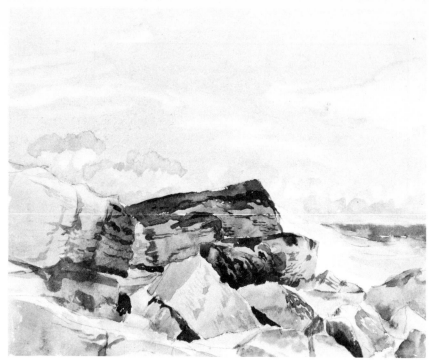

Three watercolors by Ogden N. Rood painted at Narragansett, Rhode Island, 1863.

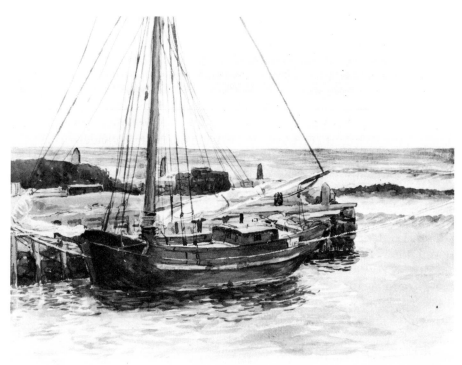

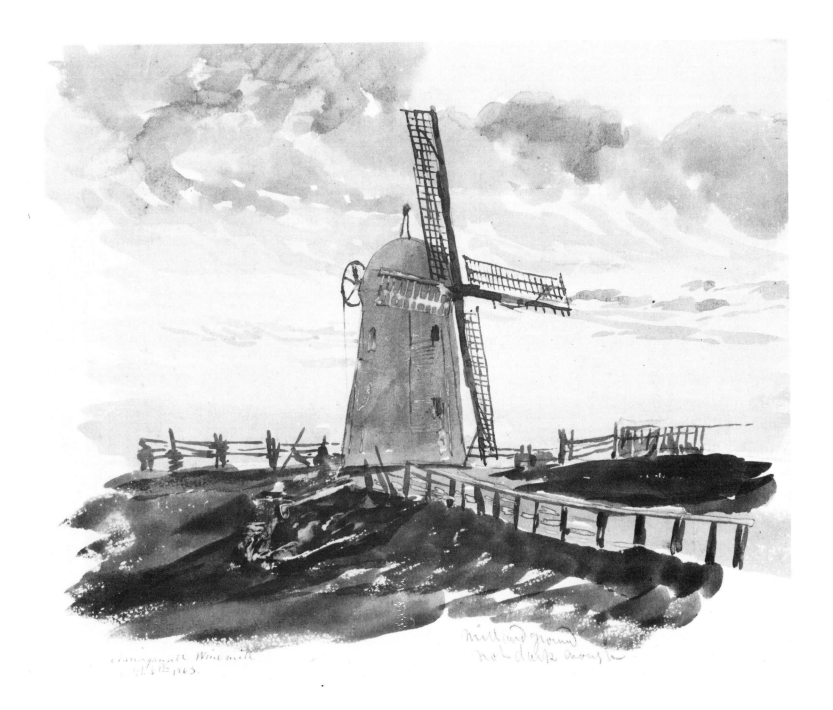

Narragansett Windmill
Sept 5th 1863.

Windmill ground
not dark enough

17

He knew Edward Everett Hale, author of *The Man Without a Country,* Unitarian minister and chaplain of the U.S. Senate. Charles Eliot Norton, scholar and professor of art at Harvard, wrote about an edition of Turner's etchings that Rood had bought.

In an unusual interest, Rood owned a collection of antiquities, such as Roman coins and Babylonian cylinders, and designed a method of making wax impressions of them. He once delivered a lecture on ancient gems at the Metropolitan Museum of Art. In appreciation of this, the Museum elected him an Honorary Fellow for Life in 1895. (See letter reproduced opposite.)

Rood lived many years on 52nd Street and on Park Avenue in New York. He belonged to the Century Club. He died on November 12, 1902. Nicholas Murray Butler, newly appointed president of Columbia, said of Rood, "He was a great scientific investigator and a character as quaint and charming as he was rugged. . . . His research laboratory was the real home of his mind and he lived the quiet, retired life of the typical scholar."

ROLAND ROOD (1863–1927)

Roland Rood was the son of Ogden N. Rood. He was born in Rhode Island in 1863, graduated as a chemist from Columbia University in 1884, and for a while assisted his father in the teaching of physics. Like his father, he had a keen interest in art. In France he studied with Purvis de Channes. In his studio in New York (1907) he did landscapes and portraits.

The younger Rood had a thorough knowledge of the old masters, particularly Turner and Rembrandt. During his life he made copious notes on art and, in the spirit of his father, was fascinated with the phenomena of vision.

Fourteen years after his death in 1927, his widow assembled his notes. A book was posthumously issued, *Color and Light in Painting.* It was edited by George L. Stout of the Fogg Museum in Cambridge and carried the imprint of Columbia University Press, New York, 1941. In it were essays on theories of beauty, sensation, light, the production of color by addition and subtraction, color fusion, successive and simultaneous contrast, color divisionism.

Honorary Fellow of Metropolitan Museum of Art, bestowed on Rood in 1895.

Impressionism

EUGÈNE DELACROIX (1798–1863)

Although Delacroix died 18 years before Rood's book was published in France, there is good reason to begin the story of Impressionism and Neo-Impressionism with him. In his revolt against the stiff classicism of his time his sudden and bold use of color and free handling of style created a new trend, which, though bitterly attacked, helped to change the course of French art.

Delacroix had the qualities of an aristocrat, was cultured, intellectual and counted among his friends such men as Victor Hugo, Stendahl, Theophile Gautier, Alexandre Dumas, Charles Baudelaire, Chopin. Among painters he thought little of his French contemporaries but paid tribute across the English Channel: "Constable, that admirable man, is one of the glories of England. . . . He and Turner are real innovators." After contemplating Constable's *Hay Wain* (see illustration) he so admired the Englishman's use of color that he retouched his *Les Massacres de Scio,* which happened to be in the same exhibition. (See Color Plate I.)

On color, Delacroix took the masterwork of Chevreul to heart and carried out many of Chevreul's experiments in simultaneous contrast. Although the two planned to meet in person, such meeting never took place. After the death of Delacroix, some 35 pages of notes on Chevreul were found among his possessions.

Heralding a new age in which discipline and science would enter the world of color in art, Delacroix wrote, "The elements of color theory have been neither analyzed nor taught in our schools of art, because in France it is superfluous to study the laws of color, according to the saying 'Draftsmen may be made, but colorists are born.' Secrets of color theory? Why call those principles secrets which all artists must know and all should have been taught?"

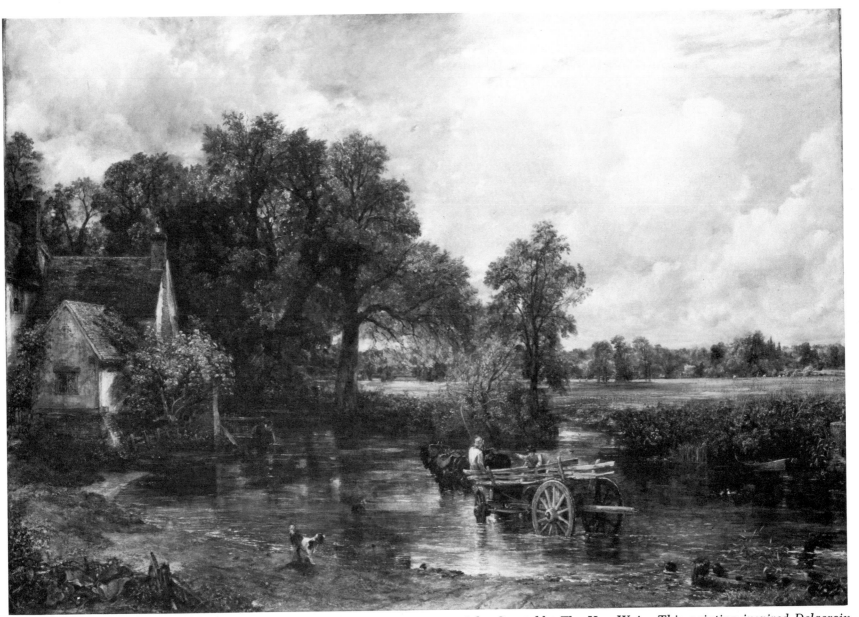

John Constable, The Hay Wain. *This painting inspired Delacroix to retouch his Les Massacres de Scio. (Courtesy the Trustees, National Gallery, London.) See Color Plate I for the Delacroix painting.*

His was a remarkable perception of nature and his lengthy *Journal* is replete with keen observations. He fought the academicians and perhaps because of this was not elected to the French Academy until he was 60 years old. He irritated painters of his day with remarks such as these: "The so-called conscientiousness of the majority of painters is only perfection applied to the *art of boring*."

"The enemy of all painting is gray."

"Banish all earth colors," advice that he failed to take himself, however.

"I open my window and look at the landscape. The idea of a line never suggests itself to me." The Impressionists were to portray light and color over form and line.

After Chevreul, "Give me mud and I will make the skin of a Venus out of it, if you will allow me to surround it as I please."

Delacroix was worshipped by the Impressionists and Neo-Impressionists. Many made pilgrimages to his striking murals at the library of the Luxembourg Palace (see illlustration) and the chapel of the Saints and Angels at St. Sulpice. He gave Manet permission to copy one of his (Delacroix) paintings. Van Gogh copied his *The Good Samaritan* (see illustration). With his usual passion he wrote to his brother that he went south "to see the stronger sun because I felt that without knowing it I could not understand paintings by Delacroix."

Renoir and Pissarro bowed in admiration. Here was art vibrant with color and a style that was impulsive, vital, and filled with action.

According to John Rewald, as young men Manet and Bazille would watch the celebrated Delacroix at work in his studio, from the window of a friend's apartment. They noted that as Delacroix painted he allowed his model to stroll about the studio.

Seurat made notes on the paintings of Delacroix and declared he wished to model his life accordingly. Signac, in 1899, wrote *D'Eugène Delacroix au neo-impressionnisme*, which gave much credit to Delacroix and well described the Neo-Impressionist movement. This ran into four editions. It mentioned the writings of O. N. Rood.

Yet Delacroix had his shortcomings. His enthusiasm for color, his writings on the subject were more exciting and in-spiring than what he put on canvas. Wrote the critic Moreau-Vauthier, "Delacroix, feverish and uneasy, was unable to materialize his thought when he took palette and brushes in hand." As to color, his life was more exhilarating than his art.

CLAUDE MONET (1840–1926)
PIERRE AUGUSTE RENOIR (1841–1919)

Unlike the aristocratic and intellectual Delacroix, several of the Impressionists came of bourgeois parents. Monet, for example, was born the son of a grocer. He had little formal education, though he showed great facility as an artist at an early age. Renoir was the son of a tailor and began his career as a painter by decorating porcelain dishes. Delacroix, on the contrary, was in the best of society during most of his years. There is little wonder, therefore, that the lowly Impressionists were enthralled by their sophisticated idol.

The Impressionist style was well established before Rood's book was published in France in 1881. At that time Pissarro was 51, Monet 41, Renoir 40. Exhibitions had been held, even though with little success and much frustration. How did it happen that this group of painters abandoned the formal styles of the past, gave up plastic qualities in art for dabs and dashes, and turned away from that which was durable and solid to that which was momentary and atmospheric?

Divisionism had been practiced long before by painters such as Claude Lorrain, Watteau, Rubens—and Turner and Constable of England. Yet, rather suddenly, the Impressionists, notably Monet and Renoir, painted in a manner rarely seen before.

One definite influence was M. E. Chevreul, the eminent French chemist who eventually was Director of Dyes for the Gobelins tapestry works, mentioned earlier. In 1835 Chevreul published a masterpiece on color, *De la loi du contraste simultané des couleurs*. This went into German in 1840 and into English in 1854. Several editions were later published in France and England. Chevreul wrote on the phenomena of simultaneous and alternate contrast, on laws of color har-

*Eugène Delacroix, mural for the Library of the Luxembourg Palace.
(Courtesy National Archives of France.)*

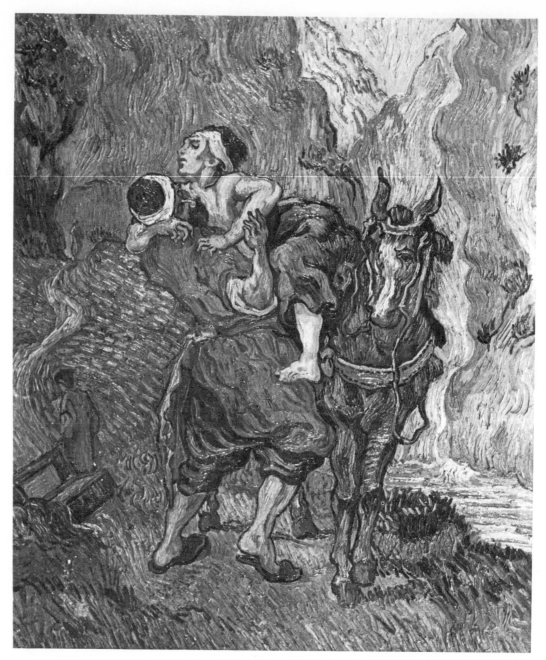

Vincent van Gogh's interpretation of
The Good Samaritan *by Delacroix.*
(Courtesy Rijkmuseum Kroller-Muller,
Otterlo, Netherlands.)

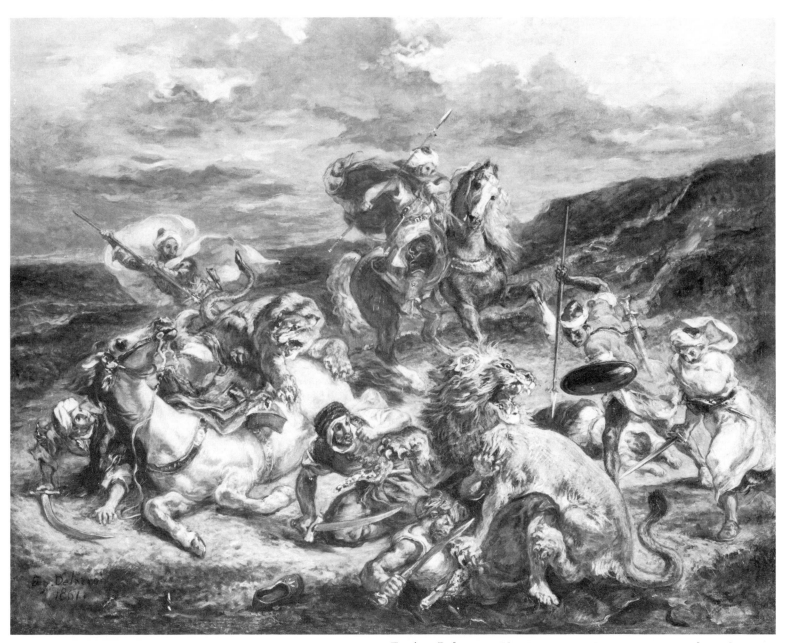

Eugène Delacroix, The Lion Hunt. *Note vigorous style and action.*
(Courtesy The Art Institute of Chicago.)

mony, *and on visual mixtures of color.* (A beautiful reprint of his work in English, edited and annotated by Faber Birren, was published by Van Nostrand Reinhold in 1967.)

In crediting Chevreul for a considerable role in the color expression of Impressionism, not much documentary record exists—except in the visual evidence of the style of the movement. As mentioned, Delacroix knew of Chevreul and admired him, while Delacroix in turn was admired by the Impressionists. Though Pissarro took an active interest in the more technical aspects of color, Monet and Renoir were not given to great intellectual effort. Yet both were influenced nonetheless.

During the Franco-Prussian War, Monet and Pissarro visited London and saw the majestic creations of Turner and Constable. Paul Signac later wrote, "In 1871, in the course of a long stay in London, Claude Monet and Camille Pissarro discovered Turner. They marveled at the wizardry of his colors; they studied his works, analyzed his technique. . . . Then they saw that these wonderful effects had been got not with white alone, but with a host of multicolored strokes, dabed against the others, and producing the desired effect when seen from a distance." While Pissarro was liberal in his admiration, Monet is said to have been indifferent "because of the exuberant romanticism of his [Turner's] fancy." This undoubtedly was a jealous reaction on the part of Monet who hesitated to pay homage to anyone. It is more than a coincidence that some of Monet's paintings done in England bear remarkable resemblance to those of Turner.

There is some evidence that Monet may have been familiar with Rood's book. In the obituary of Rood written by J. H. Van Armringe for the *Columbia Quarterly* (December, 1902), this statement appears regarding Rood: "He was not an Impressionist in theory or practice; but in consequence of a remark made by Claude Monet in writing of *Modern Chromatics*, that 'the work had been of invaluable assistance to him,' and of similar remarks by other artists of the same school, it was averred that the modern Impressionist movement received support and impetus from Rood's theory of color as set forth in that work—a responsibility which Rood himself declined."

Monet was a leading Impressionist. If he was not scientific in intellectual ways, he was one of the foremost *natural* scientists ever to devote a life to art. How else to explain his many paintings of haystacks, poplar trees, Rouen Cathedral, waterlilies! These in every sense were scientific studies that explored the fugitive qualities of natural light. In such series, he spent only a short period of time in order to catch a particular mood. As he wrote, he wanted "to get a true impression of a certain aspect of nature and not a composite picture." (See illustrations herewith and Color Plate II.)

As to Renoir, he also studied nature with a keen and inquiring eye. His verbal pronouncements may have been far from erudite, but what he perceived and what he was able to put on canvas was revolutionary. In a study such as *The Swing* (see illustration) he caught the essence of sunlight—but was accused of dusting his models with powder.

Documentation or not, Impressionism was clearly influenced by Chevreul, Delacroix, and Turner.

The Impressionists were among the first artists to be able to buy pigments in tubes. This allowed for great freedom of color mixture and application and also led to the common use of white canvas. In style, the Impressionists tended to let their brushstrokes mingle and then to intermix related hues. The Neo-Impressionists, on the other hand, tended to keep their dabs neatly separated and to introduce opposites. Also, the Impressionists liked to study colors in nature, while the Neo-Impressionists took a stricter and more scientific view.

The Impressionist technique of pointillism is eloquently described by John Rewald in his *The History of Impressionism.* "Monet had already made extensive use of vivid brushstrokes, and so had Renoir, who, in his study *Summer*, exhibited at the Salon of 1869, had introduced large dots into the background, representing leaves. At the *Grenouillère* the two friends now used rapid strokes, dots, and commas to capture the glistening atmosphere, the movement of the water and the attitudes of the bathers. What official artists would have considered 'sketchiness'—the execution of an entire canvas without a single definite line, the use of the brushstroke as a graphic means, the manner of composing surfaces entirely through small particles of pigment in different shades— all this became now for Monet and Renoir not merely a practical method of realizing their intentions, it became a necessity

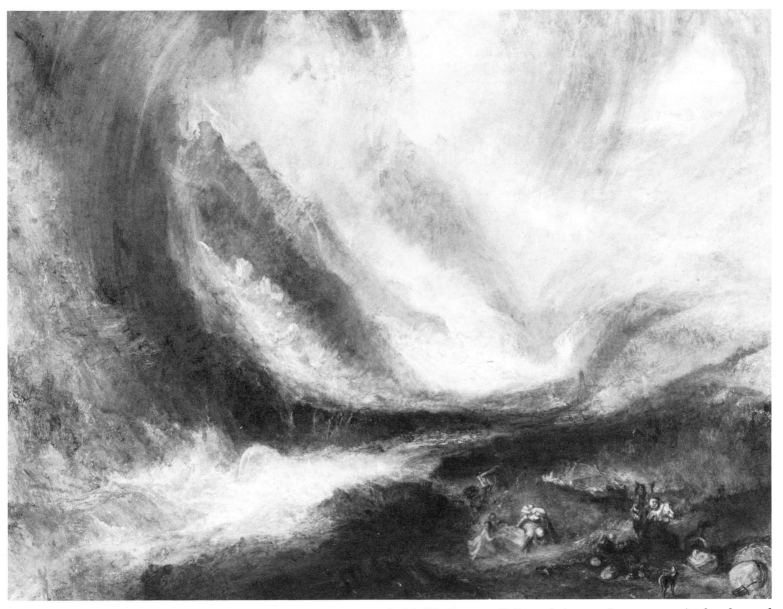

J. M. W. Turner, Valley of Aosta—Snowstorm, Avalanche and Thunderstorm. *His bold technique and original use of color became great influences in art. (Courtesy The Art Institute of Chicago, Frederick T. Haskell Collection.)*

if they were to retain the vibrations of light and water, the impression of action and life. Their technique was the logical result of their work out-of-doors and their efforts to see in subjects not the details they recognized but the whole they perceived. While Monet's execution was broader than Renoir's, his colors were still opaque, whereas the other was using brighter colors and a more delicate touch."

Ogden N. Rood lived during the time of the Impressionists. Yet he seems to have been little concerned with their efforts. This may have been because his European tours to study painting favored Germany rather than France. While his influence on Neo-Impressionism was substantial, his death in 1902 came before much of this art was shown to the public. Again, Rood was not a champion of French painting.

In an article for a magazine called *The Scrip* (April, 1906) Rood's son Roland wrote as follows:

That Professor Rood in his *Modern Chromatics* endorses Impressionism is an assertion frequently enough made; but what he himself thought about the matter is not so generally known. I once had the opportunity of finding out. I had been abroad studying painting in the Paris art schools, and had also tasted Impressionism in Giverny; my head was filled with violent violets and chrome yellows, and the forms of solid bodies seemed *à la* Giverny, as illusory as dreams. In this state of mind, with his book "under my arm," I went to call on my father to tell him that all the excellence of my pictures was due to his recipes. My enthusiasm was instantly cooled, however, when I saw him. He seemed ill and mentally much depressed.

"Are you ill?" I asked.

"No," he replied, "I am very well, but I have just been to see an exhibition of paintings at the galleries of Durand-Ruel," and he groaned.

"What are they?"

"They are by a lot of Frenchmen who call themselves 'Impressionists', some are by a fellow called Monet, others by a fellow called Pissarro, and a lot of others."

"What do you think of them?" I ventured.

"Awful! Awful!" he gasped.

Then I told him what these painters said of his theories. This was too much for his composure. He threw up his hands in horror and indignation, and cried—

"If that is all I have done for art, I wish I had never written that book!"

Some years later, I had the opportunity thoroughly to discuss the question with him. It was in the country, and together we tried many experiments in landscape painting, always referring to his book for the rules. At times, he seemed doubtful if in fact he had not endorsed Impressionism; he seemed to feel that possibly while searching for truth in one direction he had also uncovered it elsewhere. Turner he understood and considered logical. The conclusion, however, to which he finally came is summed up in the last statement he made to me regarding the matter:

"My son, I always knew that a painter could see anything he wanted to in nature, but I never before knew that he could see anything he chose in a book."

This is difficult to explain. Perhaps it was that while Rood influenced art, art in turn did not influence him.

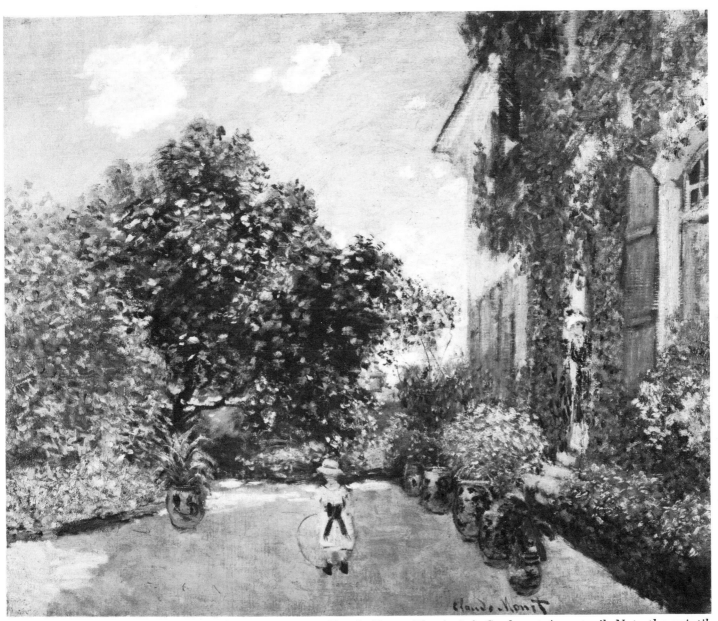

Claude Monet, The Artist's Garden at Argenteuil. *Note the pointillist technique. (Courtesy The Art Institute of Chicago, Mr. & Mrs. Martin A. Ryerson Collection.)*

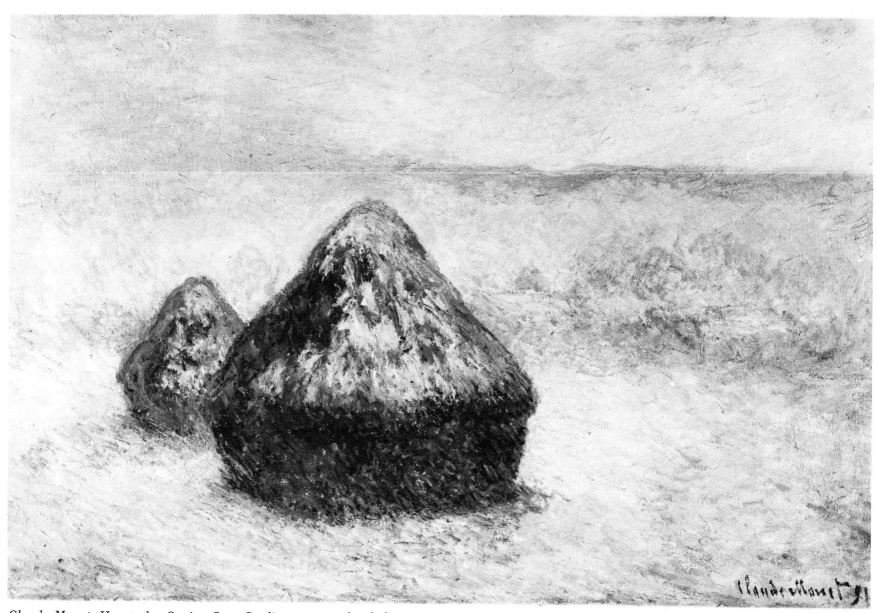

Claude Monet, Haystacks, Setting Sun. *Studies were made of the same subject at different times of the day. (Courtesy The Art Institute of Chicago, Potter Palmer Collection.)*

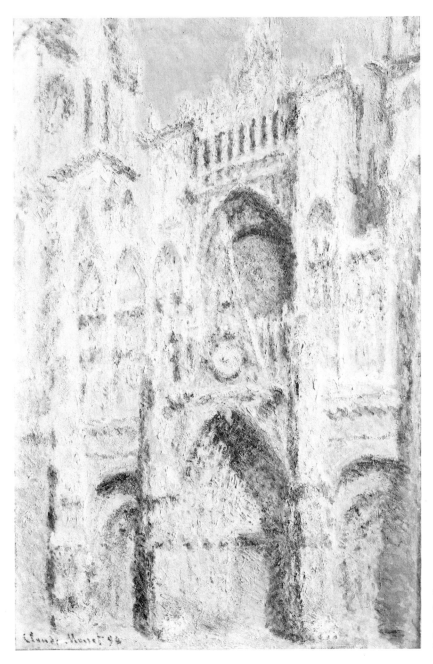

Claude Monet, Rouen Cathedral. *One of a series expressing the many aspects of sunlight. (Courtesy The Metropolitan Museum of Art, The Theodore M. Davis Collection.)*

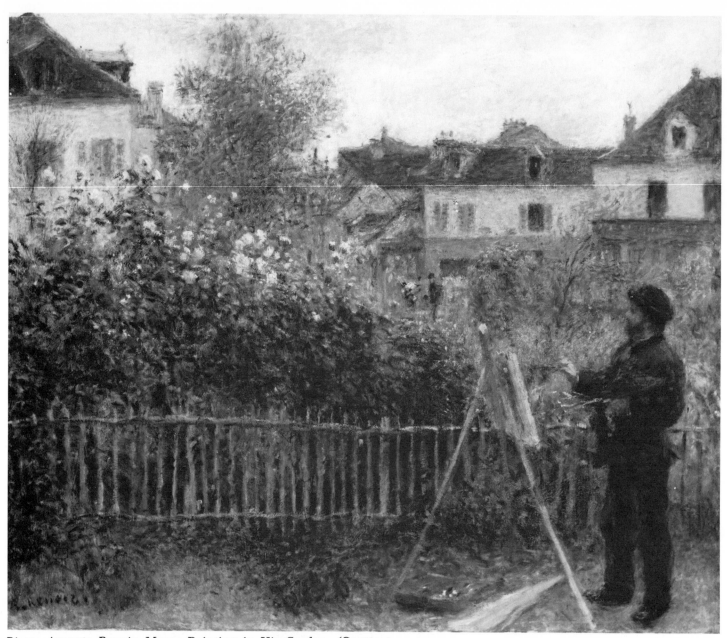

Pierre Auguste Renoir, Monet Painting in His Garden. *(Courtesy Wadsworth Atheneum, Hartford, Bequest of Anne Parrish Titzell.)*

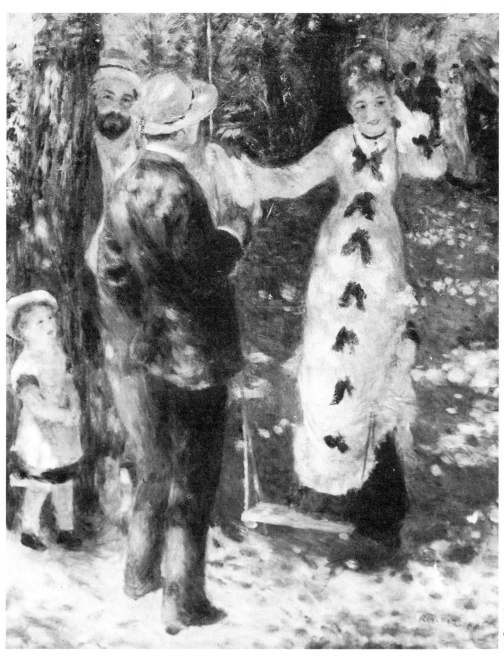

Pierre Auguste Renoir, The Swing. *The technique, style, momentary impression of nature were revolutionary. (Courtesy the Louvre, Paris.)*

33

Neo-Impressionism

CAMILLE PISSARRO (1830–1903)

Of the Impressionists, Camille Pissarro was the one most influenced by Rood and most enthusiastic over the new scientific approach to color. John Rewald tells of a letter written in 1886 (five years after Rood's book appeared in France) to his dealer, Durand-Ruel. In it Pissarro said that he wanted "to seek a modern synthesis by methods based on science, that is, based on the theory of colors developed by Chevreul, on the experiments of Maxwell and the measurements of O. N. Rood; to substitute optical mixture for the mixture of pigments, which means to decompose tone into their constituent elements; for this type of optical mixture stirs up luminosities more intense than those created by mixed pigments."

As it happened, Pissarro met Signac who in turn introduced him to Seurat in 1885, a man younger than Pissarro by some 29 years. Pissarro was later to say, "It is Mr. Seurat, an artist of great merit, who was the first to conceive the idea and to apply the scientific theory after having made thorough studies. I have merely followed his lead."

By nature, Pissarro was a friendly and enthusiastic soul. During his life he did much to placate quarrels among the Impressionists, to bolster their vanity and to keep them organized as a group. Now taken up with divisionism, he urged his old Impressionist friends also to welcome Seurat and Signac. There was bitter conflict here.

In 1886 at the eighth Impressionist exhibition there was opposition to acceptance of the works of the young artists. In consequence, Pissarro chose to show his paintings in a separate room along with those of Seurat and Signac. Pissarro's son, Lucien, who had taken up the movement, was also included.

The elder Pissarro went all out, so to speak, for the scientific technique. For a while he used a palette made up solely of spectral hues. (See Color Plate III.) For a period of four years he remained a convert—only to be disillusioned.

Yet before his apostasy, Pissarro labored hard to convince close friends to adopt the new "Chromo-Luminarism." Soon Van Gogh, Gauguin, and others were filling canvases with multitudinous dots.

Van Gogh wrote to his brother, Théo, "I have often thought that had I been blessed, two years ago, with the calm temperament of Seurat, for example, I would have been able to survive." He thought equally well of Signac and through this persuasion gave himself wholeheartedly to the divisionist style. (See Color Plate IV.) But not for long, however, for he soon abandoned himself to the far more vital and dynamic expression for which he has become one of the great masters of modern times.

As to Gauguin, he also, with his friend Van Gogh, took up Neo-Impressionism as exemplified in the work of Seurat and Signac. Soon he grew hostile, then sarcastic. In heated discussion over divisionism he, with his friend Emile Bernard, amused himself by painting Neo-Impressionist studies signed by a fictitious *Ripipoint*. The two also wrote ditties on the style. (See illustrations above and following.)

In the end, the genial Pissarro gave up the divisionist technique. He confessed at some length to a friend (H. van de Velde), "I believe it is my duty to write you frankly and tell you how I regard the experiment I made with systematic divisionism by following our friend Seurat. Having tried this theory for four years and having then abandoned it, not without painful and obstinate efforts to regain what I had lost and not to lose what I had learned, I can no longer consider myself one of the Neo-Impressionists who abandon movement and life for a diametrically opposed esthetic which, perhaps, is the right thing for the man who has the temperament for it, but which is not for me, anxious as I am to avoid all narrow and so-called scientific theories. Having found after many attempts (I speak for myself) that it was impossible to be true to my sensations and consequently to render life and movement, impossible to be faithful to the effects, so random

and so admirable, of nature, impossible to give an individual character to my drawing, I had to give up. And none too soon! Fortunately it appears that I was not made for this art which gives me the impression of the monotony of death!"

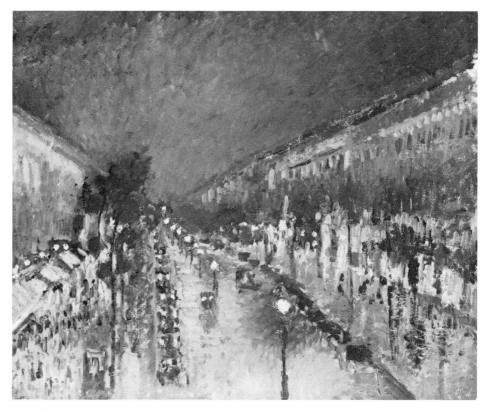

Camille Pissarro, The Boulevard Montmartre at Night. *Though simple in technique, note remarkable effect of luminosity, even in black and white. (Courtesy the trustees, National Gallery, London.)*

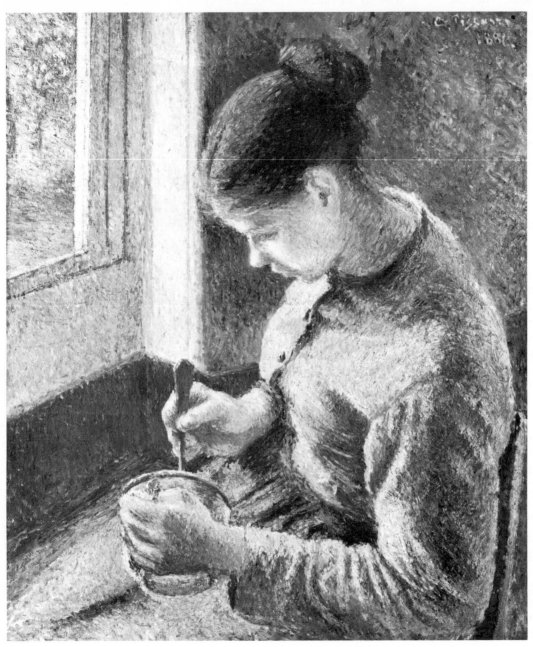

Camille Pissarro, The Cafe au Lait. Note style. This was painted, however, before his ventures into Neo-Impressionism. (Courtesy The Art Institute of Chicago, Potter Palmer Collection.)

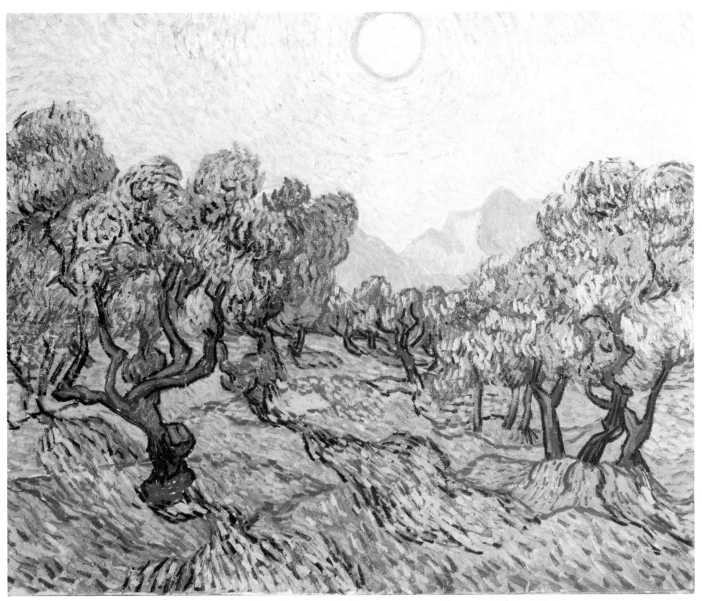

Vincent van Gogh, The Olive Trees. *Though for a short time he practiced a formal divisionism with color, a far more natural style was developed, as here. (Courtesy The Minneapolis Institute of Arts, William H. Dunwoody Fund.)*

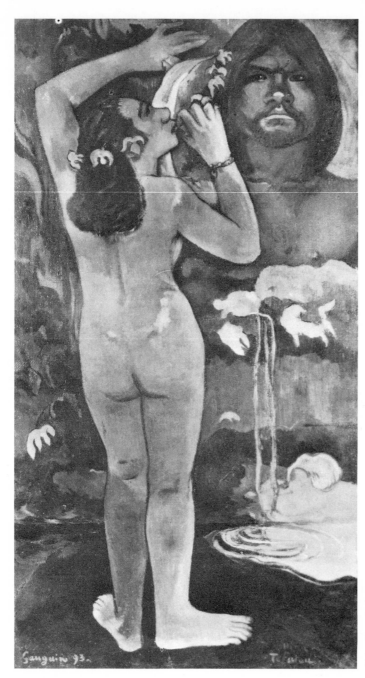

Paul Gauguin, The Moon and the Earth. *He practiced divisionism around 1886, but gave up its restrictions for a more decorative and dramatic style, as here (1893). (Courtesy The Museum of Modern Art, New York, Lillie P. Bliss Collection.)*

GEORGES SEURAT (1859–1891)
PAUL SIGNAC (1863–1935)

Seurat and Signac typically represent the great creative force of Neo-Impressionism. Both, like many of the Impressionists, came of middle-class parents but in early years revealed an innate passion for art. Seurat in particular was a precocious genius and had an amazing capacity for hard work and concentration. If he alone had painted in the divisionist style, he would have been a school all to himself. As it was, he led the movement, conceived it in large part, wrote its prescription, and became the father of a host of disciples.

Seurat and Neo-Impressionism relied heavily on intellectual effort. Science even more than nature was to be studied for many secrets. The Impressionists, on the contrary, were never noted for scholarship or mental application, although Pissarro did make a try during his life, but with little success. Renoir once said, "For me, a picture must be a pleasant thing, joyous and pretty—yes, pretty." To Seurat and his followers, art had to scale greater heights than this. Men like Chevreul, Rood, Blanc, Sutter, Henry (see later notes) delved into complex visual phenomena and at times even sought metaphysical values. For this they were often later chided and rebuked. Jean Sutter in his *Neo-Impressionism* states that before the age of 22 Seurat had annotated the writings of these men.

Seurat learned of Rood's *Théorie scientifique des couleurs* after reading a review of it in a magazine, *Figaro*. He wrote, "Rood having been brought to my nature by an article by Philippe Gille in *Le Figaro*." A new world of color magic now opened for him. Says Robert L. Herbert, "Rood must have struck Seurat with all the force of a scientific revelation."

What Rood was able to do with rare skill was to interpret scientific data in terms that could be understood by an intelligent artist. Through him the Neo-Impressionists learned of Thomas Young and James Clerk Maxwell, the great English scientists, Hermann von Helmholtz, one of the founders of the science of physiological optics, John Ruskin, Sir David Brewster, Ewald Hering, Wilhelm von Bezold, Ernest Rutherford, wise men all, concerned with the mysteries of color and vision.

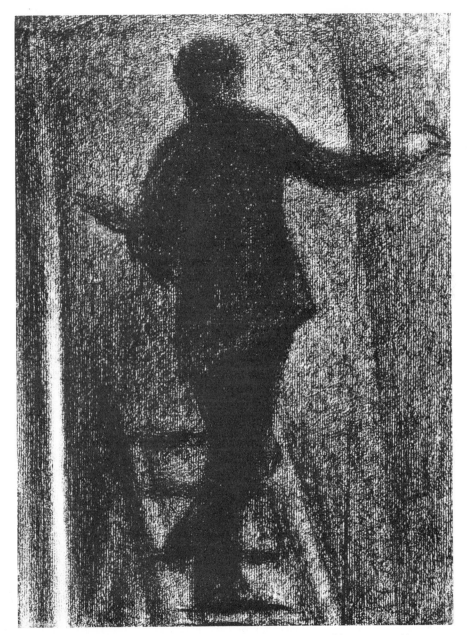

Georges Seurat, His Studio. *A wax crayon self-portrait. (Courtesy The Philadelphia Museum of Art, A. E. Gallatin Collection.)*

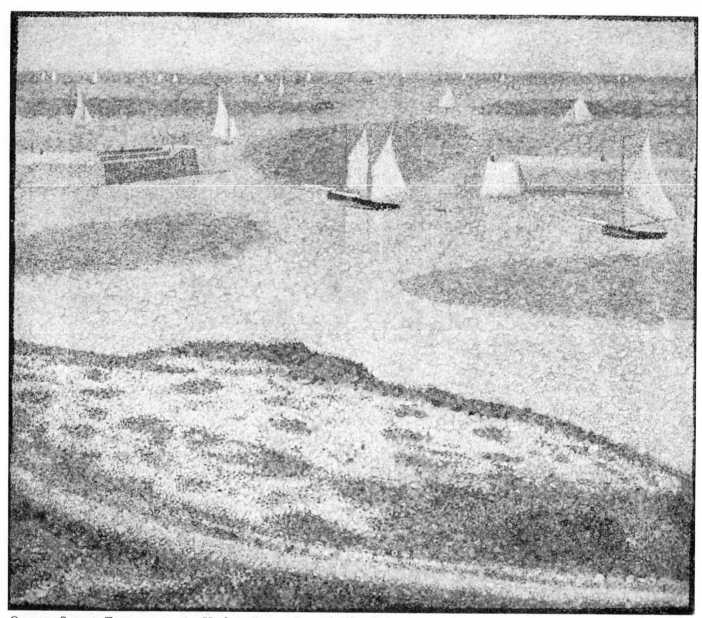

Georges Seurat, Entrance to the Harbor, Port-en-Bessin. *The divisionist style is evident. (Courtesy The Museum of Modern Art, New York, Lillie P. Bliss Collection.)*

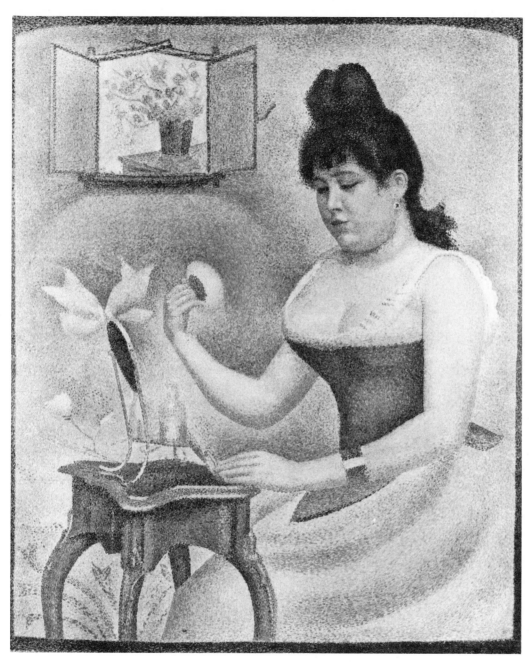

Georges Seurat, La Poudreuse. Dabs of color were applied with little respect to form. (Courtesy Courtauld Gallery, London.)

Chevreul had written of optical mixtures of color in 1839. So had Blanc in 1867. With Rood, the possibilities of applying pigments as sources of light, and of mixing paints as if they were lights, was suddenly unfolded. On page 140 of *Modern Chromatics* he wrote, "We refer to the custom of placing a quantity of small dots of two colors very near each other, and allowing them to be blended by the eye placed at the proper distance." (See facsimile pages 139-140.) As will be repeated later in notes devoted to the 18 chapters of Rood's book, Seurat and his friends and followers busied themselves with new-found techniques. Pigment colors mixed by the eye were additive (a statement not wholly true, however) and gave results quite unlike mixtures of paints, which were subtractive. Seurat could understand, through Rood, that blue and yellow *dots* formed *gray* in visual combination, not green as with pigments. What actually happened with optical mixtures could be anticipated by spinning Maxwell disks.

Rood noted correctly that visual mixtures of related colors formed rich and luminous effects, while visual mixtures of complements cancelled each other and produced dull tones. On the contrary, and as Chevreul had observed, large areas of related colors would, in simultaneous contrast, tend to deaden each other; large areas of complementary colors would lend brilliance to each other.

In his paintings, Seurat carried out Rood's principles. In his earlier canvases he employed some dull earth colors together with purer ones. It is probable that he made corrections here following the advice of Rood's book. Yet when he did his masterpiece, *Sunday on the Island of La Grande Jatte*, he used Rood as a direct source of reference. (See illustration opposite and Color Plates V and VI.)

Seurat's palette was refined during his short span of life. Shortly before he painted *La Grande Jatte* he relied on pure colors and white only.

This palette is known today and is illustrated and described in William Innes Homer's excellent book *Seurat and the Science of Painting*. Jean Sutter (*The Neo-Impressionists*) writes, "At its simplest, late in his career, his palette had nine colors, and each could be mixed with white to any degree." In his style, Seurat worked with adjacent colors, greens for grass, blues for water. As Homer comments, "Seurat lightly flecked the grass, trees, and water with strokes of orange and yellow-orange, which make the picture [*La Grande Jatte*] appear to be inundated by a unifying warm light." He similarly put dabs of blue into shadows. (This practice, however, has now been found to produce dull results not suspected at the time. See later remarks.)

An exceedingly good description of Seurat's style has been written by Robert L. Herbert in his *Neo-Impressionism*. "In a typical Neo-Impressionist painting, a meadow struck by full sunlight will have these separate colors: several different greens, representing the local color of grass which absorbs most of the colors except itself; orange, orange-yellow and yellow, representing elements of pure sunlight and only slightly altered sunlight reflected from the grassy surfaces; greenish-yellow, representing partly absorbed sunlight and simultaneously the color-opposite of the neighboring violet in the shaded portion of the field. In shadow, the field will have stronger greens since the local color is not overpowered by sunlight; blues will represent the quality of indirect light and, more importantly, the color-opposite of the orange-yellow in the sunlit areas; reddish-purples represent the opposite of the sunlit greens; some sparse oranges show the presence of particles of pure sunlight that penetrate the shade."

The Neo-Impressionists also followed Rood's theories of color harmony. Like others before and since, there was agreement that color combinations were harmonious when they were based on (a) closely related hues, (b) direct complements, or (c) triads.

Like most innovators, Seurat's striking and original paintings met with initial rejection by many museums, art critics, and the public. His *Bathers* was denied exhibition by the French Salon. His *La Grande Jatte*, which involved many preliminary sketches and two years of labor, while original and compelling, was largely ignored. He sold only a few paintings during his lifetime. But he was too absorbed in his art to be discouraged.

He had met Camille Pissarro, Vincent van Gogh, and others who also had known failure. Soon he was to be championed by his close friend Paul Signac. In relatively few years

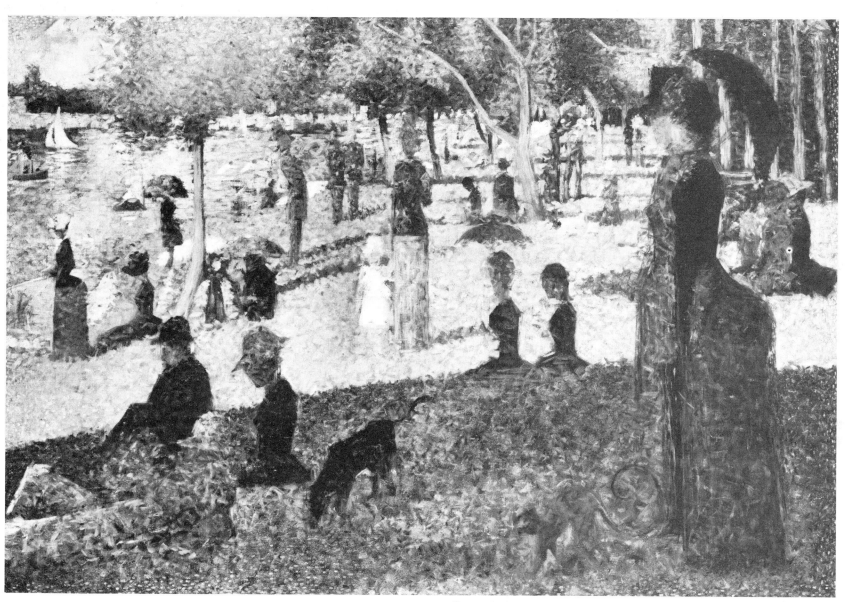

Georges Seurat, An Afternoon at La Grande Jatte, preliminary study. (Courtesy The Metropolitan Museum of Art, Bequest of Samuel A. Lewisohn, 1951.)

(he died at age 32) he had completed about 240 paintings and several hundred drawings. These sold for humiliatingly few francs. His famous *La Grande Jatte* was sold in 1900 for a price of about $160.00 in American money!

As for Paul Signac, he was four years younger than Seurat but outlived him by some 44 years! He began as an admirer of Monet, met Seurat and Pissarro and with them set forth to reshape Impressionism to scientific form. Signac was a man of passionate enthusiasm and had an intelligent and knowledgeable interest in painting, science, literature and politics. His style was less rigid than that of his friend Seurat. The two of them were largely responsible for the formulation of Neo-Impressionist theories. In many respects, Signac was the driving force of the movement. When Seurat died in 1891,

Signac undertook the task of ennobling his friend and endeavoring to tell the world of the majesty of what had been accomplished. He wrote, "And for Seurat: oblivion, silence." Yet through him, Seurat became very much an immortal. In his *D' Eugène Delacroix au neo-impressionnisme*, Signac became the historian, defender, and champion of this unique school. In articles and in a diary, he told of all that had been accomplished. He was president of the Society of Independent Artists for 26 years, vigorously advocating the principles of this new conception of art. (See illustrations herewith.)

Signac, of course, studied Rood avidly. His palette, like that of Seurat, included bright colors: cadmium yellow, vermilion, madder red, cobalt violet and blue, cerulean and ultramarine blue, emerald green, white. (See Color Plate VII.)

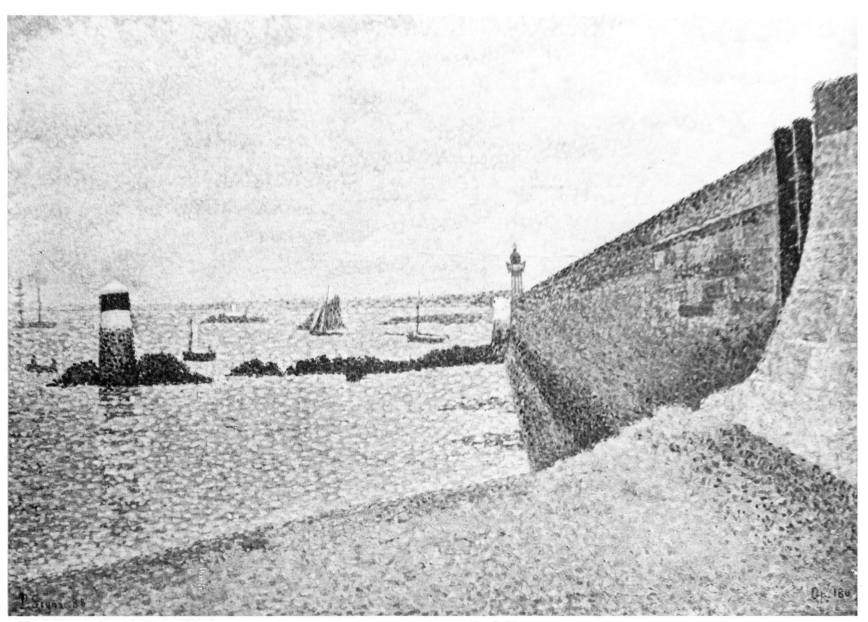

Paul Signac, Pier at Port-Rieux. *Technique dominates a rather uninteresting composition. (Courtesy Rijksmuseum Kroller-Muller, Otterlo, Netherlands.)*

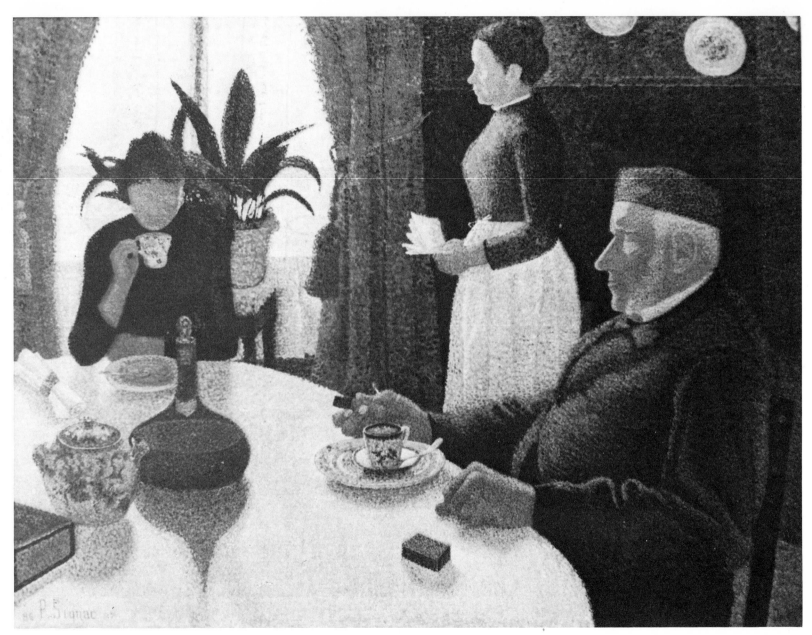

Paul Signac, The Dining Room. *Here there is more style and action. (Courtesy Rijksmuseum Kroller-Muller, Otterlo, Netherlands.)*

OTHER NEO-IMPRESSIONIST PAINTERS

Both Jean Sutter and Robert L. Herbert tell of other Neo-Impressionists who followed Seurat and Signac. Here are a few references.

Albert Dubois-Pillet (1846–1890). He was a self-taught artist, a military officer, active with the Society of Independent Artists and one of its chief organizers. He knew Seurat, Signac, Angrand, Pissarro and used the divisionist technique. Unfortunately many of his works were lost in a fire.

Charles Angrand (1854–1926). He was another of the founders of the Independents and a good friend of Seurat, Signac, Van Gogh. He accompanied Signac on a visit to Chevreul and studied Rood.

Henri-Edmond Cross (1856–1910). Although Cross became a Neo-Impressionist after Seurat's death, he adopted the style and, with Signac, wrote sensitively of color. The two of them often were hosts to artists that later founded the schools of Fauvism and Cubism—Henri Matisse, André Derain.

Maximilian Luce (1858–1941). He was artist, painter, illustrator, engineer, political activist, a man of wide acquaintanceships. He exhibited with the Independents and knew Seurat, Signac, Angrand. He went to London with Pissarro. At Seurat's death he helped Signac go over the artist's estate. (He once painted Buffalo Bill's Circus when it was in Paris.)

Louis Hayet (1864–1940). He was another self-taught artist, met Seurat, Signac, Pissarro. Like others in the movement he studied Chevreul and no doubt was introduced to Rood.

Lucien Pissarro (1863–1944). Lucien was the eldest son of Camille, was trained by his father, and naturally met most of the Impressionists, Neo-Impressionists, and Post-Impressionists of the time. He spent a summer with Signac. He was a strict technician but painted in a rather gentle manner. Because the Pissarro family dwelt on the edge of poverty, the son Lucien was sent to London in 1890 to visit a cousin and make his way as best he could. Here he remained for the rest of his life and had fair success as an illustrator and craftsman of woodcut engravings.

Fauvism

The Neo-Impressionist movement passed away in the blaze of Fauvism. Before this, it was said that Toulouse-Lautrec (1864–1901) and Emil Bernard (1886–1941), a friend of Gaugin, tried their capable hands at the technique. There also were influences in Belgium and Holland (for references see Herbert's *Neo-Impressionism*).

It was Henri Matisse (1869–1954), however, who spent time with Signac (in 1904), took an interest for about a year in Neo-Impressionism and then went on to other and original conquests of his own. (See illustrations.)

Then came André Derain (1880–1954) who knew Matisse and perhaps through him had a brief encounter with divisionism.

And with Robert Delaunay (1885–1941) color was once again glorified and given intellectual and technical attention. Delaunay came under the influence of Seurat, restudied Chevreul, and, knowingly or not, emulated and applied many of Ogden N. Rood's principles.

Henri Matisse, Sideboard and Table. *An example of Neo-Impressionism as practiced for a brief period. (Courtesy Dumbarton Oaks Collection, Washington, D. C.)*

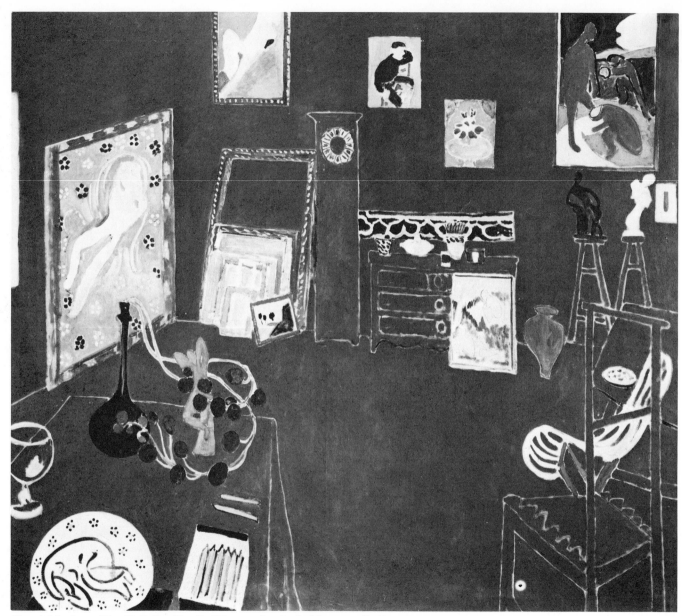

Henri Matisse, The Red Studio. *Brilliant color in bold areas distinguished Fauvism, and Matisse was leader. (Courtesy The Museum of Modern Art, New York, Mrs. Simon Guggenheim Fund.)*

Other Influences

CHARLES BLANC, DAVID SUTTER, CHARLES HENRY

In the development of Neo-Impressionism, other influences than that of Ogden N. Rood deserve mention. Important scientific progress was made in the latter part of the nineteenth century, and this in turn—perhaps for the first time in the history of art—drew the artist away from that which was subjective (inner feelings) to that which was objective (outward observations). The better artists, like Seurat, were able to combine both.

Of great importance was M. E. Chevreul who has been previously discussed. His findings and principles were studied from the time of Delacroix to that of Delaunay, a period of many decades. (Chevreul's book, in French and English, remained in print for 40 years.)

Charles Blanc (1813–1882). William Homer tells of Blanc's career. He was a leading editor, critic, and art historian, and was greatly admired by the artists of his day, particularly those of conservative views. He founded an art magazine, was a member of the Beaux-Arts Academy and taught art history at the Collège de France.

As a scholarly author, Blanc was well respected and was a "power in the official art world." His *Grammaire des arts décoratifs* was published in 1882 and again in 1886. (Blanc also wrote on painters of all nations, masterpieces of Italian art, and on architecture and sculpture.) In 1874 Hurd and Houghton of New York issued an English edition, *The Grammar of Painting and Engraving*. This was followed in 1879 by a book of the same title published by S. C. Griggs & Co. of Chicago.

While by no means as scientific as Rood, Blanc recom-

mended a serious study of color. He mentioned Chevreul and Delacroix and wrote eloquently of the latter's sense and technique of color. Directly related to pointillism and divisionism, he described optical mixtures. Blanc, with an artist's view, spoke of color as emotional and of line (composition) as mental.

David Sutter (1811–1880). According to William Homer, David Sutter, born in Switzerland, studied philosophy, mathematics, music, painting, science, came to Paris at the age of 26, wrote books and articles and gave courses in esthetics.

Although Sutter published books in 1858 and 1865 on the philosophy of art, what appealed to Seurat, Signac, and their friends was a series of articles in *L'Art*, 1880, on the "Phenomena of Vision." These were carefully read and analyzed. Color was to be studied like music. Sutter mentioned Chevreul and Blanc, and was an admirer of Goethe. (The German poet's book on color, *Farbenlehre*, 1810, although a famous one, seemed little known in France and was not mentioned even by Chevreul.)

To Sutter, the artist needed to *know* as well as *feel*. There were laws to be respected. Science could make certainties out of uncertainties. William Homer feels that Sutter's articles may have helped to turn Seurat from the academic views of the Beaux-Arts. If so, he influenced, even if in a small way, the creation of a radical new and remarkable school of color.

David Sutter's writings, unfortunately, have seldom been translated into English.

Charles Henry (1859–1926). Seurat met Charles Henry in 1886. He and Signac became close friends of this young and brilliant man. Henry's interests were wide indeed. He was the same age as Seurat and was equally precocious. By the age of 27 he had written or edited 19 books.

His lectures were attended by many of the Neo-Impressionists. Pissarro, however, was bewildered, while Seurat and Signac paid rapt attention. Signac did lithograph posters, plates, and diagrams for Henry.

In 1888 Henry published *Rapporteur esthétique* and it included an "esthetic table" by which the beauty of line and form could be scientifically measured. The original edition was in portfolio, 12 x 16½ inches, and consisted of a signed, limited edition of 124 copies.

Even more impressive was Henry's *Eléments d'une théorie générale de la dynamogenie*, 1889. This included a magnificent color circle. It was an even larger portfolio, 18 x 23½ inches, and had a limited edition of 115 copies.

(The above two works of Henry have never been put into English, perhaps because of high cost. Original French editions, however, are at the Art Library, Yale University.)

Henry's theories, which the Neo-Impressionists so admired—even if they didn't understand them too well—were highly technical, complex, esoteric, and often psychophysical in content. However, they definitely influenced the composition of Seurat and Signac. Today a scholarly and sympathetic review of Charles Henry and his works will be found in *Charles Henry and the Formation of a Psychophysical Aesthetic*, by José A. Arguelles, University of Chicago Press, 1972.

RAPPORTEUR
ESTHÉTIQUE

DE

M. CHARLES HENRY.

———

NOTICE SUR SES APPLICATIONS

A L'ART INDUSTRIEL, A L'HISTOIRE DE L'ART, A L'INTERPRÉTATION

DE LA MÉTHODE GRAPHIQUE,

EN GÉNÉRAL

A L'ÉTUDE ET A LA RECTIFICATION ESTHÉTIQUES

DE TOUTES FORMES.

PARIS

G. SÉGUIN, ÉDITEUR

Constructeur d'Instruments de Mathématiques

14, BOULEVARD SAINT-MICHEL, 14.

1888.

Charles Henry was sure he had found a scientific answer and formula for beauty.

ÉLÉMENTS

D'UNE

THÉORIE GÉNÉRALE

DE LA DYNAMOGÉNIE

AUTREMENT DIT

DU CONTRASTE, DU RYTHME ET DE LA MESURE

AVEC APPLICATIONS SPÉCIALES

AUX SENSATIONS VISUELLE ET AUDITIVE

PAR M. CHARLES HENRY

PARIS

CHARLES VERDIN

Constructeur d'instruments de précision

7, RUE LINNÉ, 7

1889

Tous droits réservés

This elegant folio book by Charles Henry not only won the admiration of Neo-Impressionists, but a gold medal for excellence of typography and printing.

54

Rood's Influence in America

This writer has devoted considerable time and research to Ogden N. Rood. In endeavoring to trace Rood's influence and that of his book in America, however, small luck has been encountered. Rood's interest in art was broad. As already stated, he studied art in Munich, belonged to a watercolor society in America, exhibited his work here, and once spoke on optics in painting before the National Academy of Design. Yet art in the late nineteenth century held little attention and prestige in America.

Before and after the turn of the century, Paris took the lead in the fine art of painting. Americans by the score crossed the ocean to study at the Beaux Arts, Académie Julien, and other schools. A few of the Impressionists-to-be studied under a Swiss painter and art teacher named Gleyre. The schools of Impressionism, Neo-Impressionism, Post-Impressionism, Fauvism, Cubism, Orphism were French inspired and had worldwide significance. (With apologies to the German school of Expressionism, which arose about the same time.)

Keeping the dates of 1879 (Rood's first American edition) and 1881 (French edition) in mind, one can appreciate that art and color education in America was, frankly, second rate for quite some time.

Back in Colonial and Federal times, Benjamin West of Philadelphia created what was known as the American School in London and became second president of the Royal Academy after Joshua Reynolds. Among his students from America were John Singleton Copley, Gilbert Stuart, Matthew Pratt, Charles Willson Peale, John Trumbull.

Around the time of Rood, however, here are a few statistical facts gathered mostly from E. P. Richardson's *Painting In America*, Thomas Y. Crowell Company, New York, 1956.

The first American art school was established by Charles

Willson Peale in 1795. However, it never gained the eminence of West's London group.

Museums, some with art schools, were organized in New York (1870), Boston (1870), Washington (1860), Chicago (1882). These were founding dates, actual museum buildings coming a few years later in most instances.

Among qualified art schools, 1805 saw the founding of the Pennsylvania Academy of the Fine Arts. Its views were quite conservative until, in 1875, Thomas Eakins returned from Paris to put it in a more vital and contemporary shape. The National Academy of Design in New York, organized in 1826, closed its school in 1875 for lack of funds—to be re-opened in 1877. Previous to its closing, however, Rood delivered two lectures there, in 1874, on "Modern Optics in Painting." These were printed in the 1874 February and March issues of *Popular Science* monthly. What is of interest here is that the lectures predated Rood's 1879 book and contained material that he had in preparation at the time. He knew members of the Academy and had a natural love of art and color. In 1877 the Art Students League of New York came into existence and developed into one of the greatest of all American art teaching centers.

It is questionable that Rood's book was used much as a text anywhere in America. One can assume this by noting Richardson's observation: "Finally, in 1888, Theodore Robinson discovered Monet and Giverny and was the first American to follow the Impressionists." The year 1888 is fairly remote from 1881 when Rood's *Théorie scientifique des couleurs* was published in Paris. And Rood's influence during Neo-Impressionism was yet to come.

Around the turn of the century, England had its colony of American painters such as Whistler. Paris was well represented by Americans such as John Singer Sargent, Childe Hassam, Mary Cassatt. During the same period, Munich greeted such painters as William Merritt Chase who later held well-attended classes at the Art Students League in New York, and Frank Duveneck who also ran a Munich school.

Yet France—over Germany, England, America—led the course of Western art. In tribute to the schools of Impressionism and Neo-Impressionism, shelves can today be filled with innumerable thick and thin volumes, monographs, magazine articles, and catalogs, many authored by Americans. Yet it was in France that Ogden N. Rood, an American, gained his highest prestige.

Technical Evaluation

THE PROBLEM OF *TRITANOPIA*

If the Neo-Impressionists tried their best to work with colors as they might with light, and to create luminous effects through optical mixtures, they both succeeded and failed. Modern scientific studies of vision have revealed facts unknown to the great Ogden N. Rood, to Seurat, Signac, and their compatriots—and to the many writers and critics who studied the movement during its day and ever since its day.

This writer has stood many times before Seurat's *La Grande Jatte* masterpiece at the Art Institute of Chicago. (He went to art school there as a youth.) The painting, which measures about 6½ x 10 feet, is awesome and beautiful to behold—*from a proper distance*. Its appeal is remindful of Rembrandt's *Night Watch*, Velasquez' *Las Meninas,* and El Greco's *Burial of Count Orgaz* for the mood and emotion aroused by the artist. It is easily the highest achievement of the Neo-Impressionist school.

But are the colors truly luminous? Does the technique of dots reflect brightly like lights, fuse in the eye and create luster? The answer is both yes and no, as will now be explained.

Artists, critics, and writers have variously written of both success and failure in the divisionist technique. How can this be? Conflict of opinion centers around how paintings are seen and particularly at what distance. William Homer has remarked on this in his *Seurat and the Science of Painting.* Writing of *La Grande Jatte* he quotes one critic who said, "One could hardly imagine anything dustier or more dull." Another, speaking of the Neo-Impressionists in general, noted that "Instead of excelling in brilliance of color the pictures painted in the ordinary way, they present the most complete spectacle of

discoloration possible to imagine." Even Paul Signac was confused and noted in his diary regarding a Seurat painting, *Les Poseuses,* "Divisionism is carried too far, the dot is too small. This gives that painting a small and mechanical quality. Parts, such as the background for example, covered with these tiny dots, are disagreeable, and all this work seems unnecessary and harmful, since it gives the whole a gray tonality. Other parts, which are treated more boldly, are of a much more beautiful color." One may assume that Seurat himself was aware of this.

Another modern critic has taken the view that "optical mixing seldom occurs in Seurat's work, because one sees separate colors even at a distance." This can hardly be true for three reasons. First, if the focus and attention of the eye are held constant by mechanical or other means, "Under these conditions of uniform or unchanging stimulation the object disappears rapidly or fades out after a few seconds." (R. H. Day, in *Human Perception.*) Second, the eye is always in "a state of oscillation or tremor." It is "primarily sensitive to *changes* in light energy." Because of this it would constantly mix or fuse any jumble of small dots. Third, the head itself, which holds the eyes, will also tend to move slightly.

Homer correctly observes that in looking at the texture in a painting like *La Grande Jatte,* at three feet the pigments will be quite distinct and separate. At six feet, slight fusion will create an effect of luster. At nine feet, although individual colors may not be clearly seen, "one can detect an alternation between warm and cool tones."

At fifteen feet, however, "certain parts of the painting . . . do in fact appear desaturated and neutral in tone." Today science has provided a convincing explanation of this latter phenomenon.

Recent scientific studies of the appearance of colors of "small subtense" have direct bearing on the divisionist technique. While there are several sources of reference, one of the best is *The Measurement of Colour* by W. D. Wright, Professor of Applied Optics at the Imperial College of Science and Technology in London and a leading authority on color vision. As the reader may not be aware, color is recorded only in the center of the retina of the eye, an area called the *fovea,* which is less than $\frac{1}{16}$ inch across but which is packed with thousands of nerve endings (called cones) responding to color, brightness, and detail. Here while there is remarkable acuity, adequate illumination levels are required for the fovea to be active. (The nerves on it become more or less dormant in darkness or near-darkness.) On the outer boundaries of the retina, where relatively fewer nerve endings are found (called rods), there is little or no response to color or detail. Yet this part of the eye is highly efficient under dim illumination.

What has been discovered is that in the *center* of the fovea, there is weak response to blue. As Wright states, "The evidence certainly suggests that the foveal center is devoid of blue receptors, and therefore differs in this respect from other retinal areas." This condition "is similar in general characteristics to the color defect known as *tritanopia.*"

Thus in viewing small dots from a distance under which they have minute "subtense," here is what happens.

Red and green may be fairly well seen and perceived. (Their fusion, however, will tend to appear dull.)

Yet blue and green will be confused.

So will yellow-green be confused with blue-violet or a dull blue.

Orange will be confused with red-purple.

There may be two "neutral" points in the spectrum where yellow may appear to be a light gray, and ultramarine blue a dark gray.

In effect, vision will be limited chiefly to red and green, with other colors holding little significance and actually appearing gray.

There is little wonder, then, that divisionism seen at a distance leads to "a gray tonality" as Signac observed. In particular dabs of yellow-orange (to add sunlight) freely applied in many compositions of Neo-Impressionism will, from a distance, produce a graying result.

The phenomenon of tritanopia for colors of "small subtense" can readily be experienced. Merely apply small dots of color on a dark gray background, keep them fairly separate, and then stand back until they are barely perceptible.

Neo-Impressionism, if distinguished by a divisionist technique of small dabs, is scientifically wanting. Better it would

be to contrast larger areas of color, such as many artists have done since. Where there is no optical confusion, complementary colors, particularly red and green, heighten the brilliance of each other due to simultaneous contrast as noted by Chevreul, Rood, and others. Op art has featured this pair. However, if such complements as red and green are fused or optically mixed, they will cancel out and form muddy browns.

Perhaps the days of optics in art are over. Now new forms of expression will go beyond mere happenings in the eye to the larger exploitation of human perception, for here the brain as well as the mechanism of seeing is involved in the esthetic process.

References

There are many excellent references on the life and career of Ogden N. Rood. Two are of particular interest. The first of these is a *Biographical Memoir* by Edward L. Nichols. This was read before The National Academy of Sciences, April, 1909, and published by the same organization at Washington, D.C., August, 1909, in *Biographical Memoirs,* Volume VI. It includes a complete bibliography of all Rood's writings.

The second is a sympathetic tribute by J. H. Van Amringe, which appeared in the *Columbia University Quarterly,* December, 1902.

At the Low Library at Columbia, in a department called Columbiana, are files regarding Rood's life and various photographs of him and his laboratories.

Columbia University in its main library has an Ogden Nicholas Rood Collection, the gift of Helen Rice, 1966. This material, which is in Special Collections, covers the period of 1855 to 1902; in several large portfolios it includes birth and death certificates, a number of sketchbooks having drawings and watercolors from various parts of America, England, France, and Germany, drawings and paintings by his children, hundreds of personal letters, and over a thousand business and professional letters addressed to him over many years. Only a few of these latter letters have so far been read and classified.

In the preceding history of Impressionism and Neo-Impressionism some references are described in detail in the text itself. Among the many other sources consulted, this writer found the following of special value.

John Rewald, *The History of Impressionism.* The Museum of Modern Art, New York, 1946.

John Rewald, *Post-Impressionism from Van Gogh to Gauguin,* The Museum of Modern Art, New York, 1956.

Rewald's works are invaluable and represent one of the

most remarkable and complete historic reviews of a period in art ever attempted by anyone.

Robert L. Herbert, *Neo-Impressionism*, The Solomon R. Guggenheim Foundation, New York, 1968. Herbert, Chairman of the Yale University Department of Art History, has been a specialist in the history of modern French painting. He assisted the Guggenheim Museum in arranging and cataloging what became probably the largest exhibition of Neo-Impressionist paintings ever before assembled. His book discusses the movement, has biographical notes on artists of the time, and illustrates over 170 compositions in black-and-white and color.

Jean Sutter, *The Neo-Impressionists*, New York Graphic Society, Greenwich, Connecticut, 1970. This is a compilation of essays on the movement and its artists by several authorities, including Robert L. Herbert. It is a large book, 10 × 11 inches, and is generously illustrated with black-and-white and color reproductions.

William Innes Homer, *Seurat and the Science of Painting*, the MIT Press (Massachusetts Institute of Technology), Cambridge, Massachusetts, 1964. This is a very scholarly work on Seurat and his friends, with a history of Neo-Impressionism and analyses of its techniques.

This writer would like to suggest his own book, *History of Color in Painting*, Faber Birren, Van Nostrand Reinhold, New York, 1965. This book of 372 pages and over 500 illustrations devotes space to Ogden N. Rood, Impressionism, and Neo-Impressionism—along with other schools of art since the time of the Renaissance.

Anyone interested in the masterwork of M. E. Chevreul, whom Rood admired and quoted, may refer to *The Principles of Harmony and Contrast of Colors*, with introduction and notes by Birren, Van Nostrand Reinhold, New York, 1967.

Color Plates

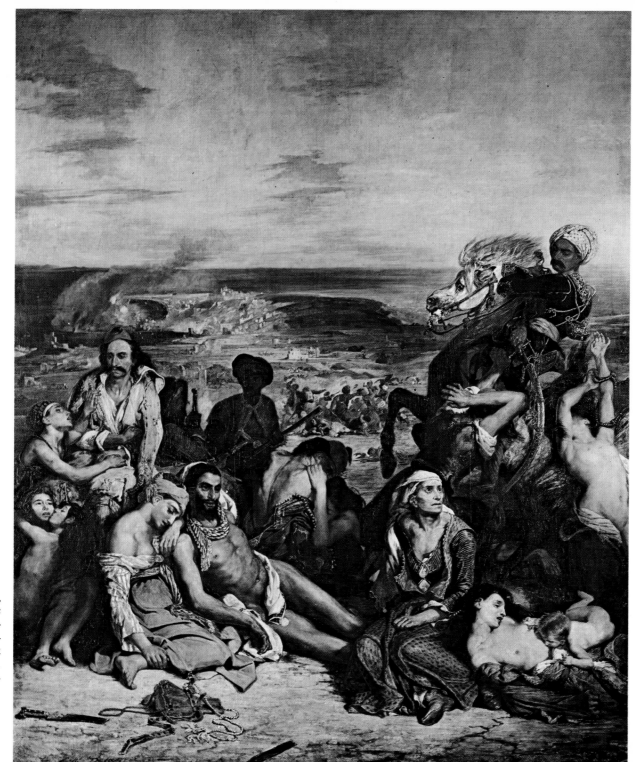

PLATE I. *Eugène Delacroix,* The Massacre of Scio. *He was greatly admired by the Impressionists and Neo-Impressionists and championed a revolt in color expression. (Courtesy the Louvre. Photograph by Giraudon.)*

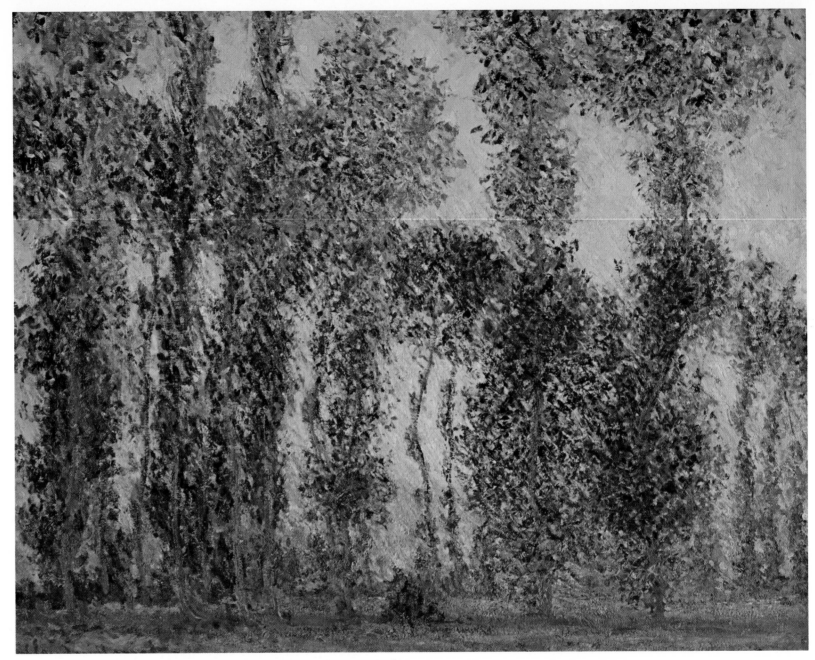

PLATE II. *Claude Monet,* Poplars at Giverny, Sunrise. *Note pointillist technique. This was painted in 1888, seven years after Rood's book appeared in France. (Collection, The Museum of Modern Art, New York, Gift of Mr. and Mrs. William B. Jaffe.)*

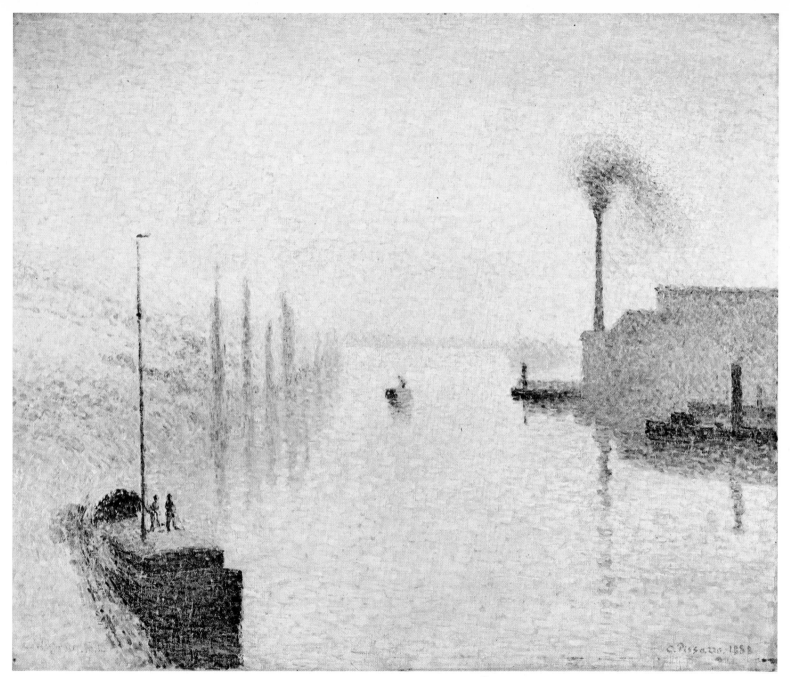

PLATE III. *Camille Pissarro, River—Early Morning. A leading Im-pressionist, Pissarro embraced Neo-Impressionism for a short per-iod. Here is an example of his divisionist style. (Courtesy of John G. Johnson Collection, Philadelphia.)*

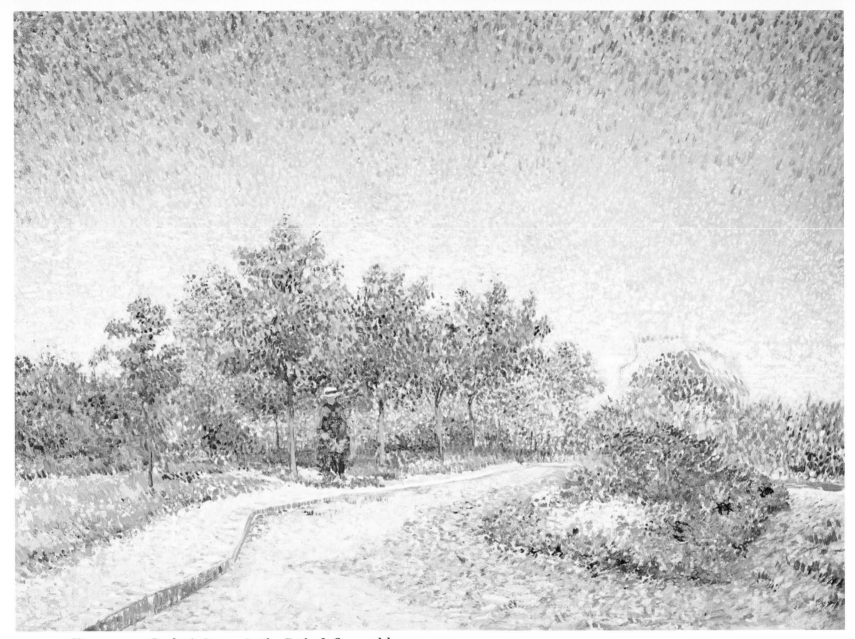

PLATE IV. *Vincent van Gogh, A Corner in the Park. Influenced by Pissarro, and, like him, Van Gogh practiced divisionism, such as here, but not for long. (Courtesy Yale University Art Gallery, Gift of Henry R. Luce.)*

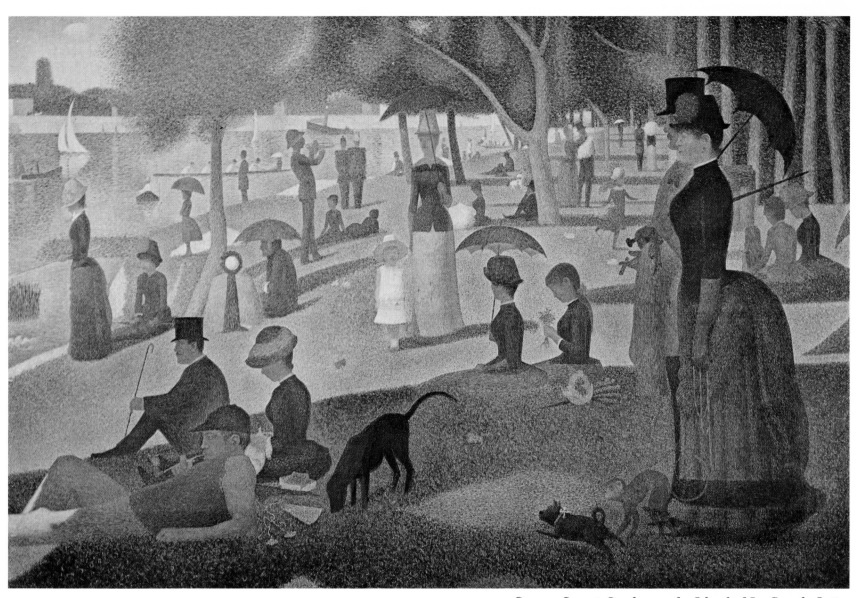

PLATE V. *Georges Seurat*, Sunday on the Island of La Grande Jatte. *This is perhaps the greatest of all paintings of the Neo-Impressionist school. (Courtesy The Art Institute of Chicago, Helen Birch Bartlett Memorial Collection.)*

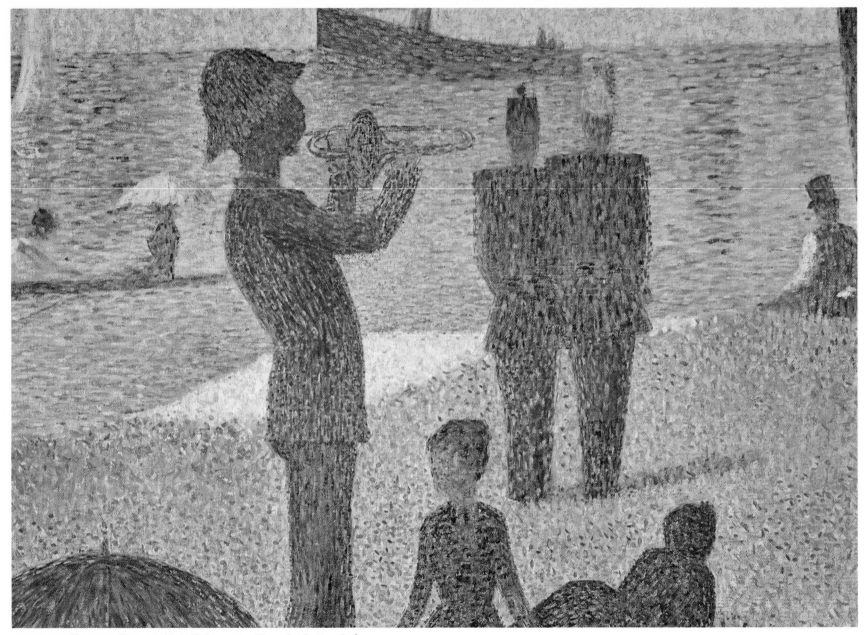

PLATE VI. Georges Seurat, *Detail from* La Grande Jatte. *Colors are applied in spots and dashes, to be mixed in the eye as though they were lights. (Courtesy The Art Institute of Chicago, Helen Birch Bartlett Memorial Collection.)*

PLATE VII. *Paul Signac*, Place des Lices, St. Tropez. *Here is a striking example of Neo-Impressionism and divisionism by one of its most eminent exponents. (Courtesy Museum of Art, Carnegie Institute, Pittsburgh.)*

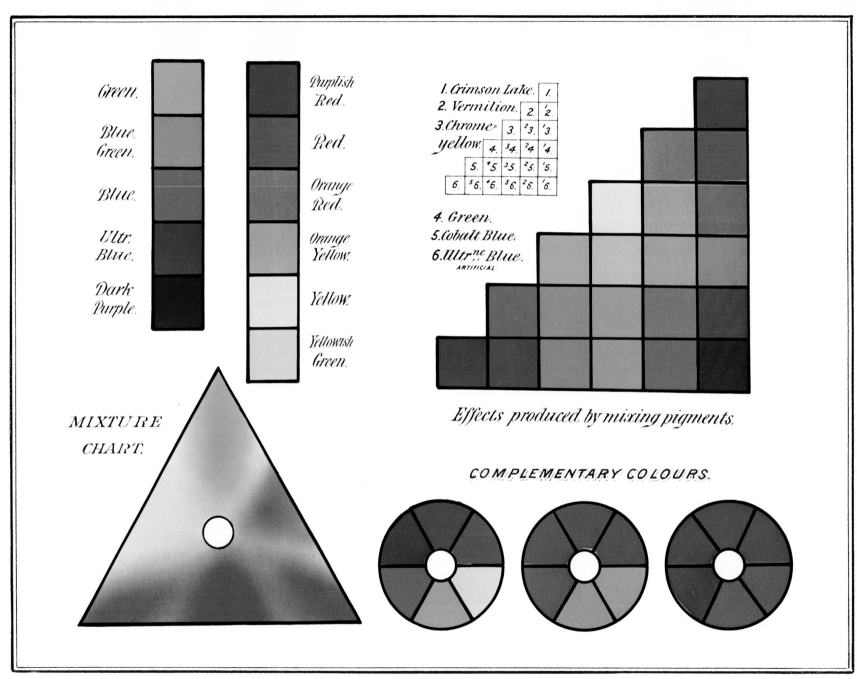

Green.

Blue Green.

Blue.

Ultr. Blue.

Dark Purple.

Purplish Red.

Red.

Orange Red.

Orange Yellow.

Yellow.

Yellowish Green.

MIXTURE CHART.

1. Crimson Lake.
2. Vermilion.
3. Chrome yellow.

4. Green.
5. Cobalt Blue.
6. Ultr.ne Blue.
ARTIFICIAL.

Effects produced by mixing pigments.

COMPLEMENTARY COLOURS.

PLATE VIII. *A rendering of the frontispiece in* Modern Chromatics *by Ogden N. Rood, 1879, using current engraving and printing processes.*

PART II

The Book, MODERN CHROMATICS

Commentary notes by Faber Birren

(Facsimile of *Modern Chromatics,* first American edition of 1879, appears after page 91)

The British Edition.

The French Edition.

The German Edition.

The last American edition, 1916, thirty-seven years after the first edition of 1879.

MODERN CHROMATICS

(Students' Text-Book of Color)
with Applications to Art
and Industry

Rood's book has had the titles shown here. The original edition of 1879 was *Modern Chromatics*. Later, perhaps, because of strong appeal to artists, the title became *Students' Text-Book of Color*. Although in this title *color* was spelled without a *u*, as in America, throughout the text itself the English *colour* will be found.

There is difficulty in trying to determine how many editions and printings were issued. While there are two copyright dates, 1879 and 1881, no editions refer to the number of actual *printings*. Also there is no difference in the text of these 1879 and 1881 editions: both are exactly the same, page by page. Checking various libraries the following title page dates for the American editions have been found: 1879, 1881, 1895, 1899, 1908, 1916, all by D. Appleton of New York.

In Great Britain the first edition of Rood's book was dated 1879, the same year as in America. The title was also the same, *Modern Chromatics*. The publisher in London was C. Kegan Paul & Co. However, at least five more editions were published up to 1910, with the title changed to *Colour, a Text-Book of Modern Chromatics*. The publisher now was Kegan Paul, Trench, Trubner & Co.

In the English language this would mean that Rood's work ran into at least eleven printings over a period of 37 years! This is a remarkable record for a book on color.

The French edition, *Théorie scientifique des couleurs*, is dated 1881 and was published in Paris by Librairie Germer Baillière et cie.

The German edition, dated 1880, had the title *Die Moderne Farbenlehre*. The publisher was F. A. Brockhaus in Leipzig.

Chapter-by-chapter notations and comments now follow for Rood's book. Faber Birren acknowledges the able help of

Ralph Evans in interpreting, in modern terms, some of the more technical aspects. Ralph Evans is a world authority on color. Associated for many years with the Eastman Kodak Company, he supervised color quality control and undertook the development of color processes and the researching of visual effects in photography. His book *An Introduction to Color* has become a general, standard reference source in the broad field of color.

NOTE: Rood's book is largely concerned with light and color. It is interesting to note that it was published in 1879, the same year in which Thomas Edison produced the first commercially practical incandescent lamp. Thus for light sources in his experiments, Rood used daylight or gaslight, as illustrated on page 155 in his book.

Too, the telephone, developed by Alexander Graham Bell around 1877, was hardly in use at the time of Rood's book. Communication at best was slow and time-consuming.

TITLE PAGE AND DEDICATION

The facsimile edition of Rood's book is that of 1879. Let it be remembered that the title was later changed to *Students' Text-Book of Color*.

Dr. Wolcott Gibbs, to whom the book was inscribed, was born in 1882 and died in 1908. He graduated as a chemist from Columbia in 1841 and became a close friend of Rood. During his life, Gibbs was Professor at the College of the City of New York, Professor of Science at Harvard, and dean of the Laurence Scientific School. He made important studies of complex compounds of cobalt and platinum metals. Rood mentions him on page 206.

In the facsimile of Rood's book, the frontispiece has been reproduced in black and white. At the time (1879) photographic halftone process printing had not been developed. Color illustrations were in lithography and were copied by the engraver from an artist's drawing. A true representation of Rood's frontispiece in different and larger arrangement—and reproduced through modern color-process methods—is shown on Color Plate VIII.

To facilitate reference between the notations included in these introductory pages and the actual pages of Rood's book, circled numbers have been placed in the margins of both. This will aid the reader in shifting his interest back and forth with minimum difficulty.

①

PREFACE

Ogden N. Rood was first an eminent scientist and second an artist of fair merit. What is intriguing about his book is his constant interest in and references to art. This is what so inspired the Neo-Impressionists and other painters. As he clearly states in his preface, he wishes "to present in a simple and comprehensible manner the underlying facts upon which the artistic use of color necessarily depends." If this could not make artists out of ordinary mortals, it would at least help to keep human attention well directed. He concludes by saying that he has "devoted a good deal of leisure time to the practical study of drawing and painting." He could understand science and be sympathetic with art—a rare combination.

①

<div align="center">—CHAPTER I—</div>

THE REFLECTION AND TRANSMISSION OF LIGHT

Rood was a remarkable man with broad knowledge, rare insight, and exceptionally keen powers of observation. He was one of the leading American physicists of his day, a pioneer in the new science of physiological optics—and an artist at heart! Most books on the science of color up to his time had concentrated on light and color phenomena as they existed apart from human experience and sensation. At the very start (page 9) Rood declared, "the sense of vision can be excited without the presence of light." This introduced a new concept, in which, as James Clerk Maxwell, the Scottish physicist, had also stated, "The science of color must . . . be regarded as essentially a mental science."

What no doubt startled the Neo-Impressionists was that the study of color as a *physical phenomenon* associated with radiant energy, wave lengths, and the like held little meaning. What went on inside human consciousness was all-important. And here Ogden N. Rood of America spoke like a prophet.

In his first chapter Rood discusses vision in general and the makeup of the eye. He then talks of light itself in the tradition of Newton.

On page 12, however, and as Ralph Evans has pointed out, distinctions are drawn today between the reflection of an ordinary polished surface (a glazed vase) and polished metal (gold, brass). With a yellow or orange ceramic glazed vase, for example, some diffuse reflection may come from below the surface, and the eye will see the yellow-orange color. The specular highlight, however, may be colorless or a mirror of the light source. With polished metal, such as gold, reflection is from the outer surface only. Here the color of the light source will be affected, reflections on gold being a reddish-yellow.

Subtleties like these were later to interest the Gestalt psychologists concerned with "modes of appearance" for color, a viewpoint not recognized at Rood's time.

In reading Rood's text there are constant references to the artist. His discussion of the colors of sky and water (page 12), while largely empirical, are directly pointed toward the artist.

On page 13 he talks of the reflection of opaque materials, or what the Gestalt psychologists later called *surface* colors. Again, with the artist in mind, he cautions that a white drapery may be many colors, due to the proximity of other colored objects near it, which will cast reflections. On page 14 he describes the effect of yellow light from the sun together with blue light from the sky, a situation in nature that had fascinated Leonardo da Vinci many generations before.

On page 14, "Nature paints always with light, while the artist is limited to pigments." However, both could paint with light, and on this point Rood would have more to say.

It is often said that transmitted colors (as seen through glass) are brighter than reflected colors (as from an opaque surface). In most instances this may be true. If a person looks at a spotlight through clear red glass, the red color seen will be far more brilliant than the color that might be *reflected* from a red surface illuminated by the same spotlight. Involved here as well is the difference between *related* and *unrelated* colors to be discussed later. As Ralph Evans points out, the difference between transmitted and reflected light may be "purely a matter of the *relative* intensity of the light reaching the eye." If the transmitted red and the reflected red are balanced as to intensity, the two may well match in a physical sense. However, they may *look* different perceptually. Red light on a white surface, white light on a red surface, and white light shining through a piece of red glass or plastic conceivably could be made to match as to hue, purity, luminosity, brightness, and the like, but there would be three quite different *appearances*. Modern studies of the psychology of perception have dealt with phenomena such as this. Many visual sensations, alike to the physicist, may well be unalike to human experience.

—CHAPTER II—

PRODUCTION OF COLOUR BY DISPERSION

This is a fairly technical chapter. In it Rood goes over the dispersion of light, repeating the prism experiments made famous by Sir Isaac Newton. While artists have little need to be interested in wave lengths, the Neo-Impressionists were probably enlightened to be told that the pure spectrum of light extended from red, through orange, yellow, into green, blue, and violet, but contained no purple.

Regarding the mathematics of color, the Fraunhofer lines mentioned by Rood (pages 20, 21, 22, 25) are today given by the scientist in terms of nanometers (*nm*), one nanometer equaling a millionth of a millimeter. Thus Rood's Fraunhofer lines on the chart on page 21 and table on page 22 can today be stated in nanometers as follows:

A (red) = 759 nm E (green) = 527 nm
a (red) = 720 b (green) = 517
B (red) = 687 F (blue) = 486
C (orange-red) = 656 G (violet-blue) = 431
D (orange-yellow) = 589 H (violet) = 410

In dividing the spectrum into 1,000 parts (pages 21, 22, reference ④) Rood embarked on an arbitrary but highly significant approach to color organization. This suggested a decimal system of color notation and probably influenced Albert H. Munsell, who studied Rood's book, corresponded and met with him, and carried out many of the experiments described by him. Munsell's eventual color solid was based on a decimal system and used color-wheel measurements that Rood set forth and credited to Maxwell.

The colors of the spectrum were not evenly divided in terms of human, visual perception. The eye, in effect, saw spectrum colors in terms of bands. As on page 22 and using 1,000 as a total, blue and blue-violet occupied the largest space (311), followed by space for violet (194), red (149), with least space occupied by yellow (10). Here Rood took the innumerable wave lengths of light and noted that in terms of human sensation, spectrum colors were not infinite in number but fell into bands or groups. (Rood gives this two interpretations, page 22 and page 24.)

Finally, on page 28 in Chapter II, Rood cautioned that in a normal spectrum "we found no representative of purple." He promised to explain later the existence of "other possible tints and hues," plus "the whole range of browns and grays."

—CHAPTER III—
THE CONSTANTS OF COLOR

By *constants*, Rood was referring to what science today calls *variables* or *parameters*. Rood's constants were purity, luminosity, and hue (page 39). These are still recognized today, but may be given different names. *Purity* referred to "the sense of freedom from white light" (page 39) in a color. *Luminosity* referred to "the relative brightness of the colours of the solar spectrum" (page 33). Rood considered this dimension to present a fascinating problem. *Hue* referred to the factor of dominant wave length that distinguished red from yellow, blue, green, violet, etc. On the matter of *luminosity* he presented a table (page 41), noting in connection with it that "the total luminosity of the warm colours will be rather more than three times as great as that of the cold colours."

The Optical Society of America has this to say about color dimensions: "The dominant characteristics of light are dominant wave length, purity, and luminance. They correspond in a very general way to hue, saturation, and brightness which are the attributes of color sensation."

Artists refer also to purity and luminosity (but with different meanings from those of Rood), plus intensity, saturation, tint, shade, tone, and many other nouns. To Munsell, there are hue, value (brightness), and chroma (saturation). As to Rood's *luminosity*, Munsell in measuring his dimension of chroma used the color-wheel and noted, as Rood did, that high percentages of cool colors were required to cancel or balance low percentages of warm colors.

There is not a great deal in this chapter of interest to artists. Rood tells of experiments in which white light is added to colored light to effect matches with surface colors. He continues to refer to the artist and to concepts of such terms as *purity* (page 32), *luminosity* (page 33). Much of this, however, is quite complex. Few artists would care to experiment with mixtures of light, no less concern themselves with the physical (not visual) aspects of color.

Yet when Rood takes up the matter of disk mixtures (page 34) his technical points get closer to problems that concern art—and Neo-Impressionism. Ralph Evans observes that "Grassmann's assumption" (page 35) is usually called "Abney's law." Rood's work was an early check on the validity "that the total intensity of the mixtures of masses of different coloured light is equal to the sum of the intensities of the separate components." This idea of totality in color (components always equaling unity) was to be employed again, but in other ways, by men such as Ewald Hering and Wilhelm Ostwald.

By endeavoring to measure his "constants," Rood laid the groundwork for systematic color order and (page 41) was able to assume that hues which were varied "by the addition of dif-

ferent quantities of white light" could lead to distinguishable tints "as high as two million." This is debatable today, the physicist getting down to fine points and insisting on high numbers, the psychologist and practical worker with color insisting that the human eye and brain struggle to see few rather than many color variations—probably in the order of 30,000 or less.

—CHAPTER IV—
PRODUCTION OF COLOUR BY INTERFERENCE AND POLARIZATION

This chapter again deals with the physical aspects of color. Rood writes at some length of the beauty of colors produced by the polarization of light. On page 44 he describes and illustrates a polarizing apparatus that makes use of a Nicol's prism. For the reader's information, ordinary light emits waves that vibrate in all directions (like water spray from a shower head). Where light is polarized, only waves vibrating on one plane are admitted; waves in other planes are blocked out.

Rood describes the effects of polarized light in eloquent terms. They are like "the most intense sunset hues . . . the spots on a peacock's tail, glowing like coals of fire." Good materials to experiment with were crystals of tartaric acid, thin layers of selenite, common sugar. He writes, regretfully (page 48), "In ordinary life the colours of polarization are never seen; the fairy world where they reign cannot be entered without other aid than the unassisted eye."

Rood would have been pleased to know that, years later, Edwin D. Land would succeed in creating plastic film that did the work of Nicol's prism. The product was called Polaroid, and it was economical in cost. Polaroid soon was used for sunglasses, camera filters, optical and photometric equipment—and then for psychedelic slides!

In so-called light shows these days, discotheques, the electric circus, polarizing crystal slides are commonly found. In these slides are bound a basic glass-mounted crystallized organic chemical, a wrinkled film of clear plastic, and a film of Polaroid. This is then projected on a screen. In front of the projector is another film of Polaroid which is slowly revolved.

Although the materials of the slide itself may be colorless, in the procedure just described there is a fantastic display of brilliant spectral color that *moves and shifts* both weirdly and spectacularly. The patterns seen may resemble frost on a window pane—but in rainbow hues. What was once, in Rood's day, a laboratory novelty, is now part of a modern age of color.

Rood ends Chapter IV with notes on colors produced by interference and diffraction—colors as seen in thin layers, such as oil on water, peacock feathers, the wings of some butterflies and beetles—and on the soap bubble "which displays every colour which can be produced by polarization" (page 50).

What would have intrigued Rood today are phenomena associated with what are called liquid crystals. These are highly sensitive to temperature changes and will change color accordingly. Perhaps the reader has seen (or purchased) a novelty called "Touch me" which looks like a coaster and has a clear center disk filled with a liquid crystal. As this is touched, pressed, twisted, the colors change like a molten mass of yellow, green, blue, violet. In medicine, and because of extreme sensitivity to heat, liquid crystals coated on the body can be used to detect certain forms of cancer, skin tumors, arthritic joints, muscular irritations. As an art form they may one day be applied to abstract paintings or plastic forms, shifting in color as they are exposed to changes in heat, or as they are touched by the art patron.

—CHAPTER V—
ON THE COLOURS OF OPALESCENT MEDIA

In reading Chapters IV and V, Ralph Evans suggested the following: "Perhaps a general note might be in order to the effect that the observations in Chapters IV and V are correct but that the explanations have been found to be considerably more complex than he [Rood] thought. The explanations include, among others, the subjects of colloidal particles, selective scattering, resonance phenomena, and metallic reflection, none of which were known at that time. They are to be found in the difficult subject of 'physical optics.' "

Because in this tribute to Rood the chief concern is with art, with Impressionism, Neo-Impressionism, and schools of color that came later, it is perhaps best to place emphasis on Rood's remarkable insight, his experiments and empirical observations, and his constant references to painting and painters.

In Chapter V, Rood took up phenomena which have intrigued artists as well as scientists. Some artists, for example, have attempted to simulate opalescent effects with pigments. Opalescence, of course, is not due to the reflection or transmission of colored materials, but to the "selective scattering" of light—with no pigments involved. Yet the beauty of opalescence has and can be convincingly duplicated by the resourceful artist.

On page 56 Rood discusses the bluing effect encountered with black- and white-pigment mixtures. A thin coat of white may appear bluish on a dark ground. And black added to yellow will form an olive-green (page 57). This might well introduce ugliness in a painting—and the bluing effect would be untrue to nature. Pigment mixtures with black did not produce the same result as color-wheel mixtures (page 57), "showing that the blue hue is not, as many suppose, inherent in the black pigment." Any artist would profit from this.

He ends with color phenomena associated with "minute suspended particles," the beauty of sunrise and sunset, which has inspired more artists than any other of nature's wonders. He offers a beautiful description of light changes in nature (pages 59, 60, 61), touches on aerial perspective (the graying effect of distance). On page 61 he lists the colors of sunset: yellow, orange, red, purple, violet-blue, gray-blue.

One wonders why he did not include pink, which Evans mentions is "the simple additive mixture of the yellow-red from the sun and the blue of the sky." And how about lack of mention of green? An artist should know that in a sunrise or a sunset, as yellow blends into blue, *in light,* green is not formed. If with watercolors, oils, or pastels, the artist includes greens in a sunset because yellow and blue mix this way, he is portraying a visual untruth.

PRODUCTION OF COLOUR BY FLUORESCENCE AND PHOSPHORESCENCE

If Rood had written this chapter today, it no doubt would have been longer than a mere two and a half pages. Fluorescence (and to a lesser extent, phosphorescence) is very much part of the modern world. These days fluorescent materials are commonly available in papers, textiles, paints, dyes, plastics, chalks, crayons, posters, "invisible inks."

Fluorescent substances exist everywhere in nature, in chemicals, minerals, metals, liquids, glass, even foodstuffs. First, there is the use of "black light," long-wave ultraviolet (UV). In night club, cocktail lounge, studio, theater, discotheque, with ordinary lights off and UV lights on, the surround is weirdly and compellingly luminous with color. Fluorescent paints, posters, textiles shine vividly and, esthetic or not, represent an uncommon experience.

Second, with ordinary lights and UV lights alternating, different colors can be made to appear (or disappear) on the same object. Works of art that are virtually colorless with ordinary lights on, will reflect red, orange, yellow, green, under UV light.

Third, daylight fluorescent colorants are now on packages, displays, billboards, magazine pages. There are reds, oranges, yellows, greens, brighter and more saturated than ever seen before. Many artists have featured fluorescent paints.

In fluorescence it is assumed that the ultraviolet component of a light source (invisible to the eye) is converted to radiant energy that becomes visible. This probably is only part of the story, for the phenomenon is quite involved and has several aspects. What is obvious, however, is that fluorescent colors are "brighter than bright" in that certain hues which formerly seemed to have a maximum purity (in average light) now are transcended and are more like luminous sources than like mere reflecting ones.

—CHAPTER VII—
ON THE PRODUCTION OF COLOUR BY ABSORPTION

On page 65, Rood mentions that his previous chapters were largely concerned with a "scientific point of view." With colors produced by absorption (selective transmission, as with glass or watercolors, or selective reflection, as with opaque materials) he came closer to the mediums of the artist. The first pages of this chapter are of technical or academic interest only. There is little value to an artist in the physical nature of color or in spectroscopy.

(12) On page 71, Rood observes that when transparent colors are seen in different thickness, there will be color change. A thin layer of yellow glass, for example, will be seen as yellow, but subsequent layers of the same yellow will form orange in transmitted light. Even more layers may produce red. A liquid solution of chloride of chromium may appear green in thin solution and dark red in thick solution. Transparent watercolors were likely to produce similar results. (Many years before, Goethe had made the same observation by studying the appearance of white at different depths in tanks of dyed liquid.)

It may be that Rood's scientific explanations would need revision today, but the empirical facts were there and were worth regarding. Then on page 73, he remarks that transparent colors (glass) have a high degree of luminosity, whereas pigment colors "appear feeble and dull, or pale." As has previously been stated (see comment ③), transmitted colors and reflected colors would probably be the same if the same amount of colored-light energy reached the eye. Rood in his day did not recognize the distinction between *related* and *unrelated* colors (nor did the great Hermann von Helmholtz in his masterful book *Physiological Optics*, 1867). When a person looks at transmitted light (unrelated) it usually will be seen in a dark environment. If such light gets bright or dim, the eye will adapt and adjust itself accordingly. Yet when opaque colors are seen, the condition is one in which the general surround is fixed and there is little or no eye adjustment. (The color is *related* to its environment.) To give a simple example, sitting in a dark room, an orange light will remain orange in sensation whether it is bright or dim, for the eye will accommodate itself to all luminous differences. Thus unrelated colors usually appear pure in hue and are not likely to have black in them. Sitting in an illuminated room, however, black paint added to orange paint will form brown, for the light in the room will hold the eye to a stable adjustment. Some black content, as Ostwald observed, nearly always exists in surface or opaque colors. Here, fluorescent colors would be excepted.

Black seems to be a negative factor with unrelated colors and a positive factor with related colors.

On pages 77, 78, Rood comments on certain visual qualities encountered with pigments and on differences found with pastels, oil paints and watercolors, facts which most artists understand. Lighting was significant: "Almost any surface looks beautiful if very brightly illuminated."

Beginning on page 78, Rood comments on the different visual qualities of fabrics, of silk, wool, cotton. "Coloured light which is reflected from silk is more saturated or intense." There are pertinent observations on the "colour of water . . . and of vegetation" (page 81). Here his excellent powers of observation would surely hold vital meaning to an artist, He writes of skies, lakes, vegetable matter, and how they appear under various conditions. Chlorophyl in plants reflected colors, which green paint did not, a fact later confirmed. Were the leaves of a tree green? "Under the red light of the setting sun foliage may assume a red or orange red hue" (page 83). Painters of the school of Fauvism were to see this, whether or not they had studied Rood's book.

In his remarks on photography (page 86) Rood was frustrated by the fact that the photographic materials of his time were based on silver, which was sensitive mainly to blue and ultraviolet. As Ralph Evans notes, sensitizing dyes for the other regions of the spectrum were not discovered until later years.

Finally, his Appendix (page 88) in which he lists pigments and their resistance to the action of light no longer applies, except in small part. Progress in the formulation of new colorants has since been substantial.

—CHAPTER VIII—
ON THE ABNORMAL PERCEPTION OF COLOUR, AND ON COLOUR-BLINDNESS

A vast fund of knowledge on color blindness has been accumulated since Rood's time. Important findings will be found in the writings of Deane B. Judd of the United States and W. D. Wright of Great Britain. What Rood had to say on the matter was good for his time, and his descriptions of color-blind individuals are essentially correct.

In this chapter, Rood once again reveals his powers of observation and his diligence in conducting experiments related to vision. On page 92 he begins a discussion of what Aristotle centuries earlier had referred to as "the flight of colors." After looking at a brilliant white surface or light source, subjective afterimages will be seen. These may be positive or negative in character. With the aid of black and white disks (page 93) color effects can be stimulated.

That vision is as much in the brain as in the eye is well confirmed these days. Edwin D. Land, inventor of the Polaroid camera, demonstrated a few years ago that by combining two projected black-and-white photographic images on a screen, through a clear and a red filter, colors such as blue and violet could be perceived—even though no blue or violet wave length existed in the light sources used to project the two images. (See *Scientific American*, May, 1959.)

Equally startling are the results of taking psychochemicals such as LSD. Under their effects a world of brilliant, luminous, and flowing color is experienced. Rood would have been fascinated. Through the taking of hallucinogenic drugs has come a school of psychedelic painting in which abstract and fanciful forms are seen and recorded. In recently popular discotheques an attempt was made to create psychedelic experience, without drugs, by pounding the senses with projected lights, mobile color, motion pictures, polarizing slides, stroboscopic flashes—plus sounds amplified to stentorian and often nerve-racking excess.

Rood's reference to Hugo Magnus on page 101 is of passing interest. Studying language as a key to color perception, Magnus concluded that the color sense evolved within the span of recorded history. However, if man in his early writings had few words for color, what he expressed in his art was clear enough; what he saw centuries ago is definitely the same as he sees today. Curiously, the eminent William Ewart Gladstone, prime minister of Great Britain, in analyzing the Homeric poems reached the same erroneous conclusion as Magnus.

—CHAPTER IX—
THE COLOUR THEORY OF YOUNG AND HELMHOLTZ

Ogden N. Rood introduced the Neo-Impressionist painters to celebrated scientists such as Sir David Brewster, Thomas Young, James Clerk Maxwell, and Hermann von Helmholtz. He inspired them to spin colored disks and to note that the results with them were not the same as with the mixture of pigments. This surprising fact turned the views of the artists from paints to lights and led to a wholly original school of color expression. Brewster's theory that the primaries were red, yellow, and blue, gave way to the triad of red, green, and blue (ultramarine) championed by Young and Helmholtz, and to the assumption that nerves in the eye responded primarily to these three hues. Ralph Evans considers Rood's presentation of the Young-Helmholtz theory excellent (page 115). Evans notes, however, that "the concept of absolute primaries as such has pretty much been abandoned." The fundamental curves, which Rood shows on page 114, must be liberally rather than literally accepted.

Beginning on page 110, Rood talks of the mixture of colored *light* and demonstrates methods of experimentation. The Neo-Impressionists took note of this and soon developed theories and techniques (divisionism) of their own. Yellow and blue formed green in pigments, but with disks they formed "yellowish grey" or "reddish grey." In lights themselves, "Helmholtz proved that the union of the pure blue with the pure yellow light of the spectrum produced in the eye the sensation, not of green, but of white light" (page 112).

It is probably not necessary to go into Rood's many details (pages 115–121). While his book was written before the days of process printing, the reader may profit from knowing that today the primaries of light (red, green, blue-violet), in the

form of transparent filters, are, in order, used to make the plates for cyan (blue-green), magenta, and yellow printing inks.

Rood ends his chapter with a prejudiced note about green that seems to be shared by many artists. Green was "troublesome to handle." When it was pure in quality "it becomes at once harsh and brilliant, and the eye is instantly arrested by it in a disagreeable manner" (page 122).

—CHAPTER X—
ON THE MIXTURE OF COLOURS

This is one of the most important of all chapters in Rood's book and one that brought excitement, enlightenment, and glee to the Neo-Impressionists. For a review of fundamentals, Rood clearly established the fact that, with pigments, red (magenta), yellow, and blue (cyan) were primary, while with light, the primaries were red, green, and blue or blue-violet (ultramarine). What he did not appreciate at the time, but which came to his attention later, was that a third set of primaries existed, these being in the visual and psychological realm. At the end of his book (page 324) Rood has a note on a theory of color then recently proposed by Ewald Hering (ca. 1878), a German psychologist. Hering assumed that through a process of "assimilation or dissimilation" the nerves of the eye responded to white (and black), red, green, yellow, and blue. In effect, there were four psychological primaries, red, yellow, green, blue. If Hering's theory has not been confirmed or accepted to explain the mystery of color vision, his concept of four primaries in vision is today admitted.

In the opening pages of Chapter X, Rood discusses mixtures of colored lights. With tables (page 128–130) he lists the results of different light combinations. All this is still quite in order.

He then proceeds to "another method of mixing coloured light.... We refer to the method of rotating disks" (page 130). If Rood had known better of the work of Ewald Hering he would not have assumed that colors mixed with lights were precisely the same as colors mixed visually on color wheels or through the optical diffusion of small dots of paint.

To explain. If 60 units of red light are cast upon a screen, and if 40 units of green light are superimposed, the brightness of the resultant yellow will equal 100 units. Here the two sums add up. However, if a visual disk-mixture of 60 per cent red and 40 per cent green is spun, the resultant color will have a brightness of only 50 units. Here the two percentages are averaged.

In defense of Rood, what is significant here is that light mixtures and color-wheel mixtures bear resemblance to each other, and differ essentially from pigment mixtures. The Neo-Impressionists were being properly directed. Rood describes color-wheel effects in some detail (pages 131–136) and gives credit to Maxwell for the method. He shows how visual mixtures of complementary hues can be made to match combinations of black and white.

Then at the top of page 140 he makes one of the several brilliant statements for which his book came to be revered. "We refer to the custom of placing small dots of two colours very near each other, and allowing them to be blended by the eye placed at the proper distance." When he adds that "The results obtained in this way are true mixtures of coloured light," he overlooks that fact, mentioned above in notation ⑯ that while light mixtures are additive, visual mixtures on a color wheel or through dots are medial. If complements in *lights* form white, on disks they will form gray. Evans remarks, "It is, of course, impossible to produce a true white by juxtaposed complementary dots as long as they are seen against the white background." The Neo-Impressionists had to expose some of Rood's statements to trial and error.

On page 140, Ruskin is quoted on the practice of English painters such as Turner and Constable of "crumbling" their paints—dragging two or more colors over the surface without a thorough mixture of them. Monet was a master of this.

On page 141 he refers to situations in nature "not much used by physicists." Where blue sky and orange sunlight may simultaneous exist within a scene, the colors of objects will naturally be modified. It takes the sensitive eye of the painter to observe this and to include it in his art.

When Rood discusses the effects of colored light shining on colored (pigment) surfaces (pages 149–158) he again

would have profited from the observations of later psychologists. When he studied the results of shining colored light on colored surfaces, as in the illustration on page 155, he did so under conditions in which *the area seen was isolated from its environment.*

In what is known as color constancy, colored areas will *tend* to appear normal under radically different conditions of *general* illumination, if such illumination pervades the larger field of view. For example, looking into an area of white enclosed within a box (such as figure 63, page 155), if red light is introduced through an aperture, the white spot will, of course, be seen as red—which indeed it will be. However, if in an open room, an area of white is placed amid areas of other surface colors—red, green, blue, or anything else—and if the room *at large* is showered with red light, the white area will persist in appearing white, despite the fact that it actually reflects red light. This is color constancy.

Thus Rood's tables on pages 152–154 hold true only if the areas viewed are isolated. Color effects in which the phenomenon of color constancy is capitalized and in which colored illumination is *implied* with pigments have been treated in Faber Birren's *Creative Color*. Here a visual art, as in Neo-Impressionism, is extended to a perceptual art in which brain functions supplement optical ones.

—CHAPTER XI—
COMPLEMENTARY COLOURS

The Neo-Impressionists were quite serious about the matter of complements. Because of Rood, and because of the newly developed divisionist technique, light complements rather than pigment complements deserved attention.

(19) Complements, of course, are not invariable; if they happen to be absolute and to form gray under one condition of illumination, hue adjustments may be necessary for other illuminations. Rood points this out on page 173 in referring to gas-light. (Incandescent and fluorescent light was not yet available.) What Rood has to say holds true mostly for daylight. On page 170 he advised the reader to construct disks

and what pigments to use for them (Appendix, page 178).

The matter of complements would be discussed later in Chapter XV.

—CHAPTER XII—
ON THE EFFECT PRODUCED ON COLOUR BY A CHANGE IN LUMINOSITY, AND BY MIXING IT WITH WHITE LIGHT

Of this chapter, Ralph Evans notes, "The modern reader will be surprised to learn that not much more is known about this subject today than what Rood has included here." This is quite flattering.

(20) Due to the phenomenon of color constancy previously mentioned in notation ⑱ color changes brought about by different intensities of illumination have only minor interest to the artist. He may do his painting under daylight, and his canvases may be seen under artificial light. A few of the old masters (notably Georges de La Tour) did compositions that appeared to be illuminated by candlelight—even when the viewer saw them in full daylight.

It is quite true that pigments mixed with white or black tend to shift in hue, but here much will depend on their tinting characteristics. Surface colors seen under bright light may also appear to have their hues shift when the light level is reduced. In empirical observation, bright light on surface colors tends to shift them toward yellow; under dim light the shift will be toward blue and violet.

Rood's explanation of such phenomena is most involved and of doubtful value to artists. Yet at times he takes the painter's view: In the painting of moonlight landscapes, "the best of them are very decided as to the prevalence of various shades of blue, greenish-blue and violet-blue" (page 187).

He mentions the Purkinje effect, in which, under dim light, blue may appear brighter than red (page 189). Recent studies (of which Rood seemed unaware) further emphasize that as light goes dim white will continue to appear white (it holds its "constancy"), while all other colors and degrees of brightness will tend to blend together and appear like black or near-black.

A gray scale, for example, will have clearly defined steps from white down to black when seen in full light. In very dim light, while white will still be seen as such, the rest of the gray scale will tend to blend together and to appear almost uniformly dark. Curiosities like this dramatize wide differences between color as sensation and color as light energy.

—CHAPTER XIII—
ON THE DURATION OF THE IMPRESSION ON THE RETINA

Rood writes (page 202), "The sensation of sight is always prolonged after the light producing it has ceased to act on the eye." (Edison's Kinetoscope, based on durations of impressions on the retina, did not reach the public until 1893.) In this chapter Evans praises Rood for the early role he played in interesting later workers in a method known as flicker photometry which led to data related to the Standard Observer in colorimetry.

While much of the chapter describes methods of studying retinal duration effects, Rood, as almost always, has something to say to the artist. Ocean waves under sunlight (page 207) resemble streaks, whereas they are indeed moving "round images of the sun," elongated by their motion. Similarly involved are turning wheels that appear transparent, running animals whose legs are only visible when "their motion is being reversed." An artist could portray this much better than "the less discriminating photograph."

—CHAPTER XIV—
ON THE MODES OF ARRANGING COLOURS IN SYSTEMS

Mention was made in the introduction that in 1892 Rood published a paper *On a Color System* and used colored paper disks spun on a color wheel to organize his thoughts. He begins Chapter XIV with the observation that there are colors to be seen by the eye that do not exist in the spectrum, such as brown. Without realizing it he was distinguishing between related and unrelated colors previously discussed in comments ③ and ⑫.

The physicist is often inclined to look upon color as color and to neglect or avoid psychological implications. In what is called *adaptation*, the sensitivity of the eye increases with decreased illumination. If brown does not exist in the full spectrum of light, it most certainly does exist as a *sensation*. A brown swatch of paint with a brightness (in foot-lamberts of 5) if seen in an illuminated room (where colors are related) would not *appear* the same as an area of reflected or transmitted orange light having the same brightness, if it is seen in a dark room (where colors may be unrelated). In effect, equal *facts* of color in the physical sense do not assure equal sensations and equal perceptions. Color constancy also plays a part in this strange but remarkable state of affairs. (See comment ⑱.)

Rood was not aware of adaptation or color constancy when, on page 210, he talks of red taken into a dark room (where visual adaptation would change) and red reduced in "luminosity" by spinning a proportion of black with it on a color wheel (where adaptation would probably not change). There is a world of difference between these two situations. With most of Rood's experiments with color-wheel mixtures it must be assumed that he conducted them in average light.

On page 214 he begins to shape up a color system or color solid by placing 12 spectral hues about an equator and scaling them toward a white center (figure 94).

When "we now diminish somewhat the luminosity of our spectral colours" by introducing black, he formed what could be called shades.

Then on page 217 he put two cones together, one reaching up toward white from a circumference of pure hues, and the other scaling down toward black. With confidence he states: "In this double cone, then, we are at last able to include all the colours which under any circumstances we are able to perceive."

Albert H. Munsell studied Rood's book and met Rood in person. He undoubtedly was influenced (a) to use a decimal system of notation, (b) to try to compromise light and pigment and visual primaries with five base hues, (c) to develop se-

quences and scales through the use of disk and color-wheel mixtures, and (d) to regard, as Rood did, the fact that to keep "luminosity" (or what Munsell called "chroma") in balance warm colors like red were "stronger" than cool colors like green.

According to Munsell's own diary, he made twirling models of two triangular pyramids and applied colors to two tetrahedrons, which he had constructed. Both forms had been conceived by Rood. (In the sphere that he eventually designed, Munsell acknowledged the previous concept of Philip Otto Runge, a German contemporary of Goethe, who had written and illustrated a monograph, *Die Farbenkugel*, in 1810.)

Rood's concept was a great deal like that of Ostwald, who also created a double cone. However, where Rood had "constants" in luminosity, wave length, and purity (page 210), and where Munsell had hue, value, and chroma, the Ostwald system was based on full color, white-content, and black-content. With little question, Munsell developed what later became the best possible system for color identification, while Ostwald's concept (based on principles set forth by Ewald Hering) is better liked by artists as being closer to psychological factors in vision. (Comparisons of the two systems can be made in books edited by Faber Birren and published by Van Nostrand Reinhold in 1969: Munsell, *A Grammar of Color*; Ostwald, *The Color Primer*.)

On page 220 Rood describes what is generally known as the Maxwell Triangle. This is illustrated in black and white on page 221 and *is in full color in Rood's frontispiece*. (For reasons unknown, the colors on the angles of the triangle on page 221 and on the frontispiece do not have the same order. The engraver or printer must have misinterpreted Rood.)

(24) The Maxwell Triangle is based on mixtures in light of spectrally pure red, green, and blue. (See also comment ⑮.) The discussion that follows in the Appendix—pages 224 to 234—would be of small interest to artists, being much involved with Rood's personal concepts of color order. The Maxwell Triangle, duly refined, has become basic to an international colorimetry system.

This generous chapter by Rood meant prophesy and gospel to the Neo-Impressionists. It dealt with afterimages, alternate and simultaneous contrast, brightness contrast effects, color circles, true complements, colored shadows, the influence of backgrounds—phenomena that were close to the heart of the painter and that needed to become an intimate part in his expression.

Just about all the experiments described by Rood could, with little difficulty, be repeated by any average person. Anyone could do more than believe what Rood said—he could literally see for himself.

He begins Chapter XV with the simple device of illustrating that a small square of red paper will appear less brilliant on a similar red ground than on a contrasting green ground. To the artist: "We can actually change colour to a considerable extent without at all meddling with it directly" (page 235).

As to afterimages and successive contrast, when the eye is exposed to an area of color for short lengths of time and the attention then transferred to another area, a complementary image will be seen. These are negative afterimages. (Positive images were referred to in comment ⑭.) Apparently as certain nerves on the retina of the eye are tired by the excitation of a particular hue, the unfatigued nerves, sensitive to the complementary color, will go into action. Explanations are unimportant. On a gray ground the afterimage of green will be rose (page 236). Red "will give rise to a greenish-blue image, blue to a yellow, violet to a greenish-yellow" (page 237). (Rood's complements are diagrammed on pages 246 and 250.) **(25)**

In "more complicated" cases, where other colors were substituted for the gray ground, more interesting effects were to be seen. A green afterimage on yellow would produce an orange (page 238). Here the red afterimage of the green, being red, would mix with the yellow ground to form orange. Such mixtures, though visual, were subtractive in nature, and artists could relate them to actual pigment mixtures.

Where a black square was held on a red ground and then removed (page 239) the afterimage of the space occupied by the black square would appear quite saturated, while the larger red area would appear comparatively dull "as though gray had been mixed with its colour."

These were examples of successive contrast. An understanding of them was vital to any artist—and the Neo-Impressionists were quite aware of this.

Regarding simultaneous contrast, on page 243 Rood properly credits M. E. Chevreul for "his great work on the simultaneous contrast of colours." (An English reprint of Chevreul's masterpiece, with annotations, is listed in the references of the introduction, page 60.) Where, for example, a gray pattern was placed on a hued ground such as green, the gray would take on a complementary tint of red. Complementary effects would be as charted on the figures of pages 246 and 250. To verify Chevreul's findings on simultaneous contrast it was to be noted that effects were best (a) when the ground hue was saturated, (b) when the ground hue completely surrounded and was larger in area than the pattern or surface being contrasted, (c) when the two colors were side by side or placed one upon the other. In Chevreul's work he further noted that effects were at a maximum where *brightness contrast was low.* In effect, simultaneous contrast with light and dark colors was not as dramatic as with colors of similar or equal value (brightness).

On page 245 (after Chevreul) Rood lists changes to be seen in simultaneous contrast. To select one simple example, red on yellow becomes purplish (the blue afterimage of the yellow mixing with the red), while the yellow becomes greenish (the green afterimage of the red mixing with the yellow). Exact complements caused no hue change but added intensity to each other.

Colors close to each other in hue tended to dull each other, while complements tended to enhance and brighten each other. "It is evident in general that the effect of contrast may be helpful or harmful to colours: by it they may be made to look more beautiful and precious, or they may damage each other, and then appear dull, pale, or even dirty" (page 251). Let the artist be aware of this.

Rood's contrast-diagram on page 250 (also on page 293) became law to some of the Neo-Impressionists. An exact copy of it, with the color names in French, was found among Seurat's possessions after his death.

Colored shadows. There is cause to wonder why Rood in his book made no reference to Goethe. Rood spoke and wrote German fluently and spent much time in Germany. Goethe's *Farbenlehre* was published in 1810, and an English translation by Charles Lock Eastlake, an eminent art authority, was issued in 1840. Goethe was world famous as a poet and devoted a number of years to the subject of color. One must conclude that Rood could hardly *not* have known of Goethe's work, but as Goethe bitterly disputed Newton and physicists in general, Rood probably passed the *Farbenlehre* aside as too empirical and unscientific.

Goethe undertook classical experiments with colored shadows, which Rood, beginning on page 254, more or less repeated. (Others had also been intrigued, including Helmholtz.) With a white background softly illuminated with white (daylight) or near-white light, the shadow cast by an object which in turn is lit by a spot of colored light coming from another direction will take on a hue that is complementary to the hue of the latter light source. (See Figures 121, 122, 123, pages 254–256.) A yellow candle-flame will appear to cast a blue shadow. With the background still illuminated by a white or near-white light, a red beam will cast a green shadow, a blue beam will cast a yellow shadow, a green beam will cast a pink shadow. The illusion is quite startling and has never been satisfactorily explained. Artists needed to know about colored shadows. Orange dusk will cast blue shadows on snow. Shadows, in effect, should be complementary, both to the tint of the light source (if it has a tint) and to the object itself. Painters of the Fauve school would later show green shadows on pink faces and red shadows from green leaves, with striking results.

With other contrast effects, on page 260 Rood describes a unique experiment attributed to H. Mayer. If a square of gray is placed within an area of strong color, the two areas will at first appear as such. But if a semi-transparent sheet or film is placed over the entire field, the gray square will now appear as if tinted with the complementary hue of the background. As

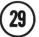

advice to the painter (page 262), "Saturated or intense colours in a painting have less effect on white or grey than colours that are pale." Whites and grays in a painting were likely to appear tinted when surrounded by chromatic hues. Strong effects of contrast needed large areas to influence the appearance of small areas.

Simultaneous contrasts tend to make weak colors look weaker and strong colors stronger when they are side by side (263). On pages 265, 266 Rood has much to say to the painter about the colors of distance in a landscape, "large masses of foliage," willow trees "agitated by the wind." These paragraphs can be read to great profit just as they are presented in Rood's book and do not need repeated notation here.

③⓪ In brightness contrast, where areas of gray are placed against each other, as in flat tones of a gray scale, the edges will be strongly influenced. The edge of the darker color will look lighter, and the edge of the lighter color will look darker. Flat strips of gray tend to appear fluted (page 268). These edges, which seem shaded, are known today as Mach bands, after Ernst Mach who noted them years ago. For the artist, when "mountains rise behind one another, the lower portions of the distant ranges [appear] lighter than the upper outlines." A sky seen at horizon may look brighter than the sky overhead (it sometimes is, however) because of contrast with the dark earth. A red on a white ground will appear darker (page 270); on black it will become more luminous. Other colors will be similarly influenced.

—CHAPTER XVI—

ON THE SMALL INTERVAL AND ON GRADATION

③① If, in relatively *large areas*, adjacent colors tend to dull each other in simultaneous contrast, and if opposite colors tend to intensify each other, where such combinations are optically mixed or blended quite contrary results may be encountered. Now Rood gets down to important points that greatly concerned the Neo-Impressionists and the divisionist technique. Chapter XVI is another one for the artist to read in its entirety.

As set forth on page 275, similar colors will blend harmoniously with each other, while opposite colors, if blended, may produce "a strange and often disagreeable effect." Rood proceeds to give a few examples of this in nature, referring to sky, grass, water. Nature creates infinite variations of color. Even a sheet of white paper (page 277) needs to be portrayed "by delicate gradations of light and shade and colour."

Long training might be required to comprehend the beauties of nature. As great effects in oratory required modulation in tone (page 278), so did art require modulation in color. Turner was particularly famous here.

On page 279, Rood again takes up the matter of visual mixtures of color. Let the reader also refer to pages 139, 140, and to comment ⑰. While visual blends correspond to color-wheel mixtures, they are not additive but medial in result. What the Neo-Impressionists came to find out was that opposite colors in small dots, seen from a short distance, tended to appear lustrous. From a greater distance, however, and when the dots could not be held separate, visually, they tended to cancel each other and appear dull. Adjacent or analogous colors, slightly mixed by the eye, also appeared somewhat lustrous; from a distance they retained a certain richness and did *not* cancel each other. Such blending can be seen in sky, water, grasses, and in "minute sparkling grains of sand" (page 281). ③②

In oil painting, visual mixtures lend "a magical charm." With unusual foresight, Rood described the technique that, under his influence, became known as divisionism and distinguished the Neo-Impressionist style: "If the stippling is formal and quite evident, it is apt to give a mechanical look to a drawing, which is not particularly pleasant; but properly used, it has great value, and readily lends itself to the expression of form" (page 282). All this, for example, will be found evident in Color Plates V, VI and VII devoted to paintings by Seurat and Signac. They are formal and mechanical, but they do express form.

—CHAPTER XVII—
ON THE COMBINATION OF COLOURS IN PAIRS AND TRIADS

Formal principles of color harmony seem academic today. On page 286 Rood notes that while some color combinations are pleasant, others are not. In his day, most art was supposed to be pleasant and harmonious. The Fauve period, which immediately followed Neo-Impressionism and which was the first new art movement of the twentieth century, changed this. Colors that shocked, irritated, broke with convention were quite acceptable and a decided relief from the niceties that had gone before.

For principles of harmony, Rood credits the great Frenchman, Chevreul. In checking the lists of excellent, good, disagreeable, and bad combinations, hardly anyone these days would be impressed. For example, is vermilion with blue excellent, and vermilion with violet bad? On page 291 Rood writes, "Green and blue, for example, make a poor combination." Op Art has introduced dramatic contrasts of green with blue, red with blue, orange with pink, and few viewers are disturbed.

There is evidence that the Neo-Impressionists respected the counsel of Rood and Chevreul and planned color schemes accordingly. If the paintings of Seurat, Signac, and others are original as to technique, their color arrangements are conventional. The interest was with light and mixtures of light, the esthetics of color harmony being of lesser importance.

Page 293 repeats the contrast diagram of page 250 and is the one copied by Seurat. Rood favored complementary hue combinations, as did the Neo-Impressionists, but even here "some of the complementary colours are quite harsh from excessive contrast." Artists today would not agree with this, having known the freedom of bold expression.

Further prejudice against green is found on page 295. Here Rood considered emerald-green to be a difficult color, and one that "exhausts the nervous power of the eye sooner than light of any other colour." Yet green predominates in nature.

On page 299 Rood brings up the harmony of triads—colors that are separated by an angle of 120° in his contrast diagram (Figure 131, page 293). Triads were found in red, yellow, blue; orange, green, violet; orange, green, purple-violet. Such combinations were quite pleasing and were used by the Neo-Impressionists. Yet again, the idea of triad harmonies seems academic.

On page 301, Rood talks of balance. He states, "It has been a common opinion among English writers on colour, that the best result is attained by arranging the relative areas of the colours in a chromatic composition in such a way that a neutral grey would result if they all were mixed together." Albert H. Munsell later thoroughly agreed with this and, using the color wheel as proposed by Rood on page 303, declared that gray-balancing arrangements of color were necessarily harmonious. To Munsell, harmonies were to be found in the balancing of light and dark values and of complementary or triad arrangements. And if the gray balance was at middle value, beauty was automatically assured. Unfortunately, modern art has rebelled at fixed rules. If beauty was to follow law, then law was open to suspicion. Rood himself (page 303) was wise enough to comment that in "the works of good colourists . . . there is always an excess of some positive colour."

Chapter XVII ends with negative remarks as to possible analogies between colors and sounds. Here Rood differed from many men before and after him. To Rood, color had only one octave; the individual hues in a mixture of color could not be distinguished as could notes in a musical chord; there were no measurable intervals in the wave lengths of color as there were vibrations in music. "Any theory of colour based on our musical experience must rest on fancy rather than fact" (page 304).

Let the reader know that relationships between color and music have been championed (if only in fancy) by such men as Aristotle, Newton, George Field (mentioned by Rood), and painters such as Wassily Kandinsky. Opposed have been Thomas Young, Goethe, Chevreul, Helmholtz. Yet color as color, related to music or not, has in recent years found expression in an independent art called lumia.

—CHAPTER XVIII—
ON THE USE OF COLOUR
IN PAINTING AND DECORATION

This is a chapter written for artists by a scientist-artist. It should be read in its entirety by artists, students of art, and students of color. Chapter XVIII, the last one in Rood's book, is largely an essay written by a sensitive and perceptive man. While the power to perceive color was not essential to human life and survival, it added vast pleasure. "The love of colour is a part of our constitution as much as the love of music" (page 305).

In Rood's day, art was primarily concerned with drawing and form. Color was "less important than form." This view, of course, was later rejected when color for the sake of color (independent of form) became the chief fascination of Abstract-Expressionism and Op Art. Color could be pursued for its own sake, having charm, beauty, and deep meaning in and of itself. Abstract art proceeded on its own, free of "representation of natural objects" (page 306).

On page 308 he writes of decorative art and unknowingly anticipates abstract art by remarking that "the ornamenter enjoys an amount of freedom in the original construction of his chromatic composition which is denied to the painter." He can disregard realism. Rood then proceeds to make suggestions and observations regarding color decorations.

There are references to the Alhambra (page 312), to Renaissance art (313), admitting (page 314) that "In decorative art the element of colour is more important than that of form." Abstract artists would later agree.

Rood's admiration of Turner is expressed on pages 315 and 318. He noted that Turner often avoided the use of green. (Turner was also known to dislike purple.)

The road to greatness in color was not an easy one. The artist did not need rules (page 316) but would profit from a study of nature and fine works of art. He was lucky who was blessed with "a natural feeling for what might be called the poetry of colour." He will work hard, "and this work will be pushed on month after month with patient energy, till, after a score of years or so, the student finally, if gifted, blossoms out into a colourist" (page 323).

PART III

Facsimile of MODERN CHROMATICS

First American edition of 1879

1. Crimson Lake.
2. Vermilion.
3. Chrome yellow.
4. Green.
5. Cobalt Blue.
6. Ultr.ne Blue. ARTIFICIAL

Green.
Blue Green.
Blue.
Ultr: Blue.
Dark Purple.

Purplish Red.
Red.
Orange Red.
Orange Yellow.
Yellow.
Yellowish Green.

Effects produced by mixing pigments.

COMPLEMENTARY COLOURS.

MIXTURE CHART.

THE INTERNATIONAL SCIENTIFIC SERIES.

MODERN
CHROMATICS,

WITH APPLICATIONS TO

ART AND INDUSTRY.

BY

OGDEN N. ROOD,

PROFESSOR OF PHYSICS IN COLUMBIA COLLEGE.

WITH 130 ORIGINAL ILLUSTRATIONS.

NEW YORK:
D. APPLETON AND COMPANY,
549 AND 551 BROADWAY.
1879.

TO

Dr. WOLCOTT GIBBS

THIS VOLUME IS INSCRIBED,

AS A SMALL MARK OF THE ATTACHMENT

AND ADMIRATION OF

THE AUTHOR.

PREFACE.

It was not my intention to write a preface to this book, as I have usually found such compositions neither instructive nor amusing. On presenting the manuscript to my publishers, however, it was suggested that, although prefaces are of no particular use to readers, yet from a certain point of view they are not without value.

I accordingly beg leave to state that my object in this work has been to present, in a clear, logical, and if possible attractive form, the fundamental facts connected with our perception of colour, so far as they are at present known, or concern the general or artistic reader. For the explanation of these facts, the theory of Thomas Young, as modified and set forth by Helmholtz and Maxwell, has been consistently adhered to. The whole class of musical theories, as well as that of Field, have been discarded, for reasons that are set forth in the text.

Turning now from the more purely scientific to the æsthetic side of the subject, I will add that it has been my endeavour also, to present in a simple and comprehensible manner the underlying facts upon which the artistic use of colour necessarily depends. The possession of these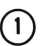

facts will not enable people to become artists; but it may
to some extent prevent ordinary persons, critics, and even
painters, from talking and writing about colour in a loose,
inaccurate, and not always rational manner. More than
this is true: a real knowledge of elementary facts often
serves to warn students of the presence of difficulties
that are almost insurmountable, or, when they are already
in trouble, points out to them its probable nature; in
short, a certain amount of rudimentary information
tends to save useless labour. Those persons, therefore,
who are really interested in this subject are urged to
repeat for themselves the various experiments indicated
in the text.

In the execution of this work it was soon found that
many important gaps remained to be filled, and much
time has been consumed in original researches and ex-
periments. The results have been briefly indicated in
the text; the exact means employed in obtaining them
will be given hereafter in one of the scientific journals.

To the above I may perhaps be allowed to add, that
during the last twenty years I have enjoyed the great
privilege of familiar intercourse with artists, and during
that period have devoted a good deal of leisure time to
the practical study of drawing and painting.

O. N. R.

CONTENTS.

MODERN CHROMATICS.

CHAPTER I.

THE REFLECTION AND TRANSMISSION OF LIGHT.

As long ago as 1795 it occurred to a German physicist to subject the optic nerve of the living eye to the influence of the newly discovered voltaic current. The result obtained was curious : the operation did not cause pain, as might have been expected, but a bright flash of light seemed to pass before the eye. This remarkable experiment has since that time been repeated in a great variety of ways, and with the help of the more efficient electric batteries of modern times; and not only has the original result of Pfaff been obtained, but bright red, green, or violet, and other hues have been noticed by a number of distinguished physicists. If, instead of using the electrical current, mechanical force be employed, that is, if pressure be exerted on the living eye, the optic nerve is again stimulated, and a series of brilliant, changing, fantastic figures seem to pass before the experimenter. All these appearances are distinctly visible in a perfectly dark room, and prove that the sense of vision can be excited without the presence of light, the essential point being merely the stimulation of the optic nerve. In the great majority of instances, however, the stimulation of the optic nerve is brought about, directly or indirectly, by the

aid of light ; and in the present work it is principally with vision produced in this normal manner that we have to deal.

Back in the rear portion of the eye there is spread out a delicate, highly complicated tissue, consisting of a wonderfully fine network woven of minute blood-vessels and nerves, and interspersed with vast numbers of tiny atoms, which under the microscope look like little rods and cones. This is the retina ; its marvellous tissue is in some mysterious manner capable of being acted on by light, and it is from its substance that those nerve-signals are transmitted to the brain which awake in us the sensation of vision. For the sake of brevity, the interior globular surface of the retina is ordinarily called the seat of vision. An eye provided *only* with a retina would still have the capacity for a certain kind of vision ; if plunged in a beam of red or green light, for example, these colour-sensations would be excited, and some idea might be formed of the intensity or purity of the original hues. Some of the lower animals seem to be endowed only with this rudimentary form of vision ; thus it has lately been ascertained by Bert that minute crustaceans are sensitive to the same colours of the spectrum which affect the eye of man, and, as is the case with him, the maximum effect is produced by the yellow rays. With an eye constructed in this simple manner it would, however, be impossible to distinguish the forms of external objects, and usually not even their colours. We have, therefore, a set of lenses placed in front of the retina, and so contrived as to cast upon it very delicate and perfect pictures of objects toward which the eye is directed ; these pictures are coloured and shaded, so as exactly to match the objects from which they came, and it is by their action on the retina that we see. These retinal pictures are, as it were, mosaics, made up of an infinite number of points of light ; they vanish with the objects producing them— though, as we shall see, their effect lasts a little while after they themselves have disappeared.

This leads us in the next place to ask, " What is light, that agent which is able to produce effects which to a thoughtful mind must always remain wonderful ? " A perfectly true answer to this question is, that light is something which comes from the luminous body to us ; in the act of vision we are essentially passive, and not engaged in shooting out toward the object long, delicate feelers, as was supposed by the ancients. This something was considered by Sir Isaac Newton to consist of fine atoms, too fine almost to think of, but moving at the rate of 186,000 miles in a second. According to the undulatory theory, however, light consists not of matter shot toward us, but of undulations or waves, which reach our eyes somewhat in the same way as the waves of water beat on a rocky coast.

The atoms, then, which compose a candle flame are themselves in vibration, and, communicating this vibratory movement to other particles with which they are in contact, generate waves, which travel out in all directions, like the circular waves from a stone dropped into quiet water ; these waves break finally upon the surface of the retina, and cause in some unexplained way the sensation of sight— we see the candle flame. Substances which are not self-luminous cannot be seen directly or without help ; to obtain vision of them it is necessary that a self-luminous body also should be present. The candle flame pours out its flood of tiny waves on the objects in the room ; in the act of striking on them some of the waves are destroyed, but others rebound and reach the eye, having suffered certain changes of which we shall speak hereafter.

This rebound of the wave we call reflection ; all bodies in the room reflect some of the candle light. Surfaces which are polished alter the direction of the waves of light falling on them, but they do not to any great extent scatter them irregularly, or in all directions. It hence follows that polished surfaces, when they reflect light, present appearances

totally unlike those furnished by surfaces which, though smooth, are yet destitute of polish ; the former are apt to reflect very much or very little light, according to their positions, but this is not true to the same extent with unpolished surfaces. The power which different substances have under various circumstances to reflect light is not without interest for us ; we shall see hereafter that this is a means often employed by nature in modifying colour.

As a general thing polished metallic surfaces are the best reflectors of light, and may for the most part be considered by the artist as reflecting all the light falling on them. Polished silver actually does reflect ninety-two per cent. of the light falling perpendicularly on it ; and though the percentages reflected by steel and other metals are smaller, yet the difference is not ordinarily and easily distinguished by an untrained eye.

The case is somewhat different with smooth water : if light falls on it making a small angle with its surface, the amount reflected is as large as that from a metallic surface ; while, if the light falls perpendicularly on it, less than four per cent. is reflected. Thus with a clear blue sky and smooth water we find that distant portions of its surface appear very bright, while those at the feet of the observer are of an almost unbelievable dark-blue tint. In this particular instance, the difference between the brightness of near and distant portions of the water is still further exaggerated by the circumstance that the sky overhead is less luminous than that near the horizon ; and the distant portions of the sheet of water reflect light which comes from the horizon, the nearer portions that which has its origin overhead. The reflecting power of water is constantly used by artists as a most admirable means of duplicating in a picture a chromatic composition, and easily affords an opportunity, by slight disturbances of its surface, for the introduction of variations on the original chromatic design.

It may here be remarked that in actual landscapes containing surfaces of still water, it ordinarily happens that the reflected pictures are not exactly identical with those which are seen directly, and the difference may often be considerable. For example, it may easily be the case that an object beyond the water, and situated at some distance from it, is not seen in the reflected picture at all, light from it either not reaching the water, or reaching the water and not being reflected to the eye of the observer.

Polished surfaces, as we have seen, reflect light not only in large quantity, but they as it were press the light well together in rather sharply defined masses ; with unpolished surfaces the case is entirely different, the light which falls on them being scattered in all directions. Hence, wherever the eye is placed, it receives some of this light, and a change of position produces far less effect on the quantity received than is the case with light reflected from polished surfaces. Owing to their power of scattering light in all directions, rough surfaces, however situated, never send very intense light to the eye.

If a surface of white linen drapery be illuminated by a dozen different sources, it will reflect to the eye a sample of each kind of light, and what we call its hue will be made up of as many constituents. When we remember that all the different objects in a room reflect some, and usually coloured light, we see that the final tint of our piece of linen drapery depends not only on the circumstance that its natural colour is white, but also on the presence and proximity of curtains, books, chairs, and a great variety of objects ; the final colour will hence not be exactly white, but some delicate, indescribable hue, difficult of imitation except by practiced artists. With objects which are naturally coloured, or which show colour when placed in white light, the case becomes still more complicated. Let us suppose that our drapery when placed in pure white light appears red ; its hue will

still be modified by the light it receives from objects in the room : for example, if it receives some green light from objects of this colour placed in its neighbourhood, the red hue will incline toward orange ; if the added portion of light be yellow, the tendency to orange will be still more marked ; on the other hand, light received from blue or violet surfaces will cause the red to pass into crimson or even purple. The grandest illustrations of these changes we find in those cases where objects are illuminated simultaneously by the yellow rays of the sun and the blue light of the clear sky : here, by this cause alone, the natural colours of objects are modified to a wonderful extent, and effects of magical beauty produced, which by their intricacy almost defy analysis. The nature of these changes will be considered in a subsequent chapter, after the principles upon which they depend have been examined.

Finally, it may not be altogether out of place to add that the majority of paintings and chromatic designs are seen by the aid of light which they *reflect* in a diffused way to the eye of the observer ; transparencies, designs in stained or painted glass, etc., are, on the other hand, seen by light which passes entirely through their substance before reaching the eye. Corresponding to this we find that by far the larger proportion of natural objects act upon our visual organs by means of reflected light, while a few only are seen by a mixture of reflected and transmitted light. It hence follows that Nature and the painter actually employ, in the end, exactly the same means in acting on the eye of the beholder. This point, seemingly so trite, is touched upon, as an idea seems to prevail in the minds of many persons that Nature paints always with light, while the artist is limited to pigments : in point of fact, *both* paint with light, though, as we shall hereafter see, the total amount at the disposal of the painter is quite limited.

In concluding this matter of reflection, we may perhaps be allowed to add that the term reflection is quite frequently confused with shadow—the reflected image of trees on the edge of quiet water being often spoken of as the shadows of trees on the water. The two cases are of course essentially different, a genuine, well-defined shadow on water scarcely occurring except in cases of turbidity.

We have seen that all bodies reflect some of the light falling on them ; it is equally true that they transmit a certain portion. A plate of very pure glass, or a thin layer of pure water, will transmit all the light falling on it, except that which is reflected ; they transmit it unaltered in tint, and we say they are perfectly transparent and colourless substances. Here we have one of the extremes ; the other may be found in some of the metals, such as gold or silver : it is only when they are reduced to very thin leaves that they transmit any light at all. Gold leaf allows a little light to pass through its substance, and tinges it bluish-green. Almost all other bodies may be ranged between these two examples ; none can be considered absolutely transparent, none perfectly opaque. And this is true not only in a strictly philosophical sense, but also in one that has an especial bearing on our subject. The great mass of objects with which we come in daily contact allow light to penetrate a little way into their substance, and then, turning it back, reflect it outward in all directions. In this sense all bodies have a certain amount of transparency. The light which thus, as it were, just dips into their substance, has by this operation a change impressed on it ; it usually comes out more or less coloured. It hence follows that, in most cases, two masses of light reach the eye : one, which has been superficially reflected with unchanged colour; and another, which, being reflected only after penetration, is modified in tint. Many beautiful effects of translucency are due to these and strictly analogous causes ; the play

of colour on the surfaces of waves is made up largely of these two elements; and in a more subdued way we find them also producing the less marked translucency of foliage or of flesh.

One of the resources just mentioned the painter never employs: the light which is more or less *regularly* reflected from the outermost surface, he endeavours to prevent from reaching the eye of the beholder, except in minute quantity, his reliance being always on the light which is reflected in an irregular and diffused way, and which has for the most part penetrated, first, some little distance into his pigments.

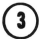

The glass-stainer and glass-painter make use of the principle of the direct transmission of light for the display of their designs. Now, as painted or stained glass transmits enormously more light than pigments reflect in a properly lighted room, it follows that the worker on glass has at his disposal a much more extensive scale of light and shade than the painter in oils or water-colours. Owing to this fact it is possible to produce on glass, paintings which, in range of illumination, almost rival Nature. The intensity and purity of the tints which can thus be produced by direct transmission are far in advance of what can be obtained by the method of reflection, and enable the designer on glass successfully to employ combinations of colour which, robbed of their brightness and intensity by being executed in oils or fresco, would no longer be tolerable.

CHAPTER II.

PRODUCTION OF COLOUR BY DISPERSION.

In the previous chapter we have seen that the sensation of sight is produced by the action of very minute waves on the nervous substance of the retina; that is to say, by the aid of purely mechanical movements of a definite character. When these waves have a length of about $\frac{1}{39000}$ of an inch, they produce the sensation which we call red—we see red light; if they are shortened to $\frac{1}{41000}$ of an inch, their action on us changes, they call up in us a different sensation —we say the light is coloured orange; and as the lengths of the waves are continually shortened, the sensation passes into yellow, green, blue, and violet. From this it is evident that colour is something which has no existence outside and apart from ourselves; outside of ourselves there are merely mechanical movements, and we can easily imagine beings so constructed that the waves of light would never produce in them the sensation of colour at all, but that of heat.

The colour-sensations just mentioned are not the only ones capable of being produced by the gradual diminution of the wave-length: between the red and orange we find every variety of orange-red and red-orange hue; the orange, again, changes by a vast number of insensible steps into yellow, and so of all the other tints. Types of all colours possible, except the purples, could be produced by this method. The colours generated in this way would not only pass by the gentlest gradations into each other, forming a long series of blending hues, but they would also be

perfectly pure, and, if the light was bright, very intense. The advantage of providing, in the beginning of our colour studies, a set of tints possessing these precious qualities, is evident without much argument.

Now, white light consists of a mixture of waves possessing every desirable degree of length, and it is only necessary to select some instrument which is able to sort out for us the different kinds of light, and neatly arrange them side by side in an orderly series. Fortunately for us, we find in the glass prism a simple and inexpensive apparatus which is able to effect the desired analysis. We may, if we are willing to take a little trouble, arrange matters so as to

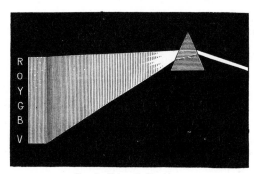

Fig. 1.—Prismatic Spectrum.

repeat the famous experiment made by Newton many years ago: viz., admit a small beam of sunlight into a darkened room, and allow it to fall on the prism, as indicated in Fig. 1. We shall notice, by observing the illuminated path of the sunbeam, that the prism bends it considerably out of its course; and, on tracing up this deflected portion, we shall find it no longer white, but changed into a long streak of pure and beautiful colours, which blend into each other by gentle gradations. If this streak of coloured light be received on a white wall, or, better, on a large sheet of white cardboard, the following changes in the colours can

be noticed: It commences at one end with a dark-crimson hue, which gradually brightens as we advance along its length, changing at the same time into scarlet; this runs into orange, the orange becomes more yellowish, and contrives to convert itself into a yellowish-green without passing noticeably into yellow, so that at first sight yellow does not seem to be present. The orange-yellow and greenish-yellow spaces are brighter than any of the others, but the rise in luminosity is so gradual that the difference is not striking, unless we compare these two colours with those at a considerable distance from them. As we pass on, the tendency to green becomes more decided, until finally a full green hue is reached. This colour is still pretty bright,

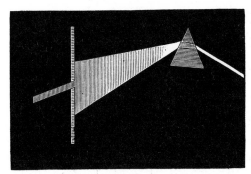

Fig. 2.—Mode of isolating a Single Colour of the Prismatic Spectrum.

and not inferior to the red in intensity; by degrees it changes into a greenish-blue, which will not at first attract the attention; next follows a full blue, not nearly so bright as the green, nor so striking; this blue changes slowly into a violet of but little brightness, which completes the series. If we wish to isolate and examine these tints separately, we can again follow the example of Newton, by making a small, narrow aperture in our cardboard, and use it then as a screen to intercept all except the desired tint, as is indicated in Fig. 2. In this manner we can examine separate

portions of our spectrum more independently, and escape from the overpowering influence of some of the more intense tints. Under these circumstances the greenish-blue becomes quite marked, and the blue is able to assert itself to a greater degree; but the yellow will not be greatly helped, for in fact it is confined to a very narrow region, and it is only by greatly magnifying the spectrum that we can obtain a satisfactory demonstration of its existence.

These experiments, though very beautiful, are quite rough; every two minutes the beam of sunlight strays away from the prism and needs again to be directed toward it; and besides that, the colours blend into each other in such a subtile, puzzling way, that, without a scale or landmark of some kind to separate them, it seems hopeless to undertake any exact experiments. In this difficulty it is to the spectroscope that we must turn for aid; it was certainly not originally contrived for such purposes as these, but nevertheless is just what we need. It is not necessary to stop to describe the instrument, as this has been done by Professor Lommel in another volume of this series; it is enough for us that it is a convenient instrument for sorting out the different kinds of light which fall on it, according to their wave-length, and that it performs this work far more accurately than a prism used according to Newton's plan. Just at this point we can take advantage of a singular discovery made by Fraunhofer, and independently to some extent by Dr. Wollaston, early in the present century. These physicists found that when the coloured band of light just described is produced by a spectroscope, or by apparatus equivalent to one, the band is really not continuous, but is cut up crosswise into a great many small spaces. The dividing lines are called the fixed lines of the solar spectrum. Almost their sole interest for us is in the fact that they serve as admirable landmarks to guide us through the vague tracts of ill-defined colour. Fig. 3 shows the positions of some of the more important fixed lines of

the spectrum. The figure is based on measurements made by the author on a flint-glass prism, with aid of a large spectroscope, or rather spectrometer, admirably constructed by Wm. Grunow, of New York. At the same time a series of observations was made on the extent of the coloured spaces in the spectrum; these are indicated in the figure, and accurately given in one of the tables that follow.* Let us suppose that the spectrum from A to H includes 1,000 parts; then the following table indicates the positions of the fixed lines:

* It will be noticed that the term *indigo*, originally introduced by Newton, has been entirely rejected in this work, and ultramarine substituted for it. Bezold suggested this change some time ago, basing his objection to indigo on its dinginess; the author, however, finds a much more fatal objection in the fact that indigo in solution, and as a pigment, is a somewhat greenish-blue, being really identical with Prussian-blue in colour, only far blacker. In the dry state this tendency to greenness is neutralized by the reddish tinge which the substance sometimes assumes: it was probably used by Newton in the dry state. A mixture of six parts of artificial ultramarine-blue, two parts white, and ninety-two parts black, when mingled according to the method of Maxwell's disks, furnishes a colour quite like that of commercial indigo in the dry state.

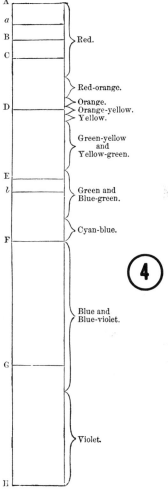

Fig. 3.—Fixed Lines and Coloured Spaces of Prismatic Spectrum.

FIXED LINES OF THE PRISMATIC SPECTRUM.

A	0	E	363·11
a	40·05	b	389·85
B	74·02	F	493·22
C	112·71	G	753·58
D	220·31	H	1000·00

The next table gives the positions of the coloured spaces in this spectrum, according to the observations of the author :

COLOURED SPACES IN THE PRISMATIC SPECTRUM.

Red begins at	0
Red ends, orange-red begins at	149
Orange-red ends, orange begins at	194
Orange ends, orange-yellow begins at	210
Orange-yellow ends, yellow begins at	230
Yellow ends, greenish-yellow begins at	240
Yellow-green ends, green begins at	344
Blue-green ends, cyan-blue begins at	447
Cyan-blue ends, blue begins at	495
Violet-blue ends, violet begins at	806
Violet ends at	1,000

The space out beyond 0 is occupied by a very dark red, which has a brown or chocolate colour, and outside of the violet beyond 1,000 is a faint greyish colour, which has been called lavender.

The third table shows the spaces occupied in the prismatic spectrum by the several colours :

Red	149
Orange-red	45
Orange	16
Orange-yellow	20
Yellow	10
Greenish-yellow and yellowish-green	104
Green and blue-green	103
Cyan-blue	48
Blue and blue-violet	311
Violet	194
	———
	1,000

In making these observations, matters were arranged so that only a narrow slice of the spectrum presented itself to the observer ; thus its hues could be studied in an isolated condition, and the misleading effects of contrast avoided. The figures given in the two latter tables are the mean of from fifteen to twenty observations. The hues of the spectral colours change very considerably with their luminosity ; hence for these experiments an illumination was selected such that it was only comfortably bright in the most luminous portions of the spectrum, and this arrangement retained as well as possible afterward.

The colours as seen in the spectroscope really succeed each other in the order of their wave-lengths, the red having the greatest wave-length, the violet the least. But the glass prism does this work in a way which is open to criticism ; it crowds together some portions of the series of tints more than is demanded by their difference in wave-lengths ; other portions it expands, assigning to them more room than they have a right to claim. Thus the red, orange, and yellow spaces are cramped together, while the blue and violet tracts stretch out interminably. Taking all this into consideration, it may be worth while to go one step further, and, without abandoning the use of the spectroscope, replace its prism by a diffraction grating, or plate of glass ruled with very fine, parallel, equidistant lines, such as have been made by the celebrated Nobert, and lately of still superior perfection by Rutherfurd. In Lommel's work, previously referred to, the mode in which a plate of this kind produces colour is explained ; at present it is enough to know that the general appearance of the spectacle will be unchanged ; the same series of colours, the same fixed lines, will again be recognized ; but in this new spectrum all the tints will be arranged in an equable manner with reference to wave-length. According to this new allotment of spaces, the yellow will occupy about the centre of the spectrum,

2

the red and different kinds of orange taking up more room than formerly ; the dimensions of the blue and violet will be greatly reduced.

Let us suppose, as before, that the spectrum from A to H includes 1,000 parts ; then the following table, which is calculated from the observations of Ångström, will indicate the positions of the principal fixed lines :

FIXED LINES IN THE NORMAL SPECTRUM.

A	0	E	638·92
a	113·74	b	664·79
B	201·61	F	749·24
C	285·05	G	902·07
D	468·38	H	1000·00

The next table gives the positions of the coloured spaces in the normal spectrum, according to the observations of the author :

COLOURED SPACES IN THE NORMAL SPECTRUM.

Red begins at	0
Pure red ends, orange-red begins at	330
Orange-red ends, orange begins at	434
Orange ends, orange-yellow begins at	459
Orange-yellow ends, yellow begins at	485
Yellow ends, greenish-yellow begins at	498
Yellow-green ends, full green begins at	595
Full green ends, blue-green begins at	682
Blue-green ends, cyan-blue begins at	698
Cyan-blue ends, blue begins at	749
Blue ends, violet-blue begins at	823
Blue-violet ends, pure violet begins at	940

The following table exhibits the spaces occupied by the several colours in the normal spectrum :

Pure red	330
Orange-red	104
Orange	25
Orange-yellow	26

Yellow	13
Greenish-yellow and yellow-green	97
Full green	87
Blue-green	16
Cyan-blue	51
Blue	74
Violet-blue and blue-violet	117
Pure violet	60
	1,000

Fig. 4 shows the normal spectrum with fixed lines and coloured spaces, corresponding to the tables just given.

If these tables are compared with those obtained by the aid of a prism of glass, it will be seen that the fixed lines and coloured spaces are arranged somewhat differently ; the main cause of this difference has already been pointed out. When, however, we compare the spacing of the colours in the two spectra, it is also to be remembered that it is affected by another circumstance, viz., the distribution of the luminosity in the two spectra does not agree, and this influences, as will be shown in Chapter XII., the appearance of the colours themselves ; very luminous red, for example, assuming an orange hue, very dark blue tending to appear violet, etc. The normal spectrum employed by the author

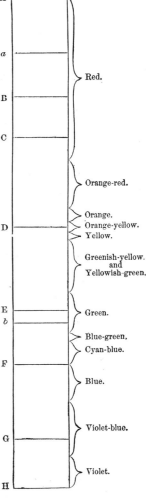

FIG. 4.—Fixed Lines and Coloured Spaces of Normal Spectrum.

was obtained by using a superb plate for which he was indebted to Mr. Rutherfurd. The plate contained nearly 19,000 lines to the English inch, and was silvered on the back, so that the colours were as bright as those from a glass prism. The spectrum selected for use was nearly six times as long as that furnished by the glass prism—a circumstance, of course, that favoured accurate observation.

The tables that have just been given enable us very easily to calculate the lengths of the waves of light, corresponding to the centres of the coloured spaces in the normal spectrum. It is only necessary to ascertain the number corresponding, for example, to the centre of the red space, then to multiply it by 3·653, and to subtract the product from 7,603 : the result will be the wave-length corresponding to that part of the normal spectrum, expressed in tenmillionths of a millimetre. The following table contains the wave-lengths corresponding to the centres of the coloured spaces :

WAVE-LENGTH IN $\frac{1}{10,000,000}$ MM.

Centre of red		7,000
"	orange-red	6,208
"	orange	5,972
"	orange-yellow	5,879
"	yellow	5,808
"	full green	5,271
"	blue-green	5,082
"	cyan-blue	4,960
"	blue	4,732
"	violet-blue	4,383
"	pure violet	4,059

The results here given differ somewhat from those obtained by Listing in 1867 ; the differences are partly due to the terms employed ; the author, for example, dividing up into orange-red, orange, and orange-yellow, a space which is called by Listing simply orange. According to the author

cyan-blue falls on the red side of the line F ; it is placed by Listing, however, on the violet side of this line. Other less important differences might be mentioned ; but, as a discussion of them would be out of place in a work like the present, the curious reader is referred for further information to Listing's paper.*

A little study of the normal spectrum, Fig. 4, will enable us to answer some interesting questions. We have already seen that change in colour is always accompanied by change in the length of the waves of light producing it ; hence if we begin at one end of our normal spectrum where the colour is red, and the length of the waves equal to 7,603 tenmillionths of a millimetre, as we diminish this length, we expect to see a corresponding change in the colour of the light : small changes we anticipate will produce small effects on the colour, large changes greater effects.

Now, the question arises whether equal changes of wavelength actually are accompanied by equal alterations of hue in all parts of the spectrum. To take an example : in passing from the orange-yellow, through the pure yellow and greenish-yellow well into the yellow-green region, we find it necessary to shorten our wave-length about 400 of our units ; now will an equal curtailment in other regions of the spectrum carry us through as many changes of hue? The answer to this is not exactly what we might expect. In a great part of the red region a change of this kind produces only slight effects, the red inclining a little more or less to orange, and the same is true of the blue and violet spaces, the hue leaning only a little toward the blue or violet side, as the case may be. Hence it seems that the eye is far more sensitive to changes of wave-length in the middle regions of the spectrum than at either extremity. This circumstance, to say the least, is curious ; but, what is more to our purpose, it is a powerful argument against any theory

* Poggendorff's " Annalen," cxxxi., p. 564.

of colour which is founded on supposed analogies with music. But more of this hereafter.

In the prismatic spectrum and in our normal spectrum we found no representative of purple, or purplish tints. This sensation can not be produced by one set of waves alone, whatever their length may be ; it needs the joint action of the red and violet waves, or the red and blue. All other possible tints and hues find their type in some portion of the spectrum, and, as will be shown in the next chapter, this applies just as well to the whole range of browns and greys, as to colours like vermilion and ultramarine.

We have seen that the mixture of long and short waves which compose white light can be analyzed by a prism into its original constituents : the long waves produce on us the

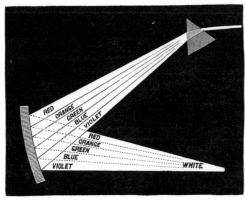

Fig. 5.—Recomposition of White Light.

sensation that we call red, and, as we allow shorter and shorter waves to act on the eye, we experience the sensations known as orange, yellow, green, blue, and violet. When, on the other hand, we combine or mix together these different kinds of light, we reproduce white light. There are a great many different ways of effecting this recom-

position ; one of the most beautiful was contrived several years ago by Professor Eli Blake. The spectrum is received on a strip of ordinary looking-glass, which is gently bent by the hands of the experimenter till it becomes somewhat curved ; it then acts like a concave mirror, and can be made to concentrate all the coloured rays on a distant sheet of paper, as shown in Fig. 5. The spot where all the coloured rays are united or mixed appears pure white.

CHAPTER III.

THE CONSTANTS OF COLOUR.

THE tints produced by Nature and art are so manifold, often so vague and indefinite, so affected by their environment, or by the illumination under which they are seen, that at first it might well appear as though nothing about them were constant; as though they had no fixed properties which could be used in reducing them to order, and in arranging in a simple but vast series the immense multitude of which they consist.

Let us examine the matter more closely. We have seen that when a single set of waves acts on the eye a colour-sensation is produced, which is perfectly well defined, and which can be indicated with precision by referring it to some portion of the spectrum. We have also found that when waves of light, having all possible lengths, act on the eye simultaneously, the sensation of white is produced. Let us suppose that by the first method a definite colour-sensation is generated, and afterward, by the second method, the sensation of white is added to it : white light is added to or mixed with coloured light. This mixture may be accomplished by throwing the solar spectrum on a large sheet of white paper, and then casting on the same sheet of paper the white light which is reflected from a silvered mirror, or from an unsilvered plate of glass. Fig. 6 shows the arrangement. By moving the mirror M, Fig. 6, the white band of light may be made to travel slowly over the whole spectrum, and thus furnish a series of mixtures of

white light with the various prismatic hues. The general effect of this proceeding will be to diminish the action of the coloured light ; the mixture will indeed present to the eye more light, but it will be paler ; the colour-element will begin to be pushed into the background. Conversely, if we now should subject our mixture of white and coloured light to analysis by a second prism, we should infallibly detect the presence of the white as well as of the coloured light ; or, if no white light were present, that would also

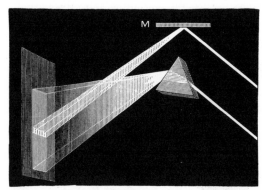

FIG. 6.—Mode of mixing White Light with the Colours of the Spectrum.

be equally apparent. Taking all this into consideration, it is evident that, when a particular colour is presented to us, we can affirm that it is perfectly pure ; viz., entirely free from white light, or that it contains mingled with it a larger or smaller proportion of this foreign element. This furnishes us with our first clue toward a classification of colours : our pure standard colours are to be those found in the spectrum ; the coloured light coming from the surfaces of natural objects, or from painted surfaces, we must compare with the hues of the spectrum. If this is done, in almost every case the presence of more or less white light will be detected ; in the great majority of instances its

preponderance over the coloured light will be found quite marked. To illustrate by an example : if white paper be painted with vermilion, and compared with the solar spectrum, it will be noticed that it corresponds in general hue with a certain portion of the red space ; but the two colours never match perfectly, that from the paper always appearing too pale. If, now, white light be added to the pure spectral tint, by reflecting a small amount of it from the mirror (Fig. 6), it will become possible to match the two colours ; and, if we know how much white light has been added, we can afterward say that the light reflected from the vermilion consists, for example, of eighty per cent. of red light from such a region of the spectrum, mixed with twenty per cent. of white light. If we make the experiment with a surface painted with "emerald green," we shall obtain about the same result, while we shall find that artificial ultramarine-blue reflects about twenty-five per cent. of white light. In all of these cases the total amount of light reflected by the coloured paper is of course taken as 100, and the results here given are to be regarded only as approximations. In every case some white light is sure to be present ; its effect is to soften the colour and reduce its action on the eye ; when the proportion of white is very large, only a faint reminiscence of the original hue remains : we say the tint is greenish-grey, bluish-grey, or reddish-grey. If one part of red light is mixed with sixteen parts of white light, the mixture appears of a pale pinkish hue. The specific effects produced by the mixture of white with coloured light will be considered in Chapter XII. ; it is enough for us at present to have obtained an idea of one of the constants of colour, viz., its purity. The same word, it may be observed, is often used by artists in an entirely different sense : they will remark of a painting that it is noticeable for the purity of its colour, meaning only that the tints in it have no tendency to look dull or dirty, but not at all implying the absence of white or grey light.

Next let us suppose that in our study of these matters we have presented to us for examination two coloured surfaces, which we find reflect in both cases eight tenths red light and two tenths white light. In spite of this, the tints may not match, one of them being much brighter than the other ; containing, perhaps, twice as much red light and twice as much white light ; having, in other words, twice as great brightness or luminosity. The only mode of causing the tints to match will be to expose the darker-coloured surface to a stronger light, or the brighter surface to one that is feebler. It is evident, then, that brightness or luminosity is one of the properties by which we can define colour ; it is our second colour-constant. This word *luminosity* is also often used by artists in an entirely different sense, they calling colour in a painting luminous simply because it recalls to the mind the impression of light, not because it actually reflects much light to the eye. The term "bright colour" is sometimes used in a somewhat analogous sense by them, but the ideas are so totally different that there is little risk of confusion.

The determination of the second constant is practicable in some cases ; it presents itself always in the shape of a difficult photometric problem. The relative brightness of the colours of the solar spectrum is one of the most interesting of these problems, as its solution would serve to give some idea of the relative brightness of the colours which, taken together, constitute white light. Quite recently a set of measurements was made in different regions of the spectrum by Vierordt, who referred the points measured to the fixed lines, as is usual in such studies.* Reducing his designations of the different regions of the spectrum to those of our spectral chart, which includes 1,000 parts from A to H (see previous chapter), and supplying the colours from the observations of the present writer, we obtain the following table :

* C. Vierordt, Poggendorff's "Annalen," Band cxxxvii., S. 200.

TABLE SHOWING THE LUMINOSITY OF DIFFERENT REGIONS OF THE PRISMATIC SPECTRUM.

Position.	Luminosity.	Colour.
From 40·5 to 57	80	Dark red.
" 104·5 " 112·71	493	Pure red.
" 112·71 " 138·5	1,100	Red.
" 158·5 " 168·5	2,773	Orange-red.
" 189 " 220·31	6,985	Orange and orange-yellow.
" 220·31 " 231·5	7,891	Orange-yellow.
" 231·5 " 363·11	3,033	Greenish-yellow, yellow-green, and green.
" 389·85 " 493·22	1,100	Blue-green and cyan-blue.
" 493·22 " 558·5	493	Blue.
" 623·5 " 689·5	90·6	Ultramarine (artificial).
" 753·58 " 825·5	35·9	Blue-violet.
" 896·5 " 956	13·1	Violet.

The author finds that with the aid of rotating disks the second constant can often be determined.* Let us suppose that we wish to determine the luminosity of paper painted with vermilion : a circular disk, about six inches in diameter, is cut from the paper and placed on a rotation apparatus, as indicated in Fig. 7. On the same axis is fastened a double disk of black and of white paper, so arranged that the proportions of the black and white can be varied at will.† When the whole is set in rapid rotation, the colour of the vermilion paper will of course not be altered, but the black and white will blend into a grey. This grey can be altered in its brightness, till it seems about as luminous as the red (Fig. 8). If we find, for example, that with the disk three quarters black and one quarter white an equality appears to be established, we conclude that the luminosity of our red surface is twenty-five per cent. of that of the white paper. This

* "American Journal of Science and Arts," February, 1878.
† See Maxwell's "Disks," chapter x.

is of course based on the assumption that the black paper reflects no light ; it actually does reflect from two to six per cent., the reflecting power of white paper being put at 100. The black disk used by the author reflected 5·2 per

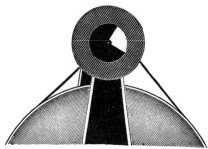

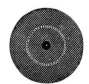

FIG. 7.—Coloured Disk, with Small Black-and-White Disk.

FIG. 8.—Coloured Disk, with Small Black-and-White Disk in Rotation.

cent. of white light ; to meet this a correction was introduced, and a series of measurements made, some of the more important of which are given in the following table :

	Luminosity.
White paper	100
Vermilion (English)*	25·7
Pale chrome-yellow †	80·3
Pale emerald-green *	48·6
Cobalt-blue †	35·4
Ultramarine ‡	7·6

These results were afterward tested by the use of a set of disks, the colours of which were complementary to those mentioned in the table, and these additional experiments and calculations showed that the original measurements differed but little from the truth. This agreement proved also the correctness of Grassmann's assumption, that the total

* In thick paste. † Washed on as a water-colour. ‡ Artificial, as a paste.

intensity of the mixture of masses of differently coloured light is equal to the sum of the intensities of the separate components.

But to resume our search for colour-constants. We may meet with two portions of coloured light having the same degree of purity and the same apparent brightness, which nevertheless appear to the eye totally different : one may excite the sensation of blue, the other that of red ; we say the *hues* are entirely different. The hue of the colour is, then, our third and last constant, or, as the physicist would say, the degree of refrangibility, or the wave-length of the light. In the preceding chapter it has been shown that the spectrum offers all possible hues, except the purples, well arranged in an orderly series, and the purples themselves can be produced with some trouble, by causing the blue or violet of the spectrum to mingle in certain proportions with the red.

FIG. 9.—Eye-piece with Dalton's Scale.

For the determination of the hue, an ordinary one-prism spectroscope can be used ; it is only necessary to add a little contrivance which enables the observer to isolate at will any

small portion of the spectrum. This object is easily attained by introducing into the eye-piece of the instrument

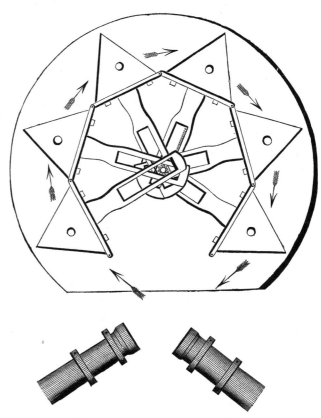

FIG. 10.—Rutherfurd's Automatic Spectroscope.

a diaphragm perforated by a very narrow slit (see Fig. 9). The observer then sees in the upper part of the field of view the selected spectral colour ; in the lower part of the field the scale is visible, and with its aid the precise position of the prismatic hue can be determined. Instead of using a

scale divided into equal parts, it is often advantageous to employ the plan suggested by Dr. J. C. Dalton, and used by him for determining the position of certain absorption bands. Dr. Dalton employs as a scale a minute photograph which shows the positions of the fixed lines, and divides up the spaces between them conveniently. Fig. 9 exhibits the appearance of the field of view and the scale. For more accurate work Rutherfurd's automatic six-prism spectroscope can be employed (see Fig. 10*). A diffraction grating can also be used—in those cases where the student of colour is so fortunate as to possess one.† With a very perfect grating of this kind, for which the author was indebted to Mr. Rutherfurd, the third constant was determined for a number of coloured disks. The following table gives their positions in a normal spectrum having from A to H 1,000 parts; the corresponding wave-lengths are also given:

Name of the Colour.	Position in the Normal Spectrum.	Wave-length in $\frac{1}{10000000}$ mm.
Vermilion (English).................	387	6,290
Red lead	422	6,061
Pale chrome-yellow......	488	5,820
Emerald-green......................	648	5,234
Prussian-blue	740	4,899
Cobalt-blue........................	770	4,790
Ultramarine (genuine)..............	785	4,735
Ultramarine (artificial)...............	857	4,472
Same, washed with Hoffmann's violet B. B............................	916	4,257

We have seen that the first colour-constant has reference to the purity of the colour, or indicates the relative amount of white light mixed with it. This constant is in all cases

* Fig. 10 is a facsimile of Rutherfurd's drawing of his six-prism spectroscope ("American Journal of Science and Arts," 1865).

† See Chapter iv. for an account of the grating.

difficult to determine; probably something might be effected by carrying out practically the idea suggested in Fig. 6, by making the necessary additions to the apparatus there indicated. It would be necessary to measure the relative luminosity of the selected spectral hue and the white light, and then to mix them in proper proportions, till the mixture matched the colour of the painted paper, etc. The second and third colour-constants can be more easily determined.

It may be well here to refer to the terms used to indicate these constants. For the first constant, the word *purity*, in the sense of freedom from white light (or from the sensation of white), is well adapted. The term *luminosity* will be employed in this work to indicate the second constant; the third constant will generally be referred to by the term *hue*. Colours are often also called intense, or saturated, when they excel both in purity and luminosity; for it is quite evident that, however pure the coloured light may be, it still will produce very little effect on the eye if its total quantity be small; on the other hand, it is plain that its action on the same organ will not be considerable, if it is diluted with much white light. Purity and luminosity are, then, the factors on which the intensity or saturation depends. We shall see hereafter that this is strictly true only within certain limits, and that an inordinate increase of luminosity is attended with a loss of intensity of hue or saturation.

Having defined the three constants of colour, it will be interesting to inquire into the sensitiveness of the eye in these directions. This subject has been studied by Aubert, who made an extensive set of observations with the aid of coloured disks.* It was found that the addition of one part of white light to 360 parts of coloured light produced a change which was perceptible to the eye; smaller amounts failed to bring about this result. It was also ascertained

* Aubert, "Physiologie der Netzhaut," Breslau, 1865.

that mingling the coloured light of a disk with from 120 to 180 parts of white light (from white paper) caused it to become imperceptible, the hue being no longer distinguishable from that of the paper.* Differences in luminosity as small as $\frac{1}{120}$ to $\frac{1}{180}$ could also, under favourable circumstances, be perceived. It hence followed that irregularities in the illumination, or distribution of pigment over a surface, which were smaller than $\frac{1}{180}$ of the total amount of light reflected, could no longer be noticed by the eye. Experiments with red, orange, and blue disks were made on the sensitiveness of the eye to changes of hue or wave-length; thus, the combination of the blue disk with a minute portion of the red disk altered its hue, moving it a little toward violet; on reversing the case, or adding a little blue to the red disk, the hue of the latter moved in the direction of purple.† Similar combinations were made with the other disks. Aubert ascertained in this way that recognizable changes of hue could be produced, by the addition of quantities of coloured light, as small as from $\frac{1}{100}$ to $\frac{1}{300}$ of the total amount of light involved. From such data he calculated that in a solar spectrum at least a thousand distinguishable hues are visible. But we can still recognize these hues, when the light producing them is subjected to considerable variation in luminosity. Let us limit ourselves to 100 slight variations, which we can produce by gradually increasing the brightness of our spectrum, till it finally is five times as luminous as it originally was. This will furnish us with a hundred thousand hues, differing perceptibly from each other. If each of these hues is again varied

* To obtain correct results it is of course necessary to know the luminosity of the coloured disk as compared with the white disk, for in the above results by Aubert they are considered to be equal. With the aid of the table of luminosities previously given, this correction can be made, and it will be found that four or five times as much white light is actually necessary as is indicated above.

† Compare Chapter x.

twenty times, by the addition of different quantities of white light, it carries the number of tints we are able to distinguish up as high as two millions. In this calculation no account is taken of the whole series of purples, or of colours which are very luminous or very dark, or mixed with much white light.

To the above we may add that interesting experiments on the sensitiveness of the eye to the different spectral colours have also been made by Charles Pierce, who found that the photometric susceptibility of the eye was the same for all colours. (See "American Journal of Science and Arts," April, 1877.)

With the aid of Vierordt's measurements previously given, and the determinations by the author of the spaces occupied by the different colours in the spectrum, a very interesting point can now be settled, viz. : we can ascertain in what proportions the different colours are present in white light. The amount of red light, for example, which is present will evidently be equal to the space which it occupies in the spectrum, multiplied by its luminosity, and the same will be true of all the other colours. The author constructed a curve representing Vierordt's results, and from this, taken in combination with his own determinations of the extent of the coloured spaces, obtained the following table :

TABLE SHOWING THE AMOUNTS OF COLOURED LIGHT IN 1,000 PARTS OF WHITE SUNLIGHT.

Red	54
Orange-red	140
Orange	80
Orange-yellow	114
Yellow	54
Greenish-yellow	206
Yellowish-green	121
Green and blue-green	134
Cyan-blue	32

Blue.. 40
Ultramarine and blue-violet........................... 20
Violet... 5

1,000

Artists are in the habit of dividing up colours into warm and cold. Now, if we draw the dividing line so as to include among the warm colours red, orange-red, orange, orange-yellow, yellow, greenish-yellow, and yellowish-green, then in white light the total luminosity of the warm colours will be rather more than three times as great as that of the cold colours. If we exclude from the list of warm colours yellowish-green, then they will be only about twice as luminous as the cold. We shall make use of this table hereafter.

It may have seemed strange that the chrome-yellow paper previously mentioned reflected eighty per cent. of light (the reflecting power of white paper being 100), while the table just given states that white light contains only a little more than five per cent. of pure yellow light. It will, however, be shown in a future chapter that chrome-yellow really reflects not only the pure yellow rays, but also the orange-yellow and greenish-yellow, besides much of the red, orange, and green light. By mixture, all these colours finally make a yellow, as will be explained in Chapter X. The high luminosity of some of the other coloured papers is to be explained in a similar manner.

CHAPTER IV.

PRODUCTION OF COLOUR BY INTERFERENCE AND POLARIZATION.

In Chapter II. we studied the spectral tints produced by a prism and by a grating ; these were found to be pure and brilliant as well as very numerous, and consequently were adopted as standards for comparison. Most nearly allied to these central normal colours are those which are produced by the polarization of light. In this class we meet with a far greater variety of hues than is presented by the solar spectrum ; and, instead of a simple arrangement of delicately shading bands, we encounter an immense variety of chromatic combinations, sometimes worked out with exquisite beauty, but as often arranged in a strange fantastic manner, that suggests we have entered a new world of colour, which is ruled over by laws quite different from those to which we have been accustomed. And it is indeed so ; the tints and their arrangement depend on the geometrical laws which build up the crystal out of its molecules, and on the retardation which the waves of light experience in sweeping through them, so that in the colours of polarization we see, as it were, Nature's mathematical laws laying aside for a moment their stiff awkwardness, and gayly manifesting themselves in play.

The apparatus necessary for the study of these fascinating and often audacious colour-combinations is not necessarily complicated or very expensive. A simple form

of polariscope is shown in Fig. 11. It consists merely of a plate of window-glass at P, which is so placed that the angle, a, is 33° as nearly as possible ; at N is a Nicol's prism, and at L a plano-convex lens with a focal length of about an inch. The distance of the prism from the plate

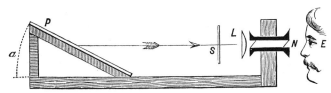

FIG. 11.—Simple Polarizing Apparatus.

of glass is ten inches ; the lens is removable at pleasure, the Nicol's prism is capable of revolving around its longer axis. If, now, light from a white cloud be reflected from the plate of glass toward the Nicol's prism, as indicated by the arrow, some of it will ordinarily traverse the prism and reach the eye at E ; the prism should now be turned till this light is cut off, and the instrument is then ready for use. Thin slips of selenite or crystals of tartaric acid placed at S, so that they are magnified, display the colours of polarization very beautifully. The arrangement just described constitutes a simple polarizing microscope ; if a compound polarizing microscope can be obtained, it will be still more easy to study the colours and combination of colours presented by the crystals of many different salts. By dissolving a grain or two of the substance in a drop of water, and allowing it to crystallize out on a slip of glass, it is possible very easily to make objects suitable for examination.

Thin plates of selenite, obtained by removing successive layers with a penknife, answer admirably if we wish to study the phenomena of chromatic polarization in their simplest forms. It will often be found that nearly the

whole plate presents a single unshaded hue, which bears a close resemblance to a patch of colour taken from some portion of the spectrum. But, however bright the colour may be, it is never free from an admixture of white light, and it is the constant presence of this foreign element which causes the colours of polarization to appear a little less intense than those of the spectrum. With plates which are somewhat thicker the proportion of white light increases, washing out the colour, till only a faint reminiscence of it is left. The more powerful tints, however, quite equal and probably surpass in purity—that is, in freedom from white light—the most intense sunset hues. Among these colours we find many shades of red and purple-red ; all the red-orange hues are represented, and the same is true of the other colours found in the spectrum. Besides, there is a range of purples which bridges over the chasm between the violets and reds ; faint rose-tints are also present in abundance, and the same is true of the pale greens and bluish-greens. In addition to this, quite thin slips furnish a distinct set of tints which are peculiar in appearance, and which, when once seen, are never forgotten ; a singular tawny yellow will be noticed in combination with a bluish-grey ; the yellow, such as it is, shading into an orange nearly allied to it, and this again into a brick-red ; black and white will be associated with these subdued tints ; the general impression produced by these combinations being sombre if not dreary.

These slips of selenite furnish neither beautiful nor complicated patterns, the tints being for the most part arranged in parallel bands, with here and there angular patches, often in sharp contrast with the other masses of colour. There is no noticeable attempt at chromatic composition, except perhaps a little along fractured edges, where we frequently meet with pale grey or white deepening into a fox-coloured yellow, followed by a red-violet, brightening into a sea-green dashed with pure ultramarine, or changing suddenly

into a full orange-yellow, after which may follow a broad field of purple. Just as often all the tints are pale, like those used on maps, with a narrow fringe on the edge, of rich variegated hues. The colour-combinations seldom rise into great beauty, though they often astonish and dazzle by their audacity and total disregard of all known laws of chromatic composition. The brilliancy and purity of these tints are so great, and they are laid on with such an unfaltering hand, that all these wild freaks are performed comparatively with impunity, and it is only when we proceed to make copies of these strange designs that we become fully aware of their peculiarities, and, from an artistic point of view, positive defects.

Crystals of tartaric acid present phenomena which are quite different: here the patterns are rich and often beautiful; the colour is full of gradation, touched on and retouched and wrought out with patience in delicate, complicated forms, which echo or faintly oppose the grand ruling ideas of the composition. We may have a wonderfully shaped mass radiating in curved lines over the entire field, tinted with soft grey and pale yellow, with here and there dashes of colour like the spots on a peacock's tail, glowing like coals of fire; all this being set off by very dark shades of olive-green, dark browns and greys. If the crystals are thin this is their appearance; but as the thickness increases so does the brilliancy of the hues, which are sure to be well contrasted with large masses of deep shade. The soft gradations, the sharp contrasts, the brilliant and pale colours, the dark shadows and the wonderful forms, all combine to lend to these pictures a peculiar charm which is not wholly lost even in copies executed in ordinary pigments.

Common sugar, if allowed time to crystallize out slowly, furnishes appearances somewhat resembling the above, but the designs are more formal and less interesting. Crystals of nitrate of potash present appearances, again, which are totally unlike those above mentioned; here we have a great

number of delicately tinted threads of light; there will be purples and golden greens or dull olive-greens and carmines, woven together so closely as almost to produce a neutral tint, which will brighten suddenly and display combinations of purple-red with green, dashed here and there with pure ultramarine. These tinted threads of light will be disposed with regularity as though it had been intended to weave them into some wonderful cashmere-like pattern, and then warp and woof had been suddenly abandoned and forgotten.

It would be useless to multiply these descriptions—every salt has its own peculiarities and suggests its own train of fancies; some glow like coloured gems with polished facets, or bristle with golden spears like the advancing ranks of two hosts in conflict, or suggest a rich vegetation made of gold and jewels and bathed in sunset hues. Artists who see these exhibitions for the first time are generally very much impressed by their strange beauty, and not unfrequently insist that their range of colour-conceptions has been enlarged. It has often seemed to the author that the cautious occasional study of some of these combinations might be useful to the decorator in suggesting new conceptions of the possibilities within his reach.

When polarized light is made to traverse crystals in the direction of their optic axes, phenomena of a different kind are presented. They were discovered in 1813 by Brewster, and, on account of their scientific interest and a certain beauty, have since then greatly attracted the attention of physicists and even of mathematicians. A series of rainbow-like hues, disposed in concentric circles, is seen on a white field; a dark-grey cross is drawn across the gayly coloured circles, and, after dividing them in four quadrants, fades out in the surrounding white field. By a slight change in the adjustment of the apparatus, the grey cross can be made white; the rings then assume the complementary tints. Other crystals, again, furnish double sets of rings, the dark

3

cross being shared by them jointly, or so altered in form as no longer to be recognizable.

These appearances have been considered by many physicists to be extraordinarily beautiful ; it is, however, to be suspected that in this case the judgment was swayed by other considerations than those of mere beauty. The rarity of the phenomenon, the difficulty of exhibiting it, the brilliant list of names identified with it, along with the insight it furnishes as to the molecular constitution of crystals, all combine to warp the judgment, and to seriously influence its final award. In point of fact, the formal nature of the figures, the constant repetition of the rainbow-tints in the same set order, which is that of the spectrum, both exclude the possibility of the charming colour-combinations so frequently presented by many salts when simply crystallized on a slip of glass. The cross and rings are not for a moment, in matter of beauty, to be compared with the appearances presented by crystals of tartaric acid.

Glass which has been heated and then suddenly cooled, or glass which is under strain, exhibits phenomena of colour closely related to the above ; we have as it were a set of distorted crosses and rings which sometimes lend themselves more kindly to the production of chromatic effects than is the case with the normal figures.

In ordinary life the colours of polarization are never seen ; the fairy world where they reign cannot be entered without other aid than the unassisted eye. This is not a matter for regret ; the purity of the hues and the audacious character of their combinations cause their gayety to appear strange and unnatural to eyes accustomed to the far more sombre hues appropriate to a world in which labour and trouble are such important and ever-present elements. The colours even of flowers have a thoughtful cast, when compared with those of polarization.

The colours which have just been considered are produced in a peculiar manner ; the complete explanation is

long and tedious, and has for us no particular interest. The main idea, however, is this : white light is acted on in such a way that one of its constituents is suppressed ; the result is coloured light. For example, if we strike out from white light the yellow rays, what remains will produce on us the sensation of blue ; if we cut off the green rays, the remainder will appear purple. The reason of this will be more fully appreciated after a study of the facts presented in Chapters XI. and XII. To effect this sifting out of certain rays a polarizing apparatus is employed ; when the crystals are removed from it, the colour instantly vanishes. Now, it so happens that there is a class of natural objects capable of displaying exactly the same hues without the intervention of any piece of apparatus—all objects that fulfill a certain condition may be reckoned in this class ; it is merely that their thickness should be very small. Thin layers of water, air, glass, of metallic oxides, of organic substances, in fact of almost everything, display these colours. The most familiar example is furnished by a soap-bubble. When it first begins to grow, it is destitute of colour and perfectly transparent ; it gives by reflection from its spherical surface a distorted image of the window, with the bars all curved, but no unusual hues are noticed till it has become somewhat enlarged.* Then faint greens and rose-tints begin to make their appearance, mingling uneasily together as if subjected to a constant stirring process. As the bubble expands and the film becomes more attenuated, the colours gain in brilliancy, and a set of magnificent blue and orange hues, purples, yellows and superb greens replaces the pale colours which marked the early stages, and by their changing flow and perpetual play fascinate the beholder. If the bubble

* It is not very uncommon to meet with paintings in which a bubble has been represented with window-bars on its surface, where nothing of the kind could have been visible. A friend has mentioned to the author four cases where different artists have introduced window-bars instead of sky and landscape, on the surfaces of bubbles which were in the open air.

has the rare fortune to live to a good old age, at its upper portion a different series of tints begins to be developed; the tawny yellow, before mentioned, begins to be seen in irregular patches, floating around among the more brilliant hues, a sign that the attenuation has nearly reached its extreme limit; but, if by some unusual chance it should be a Methuselah among bubbles, pale white and grey tints also are seen, after which it is sure to burst. A long-lived soap-bubble displays every colour which can be produced by polarization. The thin film has a sifting action on white light, which in its final result is the same as in the case of the production of colour by polarized light: certain rays are struck out, and, as before, white light deprived of one of its constituents furnishes coloured light. This elimination is accomplished by the interference of the waves of light involved; hence, colours produced in this way are called "interference colours." The colours of polarization are also just as truly interference colours, but they are not usually known under this name. From all this it follows that the colours produced by thin layers, or by very fine particles, always contain some white light, and consequently cannot quite rival in purity or intensity the spectral hues.

The colours of polarization, as we have seen, are never met with outside of the laboratory. Nature, on the other hand, here and there with a sparing hand, displays in small quantity, and as a rarity, the colours of interference. They are used as a wonderful kind of jewelry in the adornment of many birds; lavishly so in the case of the common peacock, where the breast and tail feathers in full sunshine display flashing, dazzling hues, which make our artificial ornaments appear pale and tame. In contemplating these astonishing hues, or those of that tiny winged jewel, the humming-bird, we are struck by the circumstance that they actually have a metallic brilliancy, which we in vain attempt to rival with our brightest pigments. To compete with them successfully, it is necessary to substitute a sur-

face of silver for the white paper, and to cover it with the purest and most transparent glazes. This appearance of metallic lustre depends on the circumstance that much coloured light is reflected, mingled with only a small quantity of white light, the great bulk of the latter being absorbed by the dark pigment contained in the interior of the feathers. When this dark pigment is absent, we have as before colour; but, being mingled with much reflected white light, it presents simply an appearance like that of mother-of-pearl.

There is yet another peculiarity of the colours now under consideration, which still more completely separates them from the hues furnished by pigments: it is their variability. These colours, as has been mentioned, are produced by the interference of the waves of light which are reflected from the thin films: the nature of this interference depends partly on the angle at which this reflection takes place, so that, as we turn a peacock's feather in the hand, its colour constantly changes. The same is true of the tints of the soap-bubble, and of interference colours in general —the hue changes with the position of the eye; as they are viewed more and more obliquely, the tint changes in the order of the spectrum, viz., from red to orange, to yellow, etc.

The brilliant metallic colours exhibited by many insects, particularly the beetles, belong also in this class, so also the more subdued steel-blues and bottle-greens displayed by many species of flies. So commonly does this occur that it suggests the idea that these humble creatures are not destitute of a sense for colour capable of gratification by brilliant hues. If we descend into the watery regions we find their inhabitants richly decorated with colours of the same general origin, the pearly rainbow hues which they display all depending on the interference of light. The same is true of the iridescent hues which so commonly adorn shells externally and internally. In this case candour compels one

to admit that the colours, beautiful as they are, can hardly be a source of pleasure to the occupants or to their friends.

Leaving the animated world, we find the colours of interference shown frequently, but in an inconspicuous manner, by rather old window-glass; some of the alkali seems to be removed by the rain, and in the course of time a thin film of silica capable of generating these hues is formed. In antique glass which has long remained buried this process is carried much further, so that sometimes the whole plate or vase tends to split up into flakes. Here, owing to successive reflections on many layers, the light which reaches the eye is quite bright, and the colours intense. Crimson, azure, and gold are found in combination; blue melts into purple or flashes into red; ruby tints contrast with emerald hues : each change of the position of the eye or of the direction of the light gives rise to a new and startling effect. In other cases broad fields of colour, with much gentle gradation and mingling of tender pearly hues, replace the gorgeous prismatic tints, and fascinate the beholder with their soft brilliancy.

The iridescent hues of many minerals fall into the same general class; they are beautifully displayed by some of the feldspars, and the brilliant hues found on anthracite coal have also the same origin. The blue films often purposely produced on steel are due to thin layers of oxide of iron which suppress the yellow rays. Other cases might be mentioned, but these will suffice for the present.

CHAPTER V.

ON THE COLOURS OF OPALESCENT MEDIA.

IF white light be allowed to fall on water which is contained in a clear, colourless glass vessel, some of it will be reflected from the surface of the liquid, while another portion will traverse the water and finally again reach the air. These well-known facts are represented in Fig. 12. An eye placed at E will perceive the reflected light to be white, and the transmitted light will also appear white to an eye situated at O. But, if now a little milk be added to the water, a remarkable change will be produced : light will, as before, be reflected from the surface to the eye placed at E, and this surface-light will still be white; but the little milk-globules under the surface and throughout the liquid will also reflect light to E—this light will be bluish. From this experiment, then, it appears that the minute globules suspended in the liquid have the power of reflecting light of a bluish tint. In Fig. 12 the light is represented as being reflected only in one direction; but, when the milk-globules are added, they scatter reflected light in many directions, so that an eye placed anywhere above the liquid perceives this bluish appearance.

On the other hand, after the addition of the milk, the light at O (Fig. 12), which has passed through the milky liquid, will be found to have acquired a yellowish tint. From this it appears that fine particles suspended in a liquid have the power of dividing white light into two portions, tinted respectively yellowish and bluish. If more milk be

added to the water, white light will mingle in and will finally overpower the bluish reflected light, so that it will hardly be noticed ; as the quantity of milk is increased, the colour of the transmitted light will pass from yellow to orange, to red, and finally disappear, the liquid having become at last so opaque as to cease to transmit light altogether.

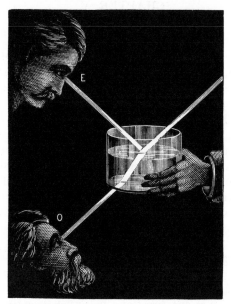

FIG. 12.—Reflection and Transmission of Light by Water.

This very curious action is not confined to mixtures of milk and water, but is exhibited whenever very fine particles are suspended in a medium different from themselves. If an alcoholic solution of a resin is poured with constant stirring into water, very fine particles of resin are left suspended in the liquid, and give rise to the appearances just described. Brücke dissolves one part of mastic in eighty-seven parts of alcohol, and then mixes with water, the water

being kept in constant agitation. A liquid prepared in this way shows by reflected light a soft sky-like hue, the colour of the light which has passed through being either yellow or red, according to the thickness of the layer traversed. The suspended particles of resin are very fine, and remain mingled with the water for months ; they are often so fine as to escape detection by the most powerful microscopes.

Some kinds of glass which are used for ornamental purposes possess the same property, appearing bluish-white by reflected light, but tingeing the light which comes through them red or orange-red. The beautiful tints of the opal probably have the same origin, and the same is true also of the bluish, milky colour which characterizes many other varieties of quartz.

Not only liquids and solids exhibit this phenomenon of opalescence, but we find it also sometimes displayed elsewhere ; thus, for example, a thin column of smoke from burning wood reflects quite a proportion of blue light, while the sunlight which traverses it is tinted of a brownish-yellow, or it may be, even red, if the smoke is pretty dense.

All these phenomena are probably due to an interference of light, which is brought about by the presence of the fine particles, the shorter waves being reflected more copiously than those which are longer ; these last, on the other hand, being more abundantly transmitted. An elaborate explanation of the mode in which the interference takes place would be foreign to the purpose of the present work ; we therefore pass on to the consideration of the more practical aspects of this matter.*

It will be well to notice, in the first place, certain conditions which favour not so much the formation as the perception of the tints in question : thus it will be found that

* Compare E. Brücke, in Poggendorff's "Annalen," Bd. 88, S. 363 ; also Bezold's "Farbenlehre," p. 89.

the blue tint, in the experiments with the liquids, is best exhibited by placing the containing glass vessel on a black surface. This effectually prevents the blue reflected light from being mingled with rays which have been directly transmitted from underneath. Indeed, the mere presence or absence of a dark background may cause the tint which

Fig. 13.—Smoke appears Blue on a Dark Background; Brown on a Light Background.

finally is perceived by the eye to change from yellow to blue, the other conditions all remaining unaltered. Thus in Fig. 13 we have thin smoke seen partly against a dark background, and partly against a sky covered with white clouds: the lower portion is blue, from reflected light, while in the upper portion this tint is overpowered by the greater intensity of the transmitted light, which is yellow-ish-brown. As a general thing, the reflected and transmitted beams are both present; dark backgrounds favour the former, luminous ones the latter.

If a thin coating of white paint, such as white lead or zinc-white, is spread over a black or dark ground, the touches so laid on will have a decidedly bluish tint, owing to the causes which have just been considered. If a drawing on dark paper be retouched with zinc-white used as a water-colour, the touches will appear bluish and inharmonious, unless especial care is taken to prevent the white

pigment from being to some extent translucent; this disagreeable appearance can only be prevented by making each touch dense and quite opaque. For the production of such effects it is not even necessary to go through the formality of laying the white pigment on a dark ground; white lead mingled with any of the ordinary black pigments gives not a pure but a bluish grey. This is very marked in the case of black prepared from cork, which hence has sometimes been called "beggars' ultramarine." If yellow pigments are mixed with black, the effect is not simply to darken the yellow, as would be expected, but it is converted into an olive-green. This is particularly the case with those pigments which approximate to pure yellow in hue, such as gamboge and aureolin; the least admixture of dark pigment carries them over toward green. But if these black-and-white or black-and-yellow pigments are combined by the method of rotating disks (see Chapter X.), we obtain pure greys or darker yellow tints, showing that the blue hue is not, as many suppose, inherent in the black pigment, but an accident due to the mode of its employment. The above-mentioned cases are marked examples of the application of these principles to painting; but in a more subtile way the whole theory of the process of oil-painting takes cognizance of them, and is so adjusted as to avoid difficulties thus introduced, or, more rarely, to utilize them. It is perhaps scarcely necessary to add that the somewhat bluish tone of drawings made with body colour, or of frescoes, is due to these same causes.

Having hinted at the influence which this peculiar optical action exerts on the infancy of a picture, we pass on to consider some of its effects on a painting in its old age. It is well known that old oil-paintings frequently become more or less covered by what seems to be a coating of grey or bluish-grey mould, which, spreading itself particularly over the darker portions, obscures them, so that all details are lost, and the work of the artist entirely destroyed. In-

vestigation has shown that this trouble is caused by an immense number of fine cracks in the painting itself, which seem to act somewhat in the same way as the mixtures which have just been considered, so that the observer is practically looking at the picture through a rather dense haze. By filling these invisible cracks up with varnish the matter is somewhat helped, but much more perfectly by the "regenerations process" of Pettenkofer. This celebrated chemist once by accident used an old, worn-out oil-cloth mat, from which the pattern had mostly disappeared, to cover a beaker containing hot alcohol. On removing the mat, some hours afterward, he was surprised to find that the portion acted on by the alcoholic vapours had been rejuvenated and the pattern restored. It was soon ascertained that the vapours had softened the pigment, and the separated grains had again been fused together. Experiments on old oil-paintings gave similar results, and the process is now in use in some of the largest European galleries.

In many other objects besides those that have been mentioned these peculiar tints can be observed ; among minor examples may be mentioned the bluish-grey or greenish-grey tint which marks the course of veins under the skin ; the blue or greenish colour of the human eye also owes its tint to the same cause. In these cases an opalescent membrane is spread over a dark background, and the colour is produced in the same manner as in the experiments described at the commencement of this chapter. In blue eyes there is no real blue colouring-matter at all.

It is, however, the sky that exhibits this class of tints on the grandest scale, as well as in the greatest perfection. Our atmosphere, even when perfectly clear, contains suspended in it immense numbers of very fine particles which never settle to the earth, and which the rain has no power to wash down. When they are illuminated by sunlight they reflect white light mixed with a certain proportion of blue, and this blue is seen on a black background, which is

nothing less than the empty space in which the earth is hung. Hence, the blue colour of the sky. This tint on clear days can be traced up tolerably near the sun, indeed, until the brightness of the sky begins to be blinding. An examination of the deepest blue portions of the sky with the spectroscope reveals the presence of much white light, so that the blue colour is very far from being pure or saturated — a fact that young landscape-painters soon have forced on their attention. In clear weather, as long as the sun is at a considerable distance from the horizon, the yellow colour which accompanies the transmission of light through an opalescent medium is not much noticed ; but, as the sun sinks lower, its rays traverse an always increasing thickness of the atmosphere, and encounter a greater number of fine particles, so that the transmitted light, late in the afternoon, becomes decidedly yellow or rather orange-yellow.

Having thus briefly considered the production of ordinary sky-tints, let us pass to the aspects assumed by a landscape under the influence of the minute suspended particles. These atoms will of course reflect light toward the observer, and this light will add itself to that which comes regularly from objects in the landscape, producing thus important changes in their appearance. The very thick layer of air intervening between the observer and the most distant mountains will send to the eye a very large amount of whitish-blue light, which will not greatly differ from a sky-tint. This will entirely overpower the somewhat feeble light reflected from portions of the mountain in shade, so that as a result we shall have all the shadows of the mountain represented by more or less pure sky-tints, and these tints will be far more luminous, far brighter, than the original shadows were. No details will be visible in these wonderfully shaped bluish patches. Those portions of the mountains, on the other hand, which are in full sunlight will still visibly send light to the eye through the haze, and

their prevailing tint will be yellowish or orange, or some other warm tone. Not many details will be visible, and the actual colours or local colours of the mountain will not at all appear, or at most will only blend themselves with the soft, warm tints due to the medium. In a word, the contrast between the light and shade will be enormously diminished, so that the general luminosity of the mountain will be hardly less than that of the sky itself, and its colour will be worked out mainly in tints which have the same origin and character with those of the sky. As we approach nearer the mountain, these effects begin slowly to diminish, and in the sunlit portions delicate greens, varied and soft greys, begin to make their appearance, while the shadows lose their heavenly blue, and, darkening, become bluish-grey. Afterward all those parts lying in sunlight display their local tints, somewhat softened, and the coloured light from the shadows begins to make itself felt, and, mingling with the blue reflected light, to produce soft purplish-greys, greenish-greys, and other nameless tints. The sunlit portions of the pine-trees will be of an olive-green or of a low greenish-yellow, the shadows on the same trees being pure grey or bluish-grey without any suggestion of green. On nearer objects these effects are less traceable, and the natural relation between light and shade more and more preserved, so that contrast of this last kind becomes progressively stronger as we turn from the most distant to the nearest objects. All these effects are readily traceable on any ordinary clear day ; they change, of course, with the condition of the atmosphere, and as it becomes misty the blue reflected light changes to grey, the transmitted light not being equally affected.

Late in the afternoon, when the sun is low, its rays traverse very thick layers of the atmosphere, and wonderful chromatic effects are produced. Near the sun the transmitted light is yellowish, but so bright that the colour is not very perceptible ; to the right and left the colour deepens into an orange, often into a red, which, as the distance from the sun increases, fades out into a purplish-grey, greyish-blue, passing finally into a sky-blue. The warm tints are produced mainly by transmitted light, the cold ones by reflected light, and the neutral hues by a combination of both. Above the sun there is, in clear sunsets, a rather regular transition upward, from the colours due to transmitted, to those produced by reflected light. As the sun sinks lower its rays encounter a greater mass of suspended particles, and the warm tints above mentioned move toward the red end of the spectrum, and also gain in intensity. The presence of clouds breaks up the symmetry of these natural chromatic compositions, and gives rise to the most magnificent effects of colour with which we are acquainted. The landscape itself sympathizes with the sky, and near the sun, chameleon-like, assumes an orange or even red hue ; while at greater distances its cold tints are warmed, even the greens being changed into olive or yellowish hues. Simultaneously the shadows lengthen enormously, bringing thus the composition into grand and imposing masses, and investing even the most commonplace scenery with an air of great nobleness and beauty.

The complete series of sunset hues, from the brightest light to the deepest shade, runs as follows :

1. Yellow.	3. Red.	5. Violet-blue.
2. Orange.	4. Purple.	6. Grey-blue.

This, as it were, normal series is often interrupted by the omission of one or more of the intermediate hues, and sometimes begins as low as the red or even purple.

CHAPTER VI.

PRODUCTION OF COLOUR BY FLUORESCENCE AND PHOSPHORESCENCE.

In all the cases thus far examined, colour has been produced either by the analysis of white light or by subjecting it to a process of subtraction, as in the examples mentioned in the last chapter. The very astonishing discovery of Stokes, however, has proved that colour can be produced in a new and entirely different way. If, in a darkened room the pure violet light of the spectrum be allowed to fall on a plate or wineglass made of uranium glass, these articles will not reflect violet light to the eye as would be expected, but will glow with a bright-green light, looking in the darkness almost as though they had suddenly become self-luminous. This kind of glass has, then, the extraordinary property of entirely altering the colour of the light that falls on it, and of causing the light to assume a quite different hue. But, as colour depends on wave-length, we are led to ask whether *this* property of the original beam of light is also affected by the uranium glass. Stokes proved conclusively that this is the case, and that in all such experiments the length of the wave is made greater. It would appear that the waves of light act on the atoms which make up (or surround) the molecules of the glass, and set them in vibration; they continue in vibration for some little time afterward, *at a rate of their own selection*, which is always less than that of the waves of light which gave the first impulse. Being in vibration, they act as luminous centres, and com-

municate vibrations to the external ether, and this is the green light that finally reaches the eye. The action takes place not only on the surface of the glass, but deep in its interior, so that, if the experiment be made with a thick cube of the glass, it actually appears milky and almost opaque, owing to the abundant flood of soft green light which it pours out in all directions. It is not even necessary to employ as a source of illumination the pure violet of the spectrum; sunlight streaming through blue cobalt glass answers as well, and the sharp change from the violet-blue to the milky-green is quite as astonishing.

Under ordinary daylight, uranium glass scatters in all directions a bluish-green light, which is due to the cause above mentioned, but the light which passes through its substance is merely tinged yellow. Both these tints make their appearance in daylight, and by their combination communicate to articles made of this glass a peculiar and rather beautiful appearance. Candle-light or gas-light furnishes but a scanty supply of blue and violet rays, hence this kind of illumination robs uranium glass entirely of its charm, and the articles made of it assume a dull yellowish hue which is neither striking nor attractive. There are many salts which have this property in a high degree: among the best known is the platino-cyanide of barium, which presents appearances similar to those above mentioned. Thallene, an organic substance derived from coal-tar, and described by Morton, must also be classed with uranium glass.* Drawings made with this substance on white paper, by daylight appear yellowish, but when placed under a violet or blue illumination flash into sudden brilliancy, and scatter in all directions a strong greenish light. There are many liquids which have the same property, and which display different colours when acted on by violet light, but for an account of them we must refer the curi-

* See "Chemical News," December, 1872.

ous reader to Dr. Pisko's work on the fluorescence of light.*

Before passing from this subject it may be as well to add that phosphorescence also often gives rise to colours which more or less closely resemble those of fluorescence. If tubes filled with the sulphides of barium, strontium, calcium, etc., be placed in a dark room and illuminated for an instant by a beam of sunlight, by the electric light, or by burning magnesium wire, they will display a charming set of tints for some minutes afterward. Some will shine with a soft violet light, others will display an orange or yellow glow; delicate blues will make their appearance, and will contrast well with the red hues, the latter resembling in the darkness living coals of fire. The tints, as such, are very beautiful and suggestive, though of course no direct application can be made of them to artistic purposes.

* "Die Fluorescenz des Lichtes," F. J. Pisko, Vienna.

CHAPTER VII.

ON THE PRODUCTION OF COLOUR BY ABSORPTION.

THE colours produced by the dispersion, interference, and polarization of light have great interest from a purely scientific point of view, and are also valuable in helping us to frame a true theory of colour, but it is to the phenomena of absorption that the colours of *ordinary* objects are almost entirely due. The pigments used by painters, the dyes employed by manufacturers, the colouring-matter of flowers, trees, rocks, and water, all belong here. Let us begin our study of this subject with a fragment of stained glass. When we place the glass flat on a surface of black cloth, and expose it to ordinary daylight, we find that it reflects light to the eye just as a piece of ordinary window-glass would under similar circumstances, and this light is white, not coloured. In this experiment, the rays of light which reach the eye have been reflected from the mere surface of the plate of glass, those rays which penetrate its interior being finally absorbed by the black cloth underneath, and never reaching the eye at all. If we now raise the glass and allow the light of the sky to pass through it and fall on the eye, we find that it has been coloured ruby-red. The light of a candle- or gas-flame is affected in the same way, and a beam of sunlight streaming through the plate of glass falls on the opposite wall as an intensely red, luminous spot. Our first and very natural impression is, that the stained glass has the power of altering the quality of light— that the white light is in some way actually transmuted

into red light. This seems to be the universal impression among those who have not particularly examined the matter. We saw, in Chapter II., that with a prism we could analyze white light, and sort out the waves composing it according to their length, and that the sensation which the waves produced on the eye varied with their length, the longest giving red, the shortest violet. The prism can also be applied to the study of the matter now under consideration. A

FIG. 14.—Red Glass placed over Slit in Black Cardboard.

screen of black pasteboard is to be prepared with a narrow slit cut in its centre ; over the slit a piece of stained glass is to be fastened, as indicated in Fig. 14. If, now, this arrangement be placed in front of a window, matters can be so contrived that white light from a cloud shall fall upon the slit and traverse the stained glass ; it will afterward reach

FIG. 15.—Spectrum of Light transmitted through Red Glass.

the prism which will analyze it. On making this experiment we find that the result is similar to what is indicated in Fig. 15 : the prism informs us that the transmitted beam

consists mainly of red light ; a little orange light is also present. The experiment can, however, be made in a more instructive way, by covering only half of the slit with the plate of glass. On repeating it with this modification, we obtain side by side an analysis of the white light direct from the cloud, and of the light which has traversed the ruby glass ; the result is indicated in Fig. 16, and we see

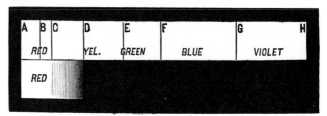

FIG. 16.—Spectrum of White and Red Light compared.

at a glance that the solution of the whole matter is simply this : the ruby glass is able to transmit the red rays, but it stops all the others ; these last it absorbs—hence we say it produces its colour by absorption. The other rays are in fact converted into heat, and raise the temperature of the glass to a trifling extent. The experiment can be varied somewhat without affecting the result ; if a solar spectrum be projected on a screen, as described in Chapter II., we shall find, when we look at it through the ruby glass, that we can see only the red space, light from the other coloured spaces not being able to penetrate the glass ; and finally, when we hold our plate of glass directly in the paths of the coloured rays, we shall notice that it stops all except those that are red. These simple fundamental experiments prove that the ruby glass does not transmute white light into red, but that it arrests certain rays, and converts them into a kind of force which has no effect on the eye ; the rays which are not arrested finally reach the eye and produce the sensation of colour.

For more careful examinations of the coloured light transmitted by stained glass a spectroscope with one flint-glass prism can advantageously be used. The stained glass is to be fastened so that it covers one half of the slit, and then we shall have, placed side by side, the spectrum due to the glass and a prismatic one for comparison. In this latter the fixed lines will be present, and we can use them as a kind of natural micrometer for mapping down our results. There is, however, another point to be attended to. When we come to examine the red glass carefully with the spectroscope, we find that it not only transmits the red rays powerfully, but that *a little* of the orange rays also passes through with still smaller portions of the green and blue rays. Hence we are dealing not only with spaces in the spectrum, but with the relative intensities of the coloured light filling those spaces. It is difficult, or rather impos-

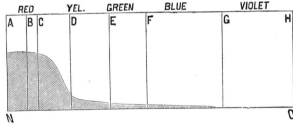

FIG. 17.—Spectrum, showing the Extent and Intensity of the Coloured Light transmitted by Red Glass. The shaded portion represents the transmitted light.

sible, to represent the different intensities by shading on paper; hence physicists have adopted a certain convention which removes this trouble, and enables them to express differences in luminosity readily and accurately. All this is accomplished by drawing a curve, and agreeing that distances measured upward to it shall represent different degrees of luminosity. We agree, then, to let the entire rectangle A H O N, Fig. 17, represent a solar spectrum, with

its different colours properly arranged, and having their natural or normal luminosities, and in this rectangle we draw the curve furnished by the red glass (Fig. 17). We find that it is highest in the red space; but even here it reaches only about half way up, showing that the luminosity of the transmitted red light is only half as great as that of the same light in the spectrum; in the orange space it falls rapidly off, the curve sinking with a steep slope; after that it runs out into the green and blue, almost to the violet, in such a way as to indicate that the red glass transmits minute quantities of these different kinds of coloured light. The luminosity, then, of all the transmitted rays, except the red, being quite feeble, the light which comes through appears pure red. Making an examination of an orange-yellow glass in the same way, we obtain the curve shown in Fig. 18: this glass, it appears, transmits most of the red,

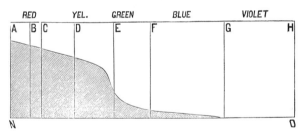

FIG. 18.—The shaded portion shows the amount of light transmitted by an orange-coloured glass.

orange, and yellow rays, with much of the green and a little of the blue. Here, of course, the orange and yellow rays after transmission make up an orange-yellow hue, and the green and red rays by their union reproduce the same colour, as we shall see in Chapter X. Hence the final colour is orange-yellow, without the least tint of red or green. Taking next a green glass, we obtain another curve, Fig. 19, showing that much green light is transmitted, but along

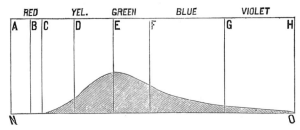

FIG. 19.—The shaded portion represents the amount of light transmitted by green glass.

with it some red and some blue. Blue glass shows the cyan-blue weakened, the ultramarine-blue and violet strong; the green is very weak, so also are yellow and orange; the red is mostly absent, except a feeble extreme red. The result is of course a violet-blue (Fig. 20). A purple glass is

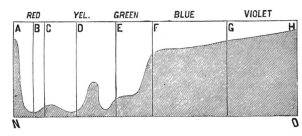

FIG. 20.—The shaded portion represents the amount of light transmitted by blue glass.

found to absorb the middle of the spectrum, i. e., the yellow, green, and cyan-blue; the red and violet are also enfeebled, but are at all events far stronger than the other transmitted rays. We have, then, as a final result, red, ultramarine-blue, and violet, which being mingled make purple. It is evident from these experiments that the colours produced by absorption are not simple, like those furnished by the prism, but are resultant hues, produced by the mixture of many different kinds of coloured light hav-

ing varying degrees of brightness. On this account, and by reason of the tendency of many kinds of stained glass to absorb to a considerable extent all kinds of coloured light presented to them, it happens that stained glass furnishes us with coloured light inferior in purity and luminosity to that obtained by the use of a prism. Nevertheless these colours are the purest and most intense that we meet with in daily life, and far surpass in brilliancy and saturation those produced by dyestuffs or pigments.

There is one property which probably all substances possess which produce colour by absorption, upon which a few words must be now bestowed. If we cause white light to pass through a single plate of yellow glass, the rays which reach the eye will of course be coloured yellow. Add now a second plate of the same glass, and the light which traverses the double plate assumes a somewhat different appearance; it evidently is not so luminous, and its *colour* is no longer quite the same. Using six or eight plates of the yellow glass, we find that the transmitted light appears orange. If the same experiment be repeated, using a considerable number of plates of the same glass, the colour will change to dark red. From this it appears that the colour of the transmitted beam of light depends somewhat on the thickness of the absorbing medium. This change in the case of some liquids is very considerable: thin layers, for example, of a solution of chloride of chromium transmit green light mainly, and so imitate the action of a plate of green glass; thick layers of the same liquid transmit less light in general, but the dominant colour is red, and objects viewed through them look as they would, seen through a plate of dark-red glass. This curious property is easily explained by an examination of the action of the liquid on the prismatic spectrum. In Fig. 21 the curve represents the relative intensity of the coloured light in different portions of the spectrum. If we cut off successively slices of the rectangle, as is done in Figs. 22

4

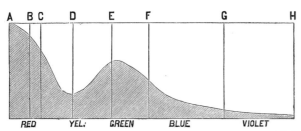

FIG. 21.—The shaded portion represents the amount of light transmitted by chloride of chromium.

and 23, we obtain the curves corresponding to a greater and greater thickness of liquid, and it is plain that at last we shall have the state of things indicated in Fig. 23; the

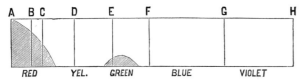

FIG. 22.—Chloride of Chromium; Effect produced by a Thick Layer.

curve is about the same as for red glass (Fig. 17), and the final colour is red. This is an extreme case, but in stained glasses, pigments, dyestuffs, etc., there is generally a ten-

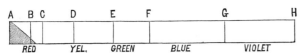

FIG. 23.—Chloride of Chromium; Effect produced by a very Thick Layer.

dency toward the production of effects of this kind, some of which will hereafter be noticed.

The colours of painted glass are similar to those of stained glass in origin and properties; both are intense, rather free from admixture with white light, and capable

of a high degree of luminosity. In these respects they far surpass the colours of pigments, which compared with them appear feeble and dull, or pale. Owing to this circumstance, chromatic combinations may be successfully worked out in stained glass, which would prove failures if attempted with pigments or dyestuffs. Hence also the wonderfully luminous appearance of paintings on glass viewed in a properly darkened room: they surpass in some respects oil or water-colour paintings to such a degree that the two are not to be mentioned together. There is no doubt but that glass-painting offers advantages for the production of realistic effects of colour and light and shade, such as the very narrow scale of oil and water-colour utterly denies; and yet great artists seem to reject this process, and severely confine themselves to work on canvas or paper, choosing to depend for their effects rather on pure technical skill and artistic feeling.

If we place on a sheet of white paper a fragment of pale-blue glass, it will display its colour, though not so brilliantly as when held so that the light of the window streams through it directly. The reason is very evident: the light which penetrates the glass falls on the paper and is reflected by it back through the glass to the eye. The light then traverses the glass twice, but this is not the only cause of its inferior luminosity, for a double plate of the same glass held before the window appears still far brighter than the single glass on the paper. The other reason is that the paper itself reflects only a small amount of the light falling on it. Upon examining the matter more closely we find also that the blue glass reflects from its surface quite a quantity of white light, which, when mingled with the coloured light, renders it somewhat pale. If, now, we grind up into a very fine powder some of the blue glass, we obtain the pigment known as smalt, and, after mixing it with water, we can wash our white paper with a thin layer of it. When it dries the

paper will be coloured blue, but the hue will be neither so luminous nor so intense as that of the light directly transmitted by the blue glass when held before a window. Its origin, however, is similar : the white light after traversing a layer of the minute blue particles reaches the paper, and is reflected backward once more through them toward the eye. In this process many coloured rays suffer absorption, and only a small portion of the constituents of the original beam finally reach the eye. In the original experiment, where the blue glass was simply laid on the white paper, it sometimes happened that the white light regularly reflected from its first surface mingled itself with the coloured light and caused it to look paler, but it was always possible to arrange matters so that this damaging coincidence did not occur. In the experiment with the blue powder spread on the paper this is impossible, for the surfaces of the little particles lie with all possible inclinations, so that, hold the paper as we will, it is sure to reflect much white along with its coloured light. What we have, then, to expect when pigments in dry powder are spread on white paper is, that they will reflect only a moderate quantity of coloured light to the eye, and that it will be rendered somewhat pale by admixture with white light.

With the aid of a little hand spectroscope these points are readily demonstrated : when we direct the instrument toward our blue paper, we find that all the colours of the spectrum are present in considerable quantities—hence some white light must be reflected from the paper ; we also notice that the red, yellow, orange, and green rays are present in less quantity than in an ordinary prismatic spectrum—hence the curve for the smalt-paper is like that given in Fig. 24. In making examinations with the spectroscope of the coloured light reflected from painted surfaces, it is advantageous to use simultaneously, along with the strip of painted paper, one which is white and a third which is black. It has been found by the author that paper painted dead-black

with lampblack, to which has been added just enough spirit varnish to prevent its rubbing off, but not enough to cause it in the least degree to shine, reflects $\frac{5}{100}$ as much light as white paper. Hence if we set the luminosity of white paper as 100, that of dead-black paper will be 5. Now, when a

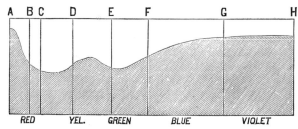

FIG. 24.—Curve for Smalt-paper : the shaded portion represents the light reflected by smalt-paper.

strip of this black paper is placed before the slit of the spectroscope it acts like white paper seen under a feeble illumination, and consequently furnishes a complete though not a very luminous spectrum. By using, then, a black-and-white strip along with the one which has been painted, we can ascertain several facts which may best be explained with the help of an example. Let us first select vermilion in dry powder, and undertake an examination of its optical properties in this way. We find that the red of its spectrum is about as powerful as the red in the spectrum from white paper, and that the other colours, though all present, are not much if any stronger than those from the black paper. This is all we can demand from any pigment : it reflects to the eye its full share of the rays it professes to reflect, and they are not mingled with more white light than is reflected by dead-black paper. Emerald-green when tested in this way proves sensibly inferior to vermilion : examined in dry powder the green space was bright, but less bright than that from white paper ; the other colours had about the same degree of luminosity as those from the black paper,

except the violet, which was not present. Chrome-yellow reflected the red, orange, yellow, and green rays about as brilliantly as white paper; the cyan-blue, ultramarine, and violet, about like black paper. Hence the great luminosity of this pigment, for it reflects not only the yellow rays abundantly, but also all the other rays of the spectrum which are distinguished for luminosity. As before remarked, the sum of these rays makes up yellow. It is plain from these experiments that a painted surface can never be as luminous as one which is white; the most that can be demanded from a painted surface is, that it should reflect its peculiar coloured light as powerfully as a white surface does; the very cause of its furnishing coloured light is, that it fails to reflect all the coloured rays equally well. Hence coloured surfaces are always darker than those which are white. If we set the luminosity of white paper as 100, that of vermilion will be about 25, emerald-green 48, and chrome-yellow as high as 75 or 80.

These experiments can now be repeated with the same pigments covered by a layer of water. The surface of the water being quite flat, the spectroscope can be held in such a way as to avoid the light directly reflected from the water, and it then becomes possible to observe certain changes which the presence of the water brings about. In the case of vermilion we find that the blue and violet portions of the spectrum almost entirely vanish, a little of the yellow, orange, and green spaces remains, and the red is nearly as powerful as before. This proves that the presence of the water has greatly diminished the amount of *white* light reflected from the surfaces of the particles of pigment, but has not much affected the brilliancy of the reflected coloured light. Experiments with emerald-green and chrome-yellow give corresponding results; less light in general is reflected, but it is somewhat purer, there being not so much white light mingled with it. By immersing our pigments in oil or varnish we push these effects still further: the

pigments appear darker, but the colour is richer, and more nearly free from white light. The explanation of these changes is well known to physicists: they depend upon the fact that light moving in a rare medium like the air is abundantly reflected when it strikes on a dense substance like a pigment; but if the pigment be placed under water we have then light moving in a dense medium (water), and striking on one which is only a little more dense (pigment): hence but little white light will be reflected from the surface of the small particles. The coloured light which is so abundantly furnished by the pigment, even under water, has its source in reflections which take place in the interior of the somewhat coarsely grained particles of the pigment itself. If the pigment is naturally fine-grained, and also is mixed with a liquid like oil, having about the same optical density as itself, scarcely any light will be reflected from it, coloured or otherwise. Prussian-blue and crimson-lake, ground in oil, are good examples. In order to exhibit their colours it is necessary either to spread them in thin layers over a light surface, or to mix them with a white pigment; alone by themselves they appear very dark, the Prussian-blue, indeed, almost black. Many other pigments are more or less affected in the same way by the presence of oil or varnish.

From what has been stated above it follows that the medium with which pigments are mixed has an important influence on their appearance. In drawings executed in coloured chalks, and in oil-paintings, we have the two extremes, works in water-colour being intermediate. Hence oil-painting is characterized by the richness of the colouring and the transparency and depth of its shadows, while in pastel drawings the tints are paler, the shadows less intense, and over the whole is spread a soft haze which lends itself readily to the accurate imitation of skies and distances. Changes in the medium are sometimes a source of embarrassment to the painter. This is particularly true in the

process of fresco-painting, and also to some extent in that of water-colour : as long as the pigment is moist it appears darker than afterward when dry, and it is necessary for the artist in laying on each wash to make a proper allowance for these changes ; this is one of the minor causes that render the process of painting in water-colours more difficult than that in oils.

As has already been stated, when we obtain our coloured light from pigments, it is apt to be more mingled with white light than when stained glass is used ; but, besides this, it is inferior to that from stained glass in the matter of luminosity. The range of illumination in our houses is small, so that practically the scale of light at the disposal of the painter in oils or water-colours is quite limited ; in point of fact he is obliged by the necessities of the case to employ means which are quite inadequate : hence the extraordinary care with which he husbands his resources in the matter of light and shade, and his constant struggle for excellence and decision in colouring. Muddy and dirty colours are instantly recognized to be such under a feeble illumination, even though they have passed muster under the blaze of full sunlight. Almost any surface looks beautiful if very brightly illuminated ; the eye is dazzled, and remains unconscious of defects that are instantly exposed under the feebler light of a gallery.

The colours which are exhibited by woven fabrics are due, like those of stained glass, to absorption. In the case of silk and wool the dye penetrates the fibres through and through, so that under the microscope they have much the same appearance as fine threads of stained glass. When white light falls upon a bundle of such coloured fibres, a portion is reflected uncoloured from the surface of the topmost fibres, while another portion penetrates to the rear surfaces of these same fibres and there is again subdivided, some rays penetrating still deeper into the bundle, while others returning to the upper surface emerge coloured.

(13)

This process is repeated on each deeper-lying set of fibres, and the result is that a good deal of strongly coloured light is sent to the eye, mingled with a portion due to the surface layers, which is more faintly coloured ; there is in addition a small portion which is quite white. It will be seen that the reflective power of the fibres is an important element in this process, for all the coloured light which reaches the eye is sent there by reflection. If we take *similar* structures of silk and wool, we can compare directly the lustre or reflective power of the individual fibres, with the aid of a lens magnifying ten or fifteen diameters. A silk-cocoon and a piece of white felting answer very well for this purpose, and when they are compared under the microscope it is very evident that the natural lustre of the silk is greatly superior to that of the wool. On comparing in this way the felting with white cotton batting, it will be found that the wool surpasses the cotton in lustre, the latter appearing almost dead-white and free from sparkle. It follows from this that the coloured light which is reflected from silk is more saturated or intense, and appears richer, than that from wool. The fibres of silk also can be made to lie in straight, parallel, compact bundles, which enables them to reflect the white light in definite directions, whereas woollen fabrics reflect it equally well in all directions. It results from this that a fabric of silk is capable, according to circumstances, of exhibiting a rich saturated colour nearly free from white light, or it may reflect much white light and exhibit a pale colour. This sparkling play of colour is beautiful, and causes the more uniform appearance shown by woollen fabrics to appear dull and tame. On the other hand, the superior transparency of the dyed fibres of wool over those of cotton give to the colours of the former material a certain appearance of richness and saturation, and cause the tints of the cotton to appear somewhat opaque.

In velvet the attempt is made to suppress all surface-light, and to display only those rays which have penetrated deeply

among the fibres, and have become highly coloured. This is accomplished by presenting to the light a surface which is entirely composed of the ends of fibres, and consequently which has little or no capacity for reflecting light. The rays then penetrate between the fibres thus set up on end, and, after wandering among them, finally again in some small quantity reach the surface as richly coloured light, which produces its full effect undiminished by any admixture of white light from the surface. In the case of silk-velvet the desired effect is for the most part actually realized : the colours are rich, and an examination with a lens shows that scarcely any of the fibres reflect white light, even when the fabric is held in unfavourable positions. If cotton-velvet is subjected to a similar examination under a lens, it will be found to reflect much surface-light, particularly when not quite new, and the surface will present a broken, rough appearance, quite different from that of its more aristocratic rival.

It would appear that at present it is actually possible to employ for woven fabrics dyes which furnish coloured light having a degree of intensity and purity which is actually undesirable. This is the case with some of the aniline dyes. Dresses dyed with some of them, when seen in full daylight, act on the eye so powerfully that mere momentary inspection gives rise to the phenomenon of accidental colours (see Chapter VIII.). These harsh effects are interesting as conveying certain information that our dyers have already touched, and indeed gone beyond, the greatest allowable limits in the matter of the intensity and purity of their hues. At least this applies to large surfaces, such as complete dresses, etc. In the case of smaller articles, such as ribbons, etc., these intense colours are more allowable, just as the flash of diamonds is more tolerable on account of their insignificant size.

We have seen, thus far, that the colours of pigments and dyestuffs are due to absorption, and to this same cause

we must attribute the colours of most objects which occur in landscapes. Two of these are so important that it will be worth while to devote a few moments to their separate consideration : we refer to the colour of water, and to that of vegetation. The colour of large masses of water, such as lakes and rivers, is so much influenced by that of the sky that many persons consider it to depend wholly on it, and are disposed to doubt whether water has any proper colour of its own. It is quite true that a small quantity of pure water, such as is contained in a drinking-glass, appears perfectly colourless, and that the light from white objects passes through it without suffering sensible absorption. If, however, we allow the white light from a porcelain plate to traverse a layer of pure distilled water two metres in thickness, it will be found to be tinged bluish. This experiment, which was first made by Bunsen, proves that an absorption takes place along the red end of the spectrum, and that water is really coloured in the same sense as a weak solution of indigo. The water of the lake of Geneva is quite pure, being produced mainly by the melting of glaciers ; the granite meal mingled with the water, being coarse, soon settles to the bottom, and leaves it free from turbidity. Hence along the wonderful shores of this lake it is easy to repeat the experiment of Bunsen, and to study the colour of this liquid. White objects, resting on the bottom in the shallow places where the depth is six or eight feet, show very plainly a greenish-blue hue, and the tint can be examined at different depths by lowering a piece of white porcelain with a string. Even on cloudy days, when the sky is overcast and grey, the lake itself displays a wonderfully intense cyan-blue colour, while on clear days, on looking down into its waters, one is tempted to believe that it is a vast natural dyeing-vat. When vegetable matter is present in small quantity the colour of water changes to a bluish-green ; many excellent examples occur among the beautiful lakes of the Tyrol. Decaying organic matter,

on the other hand, tinges water brownish, and lakes or rivers of this colour are apt to assume on cloudy days a silver-grey appearance, while under a clear sky they often appear very decidedly blue. There seems to be some reason to believe that the absorptive action of pure water on white light changes with its temperature, and that warm water is actually more deeply coloured than cold water. Heat has an action of this kind upon many coloured substances, and Wild with his photometer actually found that both distilled and pump water showed somewhat stronger colours on being heated. He accounts in this way for the more intense colour which it is claimed mountain lakes display during the summer months.

The green colour of vegetation offers a rather peculiar case. When we examine with the spectroscope any ordinary green pigment, we find that the red is absent and the blue and violet much weakened, as was the case with em-

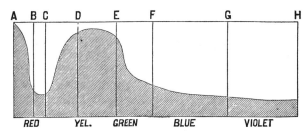

FIG. 25.—The shaded portion represents the light reflected by green leaves.

erald-green. Green leaves, however, furnish a spectrum of a different character: the extreme red is present; then occurs a deficiency of coloured light, which is followed by an orange-red space; next comes the orange, then the yellow, greenish-yellow, and yellowish-green; after this follows a little full green; the rest of the spectrum decreases rapidly in luminosity. Fig. 25 represents this spectrum. The sum of all these colours is a somewhat yellowish green, which is accordingly the colour presented by green leaves

in white light. It will be shown in Chapter X. that a mixture of red and green light furnishes yellow light, which explains the production of a yellowish-green in this somewhat singular way. It follows, from the analysis just given, that green leaves are capable of reflecting a considerable quantity of red light, where surfaces painted with green pigments would not have this power, and consequently would appear black or grey. Hence under the red light of the setting sun foliage may assume a red or orange-red hue. Corresponding to this, when the illumination is of an orange colour, foliage will partake more of this hue than would be the case with ordinary green pigments. Connected with this is also the great change of colour which foliage experiences according as it is illuminated by direct sunlight or by light from the blue sky, the tint in extreme cases varying from a yellow or slightly greenish yellow up to a bluish-green.

Simler has constructed a simple and beautiful piece of apparatus, based on the singular property which living leaves have of reflecting abundantly the extreme red rays of the spectrum; it is called an *erythroscope*. A plate of blue glass, stained with cobalt, is to be procured, having a thickness such that it will allow the extreme red of the spectrum to pass, but no orange or yellow; it should also transmit the small band of greenish-yellow just before the fixed line E, and all the green from *b* to F, also all the blue and violet. A plate of rather deeply coloured yellow glass is also needed; this should be capable of transmitting all the light of the spectrum from the farthest red up to G; that is to say, it should cut off the violet and blue-violet only. When a sunny landscape is viewed through these two glasses, it assumes a most wonderful appearance: all green trees and plants shine with a coral-red colour, as though they were self-luminous; the sky is cyan-blue,* the clouds purplish-violet; the earth and rocks assume various

* Cyan-blue is a greenish-blue.

tints of violet-grey. Pine-trees appear of a dark-red hue ; orange or yellow flowers become red or blood-red ; greens, other than those of the foliage, are seen in their natural tints, or at least only a little more bluish ; lakes preserve their fine blue-green colouring, and the play of light and shade over the landscape is left undisturbed ; the whole effect is as though a magician's wand had passed over the scene, and transformed it into an enchanted garden. For the full realization of these effects it is essential that stray light should be prevented from reaching the eyes, and accordingly the glasses should be mounted in an arrangement of wood or pasteboard which adapts itself to the contours of the face, and excludes as much as possible diffuse light. On comparing the spectrum given by the blue and yellow glasses with that of green leaves, it will be found that the two glasses cut off almost all the green light furnished by the leaves, but allow those green rays of light to pass which the leaves are incapable of supplying.

The colours which metals such as copper, brass, or gold display, are due to absorption. A quantity of white light is reflected from the real surface, but along with it is mingled a certain amount which has penetrated a little distance into the substance of the metal, and there has undergone reflection ; this last portion is coloured. If we cause this mixture of white and coloured light to strike repeatedly on a metallic surface—for example, such as gold—we constantly increase the proportion of light which has penetrated under the surface, and has become coloured. A process of this kind takes place in the interior of a golden goblet ; hence the colour in the inside is deeper and more saturated than on the outside. Some metals, like silver or steel, hardly show much colour till the light has been made to strike repeatedly on their surfaces ; when this is done with silver, the light gradually assumes a yellow colour, while with steel it becomes blue.

The true colour of metals must not be confounded with that which is often given to them by the presence of a surface-film of oxide or sulphide ; such films cause for the most part a bluish appearance, though all the colours of the spectrum may be produced on metals in this way. In fact, the hue in these cases is due to an interference of light caused by the thin layer of oxide, and is quite distinct from the actual colour of the metal. (See Chapter IV.)

Metals, whether coloured or white, are chiefly remarkable for the large quantities of light which they are capable of reflecting. Measurements made by Lambert have shown that the *total amount* of light reflected by white paper is about forty per cent. of the light falling on it. Silver, however, is capable of reflecting ninety-two per cent. ; steel sixty per cent., etc.

Polished surfaces, particularly of metals, have another property which adds to their apparent brilliancy, and increases their lustrous appearance. Those portions of the surface which are turned away from the light often reflect but little, and look almost black. This sharp contrast enhances their brilliant, sparkling appearance, and raises them quite above the rank of surfaces coloured by pigments. In consequence of this, metals cannot be used along with pigments in serious or realistic painting ; they are quite out of harmony, and produce the impression that the painter has sought to help himself by a cheap trick rather than by employing the true resources of art. In those cases where gold was so extensively used during the middle ages for the backgrounds of pictures of holy personages, or even for the adornment of their garments, the object was far more to produce symbolic than realistic representations, and here the presence of the gold was actually a help, as tending to convey the idea that the painting was not the portrait of an ordinary mortal, but rather a childlike attempt to depict and lavishly adorn the ideal image of a venerated and saintly character. On the other hand, this brilliancy of

gold, with its rich colour, preëminently adapts it for the purpose of inclosing paintings and isolating them from surrounding objects. A painted frame or wooden frame, inasmuch as its colour belongs to the same order as those contained in the picture, becomes as it were an extension of it, and is apt to injure the harmony of its colouring ; and, besides this, its power of isolation is inferior to that of gold, on account of its greater resemblance to ordinary surrounding objects.

Having now considered with some detail the colours that are produced by absorption, it may be well to add a few words concerning the attempts that have been made to reproduce colour by the aid of photography. Photographs render accurately the light and shade, why should they not also record the colours, of natural objects? In 1848 E. Becquerel announced that he had been able to photograph the colours of a prismatic spectrum falling on a silver plate which had been treated with chlorine. These colors were quite fugitive, lasting only a few minutes. In 1850 Nièpce de Saint-Victor and in 1852 J. Campbell claimed that they had rendered these colours more permanent. In 1862 the former experimenter, by washing the finished plates with a solution of dextrin containing chloride of lead, obtained coloured pictures that lasted twelve hours. In the following year he still further improved his process, the colours lasting three or four days in rather strong daylight. An examination of the details of these memoirs and of the pictures indicates that the colours thus obtained are due to a greater or less reduction of the film of chloride of silver, and are, in fact, produced merely by the interference of light, and consequently have no necessary connection with the hues of the natural objects to which they seem to owe their origin. Hence we must regard this problem as unsolved, and in the present state of our knowledge there

does not seem to be any reason to suppose that it ever will be solved. Why should the red rays when acting on a certain substance produce a red compound, the green and violet rays green and violet compounds, and so on with all the other coloured rays? But photography in colour implies exactly this.

This problem has more recently been handled in an entirely different manner, and with a more hopeful result, from a practical point of view. Suppose we place a red glass before a photographic camera, and photograph some object with brilliant colours—a carpet, for example. We shall obtain an ordinary negative picture, which will be entirely due to the red light sent by the carpet toward the instrument. Portions of the carpet having a different colour will not be photographed at all. Next let us hold before the camera a glass which transmits only the yellow rays (if such glass could be found), and we shall obtain a picture of the yellow constituents of the carpet ; the same is to be done with a blue glass. From these three ordinary negatives, three positive pictures are to be made in gelatine, the first being colored with a transparent red pigment, the second with a yellow, the third with a blue pigment. The first sheet of gelatin will contain a red picture, due to the red parts of the carpet ; the second and third, similar yellow and blue pictures. When these transparent coloured sheets are laid over each other, we shall have a picture correct in drawing, which will roughly reproduce the colours of the carpet. This gives an idea of the plan proposed in 1869 by C. Cross and Ducos du Hauron, for the *indirect* reproduction of colour by photography. In actual practice the negatives were taken with glasses coloured orange, green, and violet ; these negatives were then made to yield blue, red, and yellow positive pictures. This process has been greatly improved by Albert, of Münich, and by Bierstadt, of New York. In the final picture the gelatine is dispensed with, films of colour, laid on by lithographic stones,

being substituted. The selection of the pigments is necessarily left to the judgment of the operator, and in its present state the process is better capable of dealing with the decided colours of designs made by the decorator than with the pale, evanescent tints of Nature.

APPENDIX TO CHAPTER VII.

We give below a list of pigments which, according to Field and Linton, are not affected by the prolonged action of light, or by foul air :

White.

Zinc-white.
True pearl-white.
Baryta-white.
Tin-white.

Red.

Vermilion.
Indian red.
Venetian red.
Light red.
Red ochre.

Yellow.

Cadmium-yellow.
Lemon-yellow.
Strontia-yellow.
Yellow ochre.
Raw Sienna.
Oxford ochre.
Roman ochre.
Stone ochre.
Brown ochre.

Black.

Ivory-black.
Lampblack.
Indian ink.
Graphite.

Orange.

Orange vermilion.
Jaune de Mars.
Orange ochre.
Burnt Sienna.
Burnt Roman ochre.

Green.

Oxide of chromium.
Rinman's green.
Terre-verte.

Blue.

Ultramarine.
Blue ochre.

Violet.

Purple ochre.
Violet de Mars.

Brown.

Rubens's brown.
Vandyck brown.
Raw umber.
Burnt umber.
Cassel earth.
Cologne earth.
Bistre.
Sepia.
Asphalt.

White lead, smalt and cobalt-blue are not affected by light, but are by foul air. The last two are considered permanent in water-colour painting.

According to Field, the tints of the following pigments are not affected by mixture with lime, consequently they are adapted for use in fresco-painting :

White.

Baryta.
Pearl.
Gypsum.
Pure earths.

Red.

Vermilion.
Red lead.
Red ochre.
Light red.
Venetian red.
Indian red.
Madder red.

Yellow.

Indian yellow.
Yellow ochre.
Oxford ochre.
Roman ochre.
Stone ochre.
Brown ochre.
Raw Sienna.
Naples yellow.

Black.

Ivory-black.
Lampblack.
Black chalk.
Graphite.

Orange.

Orange vermilion.
Chrome-orange.
Orange ochre.
Jaune de Mars.
Burnt Sienna.

Green.

Terre verte.
Emerald green.
Mountain green.
Cobalt-green.
Chrome-green.

Blue.

Ultramarine.
Smalt.
Cobalt.

Purple.

Madder purple.
Purple ochre.

Brown.

Vandyck brown.
Rubens's brown.
Raw umber.
Burnt umber.
Cassel earth.
Cologne earth.
Antwerp brown.
Bistre.

As the effect of light on pigments is a matter of considerable importance to artists, particularly to those working with the thin washes used in water-colour painting, a careful experiment on this

matter was made by the present writer. The washes laid on ordinary drawing-paper were exposed during the summer to sunlight for more than three months and a half, and the effects noted; these were as follows:

WATER-COLOUR PIGMENTS THAT ARE NOT AFFECTED BY LIGHT:

Red.	*Orange.*	*Yellow.*
Indian red.	Jaune de Mars.	Cadmium-yellow.
Light red.		Yellow ochre.
		Roman ochre.

Green.	*Blue.*	*Brown.*
Terre verte.	Cobalt.	Burnt umber.
	French blue.	Burnt Sienna.
	Smalt.	
	New blue.	

The following pigments were all more or less affected; those that were very little changed head the list, which is arranged so as to indicate the relative amounts of damage suffered, the most fugitive colours being placed at its end:

Chrome-yellow becomes slightly greenish.
Red lead becomes slightly less orange.
Naples yellow becomes slightly greenish brown.
Raw Sienna fades slightly; becomes more yellowish.
Vermilion becomes darker and brownish.
Aureoline fades slightly.
Indian yellow fades slightly.
Antwerp blue fades slightly.
Emerald green fades slightly.
Olive green fades slightly, becomes more brownish.
Rose madder fades slightly, becomes more purplish.
Sepia fades slightly.
Prussian blue fades somewhat.
Hooker's green becomes more bluish.
Gamboge fades and becomes more grey.
Bistre fades and becomes more grey.
Burnt madder fades somewhat.
Neutral tint fades somewhat.
Vandyck brown fades and becomes more grey.
Indigo fades somewhat.
Brown pink fades greatly.

Violet carmine fades greatly, becomes brownish.
Yellow lake fades greatly, becomes brownish.
Crimson lake fades out.
Carmine fades out.

To this we may add that rose madder, burnt or brown madder, and purple madder, all, are a little affected by an exposure to sunlight for seventy hours. Pale washes of the following pigments were completely faded out by a much shorter exposure to sunlight:

Carmine,	Yellow lake,	Italian pink,
Full red,	Gall-stone,	Violet carmine.
Dragon's blood,	Brown pink,	

CHAPTER VIII.

*ON THE ABNORMAL PERCEPTION OF COLOUR, AND
ON COLOUR-BLINDNESS.*

WE have considered now, with some detail, the various ordinary modes of producing the sensation of colour ; but, in order to render our account more complete, it is necessary to touch on some of the unusual or extraordinary methods. In every case examined thus far, the sensation of colour was generated by the action on the eye of coloured light—that is, of waves of light having practically a definite length. As colour, however, is only a *sensation*, and has no existence apart from the nervous organization of living beings, it may not seem strange to find that it can be produced by white as well as by coloured light, or even that it can be developed in total darkness, without the agency of light of any kind whatever. If the eyes be directed for a few moments toward a sheet of white paper placed on a black background and illuminated by sunlight, on closing them and excluding all light by the hands or otherwise, it will be found that the absence of the light does not at once cause the image of the paper to disappear. After the eyes are closed it will still be plainly visible for several seconds, and will at first be seen quite correctly, as a white object on a black ground ; the colour with some observers then changes to blue, green, red, and finally back to blue, the background remaining all the while black. After this first stage the background changes to white, the colour of the sheet of paper appearing blue-green, and finally yellow. Most of these colours are

as distinct and decided as those of natural objects. If the experiment be made for a shorter time, and under a less brilliant illumination, the eyes being first well rested by prolonged closure, the series of colours will be somewhat different. Fechner, Seguin, and Helmholtz observed that the original white colour passed rapidly through a greenish blue (Seguin, green) into a beautiful indigo-blue ; this afterward changed into a violet or rose tint. These colours were bright and clear, afterward followed a dirty or grey orange ; during the presence of this colour the background changed from black to white, and the orange tint altered often into a dirty yellow-green which completed the series. If, instead of employing white, a coloured object on a grey ground is regarded intently for some time, the eyes will be so affected that, on suddenly removing the coloured object, the grey ground will appear tinged with a complementary

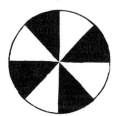
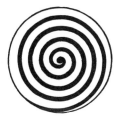

FIG. 26.—Disk with Black and White Sectors for the Production of Subjective Colour.

FIG. 27.—Black and White Spiral on Disk, for the Production of Subjective Colour.

tint ; for example, if the object be red, the after-image will be bluish green. It is not necessary to dwell longer on these phenomena at present, as a portion of Chapter XV. will be especially devoted to them. In both the cases mentioned above, the colour develops itself after the eyes are closed, or at least withdrawn from the illuminated surface. There are, however, cases where very vivid colours can be seen while the eyes are exposed to full daylight. If a disk

of cardboard painted with alternate white and black sectors, like that shown in Fig. 26, be set in rotation while exposed to full daylight, colours will be seen after a few trials. It will be found that a certain rate of rotation communicates to the disk a green hue, a somewhat more rapid rate causing it to assume a rose colour. According to Helmholtz, these effects are most easily attained by using a disk painted with a black spiral, like that in Fig. 27. These phenomena may be advantageously studied by a method which was used by the author several years ago. A blackened disk with four open sectors seven degrees in width was set in revolution by clockwork, and a clouded sky viewed through it. With

FIG. 28.—Subjective Colours seen in Sky, with aid of Rotating Disk.

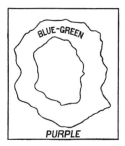

FIG. 29.—Subjective Colours, Ring, etc., seen in Sky with aid of Rotating Disk.

a rate of nine revolutions per second, the whole sky often appeared of a deep crimson hue, except a small spot in the centre of the field of view, which was pretty constantly yellow. Upon increasing the velocity to eleven and a half revolutions per second, the central spot enlarged somewhat, and became coloured bluish green, with a narrow, faint, blue border, indicated by the dotted line ; the rest of the sky appeared purple, or reddish purple. (See Fig. 28.) With the exception of fluctuations in the outline of the spot, this appearance remained tolerably constant as long as the rate of revolution was steadily maintained. When the velocity

of the disk was increased, the bluish-green spot expanded into an irregularly shaped blue-green ring, which with a rate of fifteen turns per second mostly filled the whole field of view. (See Fig. 29.) With higher rates all these appearances vanished, and the sky was seen as with the naked eye.* More than one elaborate attempt has been made to found on phenomena of this class a theory of the production of colour, though it may easily be shown that in all such cases the disk really transmits not coloured but white light, and that the effects produced are due to an abnormal state of the retina caused by alternate exposure to light and darkness.

A current of electricity is also capable of stimulating the optic nerve in such a way that brilliant colours are perceived, although the experiment is made in perfect darkness. If the current of a strong voltaic battery be caused to enter the forehead, and travel hence to the hand, according to Ritter, a bright-green or bright-blue colour is perceived, the hue depending on whether the positive current enters the hand or forehead. Helmholtz, in repeating this operation, was conscious simply of a wild rush of colours without order. The experiment is, however, interesting to us, as proving the possibility of the production of the sensation of colour without the presence or action of light.

Recently a substance has been discovered which, when swallowed, causes white objects to appear coloured greenish yellow, and coloured objects to assume new hues. Persons under the influence of santonin cannot see the violet end of the spectrum ; and this fact, with others, proves that they have become temporarily colour-blind to violet.

An observation of Tait's, and others by the author, have shown that a shock of the nervous system may produce momentarily colour-blindness to green light. White objects then appear of a purplish red, and green objects of a much

* "American Journal of Science and Arts," September, 1860.
5

duller green hue than ordinarily.* These effects are evanescent, though quite interesting, as we shall see presently, from a theoretical point of view.

Investigations during the present century have shown that many persons are born with a deficient perception of colour. In some the defect is slight and hardly noticeable, while in others it is so serious as to lead to quite wonderful blunders. This imperfection of vision is often inherited from a parent, and may be shared by several members of the same family. It is remarkable that women are comparatively free from it, even when belonging to families of which the male members are thus affected. The occupations of women, their attention to dress and to various kinds of handiwork where colour enters in as an important element, seem to have brought their sense for colour to a higher degree of perfection than is the case with men, who ordinarily neglect cultivation in this direction. Out of forty-one young men in a gymnasium, Seebeck found five who were colour-blind ; but during his whole investigation he was able to learn of only a single case where a woman was to some extent similarly affected. It not unfrequently happens that persons with this defect remain for years unconscious of it. This was the case with some of the young men investigated by Seebeck ; and in one remarkable instance a bystander, in attempting to help a colour-blind person who was under investigation, showed that he was himself colour-blind, but belonged to another class ! The commonest case is a deficient perception of red. Such persons make no distinction between rose-red and bluish-green. They see in the spectrum only two colours, which they call yellow and blue. Under the name yellow they include the red, orange, yellow, and green spaces : the blue and violet they name, with some correctness, blue. In the middle of the spectrum

* "American Journal of Science and Arts," January, 1877. A similar observation by Charles Pierce was communicated to the author while this work was going through the press.

there is for them a neutral or grey zone, which has no colour ; this, according to Preyer, is situated near the line F. For the normal eye it is greenish-blue ; for them, white. The extreme red of the spectrum, when it is faint, they fail to distinguish ; the rest of the red space appears to them of a saturated but not luminous green ; the yellow space has for them a colour which we should call bright green ; and finally, they see blue in the normal manner. Maxwell found that by the aid of his disks, using only two colours, along with white and black, he was able, by suitable variations in their proportions, to match for them any colour which presented itself ; while the normal eye requires at least three such coloured disks, besides white and black. His experiments led to the result that persons of this class perceive two of the three fundamental colours which are seen by the normal eye. Helmholtz also arrived at the same result. It is possible to render the normal eye to some extent colour-blind to red in the manner followed by Seebeck in 1837, and afterward by Maria Bokowa. These observers wore for several hours spectacles provided with ruby-red glasses ; and this prolonged action of the red light on the eye finally, to a considerable extent, tired out the nerve fibrils destined for the reception of red, so that on removing the glasses they saw in the spectrum only two colours. The second observer called them yellow and blue. Furthermore, the extreme red end of the spectrum was not visible to her, just as is the case with those who are actually blind to red ; all red objects appeared to her yellow, and dark red was not distinguishable from dark green or brown.

Dalton, the celebrated English chemist, suffered from this defect of vision, and was the first to give an accurate description of it ; hence this affection is sometimes named after him, Daltonism. It is very remarkable that, according to the observations of Schelske and Helmholtz, even in the normal eye there are portions which are naturally colour-blind to red, and when this zone of the eye is used the same

mistakes in matching colours are made. Such experiments are somewhat difficult to make without considerable practice, as it is necessary that the colored objects should be viewed, not directly, but by the eye turned aside somewhat. There is a simple means by which persons who are colourblind to red can to some extent help themselves, and prevent the occurrence of coarse chromatic blunders, such as confusing red with green. Green glass does not transmit red light; hence, on viewing green and red objects through a plate of this glass it will be found, even by persons who are colour-blind, that the red objects appear much more darkened than those which are green. On the other hand, a red glass will cause green objects to appear darker, but will not affect the luminosity of those having a tint similar to itself. The exact tints of the glasses are important, and they should of course be selected with the aid of a normal eye.

The kind of colour-blindness just described is rather common, and it has been estimated that in England about one person in eighteen is more or less afflicted with it. We pass on now to the consideration of a class of cases that is more rare. Persons belonging to this second class see only two colours in the spectrum, which they call red and blue. They set the greatest luminosity in the spectrum in the yellow space, as is done by the normal eye; and they easily distinguish between red and violet, but confuse green with yellow and blue with red. In two cases examined by Preyer, yellow appeared to them as a bright red; this same observer also found that in the spectrum, near the line *b*, the two colours into which they divided the spectrum were separated by a small neutral zone, which was for them identical with grey. A sufficient number of observations have not been accumulated to furnish means of ascertaining with certainty the exact nature of the difficulty under which they labour, though it is probable that they are colour-blind to green light. There are also observations on record of cases of temporary colour-blindness of a third kind, where the violet end of the spectrum was seen shortened to a very remarkable extent; and if it should prove that the cause was of a nervous character, rather than due to a deeper yellow colouration of the axial portions of the retina, this would demonstrate the existence of violet colour-blindness.

The subject of colour-blindness is one of considerable importance from a practical point of view, and this defect has no doubt been the occasion of railroad accidents. In 1873–'75 Dr. Favre, in France, examined one thousand and fifty railroad officials of various grades, and found among them ninety-eight persons who were colour-blind—that is, 9·33 per cent. In 1876 Professor Holmgren, in Sweden, examined the entire *personnel* of the Upsala-Gefle line, and out of two hundred and sixty-six persons ascertained that thirteen were colour-blind. These were found in every grade of the service, many of them being required daily to make use of coloured signals. It is singular that in no case had there been previously any suspicion of the existence of the defect. For further information with regard to the practical side of this matter, the reader is referred to the essay of Holmgren, which will be found in the Smithsonian Report for 1877: a French translation also exists.

In concluding this subject, it may not be amiss to allude to the very remarkable case described by Huddart, of a shoemaker, an intelligent man, where only a trace of the power to distinguish colours seemed to remain.* According to the observations, he was colour-blind to both red and green, and in general seems to have had hardly any perception of colour, as distinguished from light and shade. Curiously enough, recent observations of Woinow show that even in the normal eye there is a condition like this at the farthest limit of the visible field of view; here all distinctions of colour vanish, and objects look merely white or black, or grey. It is probable that between the case of

* "Philosophical Transactions," lxvii.

Harris, just mentioned, and that of a normal eye possessed of the maximum power of perceiving and distinguishing colours, a great number of intermediate gradations will be found to exist. Slight chromatic defects of vision generally receive no attention, or are explained in some other way. The writer recalls the case of an excellent physicist who for many years had a half suspicion that he was to some extent colour-blind, but rather preferred to explain the discrepancies by the assumption of a difference in nomenclature. Taking up the matter at last seriously, he made an investigation of his own case, and found that he actually was to some extent colour-blind to red. It has been suggested that the very inferior colouring of some otherwise great artists can be accounted for by supposing them to have been affected with partial colour-blindness; this idea is plausible, but, as it appears to us, totally without proof. There are great numbers of persons who are able to hear distinctly all the notes employed in music, who yet have no talent for it and no enjoyment of it. On the other hand, we know of cases of persons who from infancy have been afflicted with partial deafness, and have nevertheless been musicians, and even composers. It is the same in painting as in music : the possession of a perfect organ is not by any means the first necessity, and it can be proved that even artists who are actually colour-blind to red may still, with but slight external aid, produce paintings which are universally prized for their beautiful colouring. Their field of operations is of course more restricted, and they are compelled to avoid certain chromatic combinations. During the evening, by gas- or lamp-light, we are all somewhat in the condition of persons who are colour-blind to violet ; but yet, with precautions and some patience, it is possible to execute works in colour, even at this time, which afterward stand the test of daylight. It would appear probable, then, that the difficulty with the inferior colourists above alluded to was not so much anatomical or physiological as psychical.

According to a theory recently proposed by Hugo Magnus, our sense for colour has been developed during the last four or five thousand years ; previous to this period it is assumed that our race was endowed only with a perception of light and shade. The evidence which is offered is of a philological character, and tends to show that the ancients either distinguished or described colours less accurately than the moderns. The same kind of reasoning might be applied to proving that children at the present day have but little power of distinguishing tints, as they usually scarcely notice any but the most intense colours. When, however, we study the prehistoric races at present existing on the globe, and living in the same style as their ancestors, we find them quite capable of discriminating colours, and often very fond of them. Going many steps lower, we meet with animals that have the power of perceiving and even imitating a series of colours with accuracy. This is the case with the chameleon, as shown by P. Bert, and also, according to Pouchet and A. Agassiz, with certain kinds of flounders. The skin of the chameleon is provided with an immense number of minute sacs filled with red, yellow, and black liquids ; the animal has the power of distending these star-like vesicles at pleasure, and thus adjusts its colour in a few minutes (after a series of trials) so as to match that of the surface on which it is placed. Its chromatic scale covers red, orange, yellow, and olive-green, and the mixtures of these colours with black, which includes of course an extensive series of browns. The olive-green is made by distending the yellow and black sacs, the effect being similar to that obtained by combining a black and yellow disk. (See Chapter XII.)

Corresponding to this, A. Agassiz has often noticed, when a young flounder was transferred from a jar imitating in colour a sandy bottom to one of a dark-chocolate hue, that in less than ten minutes the black-pigment cells would obtain a great preponderance, and cause it to appear wholly

unlike the yellowish-grey speckled creature which a few moments before had so perfectly simulated the appearance of sand. When removed to a gravelly bottom, the *spots* on the side became prominent.

If our sense for light and shade is old, but that for colour recent and still undergoing development, we should perhaps expect that it would require more time to recognize colour than appearances dependent simply on light and shade ; but, according to the experiments of the writer, forty billionths of a second answers as well for one as for the other act of perception.*

In closing this chapter, it may be well to mention a very simple but beautiful experiment, by which we all can easily place ourselves in a condition somewhat like that of Harris, where all or nearly all sensation of colour had vanished. If some carbonate of soda be ignited in the flame of a Bunsen burner, it will furnish an abundance of pure homogeneous light of an orange-yellow hue. This light is quite bright enough to illuminate objects in a darkened room, but all distinctions of colours vanish, light and shade only remaining. A red rose exhibits no more colour than its leaves ; gayly painted strips of paper show only as black or white or grey ; their colours can not even be guessed at. The human face divested of its natural colour assumes an appearance which is repulsive, and the eye in the absence of colour dwells on slight defects in the clearness and smoothness of the complexion. If now an ordinary gas-burner be placed near the soda flame, and allowed at first to burn with only a small flame, objects will resume their natural tints to some slight extent, and begin again faintly to clothe themselves with pleasant hues, which will deepen as more light is furnished, till they finally seem fairly to

* The amount of time necessary for vision. " American Journal of Science," September, 1871.

glow with radiant beauty. Those who have never witnessed an experiment of this kind have but little conception how great would be to us the loss of our sense for colour, or how dreary the world would seem, divested of the fascinating charm which it casts over all things.

APPENDIX TO CHAPTER VIII.

Maxwell has published an account of his rather elaborate examination of the case of one of his students, who was colour-blind to red.* An apparatus was employed by which the pure colours of the spectrum could be mixed in any proportion; these colours were then mingled by the colour-blind person, in such a proportion as to produce to his eyes the effect of white. In this way the following equation was obtained: 33·7 green + 33·1 blue = white. Maxwell then, employing the same colours, obtained his own or a normal equation, which was: 26 green + 37·4 blue + 22·6 red = white. If we combine these equations by subtraction, we obtain: 22·6 red — 7·7 green + 4·3 blue = D; D being the missing colour not perceived by the colour-blind. The sensation, then,

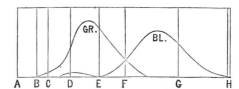

Fig. 80.—Curves of a Colour-blind Person. (Maxwell.)

which Maxwell had in addition to those of the colour-blind person was somewhat like that of a full red, but different from it in that the full red was mixed with 7·7 green, which had to be removed from it, and 4·3 of blue substituted. The missing colour, then, according to this experiment, was a crimson-red. Even normal eyes vary a little, and, if this examination had been made by Maxwell's

* " Philosophical Transactions " for 1860, vol. cl., p. 78.

assistant (observer K), the result would have been a red mixed with less blue, consequently a colour much more like the red of the spectrum. From experiments of this kind Maxwell was able to construct the curves of intensity of the two fundamental colours which are perceived by those who are colour-blind to red; these curves are shown in Fig. 30. The letters A, B, C, D, etc., mark the positions of the fixed lines in the solar spectrum; the curved line marked GR exhibits the intensity of the green element, the line marked BL that of the blue or violet. It will be noticed that the green sensation attains its maximum about half way between the lines D and E, that is, in the yellowish green; while the highest point of the other curve is about half way between F and G, that is, in the blue space. Maxwell also constructed similar intensity curves for a normal eye; they are represented in Fig. 31, the

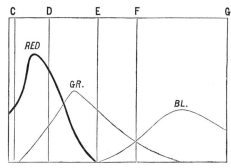

FIG. 31.—Curves of Normal Eye. (Maxwell.)

curve for red being indicated by a heavy line, the others as above. The green and blue curves have about the same disposition as with the colour-blind person, while the red attains its maximum between C and D, but nearer D—that is, in the red-orange space.

A set of observations was also made by Maxwell on the same colour-blind gentleman, with the aid of coloured disks in rapid rotation; and, from the colour equations thus obtained, the positions of the colours perceived by him were laid down in Newton's diagram, in a manner similar to that explained in the appendix to Chapter XIV. In Fig. 32, V shows the position assumed for red or vermilion; U, that of ultramarine-blue; and G, that of emerald-

green. They are placed according to Maxwell's method, at the three angles of an equilateral triangle. W would be the position of white for a normal eye, and Y that of chrome-yellow. D is the position of the defective colour, which Maxwell was able to imitate by mingling, by the method of rotating disks, 86 parts of vermilion and 14 of ultramarine-blue. A line drawn from D through W contains along its length the various shades of grey and the white of the colour-blind. The grey which they perceive when green and

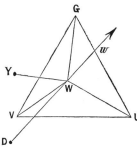

FIG. 32.—Newton's Diagram for a Person Colour-blind to Red. (Maxwell.)

FIG. 33.—Newton's Diagram for a Person Colour-blind to the Fundamental Red.

blue are mixed lies at w; the white of white paper, i. e., a more luminous grey, was on the same line but considerably farther along outside.

It may perhaps be as well to add to the above one or two remarks concerning the construction of Newton's diagram for the colour-blind. Let us suppose that the pure colours of the spectrum are employed, and that the missing colour is the fundamental red; we then place the fundamental green at G, Fig. 33, the fundamental blue or violet at U, and the missing red at D. Then along the line U G will lie mixtures of blue and green, and at w will be the white of the colour-blind person. Along the line D G will be situated various shades of green, from dark green to bright green, the latter colour predominating as we approach G. Along the line D U we shall have various shades of blue, from bright blue to dark blue, the colour being very dark near D and very bright near U. A line like the dotted one (Fig. 33) will contain various shades of green, from light green to dark green, but none of them so intense as

those situated along the line D G ; in other words, they all will be mingled with what the colour-blind call white.

If the defective colour-sensation is supposed still red, but to be only partially absent, the diagram takes the form indicated in Fig. 34 ; that is, red, instead of occupying the position at one of the angles of an equilateral triangle, will be moved up toward the centre to R'. White will also be shifted from W to w, and the white of a person thus affected would appear to the normal eye of a somewhat greenish-blue hue. Between D and R' lie, so to speak, mixtures of red with darkness, and along the line R' G will be various mixtures of red and green, in which, according to a normal eye, the green element quite predominates ; that is to say, their orange is more

Fig. 34.—Newton's Diagram for a Person partially Colour-blind to Red.

Fig. 35.—Newton's Diagram for Lamp-light Illumination.

like our yellow, their yellow like our greenish yellow, etc. Along the line R' U will be their mixtures of red and blue, or a series of purples, which will be more bluish than ours.

The condition of the normal eye by lamp-light is shown in Fig. 35. The blue or violet is moved from U, its position by daylight, up to u ; white is moved from W to w—that is, into a region that would be called by daylight yellow. Yellow itself, Y, is not far from this new representative of white, and consequently by candle-light appears always whitish. In the purples, along the line R u, the red element predominates ; and in the mixtures of green and blue, along the line G u, the green constituent has the upper hand.

If we were colour-blind to every kind of light except red, then the colour diagram would assume a form similar to that shown in Fig. 36, D representing the darkest red perceptible to eyes so constituted. This sensation would be brought about by pure feeble red

light, or by a mixture of intense green and blue light, or by either of the latter. As we advance from D toward R, the red light gains in brightness, and out at w becomes very bright and stands for white. When a red glass is held before the eyes, something approximating to this kind of vision is produced.

Fig. 36.—Newton's Diagram for Persons Colour-blind to Green and Violet.

CHAPTER IX.

THE COLOUR THEORY OF YOUNG AND HELMHOLTZ.

I⊤ is well known to painters that approximate representations of all colours can be produced by the use of very few pigments. Three pigments or coloured powders will suffice, a red, yellow, and a blue; for example, crimson-lake, gamboge, and Prussian blue. The red and yellow mingled in various proportions will furnish different shades of orange and orange-yellow; the blue and yellow will give a great variety of greens; the red and blue all the purple and violet hues. There have been instances of painters in water-colours who used only these three pigments, adding lampblack for the purpose of darkening them and obtaining the browns and greys. Now, though it is not possible in this way to obtain as brilliant representatives of the hues of nature as with a less economical palette, yet substitutes of a more or less satisfactory character can actually be produced in this manner. These facts have been known to painters from the earliest ages, and furnished the foundation for the so-called theory of three primary colours, red, yellow, and blue. The most distinguished defender in modern times of this theory was Sir David Brewster, so justly celebrated for his many and brilliant optical discoveries. He maintained that there were three original or fundamental kinds of light, red, yellow, and blue, and that by their mixture in various proportions all other kinds of coloured light were produced, in the manner just described for pigments. Brewster in fact thought he had demonstrated the existence in the spectrum itself of these three sets of fundamental rays, as well as the absence of all others; and his great reputation induced most physicists for more than twenty years to adopt this view, Airy, Melloni, and Draper alone dissenting. This theory of the existence of three fundamental kinds of light, red, yellow, and blue, is found in all except the most recent text books on physics, and is almost universally believed by artists. Nevertheless, it will not be difficult to show that it is quite without foundation. If we look at the matter from a theoretical point of view, we reach at once the conclusion that it can not be true, because outside of ourselves there is no such thing as colour, which is a mere sensation that varies with the length of the wave producing it. Outside of and apart from ourselves, light consists only of waves, long and short—in fact, of mere mechanical movements; so that Brewster's theory would imply that there were in the spectrum only three sets of waves having three different lengths, which we know is not the case. If we take up the matter experimentally, we meet with no better result. According to the theory now under consideration, green light is produced by mixing blue and yellow light. This point can be tested

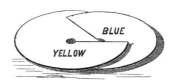

Fɪɢ. 37.—Maxwell's Disks. Blue and Yellow Disks in the Act of being combined.

with Maxwell's coloured disks. A circular disk, painted with chrome-yellow and provided with a radial slit, is to be combined with one prepared in the same way and painted with ultramarine-blue. Fig. 37 shows the separate disks, and in Fig. 38 they are seen in combination. If the compound disk be now set in quite rapid rotation, the two kinds

of coloured light will be mingled, and the resultant tint can be studied. It will not be green, but yellowish grey or

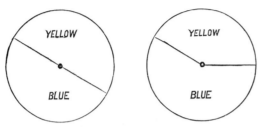

Fig. 38.—Blue and Yellow Disks in Combination.

reddish grey, according to the proportions of the two colours. These disks of Maxwell are ingeniously contrived so as to allow the experimenter to mingle the two colours in

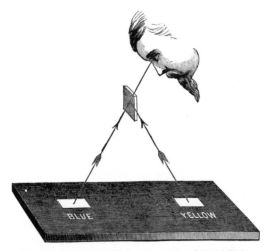

Fig. 39.—Apparatus of Lambert for mixing Coloured Light.

any desired proportion; but, vary the proportions as we may, it is impossible to obtain a resultant green hue, or in-

deed anything approaching it. Another way of making this experiment is simply to use a fragment of window-glass of good quality, as was done by Lambert and Helmholtz. This apparatus is shown in Fig. 39. The glass is supported in a vertical position about ten inches above a board painted black, and on either side of it are placed the coloured papers. The blue paper is seen directly through the glass, while the light from the yellow paper is first reflected from the glass and then reaches the eye. The result is that the two images are seen superimposed, as is indicated in Fig. 40. The relative luminosity or brightness of the two im-

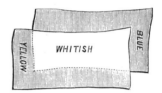

Fig. 40.—Result furnished by the Apparatus.

ages can be varied at will; for instance, moving the papers further apart causes the blue to predominate, and bringing them nearer together produces the reverse effect. In this manner the resultant tint may be made to run through a variety of changes, which will entirely correspond to those obtained with the two circular disks; but, as before, no tendency to green is observed. Helmholtz has pushed this matter still further, and has studied the resultant hues produced by combining together the pure colours of the spectrum. The following experiment, which is easy to make, will give an idea of the mode of proceeding: A blackened screen of pasteboard is pierced with two narrow slits, arranged like those in Fig. 41. The light from a window is allowed to shine through the two slits and to fall on a prism of glass placed just before the eye, and distant from the slits about a metre. Then, as would be expected, each slit

furnishes a prismatic spectrum, and owing to the disposition of the slits, the two spectra will overlap as shown in Fig. 42, which represents the red space of one spectrum falling

FIG. 41.—Two Slits arranged for mixing Two Spectra.

on the green space of its companion. By moving the slits further apart or nearer together, all the different kinds of light which the spectrum contains may thus be mingled. Using a more refined apparatus, Helmholtz proved that the union of the pure blue with the pure yellow light of the spectrum produced in the eye the sensation, not of green, but of white light. Other highly interesting results were also obtained by him during this investigation ; these will be

RED	O.	Y.	GREEN	BLUE	VIOLET			
			ORANGE		B.G.	B.VIOLET		
			RED	O.	Y.	GREEN	BLUE	VIOLET

FIG. 42.—Two Overlapping Spectra. Red and Green are mixed, also Violet and Blue, etc.

considered in the following chapter, but in the mean while it is evident that this total failure of blue and yellow light to produce by their mixture green light is necessarily fatal

to the hypothesis of Brewster. Helmholtz also studied the nature of the appearances which misled the great English optician, and showed that they were due to the fact that he had employed an impure spectrum, or one not entirely free from stray white light.

As has been remarked above, there can be in an objective sense no such thing as three fundamental colours, or three primary kinds of coloured light. In a totally different sense, however, something of this kind is not only possible, but, as the recent advances of science show, highly probable. We have already seen in a previous chapter that in the solar spectrum the eye can distinguish no less than a thousand different tints. Every small, minute, almost invisible portion of the retina of the eye possesses this power, which leads us to ask whether each atom of the retina is supplied with an immense number of nerve fibrils for the reception and conveyance of this vast number of sensations. The celebrated Thomas Young adopted another view : according to him, each minute elementary portion of the retina is capable of receiving and transmitting three different sensations ; or we may say that each elementary portion of its surface is supplied with three nerve fibrils, adapted for the reception of three sensations. One set of these nerves is strongly acted on by long waves of light, and produces the sensation we call red ; another set responds most powerfully to waves of medium length, producing the sensation which we call green ; and finally, the third set is strongly stimulated by short waves, and generates the sensation known as violet. The red of the spectrum, then, acts powerfully on the first set of these nerves ; but, according to Young's theory, it also acts on the two other sets, but with less energy. The same is true of the green and violet rays of the spectrum : they each act on all three sets of nerves, but most powerfully on those especially designed for their reception. All this will be better understood by the aid of the accompanying diagram, which is

taken from Helmholtz's great work on "Physiological Optics." In Fig. 43, along the horizontal lines 1, 2, 3 are

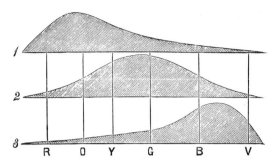

FIG. 43.—Curves showing the Action of the Different Colours of the Spectrum on the Three Sets of Nerve Fibrils. (Helmholtz.)

placed the colours of the spectrum properly arranged, and the curves above them indicate the degree to which the three kinds of nerves are acted on by these colours. Thus we see that nerves of the first kind are powerfully stimulated by red light, are much less affected by yellow, still less by green, and very little by violet light. Nerves of the second kind are much affected by green light, less by yellow and blue, and still less by red and violet. The third kind of nerves answer readily to violet light, and are successively less affected by other kinds of light in the following order: blue, green, yellow, orange, red. The next point in the theory is that, if all three sets of nerves are simultaneously stimulated to about the same degree, the sensation which we call white will be produced. These are the main points of Young's theory, which was published as long ago as 1802, and more fully in 1807. Attention has within the last few years been called to it by Helmholtz, and it is mainly owing to his labours and those of Maxwell that it now commands such respectful attention. Before making an examination of the evidence on which it rests,

and of its applications, it may be well to remember, as Helmholtz remarks, that the choice of these three particular colours, red, green, and violet, is somewhat arbitrary, and that any three could be chosen which when mixed together would furnish white light. If, however, the end and middle colours of the spectrum (red, violet, and green) are not selected, then one of the three must have two maxima, one in the red and the other in the violet; which is a more complicated, but not an impossible supposition. The only known method of deciding this point is by the investigation of those persons who are colour-blind. In the last chapter it was shown that the most common kind of this affection is colour-blindness to *red*, which indicates this colour as being one of the three fundamental sensations. But, if we adopt red as one of our three fundamental colours, of necessity the other two must be green and violet or blue-violet. Red, yellow, and blue, for example, will not produce white light when mingled together, nor will they under any circumstances furnish a green. Red, orange, and blue or violet would answer no better for a fundamental triad. In the preceding chapter it was also shown that colour-blindness to green exists to some extent, though by no means so commonly as the other case. Hence, thus far, the study of colour-blindness has furnished evidence in favour of the choice of Young, and its phenomena seem explicable by it.

Let us now examine the explanation which the theory of Young furnishes of the production of the following colour-sensations, which are not fundamental, viz.:

Orange-red.	Yellow.	Bluish-green.
Red-orange.	Greenish-yellow.	Cyan-blue.*
Orange-yellow.	Yellowish-green.	Ultramarine-blue.

Starting with yellow, we find that, according to the theory under consideration, it should be produced by the joint

* Cyan-blue is a greenish-blue.

stimulation of the red and green nerves ; consequently, if we present simultaneously to the eye red and green light, the sensation produced ought to be what we call yellow. This can be most perfectly accomplished by mixing the red and green light of the spectrum ; it is possible in this way to produce a fair yellow tint. The method of rotating disks furnishes, when emerald-green and vermilion are employed, a yellow which appears rather dull for two reasons : first, because the pigments which we call yellow, such as chrome-yellow or gamboge, are, as will hereafter be shown, relatively more brilliant and luminous than any of the red, green, blue, or violet pigments in use ; so that these bright-yellow pigments stand in a separate class by themselves. This circumstance influences our judgment, and, finding the resultant yellow far less brilliant than our (false) standard, chrome-yellow, we are disappointed. The second reason is, that green light stimulates, as before mentioned, the violet as well as the green nerves ; hence all three sets of nerves are set in action to a noticeable extent, and the sensation of yellow is mingled with that of white, and consequently is less intense than it otherwise would be. When the green and red of the spectrum are mingled, we have at least not to contend with a false standard, and only the second reason comes into play, and causes the yellow thus produced to look as though mingled with a certain quantity of white. It was found by the lamented J. J. Müller that green light when mingled with any other coloured light of the spectrum diminished its saturation, and caused it to look as though at the same time some white light had been added. This is what our fundamental diagram (Fig. 43) would lead us to expect ; it is quite in consonance with the theory of Young and Helmholtz.

Having now accounted for the fact that the yellow produced by mixing red and green light is not particularly brilliant, it will be easy to show how several of the other colour-sensations are generated. If, for instance, we dimin-

ish the intensity of the green light in the experiment above mentioned, the resultant hue will change from yellow to orange, red-orange, orange-red, and finally to pure red. These changes are best followed by using the coloured light of the spectrum, but may also be traced by the help of Maxwell's disks (Fig. 38), or by the aid of the glass plate of Helmholtz (Fig. 39). On the other hand, if, in the experiment now under consideration, the green light be made to preponderate, the resultant yellow hue will pass into greenish yellow, yellowish green, and finally green. This accounts for the production of more than half the colour-sensations in the list above given, and the remaining ones, such as ultramarine, cyan-blue, and bluish green, can be produced in the same way by mingling in proper proportions green and violet light, using any of the methods above mentioned.

In the cases thus far considered we have presented to the eye mixtures of two different kinds of coloured light, or, to speak more accurately, two kinds of light differing in wave-length ; it now remains for us to account for the production of colour-sensations in those cases where the eye is acted on only by one kind of coloured light, or by light having one wave-length. In the case of red, green, or violet light, the explanation of course lies on the surface : the red light stimulates powerfully the red nerves and produces the sensation we call red, and so of the others. But this does not quite exhaust the matter ; for, according to the theory of Young and Helmholtz, this same red light also acts to some extent on the green and violet nerves, and simultaneously produces to some small degree the sensations we call green and violet. The result then, according to the theory, ought to be the production of a strong red sensation, mingled with much weaker green and violet sensations ; or, in other words, even when the eye is acted on by the pure red light of the spectrum, this red light ought to appear as though mingled with a little white light, even if

none is actually present. Experiment confirms this theoretical conclusion, and here again decides in favour of the correctness of our theory. The simplest way of making the experiment would be to temporarily remove, were it possible, the green and violet nerves from a portion of the retina of the eye, and then to throw on the whole retina the pure red light of the spectrum. This red light ought then to appear more intense and saturated when falling on the spot from which the green and violet nerves had been removed than when received on the rest of the retina, where all three kinds of nerves were present. Now, though we can not actually remove the green and violet nerves from a spot in the retina, yet we can by suitable means tire them out, or temporarily exhaust them, so that they become to a considerable extent insensitive. If a small spot of the retina be exposed for a few moments to a mixture of green and violet light so combined as to appear bluish green, the green and violet nerves will actually become to a considerable extent inoperative; and, when the eye is suddenly turned to the red of· the spectrum, this spot of the retina will, if we may use the expression, experience a more powerful and purer sensation of red than the surrounding unfatigued portions, where the red will look as if diluted with a certain amount of white light. From this experiment of Helmholtz it appears, then, that it is actually possible to produce by artificial means colour-sensations which are more powerful than those ordinarily generated by the light of the spectrum—a point to which we shall return in the following chapter.

Having accounted now for the production of the colour-sensations red, green, and violet by red, green, and violet light, and noticed an interesting peculiarity connected with this matter, we pass on to the others. Taking up the yellow of the spectrum, we find that it can be produced by the action on the eye of waves of light intermediate in length between those which give the sensations red and green.

These waves are too short to act very powerfully on the red nerves, and too long to set into maximum activity the green nerves, but they set both into moderate action; the result of this joint action of the two sets is a new sensation, which we call yellow. Furthermore, it may be remarked that the waves of the light called yellow are far too long to produce any but a feeble effect on the violet nerves; they affect them less than green light does. From this it results that the sensation of yellow, when directly produced by the yellow light of the spectrum, is less mingled with that of white, and is purer than is the case when it is brought about by mixing red light with green in the manner before described. And this explanation may serve to account for the fact that it is impossible, by mixtures of red and green light taken from the spectrum, to produce a yellow light as pure and brilliant as the yellow of the spectrum. Let us suppose, in the next place, that, instead of presenting to the eye the yellow of the spectrum, we act on it by the light belonging to one of the other spaces—the blue, for example. The explanation is almost identical with that just given for the yellow: the waves constituting blue light being too short to powerfully affect the green nerves, and too long to accomplish this with the violet nerves, both green and violet nerves are moderately affected, giving the sensation we call blue. Meanwhile the blue light produces very little action on the red nerves, and hence very little of the sensation of white is mingled with that of blue; and consequently this blue hue is more saturated than when produced by the actual mixture of green and violet light. In fact, J. J. Müller found that green light, when mingled with light from any other part of the spectrum, produced a hue which was less saturated and more whitish than the corresponding tint in the spectrum which the mixture imitated. The production of all the other colour-sensations obtained by looking at the spectrum is explained in the same way by our theory. From all this one interesting

6

conclusion can be drawn, viz. : that there are two distinct ways of producing the same colour-sensation ; for we have seen that it may be accomplished either by presenting to the eye a mixture of green and violet light, or simply one kind of light, the waves of which are intermediate in length between those of green and violet. The eye is quite unable to detect this difference of origin, although a prism reveals it instantly.

Having examined thus, with a degree of detail which may have seemed tedious, the mode in which colour-sensations are accounted for by the theory of Young and Helmholtz, we pass to another point. In order to give more exactness to this theory, it is necessary to define with some degree of accuracy the three fundamental colours ; for there is a great variety of reds, greens, and violets. Helmholtz, as the result of his first investigation, selected a red not far from the end of the spectrum, a full green and violet ; in other words, the tints chosen were the middle and end colours of the spectrum. Maxwell, who made a series of beautiful researches on points connected with Young's theory, was led to adopt as the fundamental colours a red which in the spectrum lies between the fixed lines C and D, and is distant from C just one third of the distance between C and D. This is a scarlet-red with a tint of orange, and is represented by some varieties of vermilion. His green is situated between E and F, being distant from E by one quarter of the distance between E and F. This colour finds among pigments an approximate representative in emerald-green. Instead of adopting a full violet, Maxwell selected a violet-blue midway between the lines F and G, which is represented tolerably by artificial ultramarine-blue. By subjecting the results of experiments on the spectrum to calculation, it is possible to fix on the position of one of the fundamental colours, viz., the green. Thus Charles S. Pierce, using data given in Maxwell's paper, obtained for this colour a slightly different result from that just men-

tioned.* According to his calculations, the fundamental green has a wave-length of 524 ten-millionths of a millimetre, and is situated between the lines E and *b*, being one third of the distance E *b* from E, whereas Maxwell's green is just beyond *b*. J. J. Müller, who conducted an important investigation on this subject by a quite different method, arrived at a somewhat different result for the position of the green, and assigned to it a wave-length of 506·3 ten-millionths of a millimetre. This position in the spectrum is nearer the blue than the positions given by Maxwell and Pierce, and the tint is more of a bluish green. Again, von Bezold, basing his calculations on the experimental results of Helmholtz and J. J. Müller, reached a conclusion not differing much from those of Maxwell or Pierce. He selects a green in the *middle* of the normal spectrum between E and *b*, but nearer *b*. None of these results differ very greatly ; in fact, the differences can hardly be well indicated in a spectrum of the size of this page. All these greens may be imitated by using the pigment known as emerald-green, alone or mixed either with a small quantity of chrome-yellow or cobalt-blue. Hence all these green hues are of the most powerful or, as artists would say, overpowering character.

The exact determination of the other two fundamental colours is a more difficult matter, so that even the advocates of Young's theory have not entirely agreed among themselves upon the exact colours, Maxwell taking ultramarine-blue, Helmholtz and J. J. Müller violet, as the third fundamental. These fundamental colours are among the most saturated and intense of those furnished by the spectrum. Compared with them, the blue of the spectrum is a feeble tint, so that it has often been remarked by Rutherfurd that, in comparison with the other colours, it appears of a slaty hue. The greenish yellow is also feeble ; and, as is well

* "Proceedings of the American Academy of Arts and Sciences, 1873."

known, pure yellow is found in the spectrum in very small quantity and of no great intensity. The orange-yellow is also much weaker than the red, and the orange only becomes strong as it approaches redness in hue. From this it very naturally follows that, if a normal spectrum is cast on a white wall in a room not carefully darkened, scarcely more than the three fundamental colours will be discerned, red, green, and blue-violet; the other tints can with some difficulty be made out, but at first sight they strike the unprejudiced observer simply as the places where the three principal colours blend together. The representatives of the fundamentals among pigments are also those which surpass all others in strength and saturation. One of the fundamental colours, red, is used without much difficulty in painting and decoration; the other two are more difficult to manage, particularly the green. The last colour, even when subdued, is troublesome to handle in painting, and many artists avoid it as far as possible, or admit it into their work only in the form of low olive-greens of various shades. When the tint approaches the fundamental green, and is at the same time bright, it becomes at once harsh and brilliant, and the eye is instantly arrested by it in a disagreeable manner.

NOTE TO CHAPTER IX.

Young does not appear to be the first who proposed red, green, and violet as the three fundamental colours. As far back as 1792 Wünsch was led to the same result by his experiments on mixtures of the coloured rays of the spectrum. The title of his work is "Versuche und Beobachtungen über die Farben des Lichtes" (Leipsic, 1792). An abstract of the contents is contained in the "Annales de Chimie," LXIV., 135.

A. M. Mayer has recently called attention to the way in which Young was led to adopt red, green, and violet as the three fundamental colours, and has shown that Young at first "selected red,

yellow, and blue as the three simple colour-sensations; second, that he subsequently modified his hypothesis, and adopted red, green, and violet as the three elementary colour-sensations, showing that up to the date of this change of opinion all of his ideas on the subject were hypothetical, and not based on any observations of his own or others; third, that this change of opinion as to the three elementary colours was made on the basis of a misconception by Wollaston of the nature of his celebrated observation of the dark lines in the solar spectrum, and also on the basis of an erroneous observation made by Young in repeating Wollaston's experiment; fourth, that Young subsequently tested his hypothesis of colour-sensation, and found that it was in accord with facts reached by experiment, and that these experiments then vindicated his hypothesis and raised it to the dignity of a theory." ("American Journal of Science and Arts," April, 1875.)

Fig. 43 (page 114) shows the intensities of the three primary sensations, red, green, and violet, as *estimated* by Helmholtz. The intensities were afterward measured by Maxwell, and found to differ slightly in the case of different eyes. In Fig. 44 the letters C D E F G denote the fixed lines of the solar spectrum; the curve R R R, the

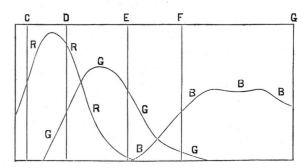

FIG. 44.—Curves showing the Intensity of the Fundamental Sensations in Different Parts of the Solar Spectrum. (Maxwell.)

intensity of the sensation of red in different parts of the spectrum; G G G is the curve for the green, and B B B that for the violet-blue sensation. Fig. 31 (page 104) shows the same curves as obtained by another observer. ("Philosophical Transactions" for 1860, vol. cl.)

CHAPTER X.

ON THE MIXTURE OF COLOURS.

THOSE who watch a painter at work are astonished at the vast number and variety of tints which can be made by mixing in varying proportions a very few pigments : from red and yellow there is produced a great series of orange tints ; yellow and blue furnish a multitude of green hues ; blue and red, a series of purples. The results seem almost magical, and we justly admire the skill and knowledge which enable him in a few seconds accurately to match any colour which is within the compass of his palette. As we continue our observations we soon find that the matter is more complicated than it appeared at first sight, each pigment having a particular set of properties which it carries into its mixtures, and these properties being by no means fully indicated by its mere colour. Thus, some blue pigments furnish fine sets of greens, while others, as beautiful and intense, yield only dull olive-greens ; some reds give glowing purples, while from others not less bright it is possible to obtain only dull, slaty purples. Before touching on these complicated cases it will be well to study this subject under its simplest aspects, and to content ourselves for the present with making an examination of the effects which are produced by mixing *light* of different colours. This can not be brought about by mixing pigments, as was for a long time supposed. In some cases the mixture of pigments gives results more or less like those produced by the mixture of coloured light, but as a general thing they differ, and in some cases the difference is enormous. In the previous chapter, for instance, it was shown that while the mixture of yellow with blue pigments produced invariably a green hue of varying intensity, the mixture of blue with yellow light gave a more or less pure white, but under no circumstances anything approaching green. The mixture of two masses of coloured light can easily be effected in a simple manner so as to be exhibited readily to a large audience. Two magic lanterns are to be employed, as shown in Fig. 45, the usual slides being replaced by plates

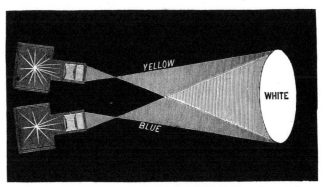

FIG. 45.—Two Magic Lanterns casting Yellow and Blue Light on the same Screen, where it forms White.

of coloured glass, as indicated. Each lantern then will furnish a large bright circle of coloured light, which can be projected on a white screen, the room in which the experiments are made being first darkened. In this way it will be found that violet-blue light when mixed with green light gives blue or greenish-blue light, according to the proportions of the two constituents ; green with red gives various hues of orange or whitish yellow, instead of a set of dull, indescribable shades of greenish, reddish, or brownish grey, as is the case with pigments. These and many

other beautiful experiments on the mixture of coloured light can easily be made ; and even the effects produced by varying the intensity of either of the masses of coloured light can readily be studied by gradually diminishing the brightness of one of the coloured circles, the other remaining constant.

To all these experiments it may be objected that we are not using coloured light of sufficient purity ; that our yellow glass transmits, as was shown in Chapter VII., not only yellow but red, orange, and green light ; and that the other stained glasses are not much better off in this respect. Hence, to meet all such objections, physicists have been finally obliged to conduct their researches in this direction on the pure coloured rays of the spectrum. The difficulties encountered in the use of this method are much greater, but the results so obtained are far more precious. Very beautiful investigations of this character have been made by Helmholtz, Maxwell, and J. J. Müller. The general character of their results is something like this : By mixing two kinds of pure coloured light they obtained, as a general thing, light having a colour different from either of the original ingredients ; for example, red and yellowish green gave an orange hue which looked in all respects like the pure orange of the spectrum ; also, in this new orange it was impossible by the *eye* to detect the presence of either red or yellowish-green light. This was true of all mixtures ; in no case could the original ingredients be detected by the eye. In this respect the eye differs from the ear ; for by practice it is possible with the unaided ear to analyze up compound sounds into the elements which compose them, at least to some extent. It was also ascertained that the same colour could be produced in several different ways— that is, by combining together different pairs of spectral colours. Thus, violet with cyan-blue gave an ultramarine hue, but violet gave the same colour when mixed with bluish-green, or even with green ; in the last case the tint

was somewhat whitish. By mixing certain colours of the spectrum, it was found that one new colour or colour-sensation could be produced which originally was not furnished by the plain pure spectrum itself ; we refer to purple, or rather to the whole class of purples, ranging from violet-purple to red-purple. These are produced by mixing the end colours of the spectrum, red and violet, in varying proportions. Furthermore, mixtures of certain colours of the spectrum gave rise to white ; this was true, for example, of red and bluish-green, and of yellow and ultramarine-blue. The white in these two cases, though so different in origin, had exactly the same appearance to the eye. Again, by mixing three or more spectral colours no new hues were produced, but simply varieties of those which could be obtained from two colours.

Such is the general character of the results obtained by mixing together masses of pure coloured light ; we propose now to enter a little more into detail respecting this very interesting matter, and to examine the laws which control the production of the resultant hues.

It was ascertained by Müller, who worked under the direction

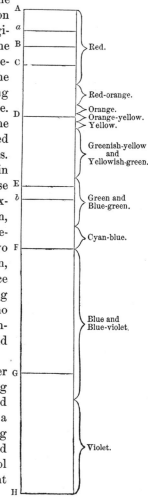

FIG. 46.—Prismatic Spectrum.

of Helmholtz, that all the colours of the spectrum, Fig. 46, from red to yellowish-green, gave by mixture resultant hues which were always identical with some of the colours situated between red and yellowish-green, thus :

TABLE I.

Red and yellowish-green gave............. Orange or yellow.*
Red and yellow gave.................... Orange.
Orange and yellowish-green gave.......... Yellow.

The effect of the mixture in these cases was to produce colours which were, to all appearance, as pure as the corresponding colours of the spectrum itself.

Furthermore, all colours of the spectrum from violet to bluish-green furnished mixtures corresponding to the colours contained between these limits, thus :

TABLE II.

Bluish-green and ultramarine-blue gave... Cyan-blue.
Bluish-green and violet gave........... Cyan-blue or ultramarine-blue.*
Violet and cyan-blue gave............. Ultramarine-blue.

In these cases also the resulting tints could not be distinguished from the corresponding spectral colours. The results thus far are simple in character, and easily remembered by any one who recollects the arrangement of the colours of the spectrum.

On the other hand, *green*, when mixed with any colour of the spectrum, gave a resultant colour, which was less saturated or intense, and appeared more whitish, than the corresponding spectral tint, thus :

TABLE III.

Green and red gave....... { Orange, Yellow, Yellowish-green, } whitish.

* According to the proportions.

Green and yellow gave............. Yellowish-green—whitish.
Green and cyan-blue gave.......... Bluish-green—whitish.
Green and violet gave............. { Ultramarine-blue, Cyan-blue, Bluish-green, } whitish.
Yellowish-green and bluish-green gave. Green—very whitish.

Müller made a careful determination of the position in the spectrum of the green which had the greatest effect in diminishing the saturation, and consequently was most influential in generating pale or whitish tints. It was situated between the fixed lines b and F, at one third the distance between b and F, measured from b. This colour is a bluish-green, and can be imitated by mixing emerald-green with a small quantity of cobalt-blue. According to Müller, as already stated, this is the fundamental green : its wavelength is 506·3 ten-millionths of a millimetre.

Having considered the effects produced by mixing the colours of the spectrum situated on either side of the green, and also the effects produced by green itself in mixture, it remains to examine the mixtures of the colours located right and left of green, thus :

TABLE IV.

Red and ultramarine-blue gave... Violet—slightly whitish.
Red and cyan-blue gave......... Ultramarine or violet—whitish.
Orange and violet gave......... Red—whitish.
Red and violet gave........... Purple—whitish.
Orange and ultramarine gave.... Purple—whitish.

These results may at first sight not seem as simple and obvious as those mentioned above, but, when the arrangement of the colour-diagram* has been explained, it will be seen that they are strictly analogous to the cases before given.

It may have been noticed by the reader that the series of pairs given in the tables thus far do not entirely exhaust

* See Chapter XIV.

all possible combinations of the spectral colours. In the cases which remain, however, the effect of mixture is not the production of coloured but of white light, thus:

TABLE V.

Red and bluish-green * gave........................ White.
Orange and cyan-blue gave......................... White.
Yellow and ultramarine gave....................... White.
Greenish-yellow and violet gave.... White.

Hence these are called complementary colours, and, on account of their importance, a separate chapter will be devoted to them. Green finds no simple complementary colour in the spectrum; it requires a mixture of red and violet, or the colour called purple.

These experiments, as will be easily understood, have furnished us with a great deal of valuable information, which could not have been derived by studying the mixtures of pigments on the painter's palette. They supply us with material which can be used in unraveling many colour-problems, presented by nature or art, which otherwise would be quite beyond our grasp. The experiments themselves unfortunately are quite difficult, and for their proper execution require knowledge and skill as well as much patience. There is, however, another method of mixing coloured light to which no such objections apply, for it is simple and quite within the reach of all who are interested in this subject. We refer to the method of rotating disks which has already once or twice been mentioned.† If a disk of cardboard be painted, as indicated in Fig. 47, with vermilion and a bluish-green pigment, and then set in rapid rotation, these colours will be mixed (in the eye of the observer), and the whole disk will assume a new and uniform tint, which will be that due to a mixture of the coloured light sent out from the two halves of the disk (Fig. 48). When

* Or rather green-blue. † See Chapter IX.

we analyze this experiment, we find that what actually does take place is this: At any one particular instant a certain portion of the retina of the eye will be affected with red light; the disk then turns and presents to the same portion of the retina bluish-green light; then follows red, then bluish-green, etc. Hence the retina is really acted on by alternate presentations of the two masses of coloured light, the intervals between these substitutions being something less than one fiftieth of a second. Now, it so happens that these alternate presentations have the same effect on the eye as simultaneous presentations. This is not the least valuable result of the spectral experiments above described,

 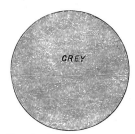

FIG. 47.—Disk painted with Vermilion and Blue-green.

FIG. 48.—Appearance presented by Red and Blue-green Disk when in Rapid Rotation.

for it enables us by an easy method to pursue our colour-investigations without having direct recourse to the spectrum. There is one respect in which the mixture by rotating disks actually does differ from that where the presentation is simultaneous. If we simultaneously present to the eye two masses of coloured light, it is plain that the luminosity of the mixture will be equal to the sum of the luminosities of the two components (or at least must approximate to it); thus, if the luminosity of our red light be 25, and that of our greenish-blue 30, the luminosity of the tint of mixture will be 55. If, however, these two masses of light act on the eye alternately, as is the case with rotating

disks, the luminosity of the mixture-tint will be not the sum but the mean of the separate luminosities ; that is, $27\frac{1}{2}$.*

This method of mixing colours was mentioned in the second century, in the "Optics" of Ptolemy.† It was

Fig. 49.—One of Maxwell's Disks.

rediscovered by Musschenbroek in 1762, and finally greatly improved by Maxwell. The last-named physicist modified the disks, so that it became possible easily to mix the colours in any desired proportion. This important improve-

Figs. 50 and 51.—Two Views of a Pair of Maxwell's Disks in Combination.

ment is effected simply by cutting a slit through the disk from the centre to the circumference, as indicated in Fig. 49. The slit enables the experimenter to combine two or even more disks on the same axis, and to adjust them so

* Compare the results obtained by the author and given in Chapter III.
† "Bibliographie Analytique," by J. Plateau (1877).

that they present their respective surfaces in any desired proportion. (See Figs. 50 and 51.) The relative proportions of the two colours can then be obtained, as was done by Maxwell, by placing a graduated circle around the disks. The author finds it better to apply a graduated circle of pasteboard to the face of the disk, this circle being made a little smaller than the disk itself ; the centring is insured by its contact with the axis on which the disk is fastened. (See Fig. 52.) Maxwell divided his circle into

Fig. 52.—Mode of measuring the Colours on the Disks.

100 instead of 360 parts ; this is convenient, and tenths of a division can readily be estimated by the eye. There is another very important feature connected with Maxwell's disks : they can easily be arranged so as to furnish colour-equations, which are of great use in chromatic studies. For example, returning to our compound disk of red and bluish-green, and remembering that these colours are complementary, it is evident that, if we give to the red and bluish-green surfaces the proper proportions, we can from them produce white, or, what is the same thing, a pure grey. But a pure grey can also be produced by rotating a white and black disk similarly arranged. Hence, in an experiment of this kind, we place on the axis, first, the disks of vermilion and bluish-green, and then on the same axis smaller disks of black and white pasteboard, cut in a similar manner with radial slits. By repeated trials we can

arrange the coloured disks so that they furnish a grey as neutral and pure as that due to the black and white disks; and these last can be arranged so that the grey furnished by them is as *luminous* as that given by the other two. In an experiment of this kind it was found that to produce a pure grey it was necessary to take 36 parts of vermilion and 64 parts of bluish-green. This grey was in all respects exactly matched by 21·3 parts of white and 78·7 parts of black. The disk when stationary presented the appearance indicated in Fig. 53; when in rotation, that of a pure, uni-

FIG. 53.—Large Disk of Red and Blue-green arranged for the Production of a Pure Grey, Small Disk of Black and White furnishes the same Grey.

form grey. All this can be put in the form of an equation by writing 36 red + 64 blue-green = 21·3 white + 78·7 black. We have here expressed the proportions in which it is necessary to take these particular colours for the production of a grey; the luminosity of this grey is also expressed in terms of black and white paper. According to our equation, if we set the luminosity of white paper equal to 100 and that of black paper equal to nothing, then the luminosity of the grey will be equal to 21·3 per cent. of that of white paper. It is not strictly true that the luminosity of black paper is equal to nothing, or that it reflects no light at all. Some careful experiments were made by the author on this point, and the following result reached: If black pasteboard is prepared by painting its surface with lamp-

black in powder to which just enough spirit varnish has been added to cause it to adhere closely, but not to shine, then a uniform surface will be obtained, which reflects a small but definite amount of the light falling on it. If, as before, we set the luminosity of white pasteboard as 100, then that of this kind of black paper will be 5·2; or, in other words, it reflects about five per cent. as much light as white pasteboard. This knowledge enables us to correct the equation just given; instead of 21·3 white, we should write 25·4.

In the above example we have taken the case of two complementary colours, and have obtained a measure for the white or grey light which they furnish by mixture;

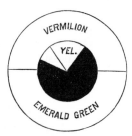

FIG. 54.—Vermilion and Emerald-green Disks arranged to produce a Yellow by Rotation. This yellow is imitated by small chrome-yellow, black, and white disks, as arranged in the figure.

when the resultant tint is not grey, but some decided colour, we can in a similar way assign to it a numerical value. Take the case of vermilion and emerald-green: Disks painted with these colours can be made to furnish a whitish yellow, as demanded by Young's theory, and we can express the value of this yellow in terms of chrome-yellow; that is, by darkening chrome-yellow and rendering it pale. This we accomplish by combining chrome-yellow with a black and a white disk. As the result of an experiment of this kind, the author obtained the equation: Verm. 51 + em.-green 49 = ch.-yel. 20 + white 8 + black 72.

The compound disk properly arranged is seen in Fig. 54. The reader may be somewhat surprised to notice that it was necessary to dull the chrome-yellow so greatly before making it similar in colour to the yellow produced by mixing the green and red light ; it must, however, be remembered that chrome-yellow does not quite belong to the same set of colours of which vermilion and emerald-green are members ; that is to say, if we represented the red space of a normal spectrum with vermilion, and the green space with emerald-green, then chrome-yellow would be too bright or luminous for the yellow space, and we should have to substitute for it a less brilliant yellow pigment.

In the same manner, with the aid of properly painted disks, we can make a series of experiments on the mixture of other colours, and satisfy ourselves of the correctness of the results already given in this chapter. For instance, by combining a yellow with a vermilion disk in various proportions, we obtain a series of orange or orange-yellow hues, which are as saturated in appearance as the original constituents. Red lead with a yellowish-green disk gave a fair yellow, and the same yellowish-green disk when combined with vermilion furnished a fine orange or yellow, according to the proportions. These correspond to the results given in Table I. In the same way those contained in the other tables can be verified. Naturally, some care must be exercised in the selection of the pigments with which the disks are painted ; thus, the author finds that the pure red of the spectrum can be imitated by vermilion washed over with carmine. Vermilion itself corresponds to the red space of the spectrum about half way between C and D ; red lead answers for a red-orange situated nearer still to D, etc. The parts of the spectrum which these and other pigments represent are indicated in Chapter III., to which the reader is referred for further information.

In preparing a set of disks for accurate experiments, it will be necessary of course to compare their colours care-

fully with those regions of the spectrum which they are intended to represent. This can be done with the aid of the spectroscope in the method indicated in Chapter III. A set of disks with carefully determined colours is quite valuable, not only for experiments of this kind, but also to enable us to produce a vast variety of tints at will, which can be recorded and afterward accurately reproduced when necessary.

We pass on now to the description of a beautiful and simple piece of apparatus contrived by Dove, for mixing the coloured light furnished by stained glass, and called by him a dichroöscope. This consists of a box 81 millimetres long, 75 high, and 70 broad ; three sides are open, but can be closed by opaque slides or by plates of coloured glass. (See Fig. 55, which shows the box in perspective.) Fig. 56

Fig. 55.—The Box of Dove's Dichroöscope. The plates of coloured glass are removed and the three sides left open. The six plates of window-glass are shown.

Fig. 56.—The Dichroöscope shown in section.

is a vertical section, in which G R and R D are plates of coloured glass ; G P is an opaque slide made of blackened cardboard, in which a square aperture has been cut ; P R represents a set of six glass plates made from window-glass of the best quality ; these are of course colourless. At 'S S, Fig. 57, is a silvered mirror, and at N a Nicol's prism. The action of the apparatus is as follows : Let us suppose that G R is a plate of green glass, and R D one of red ; then the light from the sky, striking on the mirror S S, is reflected through R D and the plates P R, and

finally reaches the eye; it will of course be coloured red. But light from the sky also falls on the plate of green glass, G R, penetrates it, is reflected from the glass plates at P R, and also reaches the eye. The eye, then, will be simultaneously acted on by red and green light; and, if the Nicol's prism at N be removed, this mixture will be seen, but we shall have no means of regulating the proportions of the red and green light. But, by restoring the Nicol's prism to its place, and rotating it, it is possible to mix the red and green light in any desired proportion.* When the appa-

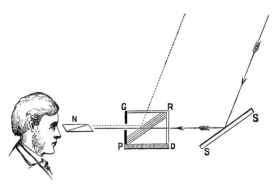

FIG. 57.—The Dichroöscope as arranged for use.

ratus is provided with red and green glass as above indicated, a dull yellow will sometimes be given without the use of the Nicol's prism; with its aid, this can always be accomplished; the yellow will pass into greenish-yellow or orange, according as the proportions of the two constituents are varied. It is best to employ glasses the tint of which is not too dark, as we do not readily recognize dark yellow as such. The author easily obtained pieces of green

* Many beautiful experiments with polarized light can be made with this little apparatus; for an account of them the reader is referred to Poggendorff's "Annalen," cx., p. 265, or to the "American Journal of Science," vol. xxxi., January, 1861.

and purple glass which gave pure white; yellow and blue glass also did the same. If the hue of the yellow glass was too deep, the white was always tinged pinkish. Red and yellow gave orange; green and yellow, yellowish-green; red and blue, purple. All these results are quite in accordance with those obtained by mixing the coloured light of the spectrum.

In the previous chapter we have described a method which was contrived long ago by Lambert for mixing the coloured light from painted surfaces (see Fig. 39, page 110). The light from the blue paper is transmitted directly to the eye, and that from the yellow paper reaches the eye after reflection; their action is of course simultaneous. By moving the two pieces of paper nearer together or farther apart, it is possible to vary their apparent brightness, and thus to regulate the proportion of blue and yellow light which reaches the eye; the yellow will predominate when the papers are near together, the blue as they are moved further apart. Chrome-yellow (the pale variety) and ultramarine-blue, when combined in this apparatus, give an excellent white, and emerald-green and vermilion give a yellowish or orange tint, according to the arrangement. It is difficult to obtain a good representative of violet among the pigments in use by artists; the author finds that some samples of the aniline colour known as "Hoffmann's violet B B" answer better than any of the ordinary pigments. If a deep tint of its alcoholic solution be spread over paper, and combined in the instrument with emerald-green, a blue, a greenish-blue, or a violet-blue can readily be produced. It is evident that a multitude of experiments of this character can be made, the number of colours united at one time being limited to two. The results of course agree with Young's theory.

Another method of mixing coloured light seems to have been first definitely contrived by Mile in 1839, though it had been in practical use by artists a long time previously.

We refer to the custom of placing a quantity of small dots of two colours very near each other, and allowing them to be blended by the eye placed at the proper distance. Mile traced fine lines of colour parallel to each other, the tints being alternated. The results obtained in this way are true mixtures of coloured light, and correspond to those above given. For instance, lines of cobalt-blue and chrome-yellow give a white or yellowish-white, but no trace of green; emerald-green and vermilion furnish when treated in this way a dull yellow; ultramarine and vermilion, a rich red-purple, etc. This method is almost the only practical one at the disposal of the artist whereby he can actually mix, not pigments, but masses of coloured light. In this connection we are reminded of an interesting opinion of Ruskin which has some bearing on our subject. The author of "Modern Painters," in his most admirable "Elements of Drawing," says: "Breaking one colour in small points through or over another is the most important of all processes in good modern oil and water-colour painting. . . . In distant effects of a rich subject, wood or rippled water or broken clouds, much may be done by touches or crumbling dashes of rather dry colour, with other colours afterward put cunningly into the interstices. . . . And note, in filling up minute interstices of this kind, that, if you want the colour you fill them with to show brightly, it is better to put a rather positive point of it, with a little white left beside or round it, in the interstice, than to put a pale tint of the colour over the whole interstice. Yellow or orange will hardly show, if pale, in small spaces; but they show brightly in fine touches, however small, with white beside them."

This last method of mixing coloured light is one which often occurs in nature; the tints of distant objects in a landscape are often blended in this way, and produce soft hues which were not originally present. Even near objects, if numerous and of small dimension, act in the same manner. Thus the colours of the scant herbage on a hillside often mingle themselves in this way with the greenish-grey tints of the mosses and the brown hues of the dried leaves; the reddish- or purplish-brown of the stems of small bushes unites at a little distance with their shaded green foliage; and in numberless other instances, such as the upper and lower portions of mosses, sunlit and shaded grass-stalks, and the variegated patches of colour on rocks and trunks of trees, the same principle can be traced.

There is another mode of mingling coloured light, which is not much used by physicists, though it is of constant occurrence in nature. We refer to the case where two masses of coloured light fall simultaneously on the same object. Sunsets furnish the grandest examples of these effects, the objects in a landscape being at the same time illuminated by the blue sky and the orange or red rays of the sinking sun. Minor cases happen constantly; among them the commonest is where a coloured object reflects light of its own tint on neighboring objects, thus modifying their hues and being in turn modified by them. The white or grey walls of a room are often very wonderfully tinted by coloured light which is cast on them in nebulous patches by the carpet, window-curtains, or other coloured objects that happen to be present. In all cases where the surface receiving the manifold illumination is white or grey, or but slightly coloured, the laws for the mixture of coloured light which have been explained above hold good; when, however, this surface has a distinct colour of its own, the phenomena are modified in a manner which will presently be noticed.

We pass on now to compare the results which are obtained by mixing coloured *lights* with those which are given by the mixture of coloured *pigments*. It was for a long time supposed that these were identical, and that experiments on mixtures of coloured light could be made with the aid of the painter's palette. Lambert appears to have been the first to point out the fact that the results in

the two cases are not always identical. Thus the celebrated experiment of combining blue with yellow light, and obtaining not green but white, was first made by him with the apparatus shown in Fig. 39, page 110. The same fact was afterward independently discovered by Plateau, and finally by Helmholtz, who, using it as a starting-point, made an examination of the whole subject. When we study this matter with some attention, we find that in mixing pigments two different effects are produced. Suppose we mix chrome-yellow and ultramarine-blue, both in dry powder. If we rub this mixture on paper, we shall produce a uniform and rather dull green. An examination even with a moderately powerful microscope will fail to reveal the separate particles of the two pigments. Yet we know that there must be a superficial layer, made up of a mosaic work of blue and yellow particles placed side by side. These two sets of particles send light of their own colour to the eye, which there undergoes a true mixture, and gives as the resultant hue a yellowish-grey. Thus far the result entirely corresponds with that produced by mixing two masses of coloured light. The second and more important effect is brought about by light which penetrates two or more layers of particles. Here the light undergoes absorption in the manner explained in Chapter VII.: the yellow particles absorb the blue and violet; the blue particles, the red, orange, and yellow rays. The green light is absorbed also by both sets of particles, but not nearly so much as the other rays. From all this it follows that chrome-yellow and ultramarine-blue jointly absorb all the colours which are present in white light, except green; hence green light, as the result, is reflected back from the surface, and reaches the eye of the observer. This green light is finally mingled with the yellowish-grey light before mentioned. When dry pigments are employed, both of the effects just described are always present. If the pigments are used as water-colours, the light from the surface is diminished, and with

it the first of these effects; and a still further diminution of it takes place if the pigments are ground up in oil. From all this it is evident that by *mingling two pigments* we obtain the resultant effect of two acts of absorption due to the two pigments: white light is twice subjected to the process of subtraction, and what remains over is the coloured light which finally emerges from the painted surface. On the other hand, the process of *mixing coloured light* is essentially one of addition; and, this being so, we find it quite natural that the results given by these two methods should never be identical, and often should differ widely. From this it follows that painters can not in many cases directly apply knowledge acquired from the palette to the interpretation of chromatic effects produced by nature, for these latter often depend to a considerable extent on the

Fig. 58.—Two Apertures in Black Cardboard covered with Red and Green Glass (natural size.)

mixing of masses of differently coloured *light*. This fact is now admitted in a general way by intelligent artists, but probably few who have not made experiments in this direction fully realize how wide are the discrepancies which exist between the results given by the two different modes of mixture. A few years ago Dove described a method of studying this subject with the aid of stained glass; and, as it would be difficult to devise a simpler or more striking mode of making such experiments, we will give his process in full. 7

In a blackened piece of cardboard two apertures are cut, about a third of an inch broad, as indicated in Fig. 58. Over these apertures are fastened pieces of stained glass— for instance, red and green ; light from a white cloud is then made to traverse the glasses. At P, Fig. 59, is an

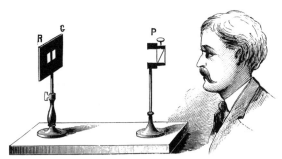

FIG. 59.—Mode of using Dove's Apparatus. R G is cardboard with red and green glass; at P is the prism of calc spar.

achromatic prism of calc spar, which doubles each of the little patches of coloured light, so that the observer on looking through the prism actually sees two red images of

FIG. 60.—The Appearance presented when Red and Green Light are mixed by Dove's Apparatus.

exactly equal brightness, and also two similar green images. Now, by revolving the calc-spar prism the experimenter can cause one of the red images to overlap one of the green, and thus it is possible to mingle the red and green

light from the coloured glasses. In one experiment made by the present writer the colour of this mixture was orange (see Fig. 60). Upon removing the glasses from the instrument, placing them one over the other and allowing white light to pass through them, the effect due to the double absorption manifested itself ; but now the colour of the transmitted light was not orange, or even brown, but dark green. If these two glasses had been ground to powder, mixed with oil, and then the mixture painted on canvas, it would have exhibited not an orange but a dark-green hue. We give below the results of a set of experiments which were recently made by the writer, and which illustrate the differences to be encountered in the two modes of proceeding :

RESULTS GIVEN BY DOVE'S APPARATUS.

Colours of Glass.	Result obtained by mixture of Light.	Result obtained by Absorption.
Red and green..........	Orange.	Dark green.
*Red and green..........	Pale yellow.	Black.
Yellow and blue.........	White.	Fine green.
*Yellow and blue........	Pinkish-white.	Fine olive-green.
Red and blue...........	Violet-purple.	Deep red.
Yellow and dark purple...	Yellow.	Deep orange.
*Yellow and dark purple..	Pale orange.	Dark brown.
Purple and green	White.	Dark green.
Yellow and red..........	Yellow, slightly orange.	Deep orange-red.
*Yellow and red	Orange.	Red.
Yellow and bluish-green...	Yellow.	Yellowish-green.
*Yellow and blue-green....	Yellowish-white.	Rich yellowish-green.
**Yellow and blue-green..	Pale greenish-yellow.	Olive-green.
Purple and blue-green....	Pale blue-green.	Dark violet.
Purple-violet and green...	Pale violet-blue.	Black.

These are not experiments selected so as to show wide dif-

* Sample more deeply tinted.

ferences ; they comprise the entire set that was made on the occasion referred to, and are simply transcribed from the author's note-book. Yet it will be seen that in not a single case do the two methods furnish the same result ; and as a general thing they differ so entirely that it would be quite impossible even to predict the nature of one of the sets of tints from a knowledge of the other. These experiments, then, exhibit the wide difference between the effects produced by mixture of light and the absorption of light ; but, as has already been remarked, when pigments are mixed on the palette, the resultant hue depends partly on the process of true mixture and partly on that of absorption, the latter of course predominating. Hence the results in the table, though instructive, are not necessarily strictly applicable to the painter's palette, which is best studied by another method.

Fig. 61.—Disk for showing the Difference between mixing Coloured Light and Coloured Pigments. The outer disk is painted with the pure pigments, the small disk with a mixture of the same pigments.

For an examination of this matter the author adopted the following mode of proceeding : Two tolerably deep washes of water-colour pigments were prepared—for instance, vermilion and ultramarine-blue—with which two of Maxwell's disks were separately painted. Afterward an equal number of drops of the same washes were mingled on the palette, and a third and smaller disk painted with this mixture. The disks were placed on a rotation apparatus,

arranged as in Fig. 61, the vermilion and ultramarine covering each one half of the larger disk ; the smaller one, exhibiting the result furnished by the palette, being placed in the centre. When the compound disk was rotated, the colours of its outer portion underwent true mixture, and it was easy to compare the resultant tint with that furnished by the palette. In the experiment referred to the result was as follows : The larger disk became tinted red-purple, alongside of which the smaller disk seemed grey, so dull and inferior was its colour. The real colour of the smaller disk was a dull violet-purple. It will be noticed, then, that not only was the colour much darker and less saturated, but it had been moved from a red-purple to a violet-purple. Next, in order to ascertain how much the pigments had been darkened by mixture on the palette and otherwise changed, a black disk was combined with the vermilion and ultramarine disks, and various amounts of black introduced into the red-purple mixture by rapid rotation. It was found impossible in this way to bring the colour of the larger disk to equality with that of the smaller one, it remaining always too saturated in hue. Some white was then added to the large disk, and equalization finally effected. It was then found that twenty-one parts of vermilion, twenty parts of ultramarine, with fifty-one parts black and nine parts white, made a tint by rotation which was identical with that given by mixing up the vermilion and ultramarine on the palette. The large amount of black which it was necessary to add strikingly illustrates the general proposition that every mixture of pigments on the painter's palette is a stride toward blackness. We give now the results of the other experiments :

TABLE SHOWING THE EFFECTS OF MIXING PIGMENTS BY ROTATION AND ON THE PALETTE.

Pigments.	By Rotation.	On the Palette.
Violet (" violet-carmine ")........... Yellow-green (Hooker's green).......	Yellowish-grey.	Brown.
Violet (" violet-carmine ")........... Yellow (gamboge).................	Pale yellowish-grey.	Sepia-grey.
Violet (" violet-carmine ")........... Green (Prussian-blue and gamboge)...	Greenish-grey.	Grey.
Violet (" violet-carmine ")......... Prussian-blue....................	Blue-grey.	Blue-grey.
Violet (" violet-carmine ")......... Carmine......................	Pink-purple.	Dull red-purple.
Gamboge....................... Prussian-blue....................	Pale greenish-grey.	Full blue-green.
Carmine....................... Hooker's green..................	Yellowish-orange (flesh-tint).	Brick-red.
Carmine....................... Green.......................	Pale reddish (flesh-tint).	Dark-red.

It will be noticed that in only one case do the results of the two methods coincide ; in all the others the tints from the palette are not only much darker, but also different. Colour-equations were then obtained for the eight cases above given in exactly the manner indicated for vermilion and ultramarine-blue ; and as they present the facts in an exact manner, showing how much black it was necessary to introduce, and how far the proportions of the two component colours had to be varied, they are given below :

Mixture on Palette.　　　　　　Mixture by Rotation.

50 violet + 50 Hooker's green.. = { 21 violet + 22·5 Hooker's green + 4 vermilion + 52·5 black.

50 violet + 50 gamboge....... = 54 violet + 20 gamboge + 26 black.

50 violet + 50 green......... = 50 violet + 18 green + 32 black.

50 violet + 50 Prussian-blue... = 47 violet + 49 Prussian-blue + 4 black.

50 violet + 50 carmine........ = { 36 violet + 37 carmine + 8 ultramarine + 19 black.

50 gamboge + 50 Prussian-blue. = { 12 yellow (gamboge) + 42 Prussian-blue + 41 green + 4 black.

50 vermilion + 50 ultramarine.. = { 21 vermilion + 20 ultramarine + 51 black + 9 white.

50 Hooker's green + 50 carmine = { 23·5 yellow-green (Hooker's green) + 8 carmine + 52 vermilion + 16 black.

50 carmine + 50 green........ = 50 carmine + 24 green + 26 black.

It will be noticed that the amount of black which it was necessary to introduce, in order to darken the *true mixture of the colours* so as to match the *mixture of the pigments*, was a very variable quantity, ranging from four to fifty-two per cent. It is for this reason that artists are so careful in their selection of pigments for the production of definite tones, particularly when they are to be luminous in quality. In four of these experiments it was found impossible to bring about equality without adding to the two original constituents a third colour, and in one case white had to be added ; so that, in more than half the cases examined, the original colours were found incapable of reproducing by a true process of mixture the tint obtained on the palette without the aid of a foreign element. These experiments serve, then, to show that the results furnished by the palette can not be relied on to guide us in the interpretation or study of effects in nature depending on the mixture of coloured light.

We propose now to consider the results which are produced when a coloured surface is exposed to a coloured illumination and at the same time to white light. Effects of this kind are very common in nature, and are frequently purposely selected by artists as themes ; in a minor degree they are always present to some extent, even when we seek to avoid them. With the knowledge which we have now gained, it is possible for us to recognize the fact that in such cases the resultant tint of the surface will depend on

three circumstances : first, on the colour which it assumes owing to the presence of the white light—that is to say, which it has owing to its natural or, as artists call it, "local colour"; secondly, on the colour communicated to it by that portion of the coloured light which is reflected unaltered from its surface ; and to these there must be added, thirdly, the effects produced by the coloured light which penetrates below the surface, and is reflected after undergoing a certain amount of absorption. It is quite easy to make satisfactory experiments on this matter with the aid

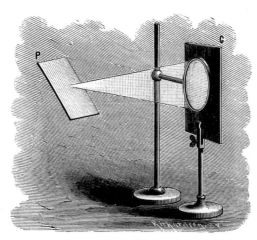

Fig. 62.—White light from a window falls on stained glass at G, and is then concentrated by the lens on a sheet of white or coloured paper at P.

of a simple arrangement contrived by the author. At a distance of some eight or ten feet from a window, a lens, with a focal length of about five inches, is placed on a table, in such a way as to concentrate the white light from the window. In front of the lens a plate of coloured glass is held, and the result is that we obtain a bright beam of coloured light, which can be thrown on any coloured surface, such, for example, as painted paper (see Fig. 62). If

the walls of the room are white, the paper will at the same time be exposed to a white illumination ; and, by turning it or removing it farther from the lens, the proportions of this double illumination can be varied at will. We will describe two experiments that were made with this arrangement : Yellow light was obtained by using a plate of glass which transmitted light having to the eye a pure yellow hue, without any tendency to orange-yellow or greenish-yellow. In this beam of light a piece of paper, painted with a very intense, deep hue of artificial ultramarine, was held. The portion illuminated by the yellow light appeared almost quite *white*, showing that a true mixture of the colours had taken place. It is well known that it is difficult to decide about the actual colour of a spot when it is surrounded by a coloured field ; hence, in order to avoid deception by contrast, it is well in these experiments to observe the spot which has received the double illumination through an aperture cut in black paper, which is to be held in such a way as to permit a view only of this spot. This precaution was taken in the present case, and also in all the experiments that are given below. The ultramarine paper was then removed, and its place supplied by some which had been painted with Prussian-blue. The spot now appeared of a bright *green* colour, which proved that an action had taken place similar to that produced by mixing pigments on the palette. The explanation is as follows : The yellow glass transmits yellow, green, orange, and red light ; and, as was explained in the previous chapter, these lights taken together make a light which appears to us yellow. That portion of this compound yellow light which penetrates the Prussian-blue undergoes a process of absorption ; the green constituent, however, is not absorbed, and consequently is reflected rather abundantly from the paper. But some of the yellow light is reflected unaltered from the immediate surface of the paper ; this mixes with the blue light (due to the white illumination), and makes white ; so that what we

finally have is green mixed with more or less white. In the experiment where the ultramarine paper was used, no doubt some absorption took place, but it was not sufficient to modify the result materially ; the blue and yellow light simply united, and formed white light. Below are given, in the form of tables, a large series of experiments made recently by the author ; and an examination of them will show that for the most part the resultant tint depends rather on a true mixture of coloured lights, and that absorption acts only as a minor agent in modifying the results :

TABLE I.

Yellow Light falling on
Paper painted with

Carmine gave	Red-orange.
Vermilion gave	Bright orange-red.
Orange * gave	Bright orange-yellow.
Chrome-yellow gave	Bright yellow.
Gamboge gave	Bright yellow.
Yellowish-green † gave	Yellow.
Green ‡ gave	Bright yellow-green.
Blue-green § gave	Yellow-green (whitish).
Cyan-blue ‖ gave	Yellow-green.
Prussian-blue gave	Bright green.
Ultramarine-blue gave	White.
Violet ¶ gave	Pale reddish tint.
Purple-violet ** gave	Orange (whitish).
Purple †† gave	Orange.
Black ‡‡ gave	Yellow.

* Mixture of red lead and Indian-yellow.
† Mixture of gamboge and Prussian-blue.
‡ Mixture of emerald-green with a little chrome-yellow.
§ Mixture of emerald-green with a little cobalt-blue.
‖ Mixture of cobalt-blue and emerald-green.
¶ Hoffmann's violet B. B.
** Hoffmann's violet B. B. and carmine.
†† Hoffmann's violet B. B. and carmine.
‡‡ Lampblack.

TABLE II.

Red Light falling on
Paper painted with

Carmine gave	Red.
Vermilion gave	Bright red.
Orange gave	Red-orange and scarlet.
Chrome-yellow gave	Orange.
Gamboge gave	Orange.
Yellowish-green gave	Yellow and orange.
Green gave	Yellow and orange (whitish).
Blue-green gave	Nearly white.
Cyan-blue gave	Grey.
Prussian-blue gave	Red-purple or blue-violet.
Ultramarine-blue gave	Red-purple or blue-violet.
Violet gave	Red-purple.
Purple-violet gave	Red-purple.
Purple gave	Purple-red or red.
Black gave	Dark red.

TABLE III.

Green Light falling on
Paper painted with

Carmine gave	Dull yellow.
Vermilion gave	Dull yellow or greenish-yellow.
Orange gave	Yellow and greenish-yellow.
Chrome-yellow gave	Yellowish-green.
Gamboge gave	Yellowish-green.
Yellowish-green gave	Yellowish-green.
Green gave	Bright green.
Blue-green gave	Green.
Cyan-blue gave	Blue-green.
Prussian-blue gave	Blue-green, cyan-blue.
Ultramarine-blue gave	Cyan-blue, blue.
Violet gave	Cyan-blue, blue, violet-blue (all whitish).
Purple-violet gave	Pale blue-green, pale blue.
Purple gave	Greenish-grey, grey, reddish-grey.
Black gave	Dark green.

TABLE IV.

Blue Light falling on
Paper painted with

Carmine gives	Purple.
Vermilion gives	Red-purple.
Orange gives	Whitish-purple.

Chrome-yellow gives	Yellowish-grey, greenish-grey.
Gamboge gives	Yellowish-grey, greenish-grey.
Yellowish-green gives	Blue-grey.
Green gives	Blue-green, cyan-blue.
Blue-green gives	Cyan-blue, blue.
Cyan-blue gives	Blue.
Prussian-blue gives	Blue.
Ultramarine-blue gives	Blue.
Violet gives	Ultramarine, violet-blue.
Purple-violet gives	Blue-violet.
Purple gives	Violet-blue, purple-violet.
Black gives	Dark blue.

These experiments, taken as a whole, show that, in calculating for the effects produced by illuminating coloured surfaces by coloured light, we must be guided mainly by the laws which govern mixtures of coloured lights, rather than by those which can be deduced from experience with pigments ; they are certainly useful in teaching us, when studying from nature, fearlessly to follow even the most evanescent indications of the eye, utterly regardless of the fact that they disobey laws which we have learned from the palette.

We pass on now to consider the changes in tint which take place when coloured surfaces are illuminated by lamp-light or gas-light. If we undertake to make experiments in this direction simply by viewing coloured surfaces by lamp-light in a room illuminated with it, correct results can not be obtained ; for by this very method we have practically rendered ourselves colour-blind to a certain extent, and have become incapable of judging correctly of quite a series of hues. Gas-light is deficient in the violet, blue, and bluish-green rays ; hence its resultant tint is not white, but orange-yellow. If we are immersed in this light, it will appear to us white, and our judgment of all colours will be more or less disturbed : yellow surfaces will appear white or whitish ; blue surfaces, more greyish-blue, or, if pale,

even pure grey. The actual changes effected by artificial illumination may readily be studied by the following simple method, contrived by the author : A camera-obscura is placed in a room illuminated by ordinary daylight ; in front of it, at a short distance, is placed a gas-flame or lamp-flame, in such a way that the lens of the camera is capable of forming an image of it of about half the natural size. (See Fig. 63.) This image is now allowed to fall on coloured stuffs or on coloured paper placed behind the lens of the camera at S ; it can be viewed, as indicated, through

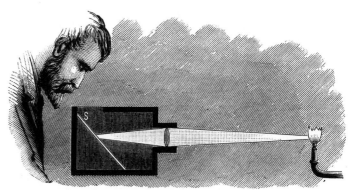

Fig. 63.—Light from Gas-flame is concentrated by Lens of Camera and falls on Coloured Paper.

the top of the camera, and the resultant tint noted. In the experiments made by the author a gas-flame was employed, along with a set of painted disks, representing the principal colours. The disks, fourteen in number, were the same as described in the following chapter, and constituted together seven pairs, the colours of which were complementary, two and two. Below are the results :

1. A carmine disk when illuminated by the gas-flame assumed an intense red hue, even more brilliant than by daylight ; the complementary disk, painted blue-green, appeared of a yellowish-green, not saturated, but rather pale.

2. Vermilion appeared of an intense fiery red ; its complement, green-blue, lost in strength, and became yellowish-green and rather pale.

3. Orange appeared brilliant ; cyan-blue, the complement, became greenish-yellow and lost in saturation.

4. Yellow became brilliant, showing a tendency toward orange ; its complement, blue, appeared white, or rather pure grey. On the same occasion disks painted with chrome-yellow were examined : two of them were rendered somewhat orange-yellow ; the third was brought to almost a full orange hue by the gas-light. A disk painted with gamboge-yellow acquired something of an orange tint under the gas-light.

5. Greenish-yellow was brought to a pure yellow ; its complement, artificial ultramarine-blue, appeared violet.

6. *Greenish*-yellow became pure yellow ; its complement, violet, was converted into a strong red-purple.

7. Full green passed into a bright, strong yellowish-green ; its complement, purple, assumed an intense purplish-red hue, displaying less blue than by daylight.

These are the actual changes produced by the artificial illumination as they appeared to an eye placed in ordinary daylight, and consequently able correctly to note the several tints. When the disks were examined at night by gas-light, in many cases a different result was reached. The carmine and vermilion disks still appeared very brilliant, the tint in the case of the former being a pure red, while the vermilion showed a tendency to red-orange. The orange disk seemed to be changed in tint to a redder orange hue ; the yellow, on the contrary, appeared paler. The greenish-yellow disks did not show much change. The full green was intense, appearing perhaps more bluish than by daylight. Blue-green was liable to be confused with blue, cyan-blue and blue with green ; artificial ultramarine-blue appeared more purplish than by daylight ; violet became purple, and purple a very red purple. Some other disks

were also examined on this occasion : gamboge and chrome-yellow showed a loss in saturation, looking whitish ; indigo appeared dull greenish-grey ; Prussian-blue was confused with blue-green ; genuine ultramarine-blue still was always blue with a slight tendency to purple ; cobalt-blue exhibited this same tendency, which reached a maximum in French-blue. All the blues appeared much duller and greyer than by daylight.

By comparing these two sets of experiments, it will be seen how greatly the judgment of colour was influenced by the circumstance that the prevailing illumination was yellow, and that hence a certain shade of yellow stood for white, and gave a false standard to which all the colours were referred. This was particularly noticeable in the case of the yellow disks ; in point of fact, as the first set of observations showed, they reflected to the eye much yellow light, and, as far as the mere physical action went, ought to have produced the sensation of a strong, brilliant yellow hue ; but, as all surfaces which professed to be white were really (owing to the gas-light) yellow, this competition caused the yellow disks to appear pale. Another case illustrates this disturbed judgment even better. In the first set of experiments it was found that the blue disk when illuminated by gas-light really assumed a pure grey hue without any trace of blue ; but at night, although it must have sent to the eye this same pure grey light, it always appeared either blue, greenish-blue, or bluish-green ; in other words, the blue disk, when held near the gas-flame, sent to the eye white light, which appeared *blue*, by contrast with the prevailing yellow illumination. It is hardly necessary to add that these causes affect our judgment of paintings and decorations at night to a very considerable degree, the blues being rendered less conspicuous, the blue-greys being mostly abolished, and the yellows losing in apparent intensity. Genuine ultramarine-blue is less affected than the other blues, cobalt and artificial ultramarine-blue becoming pur-

plish, and Prussian-blue quite greenish. It hence follows
that paintings in which the blue tones are rather overdone
appear often better by gas-light ; but this is hardly the case
when the green hues are of somewhat too great strength,
the evil seeming often to be exaggerated by artificial illumi-
nation, which must of course be due to an act of the judg-
ment, as the greens really assume a more yellowish appear-
ance by gas-light or lamp-light, as was proved by the first
set of experiments. From this it follows that, if the chro-
matic composition of a picture is quite right for daylight,
it will be more or less wrong when viewed by gas-light ;
hence it would be desirable to illuminate picture galleries
at night with some kind of artificial *white* light, a problem
which the future will no doubt solve.

All the appearances which have thus far been considered
could be satisfactorily observed and studied by a person
possessed of only a single eye. Let us now turn our atten-
tion for a moment to some very remarkable phenomena
which occur when different colours are presented to the
right and left eye. This is a case which happens occasion-
ally, particularly when we look at the reflection from pol-
ished surfaces or from water. In order to simplify matters,
let us take a case where, for instance, yellow light is pre-
sented to the right and blue light to the left eye. It is
very easy to make an experiment of this kind with the aid
of the stereoscope. Selecting one of the common paper
slides, we colour it as indicated in Fig. 64, and then view
it with the stereoscope. We have already seen that blue
and yellow light when presented to the same eye undergo
mixture on the retina and produce the sensation we call
white. This would lead us very naturally to suppose that,
if blue light were presented to the right eye and yellow to
the left, the two sensations would be united in the brain
and would call up that of white. The effect is, however,
of a much more complicated character. Viewed in the

stereoscope the figure will appear at one moment blue,
then yellow, as though it had no permanent colour of its
own ; sometimes, again, the observer seems to see one col-
our through the other, and is distinctly conscious of the
presence of both occupying apparently the same place, thus
giving rise to the idea that the object might have at the
same time two distinct colours. Meanwhile the little draw-
ing assumes a highly lustrous appearance, as though it were
made of polished glass ; this is quite beautiful, and strikes
with some astonishment those who see it for the first time.
After some little practice has been gained, the blue and
yellow colours will melt into a lustrous blue-grey or pure
grey tint now and then for a few seconds, when again the

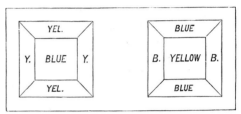

Fig. 64.—Slide for the Stereoscope, the Right and Left Hand being differently coloured.

contradictory and confusing phantoms just mentioned will
make their appearance. Taken altogether, the effect is
quite wonderful, and suggestive of something like a new
sensation. There has been a good deal of controversy as
to whether a true blending or mixture of the two colours
actually does take place in the brain. The experiments of
De Haldat and Dove, and afterward of Lubeck, Foucault,
and Régnault, all point to this result. The results obtained
by the author are also favorable to this view. But it must
be confessed that the mixture obtained by this method dif-
fers in one respect from those previously described. For,
when coloured light is mixed with the aid of rotating disks
or by Lambert's method, we see only the resultant tint, the

two components disappearing entirely to give place to it. On the other hand, in this binocular mixture of colours, the presence of each of the original colours is all the while to some extent felt, and we are disposed to say that we see a neutral or grey hue which has evidently been made out of blue and yellow. Careful experiments by the author proved that the tint of the true mixture often differed from that obtained by the use of the stereoscope ; colours which were pale, however, united more readily than intense ones, and gave less divergent results.* The binocular mixture of colours always produces more or less lustre ; it is not even necessary to employ distinct colours, the same effect being brought about by the mixture of a light and dark shade of the same colour, or simply by the binocular union of white and black, as was shown by Dove. The lustrous appearance of waves, ripples, and broken reflections in water is in each case mainly produced in this way, and hence, strictly speaking, can not be imitated by artists, who are necessarily obliged to present the same colours, the same light or dark shades, impartially to both eyes. It is for reasons similar to the above that a somewhat lustrous appearance is communicated to an oil painting by varnish, or to a water-colour drawing by glass ; the eye sees the picture through the light slightly reflected from the glass or varnish, and is enabled apparently to penetrate beneath the mere surface of the pigment, and this slight illusion falls in with and helps the design of the artist.

* " American Journal of Science," May, 1865.

CHAPTER XI.

COMPLEMENTARY COLOURS.

In the previous chapter we found that the mixture of two masses of coloured light in some cases produced white light ; this was, for example, true of mixtures of ultramarine-blue and yellow, or of red and greenish-blue. Any two colours which by their union produce white light are called complementary. An accurate knowledge of the nature and appearance of the complementary colours is important for artistic purposes, since these colours furnish the strongest possible contrasts. The best, in fact the only, method of becoming acquainted with the appearance of colours which are complementary is by actually studying them with the aid of suitable apparatus. The results thus obtained should be at the time registered, not in writing, but by imitating as far as possible the actual tints with brush and palette. By the aid of polarized light it is possible to produce with ease and certainty a large series of colours which are truly complementary. There are quite a number of instruments for accomplishing this, but perhaps the simplest and best is that which was contrived by Brücke for this express purpose, and called by him a schistoscope. (See Fig. 65.) This little apparatus is merely a combination of a low-power simple microscope with a polariscope, and can easily be constructed. Starting from below, P is a piece of white cardboard, which is fastened to the stand as indicated, and is consequently capable of being turned so as to reflect upward more or less white light, as may be required. N is

a Nicol's prism, which polarizes the light thus reflected ; it is attached to a blackened stage, S. At A is a small square aperture two millimetres in size. C is a crystal of calc spar ; L is a convex lens of a focus such as to cause the two images of the square opening furnished by the calc spar just to touch each other. G and G are polished wedges of glass, the angles being 18° ; for rough experiments they may be dispensed with. In order to use this apparatus,

FIG. 65.—The Schistoscope, for the production of Complementary Colours. (Brücke.)

the tube containing the calc spar is to be moved till distinct vision is obtained of the square opening in the stage by the eye placed at L, or rather of the *two* square openings which will be seen ; the tube is then to be revolved till one of these images disappears entirely, and is to be left in this position. Besides the instrument it is necessary to provide a large number of thin slips of selenite or crystalized sulphate of lime. If a clear transparent piece of this substance is procured, it will be easy with a penknife to split off two or three hundred thin slips, and then with the aid of the instrument to select those which are worth pre-

serving. To observe the colours it is only necessary to lay one of the slips on the stage between the calc-spar prism and the Nicol's prism, and then to turn the selenite till two brightly coloured squares are seen, as is indicated in Fig. 66. These two squares will always have colours which are

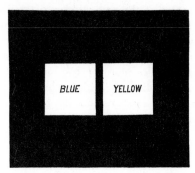

FIG. 66.—Complementary Colours as exhibited by the Schistoscope of Brücke.

complementary. The object of preparing a large number of the slips of selenite is the production of a large series of complementary tints. The thinner slips furnish colours that are more saturated ; those which are thick give pale colours, or colours mixed with much white light. It will be found in this way that the following pairs of colours are complementary :

TABLE OF COMPLEMENTARY COLOURS.

Red....	Green-blue.*
Orange................................	Cyan-blue.

* Following Helmholtz, most writers give bluish-green as the complement to red. These observations of Helmholtz were made on the spectrum, the field being small and only a single eye employed. Extended observations with coloured disks, the hue of which can be studied in a more natural way and with both eyes simultaneously, have convinced the present writer that the complement of vermilion is a very green blue, and even the complement of carmine is a very green blue rather than a blue-green.

Yellow................................. Ultramarine-blue.*
Greenish-yellow......................... Violet.
Green............................. Purple.

In Fig. 67 these complementary colours are arranged in a circle. They are of course only a few of the pairs that can be noticed. The tints situated between red and orange will have complements lying between greenish-blue and cyan-blue; those between orange and yellow, again, will find complements between cyan-blue and ultramarine-blue, etc. As before remarked, it is a good plan to copy the results with water-colours; this fixes the facts in the memory far better than mere momentary inspection.

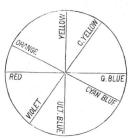

FIG. 67.—Complementary Colours arranged in a Circle.

To study the complementary colours with the aid of the spectrum is a much more troublesome process; still, it is of interest for us to know that the results are the same as when polarized light is employed. Another point now deserves consideration. It might be supposed that the luminosity or apparent brightness of colours which are complementary would be the same, but this is far from being true; yellow, for example, is much more luminous than its complementary blue, and the difference between greenish-yellow and violet is still greater. Helmholtz, using the pure col-

* The complement of genuine ultramarine-blue is yellow, that of artificial ultramarine being a greenish-yellow. The artificial pigment, or French-blue, is a violet-blue.

ours of the spectrum, ascertained that the order of the luminosities of the complementary colours is about that given in the following table:

Yellow.
Orange and green about the same.
Red and cyan-blue about the same.
Ultramarine-blue.
Violet.

From this it follows that a violet which appears to the eye quite dark is able to balance a bright greenish-yellow, and form with it white, and the same is true of ultramarine-blue and yellow; red and its complement green-blue have about the same luminosities; orange is somewhat brighter to the eye than its complement cyan-blue. There is another way of stating these facts: we can say that in mixtures violet has a greater power of saturation than any of the colours; next follows ultramarine-blue, then red and cyan-blue, etc.

The method of studying complementary colours with the aid of polarized light and plates of selenite is simple and beautiful, but there are many cases which it does not reach; above all, it fails to furnish us with the means of ascertaining the complementary tints in just those instances which are of particular interest, viz., the pigments. This happens because the colours furnished by the plates of selenite are for the most part quite like those of the spectrum, only mixed more or less with white light. We should seek in vain among them for good representatives of olive-greens or chocolate-browns and many other common tints. One of the problems that present themselves most frequently is to ascertain the complementary colour of some particular pigment or mixture of pigments. For the rough solution of such questions a method given by Dove can be employed: A small square of paper, an inch or less in size, is to be painted with the pigment in question and placed on a sheet

of black paper, and viewed through an achromatized prism of calc spar. This is shown in Fig. 68, and has the property

FIG. 68.—Achromatic Prism of Calc Spar.

of furnishing when held before the eye two equally bright images of objects viewed through it. It is used in this experiment instead of a plain calc-spar prism, because it gives a greater separation of the two images, and thus allows the employment of larger squares of coloured paper. As the finding of the colour which is complementary to any given one depends entirely on experiment, a second piece of paper, also an inch square, is now to be painted with the colour which it is supposed will be complementary to the first, and the two painted papers are to be combined together with the aid of the calc-spar prism. Let us suppose that we wish to obtain the complement of a dull reddish-brown. The red-brown square is placed on the black paper; beside it we lay a piece painted with a dull bluish-green grey, and arrange matters so that an image of the red-brown paper falls on one furnished by the blue-grey paper. If the two colours are complementary, their joint image will be white, or rather pure grey. If, instead of pure grey, it shows a tendency to reddish-grey or bluish-grey, the colour of the second slip of paper must be modified accordingly. This operation is facilitated by constantly comparing the tint obtained with that of a slip of pure grey paper, placed on the same sheet of black paper. When the process is finished, the appearance will be that indicated in Fig. 69.

The practical objections to this mode of experimenting are, that the calc spar reduces the luminosities of the coloured papers, and that, owing to the imperfect means of

comparison, one is too apt to accept as pure grey any approximation to this tint. For all accurate work it is far better to employ Maxwell's disks in the manner now to be described.* Let us suppose that we wish to obtain the

FIG. 69.—Red-brown and Blue-grey are combined in the central Image, and form a Pure Grey. Below is a Grey placed for comparison.

complement to a somewhat dark vermilion-red. The details in an actual experiment were as follows: A disk was painted with the tint in question, and combined with two others painted with emerald-green and ultramarine-blue, as it was known beforehand that the desired colour would be a bluish-green of some kind. See Fig. 70, which shows also smaller black and white disks placed on the same axis for the purpose of obtaining a pure grey for comparison. It will be noticed that the red colour has been made to occupy just one half of the disk, or 50 parts; the remaining 50 parts are to be divided up between the blue and green, as is found by experiment necessary. The result showed

* For an account of Maxwell's disks, see previous chapter.

8

that 50 parts of red were neutralized by 31 parts of emerald-green and 19 parts of artificial ultramarine-blue; the three colours gave a grey identical with that furnished by 13 parts white and 87 black. Putting this in the form of an equation, we have : 50 red + 31 em.-green + 19 ult.-blue = 13 white + 87 black.

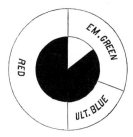

Fig. 70.—Emerald-green and Ultramarine-blue Disks arranged so as to neutralize Red and produce with it a Pure Grey. Central Black and White Disk for the production of a Pure Grey

Fig. 71.—Disks of Emerald-green and Ultramarine-blue arranged so as to give a Colour Complementary to Red.

The next operation is to mix emerald-green and ultramarine-blue in the proportion of 31 to 19, which will evidently give us the correct complement of our red. As these two colours in the last experiment occupied exactly one half of the disk, it evidently will be necessary to double them if they are to be spread over a whole disk; accordingly, we combine them together, taking 62 parts of the green and 38 of the blue. (See Fig. 71.) This compound disk when set in rapid rotation gives us accurately the complementary colour of our red. It is seldom in practice that so complete a result as this can be obtained; for it is evident that, if the red colour had been more luminous, it would have been impossible to balance 50 parts of it with 50 parts of the blue and green, however arranged; the resultant tint would always have been a *reddish*-grey. Conversely, if the red had been less luminous, a similar

difficulty would have occurred : the resultant tint would have always been somewhat bluish green instead of pure grey.

We give now an actual experiment which illustrates the way in which the matter usually falls out, and shows at the same time the nature of the result to be expected. It was desired to obtain the complement to a dull yellow, somewhat like the tint of brown pasteboard. A disk was painted with this colour and combined with one of artificial ultramarine-blue, the small black and white disks of course being present. When this arrangement was set in rotation, it was found impossible to produce a pure grey, however the proportions of the blue and yellow disks were varied; at the best the tint furnished was a purplish-grey. This of course indicated the necessity of adding some green to the blue : a disk of emerald-green was now added, when it was found that 43 parts yellow, combined with 43 parts ultramarine-blue and 14 parts emerald-green, gave a grey identical with that furnished by 24 parts of white and 76 black. The equation then reads : 41 yellow + 45 blue + 14 green = 24 white + 76 black. From this it follows that, by mixing ultramarine-blue and emerald-green in the proportion of 45 to 14, a colour complementary to our yellow could be obtained. We then divide up 100 in this ratio, and assign 76·3 parts to the blue and 23·7 to the green, combine the blue and green disks in this ratio, and by rotation obtain the complementary colour, which is a fine blue. This blue is, however, somewhat darker than the true complement of our yellow, for in the first experiment the yellow did not occupy fully one half of the disk, or 50 parts, but only 41 parts; if we had made it fill half the disk, the other colours would not have been luminous enough to balance it, and grey would not have been produced. It is easy for us to calculate how much too dark the tint is which we have obtained as the complement of the yellow : if we call the luminosity of the true complement 100, then that which we

actually obtain is 69·5.* Hence, in using this complement, we must always allow for the fact that it is less luminous than the true complement in the degree above indicated. Furthermore, no better result could be obtained with the disks of blue and green which were used ; to improve the result, it would have been necessary to alter them so that they would become able to reflect more blue and green light to the eye. On the other hand, if they had originally reflected too much green and blue light, this might have been diminished with the aid of a black disk, and the true complement accurately obtained. Hence it follows that we can obtain the *true* complement to a given colour with accuracy only in those cases where we have at our disposal representatives of this complementary colour which are sufficiently intense—that is, at the same time luminous and saturated. The practical effect of this is, that we can not directly obtain the complementary tints of the most intense of the warmer pigments, such as carmine, vermilion, red lead, chrome-yellow ; the colder pigments, like emerald-green, cobalt-blue, Prussian-blue, ultramarine, etc., all falling considerably below them in intensity.

For many purposes it is convenient to possess a set of disks arranged in pairs and representing the main complementary colours. It would of course require much time and patience to construct a set in which the colours were quite correct in the matter of hue and also in that of luminosity ; and in such a set, with the pigments at our disposal, the red and orange hues would be quite dull, and the yellows little more than browns or olive-greens, for the reason above given. The author recently constructed a set .in which the hues were nearly correct, and the luminosities as favourable as could be obtained without too much expenditure of time and trouble. Their relative intensities as pairs were also determined, as well as the amounts of white light which they furnished when combined in pairs.

* See appendix to this chapter.

TABLE OF COMPLEMENTARY DISKS.

Colour.	Intensity.	Colour.	Intensity.	Amount of white light furnished by the combination.
Carmine	100	Blue-green. . . .	68·6	25
Vermilion.	100	Green-blue . . .	56·2	25·3
Orange	100	Greenish-blue.	88·7	27·2
Yellow	100	Blue.	64·5	25·6
Greenish-yellow. .	89·7	French-blue . .	100	28·9
Greenish-yellow. .	88·7	Violet	100	32·2
Green	100	Purple.	86·9	25·7

It will be noticed that an attempt was made to have the set so arranged as to furnish in each case, as far as possible, about the same amount of white light, so that in this respect the disks should have nearly the same rank. For an account of the pigments that were used, the reader is referred to the appendix to the present chapter. With the aid of this set of complementary disks, hundreds or even thousands of pairs of complementary colours can be quickly produced. This is effected by combining any pair either with white or with black, or with both. For instance, all the reds darker than carmine can be obtained by combining the carmine disk with different proportions of a black disk, the corresponding complementary colours being furnished by the blue-green disk similarly treated ; in the same way, the reds paler than carmine and their complements are to be obtained by the addition of a white disk ; and finally, all the complementary red and blue-green *greys* are yielded by adding a white and a black disk to either of the two coloured disks. Hence it will be seen that, though a set of disks of this kind costs some trouble at the start, yet afterward it more than repays the labour, by quickly supplying us with a vast range of colours which are either truly com-

plementary in all respects, or defective only in the matter of luminosity to a calculable extent.

We come now to a matter which at first sight will seem strange. We have seen that every colour has its complementary colour, but more than this is true : every colour has many different complementary colours. This may best be illustrated by an experiment. Let us suppose we wish to study the colours which are complementary to that of our green-blue disk : We combine this disk with one of vermilion, to which it is complementary, so that we have 50 parts of green-blue and as much vermilion as is found necessary. Now, as considerably less than 50 parts of vermilion will represent the complement of our green-blue, we fill up the blank space left by the vermilion with black. After being adjusted so as to give a grey, the disk was found to be arranged as indicated in Fig. 72. It was found, namely, that 50 parts of green-blue were just balanced and neutralized by 27 parts of vermilion, leaving 23 parts of the disk to be occupied by black. To render visible *this*

FIG. 72.—Green-blue and the complementary amount of Vermilion.

FIG. 73.—This Disk by rotation gives one of the Complements of Green-blue.

complement of the green-blue, we combine a black and vermilion disk in the proportion 23 to 27, or, what is the same thing, in that of 46 to 54, and rotate it. (See Fig. 73.) This furnishes us with a somewhat dark vermilion-red ; it is one of the complements of the green-blue. If we now replace the

black in Fig. 72 by white, the proportions still remaining as 46 to 54, we produce a light-reddish flesh tint, quite different in appearance from the dark-red colour before obtained, but still accurately complementary to our green-blue, since it contains the same amount of red. If the 46 parts of black are gradually replaced by white, a series of tints will be obtained differing in luminosity, but all reddish, and all complementary to the same green-blue. The set of complementary disks above described furnishes great facilities for studying the different appearances assumed by pairs of complementary colours under these circumstances.

Another point now deserves attention. Suppose that we select by daylight two painted surfaces with colours that are strictly complementary—for instance, red and green-blue. Afterward, if we view these two surfaces by lamp-light or gas-light, it will not at all follow that the colours will still neutralize each other and remain complementary. It is easy to experiment on this matter with the aid of our set of complementary disks. By daylight it was found that 41 parts of carmine neutralized 59 parts of green-blue and gave a true grey : by gas-light these colours were no longer complementary, but, in the above-mentioned proportions, furnished a pretty strong red-purple. Experimenting still by gas-light, the red was reduced to 29 parts and the green-blue increased to 71, when the tint of the mixture became less red, but still neutralization could not be effected : the two colours had by gas-light ceased to be complementary, and it was found necessary to add 13·5 parts of green to reëstablish this relation between them. The same fact was observed with the following pairs of complementary colours :

Vermilion and green-blue.
Orange " cyan-blue.
Yellow " blue.

With the pair greenish-yellow and ultramarine-blue, the effect was reversed : it was necessary by gas-light to reduce the greenish-yellow somewhat and to replace a portion of it by orange. The pairs greenish-yellow and violet, green and purple, remained complementary alike by daylight and gas-light. The following table shows the results when the disks were arranged so as to appear complementary by daylight and by gas-light :

Colours.	By daylight.	By gas-light.
40·7 carmine and 59·3 green-blue.......	Grey.	Red-purple.
36 vermilion and 64 green-blue........	"	Purplish-red.
47 orange and 53 cyan-blue	"	Purplish-red.
39·2 yellow and 60·8 blue............	"	Greyish-purple.
52·7 greenish-yellow and 47·3 French-blue *.........................	"	Greenish-grey.
53 *greenish-yellow* and 47 violet.......	"	Grey.†
46·5 green and 53·5 purple..........	"	Grey.†

Below follow the proportions when the disks appeared complementary by gas-light :

Colours.	By daylight.	By gas-light.
29 carmine, 57 green-blue, and 14 green.....	Strong green.	Grey.†
27 vermilion, 57 green-blue, and 16 green ...	" "	"
37 orange, 50 cyan-blue, and 13 green	Strong green-grey.	"
37·5 yellow, 56 blue, and 6·5 green........	Greenish-grey.	"
45 greenish-yellow, 48 French-blue, 7 orange.	Purplish.	"
52 *greenish*-yellow, 48 violet..............	Grey.	"
47 green, 53 purple.....................	"	"

These changes depend on two causes. First, the composi-

* Artificial ultramarine-blue.
† Really a dark yellow, which *appeared* by gas-light grey.

tion of gas-light is different from that of white light ; the violet, blue, and greenish-blue rays in gas-light are comparatively feeble, and, owing to this circumstance, the disks must of course present a different appearance when illuminated with it, the violet, blue, and green-blue pigments appearing relatively darker. This circumstance would, however, merely require us to use more of these hues, and would not necessitate the introduction of foreign colours. The second cause is that by gas-light we are able to effect neutralization only when the mixture of the two colours has a tint similar to that of the general illumination itself, which in this case is not white, but yellow, inclining toward orange. It follows from these experiments that if red or orange is to be contrasted with its complement by gas-light, it will be necessary to make the contrasting colour more greenish than would be allowable by daylight ; the same is true to a less extent of orange-yellow and of yellow itself.

Leaving these practical matters for a moment, let us turn our attention to a couple of theoretical points which are not without interest. In a previous chapter we have seen that colour varies with the length of the waves of light : knowing this, we are very naturally led to inquire whether there is any fixed relation between the lengths of waves which produce upon us the sensations of complementary colours. Upon studying the matter with the help of a chart of the normal spectrum, we find that no such relation exists, owing to the circumstance that the change in colour in different parts of the spectrum is not directly proportional to the change in wave-length, as was pointed out in a previous chapter. Helmholtz found that the relation which does exist is not a fixed one for all the different pairs of complementary colours, but that it varies considerably. With some of the pairs this relation is as 1 to 1·2, in others as 1 is to 1·333 ; or, using the musical notation, we would say that the relation varies from that existing between a note and its fourth to that between a note and

its diminished third. This is one of the many facts which are fatal to any chromatic theory that has a musical basis for its foundation.

The other matter demanding our attention is the mode in which the phenomena of complementary colours are explained by the theory of Thomas Young. In a previous chapter we saw that a mixture of red, green, and violet light, when presented to the eye, produced the sensation of white ; and in the present chapter we have found that this same sensation can be produced by the mixture merely of *two* properly selected colours. Now, according to Young's theory, the sensation of white is produced when the three sets of nerve-fibrils with which the retina is provided are stimulated to about the same degree of activity ; hence it must follow that *two* colours can stimulate all the three sets of nerves as effectually as the *three* fundamental colours. It is this fact that we are called on to account for, and the explanation in the principal cases is as follows :

Red and green-blue are complementary colours, because red light stimulates the red nerves, and green-blue light both the green and violet nerves ; the joint action of the three sets gives white light. Orange and cyan-blue is the next pair : orange light sets in action the red nerves powerfully, also somewhat the green nerves ; cyan-blue sets in action the green and the violet nerves ; all three sets of nerves acting, the result is the sensation of white. The case is much the same with yellow and genuine ultramarine-blue : both colours stimulate two sets of nerves ; that is, the yellow acts on the red and green nerves, the blue on the green and violet nerves. With green and purple the first colour acts of course on its own set of nerves, the second on the red and violet nerves. All this is strictly in accordance with the principles of Young's theory, as will be found by reference to the chapter in which it is treated.

This explanation enables us to understand a fact which otherwise might appear quite strange, viz. : that if we take

away from white light any colour, the light which remains will have the complementary hue. Thus, if we strike out from white light the orange rays, the remainder will appear of a rather pale cyan-blue. The table of complementary colours explains this result ; thus,

Red and green-blue make . White.
Orange and cyan-blue make . White.
Yellow and blue make . White.
Green-yellow and violet make White.
Green and purple make . White.

All these five pairs of colours are present in white light. If we remove from it orange, then cyan-blue is the only colour which is not neutralized ; all the other colours balance up and make white light, which mixes with and pales the uncombined cyan-blue. The explanation is the same in all the other cases. It follows from this that the complementary colours produced by the method of striking out a colour are rendered rather pale by the presence of a considerable amount of white light. This is the reason why the complementary colours obtained by the use of polarized light are always rather pale. The presence of this white light, as will be shown in the following chapter, actually somewhat alters the tint of the coloured light mixed with it ; red is made to incline to purple, orange to red, purple and ultramarine to violet.

Before closing this chapter it may be well to make some remarks concerning the complement of pure yellow, and the complements of the several varieties of the more common blue pigments. In different works the complement of yellow is given as indigo-blue, ultramarine-blue, or simply as blue. *Genuine* ultramarine-blue is complementary to pure yellow, the complement of artificial ultramarine-blue being a decidedly greenish-yellow. Gamboge gives a yellow which is slightly orange ; its complement is the pig-

ment known as cobalt-blue. The complement of Prussian-blue was determined and found by the author to be a somewhat orange-yellow; it was made by mixing with a rotating disk 65 parts of pale chrome-yellow with 35 parts of vermilion. The complement of indigo, used as a water-colour pigment, was also determined with care, and found to correspond quite closely with that of Prussian-blue; it hence follows that indigo may be considered to be the same as darkened Prussian-blue, and not to represent, as some authors have suggested, darkened ultramarine-blue. The term indigo was applied by Sir Isaac Newton to designate the more refrangible blue of the spectrum; to this it does not really at all correspond in any respect, and in the present work the term ultramarine-blue is substituted for it. If the different blues be arranged in the order of the spectrum, we shall have cyan-blue, indigo or Prussian-blue, cobalt-blue, genuine ultramarine and artificial ultramarine, the last being a violet-blue. Among the yellow pigments the somewhat orange-tinted chrome-yellow is complementary to indigo and Prussian-blue; chrome-yellow with a still more orange hue has a complement nearer to cyan-blue.

APPENDIX TO CHAPTER XI.

THE mode of calculating the relative intensities of pigments which are complementary is quite simple, and is here illustrated by an example. Let us suppose that 25 parts of a certain red neutralize 75 parts of a green-blue. The compound disk will then appear as in Fig. 74. It is evident that the intensity of the green-blue is only one third of that of the red, since it takes three times as much green-blue as red to effect neutralization. Let I be the greater intensity and I′ the lesser; then we have—

$$25 \, I = 75 \, I'$$

Making the greater intensity 100, we have—

$$25 \times 100 = 75 \, I'$$
$$I' = 33 \cdot 3$$

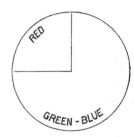

FIG. 74.—Disk with 25 Parts Red and 75 Parts Green-blue.

That is, if we call the intensity of our red 100, that of the green-blue will be only 33·3. In the case given in the present chapter we have—

$$41 \, I = 59 \, I'$$
$$41 \times 100 = 59 \, I'$$
$$I' = 69 \cdot 5$$

PIGMENTS USED IN THE SET OF COMPLEMENTARY DISKS.

Carmine as a water-colour; for its complementary green-blue, a mixture of cobalt-blue and emerald-green.

Vermilion as a water-colour; for its complement the same as above, the proportions being changed.

For the first two pairs, then, we can employ two of our most intense and saturated pigments; this, however, is not possible with orange and yellow, without producing disks of a rank different from the preceding, or obtaining disks which show greater differences in luminosity than any which have been tolerated in the table given in the present chapter. Thus a fine orange colour was mixed from red lead and Indian-yellow, which would have been considered by most painters, as I suppose, a fair companion for the carmine and vermilion; or, if objection had been made, it would have been rather to its want of intensity. Placing the intensity of this orange as 100, the intensity of its complement (made of cobalt-blue and emerald-green) was only 47, a figure smaller than any in the table.

These two colours, however, furnished a white such as could be obtained by mixing, with the aid of disks, 36 parts of white with 64 of black; this number is considerably higher than those allowed in the table. The combination then was rejected, because it was faulty in two respects, and a dull-looking orange substituted for it. This dull, rather poor-looking orange balanced its complementary cyan-blue well, and with it gave 27 per cent. of white light, which was fully up to the average, and proved that in the matter of luminosity it belonged in the set rather than the disk just mentioned.

A similar experience was encountered with yellow. Two beautiful disks were prepared with gamboge and cobalt-blue. Setting the intensity of the gamboge as 100, that of the cobalt was 90, which was nearly what was wanted. The combination, however, gave on rotation a white which was about 100 per cent. too bright, showing that the two disks belonged in a set such as would be furnished by pigments twice as bright as those employed by me; but no such pigments exist. This is only another illustration of the fact, already several times mentioned, that our bright-yellow pigments, such as gamboge, chrome-yellow, cadmium-yellow, etc., can not properly be reckoned as the equal companions of the other pigments ordinarily found on the painter's palette. This circumstance affects our judgment, and we are surprised at the lack of brilliancy of the yellow space even in the prismatic spectrum, and at the fact that mixtures of red and green light produce yellow light of so inferior a character. On the other hand, the possession of such exceptional pigments as the bright yellows and orange-yellows enables the artist at will to extend his scale of brilliancy in an upward direction much farther than otherwise would be possible.

The greenish-yellows were made with gamboge mixed with a little Prussian-blue, the pigments being laid, not on drawing-paper, but on rather absorbent cardboard, which dulled the colours to a desirable extent. For violet, "Hoffmann's violet B. B." was employed, none of the violet pigments used by artists being of the slightest use on account of their very dull appearance and poverty in the matter of violet light. The green was made by mixing a little chrome-yellow with emerald-green; the purple was "Hoffmann's violet R. R. R."

CHAPTER XII.

ON THE EFFECT PRODUCED ON COLOUR BY A CHANGE IN LUMINOSITY, AND BY MIXING IT WITH WHITE LIGHT.

IN our study thus far of coloured surfaces it has been tacitly assumed that their action on the eye is a constant one, and that a red surface, for example, will always appear red to a healthy eye as long as it remains visible. In point of fact, however, this is not quite true, for it is found that coloured surfaces undergo changes of tint when they are seen under a very bright or very feeble illumination. Artists are well aware that scarlet cloth under bright sunshine approaches orange in its tint; that green becomes more yellowish; and that, in general, a bright illumination causes all colours to tend somewhat toward yellow in their hues. Helmholtz, Bezold, Rutherfurd, and others have made similar observations on the pure colours of the prismatic spectrum, and have found that even *they* undergo changes analogous to those just indicated. The violet of the spectrum is very easily affected: when it is feeble (that is, dark), it approaches purple in its hue; as it is made stronger, the colour changes to blue, and finally to a whitish-grey with a faint tint of violet-blue. The changes with the ultramarine-blue of the spectrum follow the same order, passing first into sky-blue, then into whitish-blue, and finally into white. Green as it is made brighter passes into yellowish-green, and then into whitish-yellow; for actual conversion into white it is necessary that the illumination should

be dazzling. Red resists these changes more than the other colours ; but, if it be made quite bright, it passes into orange and then into bright yellow.

It is remarkable that these changes take place with the *pure* colours of the spectrum ; but the explanation, according to the theory of Young and Helmholtz, is not difficult. Let us illustrate it by an example, taking the case of green light, which, as we have seen, acts most powerfully on what we termed the green nerves, less powerfully on the red and violet nerves. Now, as long as the intensity of our green light is small, it acts almost entirely on its own peculiar set of nerves ; but, when the green light is made brighter, it begins to set into action also the red and to a lesser extent the violet nerves ; the result of this is that the sensation of white begins to be mingled with that of green, all three sets of nerves being now to some extent in action. As in this process the violet nerves lag behind, the main modification of the colour at this stage is due to the action of the red nerves, which cause it to appear more yellowish ; hence it changes first to a yellowish-green, then to greenish-yellow, and finally, if the light is very bright, to a whitish-yellow. Corresponding to this, when red light is made very bright, the red and the green nerves are set into action, the result being that the colour changes in appearance from red to yellow. In this case the violet nerves play a secondary part, and their action merely causes this yellow to appear somewhat whitish. When pure violet light is made quite bright, immediately the green nerves begin to add their action to that of the violet, and the tint quickly changes from violet to ultramarine-blue ; the red nerves are soon also stimulated, and, in connection with the green, furnish the sensation of yellow ; this yellow, mixing with that of the ultramarine-blue before mentioned, gives as a resultant tint a whitish-grey with a faint tint of blue or violet-blue. The explanation of the changes which the intermediate colours of the spectrum undergo is analogous to that

just given. The tendency in all cases is to the production of a yellowish-white, or to a white, if the coloured light be very bright. If its brightness be more moderate, the colour will still appear paler and as though mixed with a certain amount of yellow. Artists, by taking advantage of these facts, are able to represent in their paintings scenes under high degrees of illumination. According to Aubert, the whitest white paper is only 57 times brighter than the darkest black paper ; and it is within these narrow limits that the painter is compelled to execute his design : hence the necessity of employing illusions like the one just mentioned. Many effects in nature are beautiful and striking, as much on account of their high degree of luminosity as for any other reason. The artist is not able to transfer to his canvas the brightness, which in this case is really the attractive element ; but by the use of pale colours, well modulated, he suggests a flood of light, and we are delighted, not so much with the pale tints as with the recollections they call up.

We have just examined the remarkable alterations which the pure colours of the spectrum undergo when their luminosity is made very great, and pass now to the changes which occur when the intensity of coloured light is made very feeble. Von Bezold has made some interesting observations of this character on the colours of the spectrum. With a very bright prismatic spectrum he was able to see a pure yellow near D and a whitish-blue near F, the other colours being in their usual positions. When the illumination was only moderately bright, the yellow space diminished and became very narrow ; the ultramarine-blue vanished, and was replaced by violet. With less illumination, the orange-yellow space assumed the colour of red lead, and the yellow vanished, being replaced by a greenish tint ; the cyan-blue was replaced by green, the blue and ultramarine-blue by violet. The spectrum at this stage presented scarcely more than the three colours, red, green, and violet. With

a still lower illumination, the violet vanished, the red became red-brown, and the green was visible as a pale-green tint; then the red-brown disappeared, the green still remaining, though very feeble. With still less light, even this suggestion of colour vanished, and the light appeared simply grey.

The tendency in these experiments is evidently just the reverse of what was observed where the illumination was very bright. In that case the coloured light as it increased in brightness gradually set all three sets of nerves into action, and the result was white or yellowish-white; but here the action of the coloured light as it grows feebler is more and more confined to a single set of nerves. From this it results that those colour-sensations which are due to the joint action of two sets of nerves speedily diminish when the colour is darkened, and are replaced by the primary sensations, red, green, or violet. The sensation of orange is produced by those light-waves in the spectrum which have a length such as to enable them to stimulate the red nerves strongly and the green nerves to a lesser degree; hence, when orange-coloured light is made very weak, it fails to act on the green nerves while still feebly stimulating the red, and consequently the sensation of orange passes over into red. For similar reasons the sensations of yellow and greenish-yellow pass into green, as do also those of greenish-blue and cyan-blue; in the same way the sensations of blue, ultramarine-blue, and violet-blue pass into violet. It is quite evident that these changes furnish another argument in favour of Young's theory of colour, and also tend to approve the selection of red, green, and violet as the fundamental colour-sensations.

In the experiment of Von Bezold just mentioned, after the spectrum had been darkened to a certain degree only three colours remained—red, green, and violet; this dark red, however, as far as sensation goes, is somewhat changed in character, and, according to the unpublished experiments

of Charles Pierce, has become somewhat purplish; the same is true of the green, which is more bluish; the violet alone is unchanged. Now, just these same effects can be produced by mixing small quantities of violet with red or green; hence the final effect of darkening on all the colours of the spectrum is virtually to mix them with increasing quantities of violet light. The cause of these peculiar changes, according to the theory of Young and Helmholtz, resides in the fact that the violet nerves act more powerfully, relatively to the red and green nerves, when the light is feeble. For example, if we present to the eye pure green light, it will stimulate the green nerves strongly, the red and violet to a much less degree: we thus obtain a certain sensation, and call it green. If now we greatly diminish the intensity of the green light, it will of course affect the green nerves to a minor degree; but, besides this, it has now less action on the red than on the violet nerves, so that virtually we have a mixture of green and violet, which will cause the green to appear bluish-green. The same explanation holds good for the red, dull red light producing less effect on the green than on the violet nerves.

The change which colour undergoes when darkened is interesting from a practical point of view; and accordingly the author made a series of experiments on this subject, using for that purpose coloured disks and the method of rotation. In these experiments we do not deal with the pure colours of the spectrum, but with surfaces painted with brilliant pigments, which correspond more nearly to the cases that present themselves to the artist and decorator. A black disk was in each case combined with a coloured disk, as indicated in Fig. 75; a smaller disk of the same colour being either attached to the axis for comparison or held from time to time near the rotating disk. It was ascertained by previous experiments that the amount of white light reflected by the black disk was small; if we set the amount of light reflected by white cardboard as 100,

then the black disk which was employed on this occasion reflected two per cent. of white light, or $\frac{1}{50}$. The colour of the painted disks was in every case as intense, saturated,

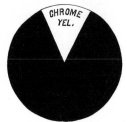

FIG. 75.—Chrome-yellow and Black Disks in combination.　　FIG. 76.—The disk of Fig. 75 when in rotation becomes coloured olive-green.

and brilliant as possible. The results obtained by rotation —that is, by reducing the luminosity of the colours by mixing black with them—are briefly indicated below :

TABLE I.

Name of Colour.	Effect of reducing its Luminosity.
Fundamental red (carmine and vermilion)........	Not changed, or made *slightly* purplish.
Vermilion...............	More red, less orange-red.
Red lead	More red, less orange-red.
Orange..................	Brown.
Chrome-yellow or gamboge.	Olive-green.
Greenish-yellow....	More greenish.
Yellowish-green..........	More pure green.
Fundamental green........	Not changed, or made *slightly* more bluish.
Emerald-green	More green, less blue-green.
Blue-green	More green, less bluish.
Cyan-blue...............	More greenish.
Prussian-blue............	Dark grey-blue (not changed).
Cobalt-blue	Dark grey-blue (not changed).
Ultramarine-blue (artificial).	More violet, less blue.
Violet..................	Dark violet.
Purple..................	More violet, less red.
Carmine................	Not much changed.

It will be noticed that these results correspond more or less closely with those of Von Bezold, before given.

Some of the changes in the experiments just mentioned were so great as to be quite astonishing, and might well tempt the beholder to believe that the black disk exercised some peculiar influence on the result ; this, however, was not the case, as the same results can be obtained without the black disk by simply reducing the illumination of the coloured disks by holding before the eye two Nicol's prisms, and turning them so as gradually to cut off the coloured light. On the other hand, if the tints that are obtained by using the black disk give the true appearances of surfaces painted with pure pigments, but viewed under a feeble illumination, then accurate copies of them ought, when powerfully illuminated, to appear once more brightly coloured, and of the original tints. This was found to be the case, for example, with gamboge, where the change in colour by darkening was from a slightly orange-yellow to a fine olive-green. The olive-green colour was carefully copied with water-colours on a slip of paper, and afterward held in bright sunlight ; this caused it to appear yellow, and made its colour resemble that of the gamboge disk placed near it, but in the shade.

The general result of these experiments is, that, if the illumination is feeble, the colours become weaker, and there is on the whole a general tendency toward a darkish blue ; just as in the reverse case, where the colours are made very bright, there is a tendency toward a whitish-yellow. This average tint can best be studied by observing moonlight effects : here the more luminous colour appears to be a somewhat greenish-blue, the darker shades more like an ultramarine-blue. With regard to this delicate point, the painters of moonlight landscapes are as good an authority as we have, and the best of them are very decided as to the prevalence of various shades of blue, greenish-blue, and violet-blue. Similar effects, though smaller in degree, are ob-

served on dull, cloudy days, when the prevailing tint is a bluish-grey. Indeed, as Helmholtz remarks, simply viewing a sunlit landscape through a pale-blue glass suggests the idea of a cloudy day ; while reversing the process, and viewing a landscape on a dull, cloudy day through a pale-yellow glass, gives the impression of sunshine. Corresponding to this, accidental streaks of yellow ochre or sawdust on the shaded pavement often suggest forcibly the idea of stray sunbeams ; and other examples of this kind of illusion might be mentioned. If we mix lampblack directly with pigments on the palette, their colour will of course be darkened, but the effects produced are not identical with those obtained by the method of rotation. Paper was painted with a strong wash composed of carmine and lampblack, which imparted to it a dark-reddish, purplish hue. From this a disk was cut and an attempt made to match its tint by mixing, according to the method of rotation, carmine and lampblack. In order to accomplish this, it was

FIG. 77.—Small central Disk composed of Cardboard washed with a Mixture of Carmine and Lampblack. This is nearly matched by disks painted with carmine, black, and white, in the proportions indicated.

found necessary to introduce into this rotation-mixture a quantity of white ; the best match being effected when the compound disk was arranged as indicated in Fig. 77. This shows that the saturation or intensity of a coloured pigment is greatly reduced by mixing lampblack with it on the palette, and is one reason why artists refuse to adopt this

method of producing dark shades of colour. The mechanical mixture of lampblack with pigments, besides reducing their saturation, also usually at the same time changes somewhat their hue. In the experiment just mentioned, after matching the two colours as well as possible, it was found that the carmine which had been mixed with lampblack on the palette was more violet in hue than that which had been mixed with black optically. Corresponding results were obtained with vermilion when mixed mechanically and optically with lampblack. In the first case the colour was more of an orange-red hue than in the last. Prussian-blue and lampblack on the palette give a much more greenish tint than when mixed by rotation, and similar changes can be observed with many other pigments.

We have seen thus far that, as we change the luminosity of a coloured surface, so do we at the same time affect its hue, all coloured surfaces when very bright tending toward a whitish-yellow tint. Changes in luminosity, however, produce still other effects which are quite remarkable. If we arrange by ordinary daylight sheets of red and blue paper, which have as far as we can judge about the same degree of luminosity, and then carry them into a darkened room, we shall be surprised to find that the blue papers appear brighter than the red. Indeed, the room may be darkened so as to cause the red paper to appear black, while the blue still plainly retains its colour. These facts seem first to have been recorded by Purkinje and Dove. By similar experiments it can be proved that red, yellow, and orange-coloured surfaces are relatively more luminous when exposed to a bright light than blue and violet surfaces ; the latter, on the other hand, have the advantage when the illumination is feeble. Thus Dove noticed a long time ago that this circumstance disturbs somewhat the balance of the colours in paintings, if the observer lingers in a picture gallery as the twilight deepens. From this it follows that the chromatic composition of a painting should

be somewhat varied, according as the picture is likely generally to be seen under full daylight or in a darkened room. More attention would no doubt be paid by artists to this point if they were not obliged to contend with a still more serious obstacle in the large change which the tint of the illuminating light undergoes, according as daylight or gaslight is employed.

It follows from what has just been said that photometric comparisons of the brightness of differently coloured surfaces, if made under bright daylight, will no longer hold good in twilight, and that consequently we can not under a certain illumination establish photometric relations that shall hold good under all other illuminations. For example, we may find under ordinary daylight that a certain piece of blue paper is just half as luminous as a piece of red paper; but it by no means follows that this statement will be true in a darkened room. Helmholtz found that even the pure colours of the spectrum act in this same manner, particularly yellow and ultramarine-blue, or greenish-yellow and violet, the changes with the other colours being smaller. This fact suggests an interesting experiment: Yellow and ultramarine-blue are complementary, that is, together make up white light; suppose now we mingle yellow and ultramarine-blue so as to produce white, a high degree of illumination being employed; will they still produce white if they are both correspondingly darkened? We might very naturally suppose that the blue would not outweigh the yellow, and that instead of white we should obtain bluish-white. This was, however, found by Helmholtz, using pure spectral colours, not to be the case: the darkened mixture of yellow and blue still exactly resembled sunlight which was correspondingly darkened. The same result was also obtained when a mixture of another pair of complementary colours, greenish-yellow and violet, was used. These results apparently contradict the statement that yellow or greenish-yellow acts more power-

fully on the eye when bright than blue or violet. Helmholtz accounts for it in this way: Our standard for bright white is bright sunlight; we cause the mixture of yellow and blue to match this sunlight, and then call it white; we then darken our sunlight very much, and make it our standard for a feeble white having a small degree of luminosity; we call it darkened white or pure grey, and find that our darkened mixture of blue and yellow still matches it perfectly. But, according to Helmholtz, this pure grey is really somewhat bluish, and it is owing to this circumstance that it is able still to match the darkened yellow and blue, which is also really bluish. Pure grey has always appeared to the present writer as somewhat bluish compared with pure white, and the following experiment tends to show that this is indeed the case: A pure grey was generated on a rotating disk by mixing fifty parts of white

Fig. 78.—Small White-and-Black Disk arranged so as to make a Grey by rotation. This grey looks more bluish than the larger white disk; 17 per cent. of an indigo disk is then mixed with the white.

with a like proportion of black. This compound disk was placed on the same axis with a white disk, but when set in rotation the grey portion appeared slightly more bluish than the white. In order to cause the white disk to match in hue (not in luminosity) the grey disk, a disk painted with a tolerably deep wash of indigo was combined with the white disk, as indicated in Fig. 78. An assistant arranged the disks and made the measurements, while the

9

author simply ordered the proportion of blue to be increased or diminished till the result seemed satisfactory ; at the termination of the experiment he was informed of the result. The amounts of added blue in nine consecutive experiments were as follows, in percentages : 17, 20, 18, 16, 13, 14, 21, 19, 16 ; average, 17. According, then, to these experiments, it was necessary to add to white 17 per cent. of a strong tint of indigo, in order to cause it to match in hue a grey disk made up of equal parts of white and black. It may be remarked in this connection that the addition of the blue to the white, although slightly changing its tint, produced no particularly noticeable effect on its luminosity ; that is, it was only a little darkened.

All these phenomena can be explained by the theory of Young as modified by Helmholtz. According to this theory, the sensation of white is produced when the red, green, and violet nerves of the retina are stimulated to about the same degree of activity ; furthermore, with a feeble degree of stimulation of all three sets of nerves, the activity of the violet nerves predominates over that of the green, and that of the green again over that of the red. When the stimulation is made powerful, these conditions are reversed, the red nerves leading, the green and violet following. These relations of nerve-action are indicated by three curves in Fig. 79. The horizontal line represents increase of actual intensity of white light ; thus the portion A B stands for feeble white light, A C for white light which is twice as strong, etc. The vertical line B R measures the intensity of the red sensation produced by this feeble white light ; B G and B V give the strength of the sensations in the case of the green and violet nerves. We see that the violet sensation, as it is represented by the longest line, prevails over the others, and that the light, instead of appearing white, will be such as would be produced by mixing equal parts of the sensations red, green, and violet ; i. e., by mixing the sensation of white with a little green

and a little more violet. Now, as we have previously seen in Chapter IX., the sensations of green and violet when mixed produce that of blue, so that on the whole we have a mixture of the sensation of pure white with blue, i. e., bluish-white. If we examine in the same way the line D V G R, we shall find the conditions reversed ; here we have the sensation of pure white mixed with a slight excess of that of green, and again with a little more of red ; as green and

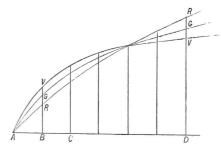

Fig. 79.—Three Curves showing the action of the Red, Green, and Violet Nerves when stimulated by White Light of different degrees of Brightness.

red when mixed furnish yellow, our result now will be white mixed with yellow, or yellowish-white. This same diagram also represents in a symbolic manner the fact that red surfaces are most luminous by bright light, and violet surfaces by feeble light. It can also be used to explain the changes which pure colour undergoes when made very bright or very pale, after the manner employed in the early part of the present chapter.

We have examined now with some detail the relative changes in luminosity which coloured surfaces undergo when exposed to bright and feeble illuminations ; but, before leaving this part of our subject, it may not be amiss to mention the fact that *all* comparisons between the luminosities of differently coloured surfaces are quite valueless as the expression of objective facts. An illustration will make

this clear. Suppose we compare together by the eye two white surfaces or two red surfaces, and find that they appear to us equally luminous ; now, this will be not only a fact as far as the eye is concerned, but it will be an objective fact in nature ; it will be equally true in a mechanical sense, and on, converting our two masses of white light or red light into heat, we shall obtain equal amounts of heat. If, however, we take two differently coloured surfaces, red and blue for example, and make them equally luminous, equally powerful so far as the eye is concerned, and then convert the light they reflect into heat, a delicate thermometric apparatus will speedily inform us that we are not dealing in the two cases with equal amounts of force. In fact, the maximum heating effect was found by Melloni to be produced by the ultra-red rays which are quite invisible to the eye ; here, from an objective point of view, resides the greatest force, but the waves are too long to affect the eye at all. From this it is evident that the intensity of our visual sensations depends not only on the strength (height or amplitude) of the waves of light, but also on their length ; the maximum effects being produced by yellow light, which affects simultaneously the red and green nerves. In spite of the fact that photometric comparisons of differently coloured surfaces have no objective value, still for our purposes they may often be quite precious, or even actually indispensable, if we propose to give our work a quantitative character.

Having now considered the changes which colour undergoes when made very luminous or very feeble, we proceed to study the effects produced by mingling white with it. The general result can be expressed quite concisely : the colour becomes paler, and when the proportion of white is made large entirely disappears, leaving recognizable only a white surface. When a disk painted as in Fig. 80 is rotated, the red by mixture with the white gives a ring of pale red, like that indicated in Fig. 81. Upon reducing the

amount of the colour, it becomes very whitish and pale ; and Aubert found that the red when mixed with from 120 to 180 parts of white entirely disappeared. If we set the luminosity of vermilion as one fourth of that of white paper, it follows from Aubert's experiment that mixing vermilion

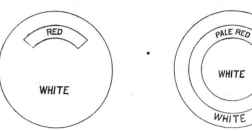

Fig. 80.—White Disk partially painted Red with Vermilion.

Fig. 81.—Indicates the appearance presented by the previous disk when set in rapid rotation so as to mix the red and white light.

with 720 parts of white light, having a brightness equal to its own, causes the red colour to disappear. Or we may express the fact thus : Take red light and white light of equal intensities ; then, if one part of red light be presented to the eye simultaneously with 720 parts of white light, the eye will be unable to recognize the presence of the red constituent. Smaller quantities of white light produce very great changes in the appearance of the colour. If we rotate a disk like that indicated in Fig. 79, we shall be surprised to find that, though one quarter of the disk is covered with vermilion, yet the resultant red tint is quite pale. In this case twelve parts of white light are mixed with one part of equally bright red light, and when stated in this manner the result seems more natural.

When we undertake to study more carefully the mixtures of white with coloured light, certain curious anomalies present themselves. If we arrange disks of artificial ultramarine-blue and white, in the way shown in Fig. 82,

and set them in rapid rotation, we shall find that the addition of white, instead of producing merely a paler blue,

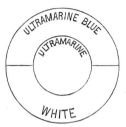

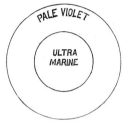

FIG. 82.—White Cardboard Disk partially painted with Ultramarine-blue (artificial).

FIG. 83.—Indicates the appearance produced by mixing white with ultramarine-blue light.

actually changes the colour to a pale violet. (See Fig. 83.) If we substitute orange for the ultramarine-blue, the pale-orange hue generated by rotation shows a tendency toward red. These two facts have been known for a long time, and various explanations of them have been proposed. According to Brücke, ordinary white daylight is itself slightly reddish in tint, and, when we mix white light with coloured light, we really add at the same time a little red ; hence these changes. Aubert, on the other hand, following a suggestion of Helmholtz, supposes that the true pale shade of ultramarine-blue is actually violet, but that our judgment is perverted by experience drawn from the colour of the sky, which according to him is a greenish-blue, and retains this tint when mixed with white. This is an explanation which artists would hardly accept, and the experiments given below show that both it and the one previously cited are insufficient. In an examination of this matter it was found by the author that changes of this kind are not confined to the colours orange and artificial ultramarine-blue, but extend over all the colours except violet and its complement greenish-yellow ; the main results are given in the following table :

TABLE II.—SHOWING THE EFFECTS OF MIXING WHITE WITH COLOURED LIGHT.

Name of Colour.	Effect of adding White.
Vermilion	More purplish.
Orange	More red.
Chrome-yellow	More orange-yellow.
Pure yellow	More orange-yellow.
Greenish-yellow	Paler (unchanged).
Green	More blue-green.
Emerald-green	More blue-green.
Cyan-blue	More bluish.
Cobalt-blue	A little more violet.
Ultramarine (artificial)	More violet.
Violet	Unchanged.
Purple	Less red, more violet.

It follows from these experiments that, when we mix white with coloured light, the effect produced is the same as though we at the same time mixed with our white light a small quantity of violet light. Such mixture would account for all the changes given in the table, as could be shown by reference to the colour-diagram explained in the next chapter. This, of course, is only stating the facts in different language, and is not an explanation.

In the experiments just mentioned the light from *brilliantly coloured* disks was mixed by rotation with from 5 to 50 per cent. of white light, some of the disks requiring a larger admixture of white light than others to produce the changes in hue recorded in the table. If now we first darken our colours very much, and then add a little white to them, the results will again be somewhat different from those given in the table, because here two causes are at work, which sometimes produce opposite results, as we can see by a comparison of Tables I. and II. In the next set of experiments, in every case except that of chrome-yellow, 5 parts of the coloured disk were combined with 90 parts of *pure* black and 5 parts of white ; 10 parts of chrome-yel-

low were combined with 85 parts of pure black and 5 of white. The changes of hue are given below :

TABLE III.—SHOWING THE EFFECT OF MAKING COLOUR VERY DARK AND ADD-
ING TO IT A SMALL PORTION OF WHITE. (The experiments were made by rotating disks.)

Vermilion became a................ Dull greyish-purple.
Orange became a.................. Brown (slightly bluish).
Chrome-yellow became a........... Greyish olive-green.
Emerald-green became a........... Dark green (less bluish).
Cyan-blue became a............... Dark greenish-grey.
Prussian-blue became a........... Dark grey-blue.
Cobalt-blue became a............. Dark grey-blue.
Ultramarine (artificial) became a..... Dark grey violet-blue.
Violet became a.................. Dark grey-violet.
Purple became a................. Dark grey-violet (less red).

In many of these cases the results are similar in charac-ter to those given in Table II. This, however, is not the case with chrome-yellow, as in one case it was made to appear more orange, while in the other it became a whitish olive-green. It is evident that in this instance the effect of darkening the colour overbalanced that of adding white to it. With emerald-green and cyan-blue a similar result seems to have been reached, though the phenomena were less decided. The general effect, then, of first reducing greatly the luminosity of colour and then adding small amounts of white, is the production of greys which have a tendency toward blue or violet, this being the case even when the original colour is as decided as that of vermilion. The experiments given in the last two tables will account for the fact that it is almost impossible to produce a fine red with the aid of polarized light, the tint being always rather of a rose-colour, that is, showing a tendency toward a purplish hue.

It has been shown in the preceding pages that the effect of mixing white with coloured light is to cause the colour to become paler, and at the same time to change it slightly,

as though simultaneously a small amount of violet light had been added to the mixture. This fact naturally sug-gests an experiment like the following : Suppose we com-bine a purple and a green disk as indicated in Fig. 84, employing equal parts, and thus obtain a pure grey. Let

FIG. 84.—Purple and Green Disk :
when rotated, it makes a Pure
Grey.

FIG. 85.—Purple, Green, and White
Disk : when rotated, it makes a
Pure Grey.

us now replace 10 parts of purple by white, also 10 parts of the green by white (Fig. 85) : will we then still obtain a pure grey, or will the grey be tinged with violet ? Several experiments of this kind have been accurately made by the author, but in every case the result was the production of a grey identical with that given by mixing by rotation black and white. The explanation would seem to be that the green and purple instantly combine to produce the sensa-tion of grey, and then of course adding white to this grey can only make it paler, but can not at all alter its tint. It would seem from this that, when a colour is altered in the manner above described by admixture with white, *time* comes in as a necessary element in the process ; the mixture of white and coloured light must be allowed to act on the eye undisturbed during an interval of time which is not too short, otherwise these peculiar effects will not be produced.

One might suppose that the same result would be pro-duced by spreading thin washes of coloured pigments on

white paper that is obtained by mixing white with coloured pigments by the method of revolving disks. The tint in these two cases, however, is usually somewhat different. A pale wash of carmine, for example, was allowed to dry on white paper, and an effort was made to imitate it by combining a deep-coloured carmine disk with one of white cardboard by the method of rotation. It was soon ascertained that the hue of the water-colour wash was considerably more saturated or intense than a tint of equal luminosity produced by the rotating disks; it was also found to be more of a purplish hue. When the luminosities in the two cases were made equal, the water-colour wash showed far more colour than did the simple mixture of the red and white light. Treated in the same way, a thin wash of vermilion was more orange in hue than a mixture of vermilion-coloured light with white light; a thin wash of gamboge looked yellow, while the mixture by rotation had more of an orange-yellow appearance. The reason of these changes is quite evident, and lies in the well-known fact that thin layers of coloured substances have in general a different absorptive action on white light from thicker layers of the same substances. A thin layer of vermilion allows, for example, more of the orange rays to pass; hence in very thin layers this pigment is sometimes used by artists to represent very pale tints of orange, or even of orange-yellow. The other fact above mentioned, viz., that thin layers are often relatively more saturated than those that are thick, is to be explained in a different way. It was shown in Chapter X. that, when a pigment is mixed with one of a different colour, not only is the hue changed, but an effect is produced as though at the same time some black had been added to the mixture. It now appears that, even when a pigment is made darker by mixing with it a larger quantity of itself, a similar change is to some extent produced, the darker wash of the pure pigment acting as though some black were mingled with it. In the experiment with the pale wash of

carmine it was actually found necessary to combine black by rotation with the water-colour wash, so as to reduce it, before it could be matched by a disk composed of white and a deep tint of carmine.

The fact now under consideration can perhaps be rendered more intelligible by a different statement. Carmine, as we know, absorbs powerfully nearly all the coloured rays of light except the red; these latter it reflects in considerable quantity, and to this circumstance its red colour is due. But the experiments just mentioned indicate that it absorbs also to a considerable extent even the red rays, so that a deep wash of carmine sends to the eye less red light than we should expect. The author found that yellow glass presented a parallel case. Yellow glass transmits the orange-yellow, yellow, and greenish-yellow rays abundantly, and to this power mainly its yellow colour is due. But it does not transmit even these rays at all as perfectly as ordinary window-glass. In one experiment it was found that a plate of yellow glass absorbed about 25 per cent. even of these rays. Most coloured substances, pigments, and glasses probably act in a similar way.

CHAPTER XIII.

ON THE DURATION OF THE IMPRESSION ON THE RETINA.

AMONG different forms of fireworks none excite more admiration than revolving wheels of fire with their brilliant colours, ruby, emerald, or sapphire, and their wonderfully blended surfaces, which so often suggest fanciful resemblances to roses, carnations, and other flowers. It is quite possible to arrange matters so as to obtain an instantaneous view of one of these fiery objects, without at all interfering with its rapid movement; and when this is done, it is seen that much of its beauty depends upon an illusion: the broad, variegated, shaded surface vanishes, and we have before us simply a few jets of coloured fire, in no wise particularly remarkable. The appearance of these brilliant objects depends, then, upon an illusion, and this has for its foundation the fact that the sensation of sight is always prolonged after the light producing it has ceased to act on the eye.

The most familiar illustration of this fact we find in an old experiment, which no doubt was the parent of our revolving fireworks: If a lighted coal on the end of a stick is caused to revolve rapidly, it describes a ring of fire which is plainly seen at night to be quite unbroken. The light from the moving coal falls upon the retina of the eye, and an image of it is produced, let us say at the point 1, Fig. 86; an instant afterward, owing to its having moved into a new position, the image will be found at 2 and then at 3,

and so on all the way around the circle. Now, if the sensation due to the first image lasts while the circle is being traversed, then it will be renewed before it has a chance to fade out, and consequently will be present continuously; the same will be true of all other points on the circle, which consequently will produce on the beholder the appearance of an unbroken ring of light. In order to produce this condition of things, it is necessary of course that the coal of fire should move with a certain velocity; according to

FIG. 86.—Appearance of a Coal of Fire in Three Positions.

the observations of D'Arcy, it is essential that it should traverse its circular path completely in thirteen hundredths of a second.

It is very easy to experiment on matters like these with the aid of revolving disks. If we take a circular disk which is painted black, and has on it a white spot like that represented in Fig. 87, and set it in rotation, as soon as the motion is quick enough we shall see a ring of white, just as in the previous case we obtained a ring of fire. Fig. 88 shows the appearance of the disk when in rapid rotation.

The duration of the sensation of light, or duration of the impression on the retina, as it is called, varies with the intensity of the light producing it, and in the case of our white paper is not by any means so great as with the coal of fire. According to an experiment of Helmholtz, the impression on the retina lasts in this case, with undiminished strength, about one forty-eighth of a second; hence it is necessary for the disk to revolve forty-eight times in a second in order to produce the appearance of a steady, uniform ring of light. While, as just stated, the impression lasts with undiminished strength for one forty-eighth of a second, its total duration with decreasing strength is much greater, being perhaps as high as one third of a second, though this interval varies somewhat with the circumstances, and is a little difficult of determination.

FIG. 87.—Disk with White Sector.

FIG. 88.—Disk of Fig. 87 in Rapid Rotation.

It is not, however, to be supposed that, in the experiment indicated in Fig. 88, the ring of white light will have the same degree of luminosity as its source, viz., the slip of white paper pasted on the black disk; on the contrary, the luminosity of the ring will be much feebler than that of the spot. The reason of this is quite evident: we have virtually spread out the light of the spot over a much larger surface, and it will be proportionately weaker; if the surface of the ring is one hundred times as great as that of the spot, then the luminosity of the ring will be exactly one hundredth of that of the spot. That this relation is always

strictly quantitative can be proved by a photometric arrangement like that used by Plateau for this purpose, or by the aid of a crystal of calc spar which divides ordinary light up into two beams of equal intensity. In this latter case we arrange a disk by making half of its surface white, the other half black, as represented in Fig. 89; alongside of it, on a black ground, we place a strip of the same white paper; the disk is then set in rotation, and assumes a grey appearance. With the aid of the calc-spar prism we then view the strip of paper, which will appear doubled, as shown in Fig. 90, each image having one half the brightness of the

FIG. 89.—Arrangement of Disk and Strip for Photometric Comparison.

FIG. 90.—Appearance of Disk in Rotation, the Strip being viewed through a Calc-Spar Prism.

original strip; but either of these images will be as bright as the grey disk, showing that the luminosity of the grey disk is just one half of that of the white. This gives an idea of the method of proceeding, but numerous corrections must be introduced, some of which will no doubt suggest themselves to the ingenious reader; of them we will mention only one, viz.: that, according to the recent investigations of Wild, the two images furnished by calc spar do not really have exactly the same luminosity, but differ by about three per cent.* Dove has proved that the relation we have been speaking of above also holds good for coloured

* Poggendorff's "Annalen," vol. cxviii., p. 225.

light. This fact is of much importance to us, for on it is based the principle involved in Maxwell's disks, which we have already found so indispensable in quantitative investigations on colour.

The duration of the impression on the retina in the case of light of different colours has not yet been studied carefully. Some experiments were made by Plateau with papers coloured by gamboge, carmine, and Prussian-blue, and it was ascertained that in these cases the duration differed somewhat. Dr. Wolcott Gibbs suggested to the author a method which would probably solve this problem in a satisfactory manner, and which is about as follows : With the aid of a spectroscope a diffraction spectrum is to be presented to the eye in the form of a series of contiguous coloured bands, this division into bands being effected by a suitable diaphragm placed in the eyepiece of the instrument. In front of the slit of the spectroscope a revolving disk with one or more openings should allow the light to enter the instrument ; and, by regulating carefully the velocity of rotation, it would be possible to seize the exact moment when one or more of the coloured bands ceased to flicker, and presented a steady, uniform appearance. This observation would give correctly the interval during which the impression remained with undiminished strength on the eye, in the case of the selected colour.

If quite bright light like that from a window is presented to the eye, the impression lasts several seconds—of course with diminishing strength. The experiment is easily made, and the observer will find, after the eyes have been closed, that there is time enough to recognize a good many details before the disappearance of the image. With intensely bright light like that of the sun, the image lasts several minutes, and finally fades out after having undergone a series of complicated changes in colour. It may perhaps be as well to mention here a fact which must be borne in mind when we undertake to study the after-sensations that follow

the action of white or coloured light on the eye. If the light be allowed to act for a short time on the eye, when it vanishes, as before stated, the sensation remains for a fraction of a second, this after-sensation being in all respects identical with the original sensation, except that it gradually becomes weaker and weaker : thus, if the original sensation is red, the after-sensation will entirely correspond to this colour. This after-image, which is the only one thus far treated of in this chapter, is called the *positive* image. After a little while, however, the positive image vanishes, and is replaced by an image of a different character, which is known as the *negative* image : thus, if the light originally acting on the eye was red, the negative image is coloured greenish-blue, or has the complementary colour. These negative images are quite important, as many matters connected with contrast depend on them, and they will be considered at length in Chapter XV.

We have seen that the positive after-images are useful in furnishing us, in the case of revolving disks, with a mode of mixing together masses of coloured light in definite proportions ; and it may be well to mention some other cases where these images play an important part. The appearances presented by water in motion depend largely on them. Thus, if we study the ocean waves under direct sunlight, we shall find that much of their character depends on elongated streaks of light, which serve to interpret not only the forms of the larger masses of water, but also the shapes of the minor wavelets with which these are sculptured. If now we examine these bright streaks, so well known to artists, with a slowly revolving disk having one open sector, we shall find that in point of fact there are no streaks at all present, but simply round images of the sun, which, owing to their motion, become thus elongated. Instantaneous photographs give the same true result, and hence appear false. An analogous action takes place even in cloudy weather, and streaks of light are produced which give the

waves a different appearance from what they would have if suddenly made solid, while yet retaining all their glassy appearance. Again, for the same reason, waves breaking on a beach appear to us different from their instantaneous photographs : when viewing the real waves we obtain an impression which is made up of the different views rapidly presented during several minute intervals of time, whereas the photograph gives us only what takes place during *one* of these small intervals. All this applies also more or less to the case of falling water, as fountains or waterfalls, and explains the transparency of rapidly revolving wheels. Owing to the same cause, the limbs of animals in swift motion are only visible in a periodic way, or at those moments when their motion is being reversed ; during the rest of the time they are practically invisible. These moments of comparative rest are seized by artists for delineation, while the less discriminating photograph is as apt to reproduce intermediate positions, and thus produce an effect which, even if quite faithful, still appears absurd.*

* For a complete list of what has been published on this whole subject, see a memoir by J. Plateau published by the Belgian Academy of Sciences in 1877.

CHAPTER XIV.

ON THE MODES OF ARRANGING COLOURS IN SYSTEMS.

As we have seen in the previous chapters, the variety of colours presented to us by nature and art is enormous, ranging from the pure brilliant colours of the spectrum down to the dull, pale tints of rocks and earth, and including whole classes which seem at first glance to have but little affinity with each other. It would be difficult, for example, to find anything in the prismatic spectrum which reminds us in the least of the colour brown ; the various pale tints which wood assumes when worked seem quite unrelated to the spectral hues ; and it is the same with the vast multitude of greys with which we are acquainted, and which so largely constitute the colours of natural scenery. If, instead of comparing with the colours of the spectrum the strange, wonderful, indescribable tints which nature so abundantly displays, we descend a step and think of them in connection with the hues furnished by our brightest pigments, such as vermilion, red lead, chrome-yellow, emerald-green, or ultra-marine-blue, we scarcely improve the matter : even such colours as these seem to have no affinities with the modest throng of greys and browns ; they appear to belong to a more princely caste, and utterly refuse to mingle on equal terms with the humbler multitude.

The colour of vermilion depends, as we learned some time ago, on three things : first, on the quantity of coloured light which it sends to the eye, or on the brightness of the

coloured light that it reflects ; second, on the wave-length of this red light ; and third, on the amount of *white* light which is mingled with the red. Its colour depends, then, on its luminosity, wave-length, and purity ; these quantities, as we have seen, are called the constants of colour.* In certain cases we can easily alter these constants considerably, and thus ascertain their significance with regard to colour. Let us take a circular disk painted with pure vermilion, and undertake to reduce its luminosity. This could be very efficiently accomplished by removing the disk to a darkened room, when it would be found that the colour was changed to dark red, or even to black. There is, however, an objection to this mode of experimenting : we have always, under such circumstances, a strong tendency not simply to receive the tint that is actually presented to us, but to make, unconsciously, an allowance for the degree of illumination under which we view it. We know that red in a darkened room presents a certain appearance ; when we see this appearance in the darkened room, we say we see dark red ; to the same appearance in a light room we would give a different name. This objection applies to all experiments of this character, whether the object be to expose a surface to a very small or to a very great illumination : we ourselves should, as it were, always be immersed in a medium illumination, so as to retain an undisturbed judgment. In the present case this difficulty is easily avoided. We take our vermilion disk to a room illuminated with ordinary daylight, and reduce its luminosity by combining it with a black disk, as indicated in Fig. 91. When the compound black and red disk is set into rapid rotation, we in effect spread out over the whole surface of the disk the small amount of red light which is reflected from the exposed red sector ; its luminosity can thus be reduced to any desirable extent. It will be found, when we combine 10 parts of

* See Chapter III.

vermilion with 90 of black in this way, that the red colour is converted into a chocolate-brown that bears no close resemblance to the original hue. It can be objected to this mode of darkening colours that there may be in the black disk something that exercises a peculiar effect on the result. If, however, we analyze the faint light which comes from

Fig. 91.—Disk with 10 Parts Vermilion and 90 Parts Black : gives by rotation a dark-reddish chocolate-brown.

the black disk with the aid of a prism, we shall find that it is essentially white, all the prismatic colours being present. Or we may expose our black disk to sunlight, analyze its light with the prism, and compare this analysis with that obtained from a piece of white paper not exposed to sunlight and shaded from the diffuse daylight. When by this proceeding the luminosities of the black and white papers have been equalized, it will be found that the colours which they furnish to the prism differ very little. The fact that the black disk darkens the red one as it would be darkened by a dark room can also be proved in another way : If we first darken a room just as much as we please, and then contrive an aperture opening into it a little larger than our red disk, and arrange matters so that not much light enters the room through this aperture, then we can virtually mix the darkness of this room with the red light of our disk. We simply place a *red sector* on the rotation machine arranged in front of the opening into the dark room, as indicated in Fig. 92, and set the coloured sector into rapid

rotation. We now have the red light of a small portion of the red disk spread out over the darkness due to the darkened room, and the result is the same: we have the same chocolate-brown (Fig. 93). The use of the black disk being thus justified, we may employ it further in our investigation; and we shall find that by simply reducing the red light of our vermilion disk with its aid, we produce not only a series of dark, dull reds, but a number of rich, peculiar-looking browns. When we make a corresponding set of experiments

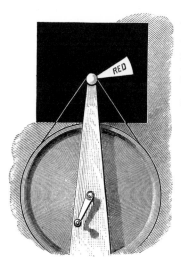

FIG. 92.—Red Sector arranged with Dark Room as a Background.

FIG. 93.—Shows the appearance presented when the sector of Fig. 92 is made to rotate rapidly.

with our red-lead disk, we obtain a series of reddish, warm-looking browns; the chrome-yellow disk gives a set of strange-looking, dull yellows and dark olive-greens; the green and blue disks furnish sets of dark green and blue tones. Experiments like these show what changes are produced simply by reducing the intensity of the coloured light, without in any other way tampering with it.

By a corresponding set of experiments we can study the effects of mixing white light with our coloured light: we need only combine the coloured disk with one that is white, and rapid rotation gives us the desired result. In this way

we can produce a series of pale tints that are reddish, greenish, or bluish, according to the disk employed.

Thus, either by reducing the luminosity of our coloured light or by mixing it with more or less white, a great number of tints can be produced; but we soon find that to match many natural colours it is necessary to employ both these proceedings simultaneously. By combining with our coloured disk a black and a white disk, we then become able to imitate a far greater number of the pale, indescribable tints of natural objects. To make our power more complete, we ought also to be able at will to alter the wave-length of the light reflected from the coloured disk.* There are, however, practical difficulties which prevent us from making these changes in a definite and perfect manner, and we find ourselves finally driven to abandon our very convenient and instructive disks, and to turn for help to the colours of the solar spectrum. These colours are pure in the sense of being free from any admixture of white light, their luminosity can be varied to any extent, and the lengths of the various waves which generate them have been measured with a high degree of accuracy; we also can mix white light with them at our pleasure. With the colours of the spectrum, and a purple formed by mixing the red and violet of the spectrum, we can match any colour whatsoever, provided we are allowed to increase or diminish the luminosity of our spectral hues, and to add the necessary amount of white light. This fact furnishes us with a clue toward a classification of colours. The series red, orange, yellow, green, blue, violet, and purple is one which returns on itself, and hence can be arranged in the form of a circle, as was first done by Newton. In making a colour-chart we can place the complementary colours opposite each other, and white in the middle; the pure colours of the spectrum will be situated on the circumference of the circle, and the

* For an account of the effects produced by alteration of wave-length, see Chapter III.

mixtures of these with white will lie nearer the centre, as is roughly indicated in Fig. 94. A chart of this kind will contain all colours that are possible under a given degree of illumination, arranged in an orderly manner. In the sector devoted to the reds we shall find along the circumference every kind of pure red, from purple-red to orange-red, and, as we advance inward toward the centre of the circle, a great number of tints produced by mixing these various reds with increasing quantities of white. It is the same

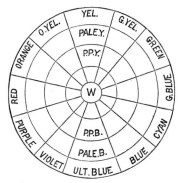

Fig. 94.—The colours of the spectrum are supposed to be on the circumference of the circle, and the mixtures of these with increasing quantities of white are in the interior. White is at the centre. (The spaces for most of the pale or greyish tints are left blank, for want of room.)

with all the other pure colours : every possible hue and tint belonging to the adopted grade of illumination will be found somewhere within the circle ; all the manifold greens and blues, also the whole range of purples, from purplish-red to purplish-violet—all will be represented. At the start, one of our conditions was that complementary colours should be opposite each other ; hence we must give to our blue not only the right hue, but a luminosity such that it is able exactly to neutralize the yellow which is opposite to it. These two colours must also have a luminosity such

that, when they are mixed, the mixture will furnish a white which is twice as bright as that at the centre of the circle. The same must be true of all the other pairs of complementary colours, whether situated on the circumference or in the interior of the circle. This mode of operating gives us a chart in which all the colours of corresponding intensity are well arranged with regard to each other, and it enables us at a glance to see some of the relations of the colours to each other.*

In the construction of this colour-chart we imagined the brilliant colours of the spectrum to be situated on the circumference of the circle, and as we advanced toward the centre a larger and larger proportion of white light was to be mixed with them. Suppose now we diminish somewhat the luminosity of our spectral colours ; this will change every tint in the chart correspondingly, and also the central white ; all will be darkened proportionately ; we shall obtain a new colour-chart, having less luminosity, but in other respects closely resembling the first. With a further reduction of the light a corresponding result will again be reached ; and, as we continue the process, we go on accumulating new colour-charts, each being darker than the last. Our two limits evidently are the brilliant colours of the spectrum on the one hand and total blackness on the other ; between these we shall be able to place a series of several hundred colour-charts, differing perceptibly in luminosity, but in other respects resembling the original type as nearly as may be.

If we arrange this whole series of charts one above the other in proper order, the most luminous one, or that with which we started, being placed at the top, we shall obtain a cylinder which will contain within itself an immense series of colours. The axis of the cylinder at the top will be

* In this case we consider colours equally intense which, when mixed, neutralize each other and produce the same white. The luminosity of such colours, measured by the eye, will often be quite different.

10

white, and as we descend it will pass through a great series of darkening greys, finally to end in black. If we make a vertical section of the cylinder, its appearance then will be of the nature roughly indicated in Fig. 95, the axis darkening as we descend, also the charts. Now, we know it to be a fact that, as coloured surfaces are more and more feebly illuminated, so does the number of tints which we can dis-

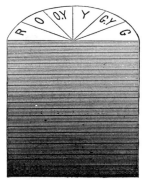

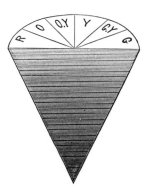

Fig. 95.—Section of a Pile of Colour-Charts, the most luminous ones being at the top.

Fig. 96.—Section of a Colour-Cone.

tinguish on them constantly decrease. Hence, in the case of our cylindrical pile of charts, smaller surfaces will answer equally well for the display of the darker tints, and we may as well reduce our cylinder to a cone, as indicated in Fig. 96. This colour-cone is analogous to the colour-pyramid which was described by Lambert in 1772.

It will be remembered that we began our colour-chart with the colours of the spectrum, and these colours, along with their mixtures with white, constituted the base of our cone. The colours of the spectrum in this case were supposed to have only a moderate degree of brightness, such as would be suitable for prolonged observation. These are the brightest colours thus far contained in our cone, but

they are by no means the brightest colours that we are able to see; above them occur a great series of hues which we can more or less perfectly distinguish. As our ability to discriminate very luminous colours diminishes as their luminosity increases, the colour-charts devoted to this new set may be treated like those used for the darker colours. In this way we once more obtain a second cone, which will be placed over the one before described. At the apex of this last cone we have the brightest white which the eye is capable of perceiving; a little below and around it are situated a series of very luminous spectral colours and a purple, all being so bright as to differ, so far as the eye is concerned, not much from a brilliant white; farther down on the sides of the cone are still quite bright colours, and in its interior their mixtures with white. In this double cone, then, we are at last able to include all the colours which under any circumstances we are able to perceive; they are arranged in an orderly manner, which at once exhibits their hues and luminosities, and the amount of white light that has been mixed with them. They are arranged throughout in complementary pairs, and some of their other relations to each other are plainly exhibited.

Now, a word with regard to the possibility of executing this colour-cylinder or the double cone. In the first place, we have no pigments with which we can at all properly represent the colours of the spectrum even when their luminosity is quite moderate; our best pigments all reflect more or less white light mixed with their coloured light. If with their aid we undertook to construct a colour-chart, we should not only be obliged to descend in the cone, Fig. 96, a good distance toward its black apex, but besides this our chart would be smaller than the section of the cone at that point, owing to the presence of the foreign white light reflected by the pigments. It would be next to impossible to prepare pigments of different colours suitable even for the production of a single chart of the series; for it would be ne-

cessary that they should be right in the matter of hue, luminosity, and greater or less freedom from white light.

There are still other objections to the system as just proposed. It furnishes us with no means of giving the colours a proper or rational distribution on the circumference of the circle ; we do not know whether the yellow is to be placed 90° from the red or at some other distance ; the same is true with regard to the angular distribution of all the other colours ; the system gives us no information on this point. It also gives us no information about the effects that are produced by mixing together colours that are not complementary.

There is another mode of attacking this problem which has been much used of late, and which offers certain advantages to the student of colour. Let us suppose that we place red of a certain luminosity at R, and green of the same luminosity at G, Fig. 97 ; then along the line R G we can arrange, or imagine to be arranged, all possible mixtures of these two colours. To do this we imagine that R and G have certain weights corresponding to their luminosities (or to the quantities of them which in a particular case we employ), and then proceed as if we had before us

Fig. 97.—Along the line R G we can arrange all the mixtures of red and green. The diagram represents the case where equal parts of red and green are employed. Then the point of support (mixture-point) must be in the centre of the line R G.

Fig. 98 —A mixture of equal parts of red and green furnishes a yellow; the position of this yellow on the line of mixtures, R G, is at Y.

a mechanical problem. An example will make this plain : Let the luminosity of the red and green both be 10 ; we now mix 5 parts of red with 5 of green, and obtain a yellow ; the position of this yellow will be at Y, Fig. 98, half

way between R and G. We put the position of yellow at Y because, in order that 5 parts of red may balance 5 parts of green, the point of support must be half way between R and G. We have now determined accurately on the line R G the position of a yellow made by mixing equal parts of our original red and green. This yellow, made by mixing 5 parts of red and 5 of green, will also have the same luminosity as the original red or green. If we mix 7 parts of red with 3 of green, the position of the mixture will be at O, Fig. 99. If we divide up the line R G into

Fig. 99.—Seven parts of red are mixed with three parts of green ; the mixture is orange in colour, and situated on the line R G at O.

10 equal parts, then O will be distant from R by 3 parts, but from G by 7 parts ; for in this way alone a balance can be obtained. In general we shall always obtain a balance or equilibrium when the weight of R multiplied by its distance from O is equal to the weight of G multiplied by the distance of G from O. In this last case (Fig. 99) the mixture at O will be orange in colour, and will have a luminosity identical with the original red and green. So we can go on filling up the line R G with all possible mixtures of the original red and green. Now, this is a process which can actually be carried out in practice. We can take for our red a vermilion disk, and then select for our green a disk having a colour as nearly as possible of the same luminosity, and by the method of rotation produce all the tints above indicated. We can copy these tints, and arrange the copies along the line R G ; or, if we do not wish to take this trouble, we can at least always reproduce at will, with aid of the red and green disks, any of the tints belonging on the line R G. This explanation will serve to render clear the fundamental idea on which the colour-diagram of Newton and Maxwell rests.

Thus far we have employed only two colours, red and green, and have been able by mixing them in different proportions to obtain various hues of orange, yellow, and greenish-yellow. If we wish to include the other colours, blue, violet, purple, and the mixtures of all the colours with white, we must employ at the start three instead of two colours. Maxwell selected vermilion, emerald-green, and ultramarine-blue, since according to his researches they approximately represent the three fundamental colours. These he placed at the three angles of an equilateral triangle, and ascertained in a manner afterward to be explained the position of white (or grey) in the interior of the triangle. Every colour that can be obtained by mixing red with green will lie on the line joining red and green; it is the same with green and blue, also with red and blue. Fig. 100 shows these colours disposed along the sides of the triangle; they are also so arranged that complementary colours are opposite each other; white is in the interior, and along the lines joining the sides with the centre are placed the various colours mixed with more and more white as they are situated nearer to the centre. The colours made by mixing red with green, or green with blue, being situated on the sides of the triangle, are consequently as a general thing nearer to the position of white than the three fundamental colours at the three angles of the triangle. This indicates in a geometrical manner the fact that the tints produced by the mixture of two fundamental colours are paler, or mixed with more white, than the fundamentals themselves. In general, in a chart of this kind, the farther we go from the centre or from the position of white, the more do we obtain colours which are free from admixture with white. The angular position of the colours is to some extent arbitrary, being determined partly by the process of mixture, and partly by the assumption that particular hues of red, green, and blue represent the fundamental colours. If we should assume as our fundamental colours red lead,

grass-green, and violet, the angular position of all the other colours would be disturbed. Still, in spite of this and other drawbacks, the colour-diagram is valuable for purposes of

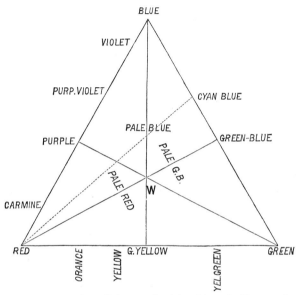

Fig. 100.—Shows the colours that are produced by mixing red with green, etc. The pale colours, or those mixed with white, are situated in the interior of triangle, and grow paler as they are nearer W, or white.

study, and enables us to express our ideas about colour in a geometrical form and with a certain degree of precision. It is easy, for example, with its aid to ascertain the result of mixing together any of the colours contained, or supposed to be contained, in it; if we mix equal parts of red with cyan-blue, it is evident by inspection that the result must be a whitish-purple; so again equal parts of yellow and cyan-blue will furnish a whitish-green. (See Fig. 100.) With the aid of this diagram we can accomplish even more: we can mix together any number of colours, and

ascertain the position and consequently the tint of the resultant hue. We select any two, join them by a line, and ascertain, as previously explained, the position of the mixture tint; we then join the third colour by a straight line with the point just ascertained, and again construct the position of the second mixture, and so on. An account of the mode of making a colour-diagram of this kind will be found in the appendix to this chapter, where the method will also be explained which Maxwell employed for the introduction of colours more or less luminous than the three fundamental ones.

The colour-charts which thus far have actually been published and laid before the world have been of a different character from those above indicated, and are calculated to display the effects, not of mixing coloured light, but coloured pigments. Among the older attempts we may mention those of Le Blond in 1735, and of Du Fay in 1737. In 1758 T. Mayer published an account of his experiments. As three fundamental colours he selected vermilion, a bright yellow, and smalt-blue. Lambert in 1772 used for the construction of his pyramid carmine, gamboge, and Prussian-blue. These colour-charts were constructed by mingling weighed portions of the fundamental pigments and of lamp-black in such a manner as to obtain as great a variety of tints as possible, which were then arranged in an orderly series. The very beautiful colour-charts of Chevreul are essentially of the same nature with those just mentioned. Chevreul employed a circle with three radii which were 120° apart, and placed on these radii red, yellow, and blue; the hues of these colours were copied from certain portions of the prismatic spectrum which were selected as standards. Between red and yellow the various hues of orange and orange-yellow were introduced; between yellow and blue the greens, the purples being situated between violet and red. This constitutes the first chromatic circle, which contains also the purest and most intense colours. In the sec-

ond circle the same colours are shown mixed with a small, definite amount of black; the third circle is like the second, only still more darkened, and so on. There are ten of these circles, each containing seventy-two tints; complementary colours are situated opposite each other. Besides the circles, there are charts containing colours arranged in parallel bands; these are intended to exhibit the effects of mixing black and white with the colours contained in the first circle. They consist of twenty-two bands, the 0 band being white, the 21st black, and the 10th band the same as the corresponding colour in the first circle. Starting, for example, from the 10th band, as we move to 0 the colour grows continually paler, being mixed with more and more white; if we advance in the other direction, the colour becomes darker, and ends finally in black. There are seventy-two sets of these bands, also one for black and white.

The ideas upon which this chart is based are not only in the main arbitrary, but also vague, and the execution of the sample examined by the author left much to be desired. We can not regard this colour-chart as a true step toward a philosophical classification of colours, but rather as a more elaborate repetition of the work of Mayer, Lambert, and Runge. In point of fact, our knowledge of colour and our means of experimenting on it are not at present sufficiently advanced to enable us even to propose a plan for a truly philosophical classification, and between the proposal and its execution there would be many weary steps. Hence, the matter contained in this chapter and its appendix is rather to be regarded as setting forth the problem than as attempting its solution.

————

APPENDIX TO CHAPTER XIV.

COLOUR-DIAGRAMS.

FOLLOWING a suggestion of Newton's, Maxwell constructed a diagram in which the colours of pigments and many natural objects can be laid down in accordance with certain principles and assumptions presently to be explained. Now, although some of the assumptions are arbitrary, yet if they are accepted a chart is obtained which presents many valuable features for the student of colour. The nature and scope of this colour-diagram will perhaps best be made evident by tracing the actual construction of one as made by the present writer.

Following Maxwell, vermilion, emerald-green, and artificial ultramarine-blue were assumed as the three fundamental colours, and positions at the three angles of an equilateral triangle assigned to them. The length of each side of the triangle was 200 divisions of the scale employed. The first step was to determine the position of white in the triangle. For this purpose disks of vermilion, emerald-green, and ultramarine were combined as shown in Fig. 101, smaller central disks of black and white being placed on the

FIG. 101.—Compound Disk of Vermilion, Emerald-green, Ultramarine, White and Black, arranged for the production of Grey.

same axis. It was found, when the colours were mixed by rapid rotation, that 36·46 parts of vermilion, with 33·76 of emerald-green and 29·76 of ultramarine, gave a grey similar to that obtained by mixing 28·45 parts of white with 71·55 of black. In the experiment 24·5 parts of white were actually obtained; but this was cor-

rected by adding to it the white due to the black disk, it having been previously ascertained that, if the luminosity of the white paper composing the white disk was taken as 100, that of the black disk was 5·24. The same correction was made in all the cases that follow. The equation then reads:

$$36·46 \text{ R} + 33·76 \text{ G} + 29·76 \text{ B} = 28·45 \text{ W} \ldots\ldots(1).$$

The next step is to divide up the line R G, Fig. 103, in the ratio of 36·46 to 33·76:

$$(36·46 + 33·76) : 36·46 :: 200 : 103·5.$$

That is, if we mix vermilion and emerald-green in the proportion of 36·46 to 33·76, the mixture-point (a) lies on the line R G, and is 103·5 divisions distant from G, Fig. 103. This point is the position of the complement of the fundamental ultramarine, B. We now connect this point (a) with B by a straight line, find the length of the line to be 173·5 divisions, and seek the mixture-point of 36·46 R + 33·76 G and 29·76 B, which is obtained by the following proportion:

$$[(36·46 + 33·76) + 29·76] : 29·76 :: 173·5 : 51·64.$$

This mixture-point is the position of white; for vermilion, emerald-green, and ultramarine, when mixed in the above proportions, produce white. Hence, white (W, Fig. 103) will be on the line a B, 51·64 divisions from a. (It evidently must be somewhere on this line, for at the two extremities of the line are colours which are complementary, and there must be a mixture-point on the line which is white.) It will be noticed that in this proceeding the colours have been heated, according to Newton's suggestion, as though they were weights acting on the ends of lever-arms, and these arms have been taken of such lengths as to bring the system into equilibrium. It will also be observed that it has been assumed that the pigments, vermilion, emerald-green, and ultramarine, have the same intensity, or that equal areas of them have the same weight. Thus, 36·46 parts of vermilion and 33·76 of emerald-green, acting on a lever-arm 51·64 divisions in length, balance 29·76 parts of ultramarine acting on an arm with a length of 121·86 divisions. The lever-arms of the vermilion and emerald-green passing through W are also similarly balanced, and the whole system is in equilibrium.

The white or grey which was obtained in equation (1) was the

equivalent of 100 parts of colour; by multiplying 28·45 by 3·51 we obtain 100, and we set these 100 grey units in the place of 28·45 W in equation (1), and obtain what Maxwell calls the corrected value of the white. The factor 3·51 is called the coefficient of the white, and is used to establish a relation between equation (1) and those that follow. The coefficients of vermilion, emerald-green, and ultramarine have at the outset been assumed as 1, and hence in its corrected form equation (1) reads thus:

$$36·46 \text{ R} + 33·76 \text{ G} + 29·76 \text{ B} = 100 \text{ w} \ldots \ldots (2).$$

We have now laid down upon our colour-diagram the position of our three fundamental colours and that of white, and are prepared to assign positions to all other pigments or mixtures of pigments. For example, to determine the position of pale chrome-yellow, a disk covered with this pigment is to be combined with disks of emerald-green and ultramarine, and set in rotation (Fig.

Fig. 102.—Compound Disk of Chrome-yellow, Emerald-green, Ultramarine, White, and Black, arranged so as to give a pure Grey by rotation.

102). This experiment was made, and the following equation obtained:

$$26·9 \text{ Y} + 12·5 \text{ G} + 60·6 \text{ B} = 32·4 \text{ W} + 67·6 \text{ b} \ldots \ldots (3).$$

Before using equation (3), it is necessary to bring it into relation with equation (2), and the first step is to express the value of the white in the same manner as in equation (2), viz.: we multiply it by the coefficient 3·51, and obtain in this way the value of the corrected white, or 113·87. This quantity we substitute in equation (3), which then reads:

$$26·9 \text{ Y} + 12·5 \text{ G} + 60·6 \text{ B} = 113·87 \text{ w} \ldots \ldots (4).$$

We must now introduce a corrected value for the chrome-yellow, so arranged that we shall have the same number of units, grey or coloured, on both sides of the sign of equality:

$$113·87 - (60·6 + 12·5) = 40·77.$$

40·77 is then the corrected value of the chrome-yellow, and equation (3) in its corrected form finally reads:

$$40·77 \text{ Y} + 12·5 \text{ G} + 60·6 \text{ B} = 113·87 \text{ w} \ldots \ldots (5).$$

To obtain the coefficient of the chrome-yellow, we divide the corrected value by the original value:

$$\frac{40·77}{26·9} = 1·51 = \text{coef. of ch.-yel.}$$

We are now prepared to determine the position of chrome-yellow in the diagram. We divide the line B G into two parts having the ratio of 12·5 to 60·6:

$$(12·5 + 60·6) : 12·5 :: 200 : 34·2.$$

The position, then, of the complement of chrome-yellow is on the line B G, Fig. 103, at the spot marked cobalt, and is distant from B by 34·2 divisions; the distance of this point from W is found by measurement to be 94·1 divisions. We connect the point by a straight line with W, and produce the line some distance beyond; the position of chrome-yellow will be on this line, and may be found by the following proportion: Weight of chrome-yellow : weight of emerald-green and ultramarine :: distance of emerald-green and ultramarine : distance of chrome-yellow; or,

$$40·77 : (60·6 + 12·5) :: 94·1 : 168·7.$$

Chrome-yellow is consequently distant from the neutral point or white 168·7 divisions; we insert it in the diagram along with its coefficient 1·51. By a corresponding process the positions and coefficients of a number of the more ordinary colours have been laid down in the diagram. See Fig. 103. If the diagram is examined, it will be found that along any single radius the pale colours, or those mixed with much white, are located nearer W than those that are more free from such admixture; it will also be noticed that the more luminous colours have higher coefficients. By the aid of this diagram we obtain relative measures of the luminosity and saturation of colours on the same or on closely adjacent radii; the

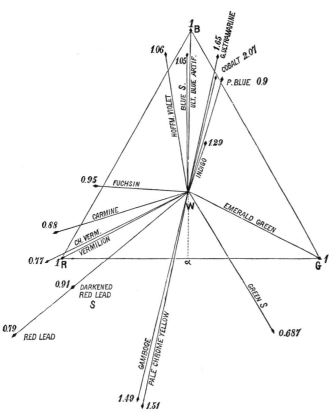

FIG. 103.—Maxwell's Colour-Diagram as constructed by O. N. R.

colours also have angular positions assigned to them, so that they are fairly defined as to angular position, intensity, and greater or less freedom from white.

It is, however, to be remarked that the construction rests upon several more or less arbitrary assumptions, as: 1. That vermilion, emerald-green, and ultramarine-blue really correspond to the three fundamental colours. If we substitute in place of them other colours, such as red lead, grass-green, and violet, we obtain different

angular positions for all the colours afterward introduced, and also different coefficients. 2. The assumption that vermilion, emerald-green, and ultramarine have the same intensity or the same coefficient is quite unwarranted, the intensity of emerald-green being evidently greater than than of ultramarine-blue. From this it follows that the coefficients and distances from the central white, W, are not comparable along different radii.

The author has reconstructed the same colour-diagram, introducing coefficients which represent the actual luminosities of the three fundamental colours. These coefficients were obtained by the method described in Chapter III. Vermilion, emerald-green, and artificial ultramarine-blue were, as before, assumed as the fundamental colours, and placed at the three angles of an equilateral triangle. Taking the luminosity of white paper as 100, the luminosities of the three pigments were as follows: Vermilion, 26·85; emerald-green, 48·58; ultramarine-blue, 7·57. Introducing these coefficients into equation (1), it becomes:

Vermilion. Emerald-green. Ultramarine. White.
$$(26\cdot85 \times \cdot3646) + (48\cdot58 \times \cdot3376) + (7\cdot57 \times \cdot2976) = 28\cdot44.$$

That is :

$$9\cdot8 \text{ verm.} + 16\cdot4 \text{ em.-green} + 2\cdot2 \text{ ult.} = 28\cdot44 \text{ white} \ldots \ldots (6).$$

With the aid of equation (6), the position of white was determined in the manner previously employed, and found to be that indicated in Fig. 104, being only 13·55 divisions distant from the line V G. Making use of equation (3), the coefficient of chrome-yellow was determined as indicated below, X being this quantity :

$$(48\cdot58 \times \cdot125) + (X \times \cdot269) + (7\cdot57 \times 0\cdot606) = 32\cdot4.$$
$$X = 80\cdot82.$$

We then have—

$$6\cdot072 \text{ em.-green} + 21\cdot74 \text{ ch.-yel.} + 4\cdot587 \text{ ult.} = 32\cdot4 \ldots \ldots (7).$$

With the aid of this last equation the position of chrome-yellow can be laid down in the manner previously described. In Fig. 104 the positions of the same pigments are shown which were employed in the first colour-diagram, Fig. 103; and it will be noticed that white has been moved toward the line R G, and that the angular positions of the colours have been considerably altered. In this second colour-diagram the coefficients of pigments situated along different

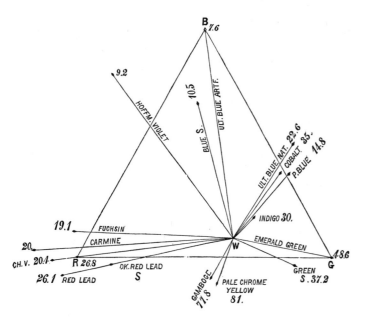

Fig. 104.—Maxwell's Diagram as reconstructed by the Author, correct Coefficients being employed.

radii are comparable with each other, since they represent the luminosities of the pigments compared with that of white paper taken as 100.

The author has constructed a new kind of colour-diagram, in which the colours are arranged in a different manner from those just described.

Idea of the New Diagram.—Let us suppose that we take a certain quantity of pure red light and locate it on the circumference of a circle at R, Fig. 105, and draw the diameter R G B, and at the point G B locate a quantity of pure green-blue light, just sufficient to neutralize the red light, or form with it a mixture which appears to the eye white. The position of white will then be at the centre of the circle, or at W. The red and green-blue light employed will be considered equal in intensity, though in actual luminosities they

may differ considerably; they will, in point of fact, relatively to each other, have equal saturating powers. We next lay down on the circumference at Y a certain amount of pure yellow light, draw the diameter Y B, Fig. 105, and at B locate an amount of blue light

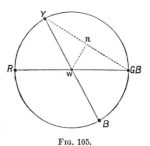

Fig. 105.

just sufficient to neutralize it, arranging matters so that the yellow and blue light when mixed shall reproduce a white identical in luminosity with that furnished by the mixture of the red and green-blue. The yellow and blue will differ greatly in luminosity, but, as they neutralize each other, will be considered to have equal intensity. *Each* of the four colours will also be considered to have equal intensity in the sense in which the word has just been employed; or, instead of using the term intensity, we may say that each of the four colours will have corresponding powers of saturation. The same will be true of any other colours belonging on the circumference. In order to realize this idea, and to obtain means of assigning to the colours proper angular positions, some other considerations must be entertained. Suppose we mix the yellow located at Y with the green-blue located at G B: we shall by varying the proportions finally obtain a mixture which, although it is not white, yet will be paler or more whitish than any other mixture; this, of course, is a well-known fact. In the practical construction of the diagram, it is assumed that this most neutral mixture will be obtained when the whole mass of the yellow at Y is mixed with the whole mass of green-blue at G B; and it is evident that, even if this assumption is not strictly true, it will approximate to the truth just in proportion as the angular distance between R and Y happens to be a small quantity. If the angular distance between R and Y is a large quantity, the assumption may or may not hold good;

at present we have no means of deciding this point. We will take it for granted till the contrary is proved, and from n, the most neutral point, we draw a perpendicular; it will pass through the centre of the circle, or through the position of white. The same will hold good when any other point not far distant from R is connected by a straight line with G B; here also a perpendicular drawn from the most neutral point will pass through white.

Realization of the Diagram.—In order to construct this diagram it is necessary to prepare three coloured disks having equal intensities, in the sense above employed, or equal saturating powers. These disks must also have such colours that by optical mixture they may be capable of furnishing white light. The colours selected were red lead, a grass-green, and artificial ultramarine-blue. The green disk was combined with the blue disk, and, by a rather elaborate series of experiments, it was ascertained that the most neutral mixture was obtained when equal areas were optically mixed, from which it was concluded, according to the fundamental assumption, that the saturating powers of the two disks were equal. After several trials, a similar equality was established between the green disk and one painted with slightly darkened red lead. These disks when combined gave the following equation :

$$23 \cdot 06 \text{ red lead} + 42 \cdot 16 \text{ green} + 34 \cdot 76 \text{ blue} = 22 \cdot 1 \text{ white.}$$

The coefficients of the three colours were taken as unity, since the colours had equal saturating powers. The relative areas of the colours in the above equation were then used as weights, and furnished the means of determining the positions of the three colours on the circumference of a circle in which white was placed at the centre. This was accomplished by placing the three colours at such angular distances apart as brought the whole system into equilibrium; for example, if the weights had been equal, the angular distance of the three points would have been 120°. The proper angular distances being now laid down, the positions of darkened red lead, grass-green, and ultramarine were determined; and with their aid the positions of other pigments could be ascertained by the process of mixture previously explained. (See Fig. 106.) The points laid down in this diagram indicate colour or hue by angular position, and saturation or intensity by greater or less distance from W. The relative amounts of white light reflected by the pigments situated on any particular radius can easily be determined, since distance

from the centre measures the amount of coloured light reflected, and the total amount of coloured and white light reflected can be measured by the process described in Chapter III. We have, however, at present no means of generalizing this process and applying

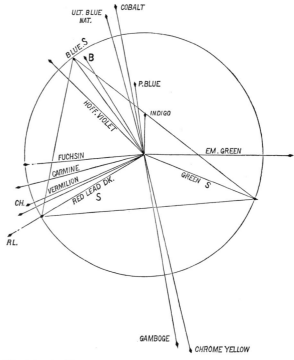

Fig. 106.—Saturation-Diagram according to Rood. The three colours used in its construction are marked S.

it to colours situated on different radii, since we have not the power of ascertaining, for example, whether our standard yellow disk at Y reflects the same amount of *white* light with the standard red disk at R, or more or less; we know that they reflect corresponding quantities of coloured light, but nothing more. Before we can

solve this problem it will be necessary for us to know the relative luminosity of all the pure colours (free from white light) which, according to the construction, fall on the circumference of the circle, and this could only be ascertained by an especial study of the spectral colours with reference to this point; but no such study has yet been made. We know that corresponding amounts of yellow and greenish-yellow have not only higher degrees of luminosity than their complements, blue and violet, but even higher than any of the other colours; but thus far no quantitative determinations have been made. Fig. 106 exhibits a diagram of the kind just described, containing the same colours or pigments previously employed: it is perhaps best called a saturation-diagram.

CHAPTER XV.

CONTRAST.

WE have now studied with some care the changes which coloured surfaces experience when viewed under various kinds of illumination, or when modified in appearance by the admixture of more or less white or coloured light. The appearance which a coloured surface presents to us can, however, be altered very materially by a method which is quite different from any of those that have thus far been mentioned: we can actually change colour to a considerable extent without at all meddling with it directly, it being for this purpose only necessary to alter the colour which

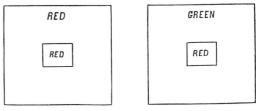

FIG. 107.—Sheets of Red and Green Paper with Red Squares.

lies adjacent to it. We can satisfy ourselves of this fact by a very simple experiment. If we cut out of a sheet of red paper two square pieces an inch or two in size, and then place one of them on a sheet of red and the other on a sheet of green paper, as indicated in Fig. 107, it will be found that the red square on the red paper will not appear nearly so

brilliant and saturated in colour as that placed on the green ground, so that the observer will be disposed to doubt whether the two red squares are really identical in hue. By a somewhat analogous proceeding we can cause a surface which properly has no colour of its own, which is really grey, to appear tinted red, blue, green, etc. These changes and others of a like character are produced by what is called contrast, and are partly due to actual effects generated in the eye itself and partly to fluctuations in the judgment of the observer. The subject of contrast is so important that it will be worth while to make a somewhat careful examination of the laws which govern it ; and for

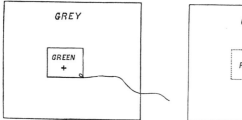

FIG. 108.—Grey Paper with Green Slip. FIG. 109.—Grey Paper with Rose-coloured Image.

this purpose it will be well for the reader to repeat some of the simple experiments described below.

If we place a small piece of bright-green paper on a sheet of grey drawing-paper, in the manner indicated in Fig. 108, and then for several seconds attentively look at the small cross in the centre of the green slip, we shall find, on suddenly removing it, that in its place a faint image of a rose-red colour makes its appearance, Fig. 109. This red image presently vanishes, and the grey paper resumes its natural appearance. The rose-red ghost which is thus developed has a colour which is complementary to that which called it into existence, and this will also be the case if we

employ little squares of other colours : red will give rise to a greenish-blue image, blue to a yellow, violet to a greenish-yellow, etc., the colour of the image being always complementary to that which gave rise to it. On this account these images are called *negative*, since, as far as colour goes, they are just the reverse of the images which are first presented to the eye of the observer. They are also often spoken of in older treatises on optics as "the accidental colours." It is quite easy to explain their production with the aid of the theory of Young and Helmholtz. Let us take as an example the experiment just described. According to our theory, the green light from the little square of paper, acting on the eye, fatigues to some extent the green nerves of the retina, the red and violet nerves meanwhile not being much affected. When the green paper is suddenly jerked away by the string, grey light is presented to the fatigued retina, and this grey light may be considered to consist, as far as we are concerned, of red, green, and violet light. The red and violet nerves, not being fatigued, respond powerfully to this stimulus ; the green nerves, however, answer this new call on them more feebly, and in consequence we have presented to us mainly a mixture of the sensations red and violet, giving as a final result rose-red or purplish-red. The green nerves, of course, are not so fatigued that they do not act at all when the grey light is presented to them, but the only effect that their partial action has is to render the rose-coloured image somewhat pale or whitish in appearance. The fatigue of the optic nerve, mentioned here does not differ essentially from that which it undergoes constantly, even under the conditions of ordinary use, where the waste is continually made good by the blood circulating in the retina, and by the little intervals of rest frequently occurring. In our experiment we have merely confined the fatigue to one set of nerves, instead of distributing it equally among the three sets.

The above experiments and explanation will enable us

easily to comprehend the more complicated case, where, instead of placing our little green square on grey, we lay it on a sheet of coloured paper. Instead, then, of grey, let us take yellow paper, placing the green square on it as before, Fig. 110. On suddenly withdrawing the green square, we find it replaced by an orange-coloured ghost, Fig. 111,

FIG. 110.—Yellow Ground with Green Slip.

FIG. 111.—Yellow Ground with Orange-coloured Image.

which we account for thus : As before, the green nerves are fatigued, the red and violet nerves remaining fresh ; when the square is removed, yellow light is presented to the retina, and this yellow light, as explained in Chapter IX., tends to act on the red and green nerves equally ; but the green nerves in the present case do not respond with full activity, hence the action is more confined to the red nerves, and, as explained in Chapter X., the resultant tint is necessarily orange—that is to say, we have a strong red sensation mingled with a weak green sensation, and the result is the sensation called orange. In this experiment the violet nerves do not come into play to any great extent. If the green square is placed on a blue ground, the image becomes violet, for the reason that the blue light which is presented to the fatigued retina acts, as explained in Chapter IX., on the green and violet nerves ; but the green nerves being fatigued, the action is mostly confined to the violet nerves, and hence the corresponding sensation. In this case the red nerves hardly come into play at all.

It follows from the above examples and reasoning that the final effect is, that we obtain as an after-image what amounts to a mixture of the *complementary* colour of the small square with the colour of the ground ; and, by recollecting this, we can easily retain this class of facts in the memory.

There is another similar experiment which is simpler than those just described, but which is nevertheless instructive. A small square of black paper is to be placed on a sheet of red paper, and the attention in this case is to be directed to a mark on the edge of the former. (See Fig. 112.) When the black square is suddenly removed, the ob-

FIG. 112.—Red Ground with Black Paper.

server sees in place of it a more luminous spot, which in the case before us will of course be red ; but what is remarkable is the circumstance that this red image will be more intense or saturated in colour than the rest of the ground. The rest of the sheet of red paper will look as though grey had been mixed with its colour, Fig. 113. This experiment will of course succeed with paper of any bright colour, and Helmholtz has found that the same effects can be obtained with the pure colours of the prismatic spectrum. The explanation, according to our theory, runs about thus : While we are in the act of looking at the edge of the black square, red light is passing into the eye, and is

11

fatiguing all those portions of the retina that are not protected by the presence of the black square; it thus happens that the ability of the larger portion of the retina to receive the sensation of red is considerably diminished; the ability of the protected portion of course suffers no such change.

FIG. 113.—Red Ground with Intense Red Image

When the black square is suddenly removed, the unfatigued portion of the retina receives a powerful impulse from the red surface, but the effect produced on the rest of the retina is inferior in degree. This accounts for the fact that the image of the square is brighter or more luminous; and we can easily understand why it is at the same time more intense, or saturated in colour, if we remember, as explained in Chapter IX., that red light excites into action not only the red nerves, but to a less extent the green and violet nerves. Now, as the red nerves begin to be fatigued, the action of the other two sets will be relatively more powerful than at first, so that gradually the sensations of green and violet begin to add themselves to that of red (or, what is the same thing, the sensation of white mingles itself with that of red), and the red colour of the paper looks a little greyish. The success of the experiment with the pure colours of the prismatic spectrum, which contain no white, is easily accounted for by the explanation just given.

This matter can be pushed even further if, instead of

employing a black square, we take one which has a colour complementary to that of the ground. We substitute then for the black square one coloured with emerald-green, and repeat the experiment. (See Fig. 114.) The result is much the same as before, except that the red ghost is now still more intense or saturated in colour, Fig. 115. When the

FIG. 114.—Blue-green Slip on Red Ground. FIG. 115.—Intense Red Image on Red Ground.

experiment is made in this way we accomplish two objects: first, we protect a small portion of the retina from red light, so that it may be very sensitive to this kind of light afterward; second, we fatigue the green and violet nerves of this portion by presenting to them bluish-green light, so that afterward the red light from the red paper will be unable to stimulate them even in a small degree; hence the sensation that we receive is that of pure red, the action of the green and violet nerves being excluded.

All these phenomena are cases of what is called successive contrast, because we look in succession from one surface to another. When coloured surfaces are placed near each other and compared in a natural manner, successive contrast plays an important part, and the appearance of the colours is more or less modified according to its laws. If we attempt to confine our attention to only one of the coloured surfaces, this still holds good; for the eye involuntarily wanders to the other, and to prevent this requires a

good deal of careful practice, for fixed vision is quite opposed to our natural habit. It follows from this that, in the natural use of the eye, the negative images, although present to some extent, are not sharp and distinct, and hence usually remain unobserved by persons not trained to observations of this character. Nevertheless these images modify to a considerable extent the appearances of coloured surfaces placed near each other, and the *changes* of hue are visible enough to the most uneducated eye.

One of the most common cases belonging here is represented in Fig. 116. We have a grey pattern traced on a

GREEN GROUND

FIG. 116.—Grey Figure on a Green Ground.

green ground ; the tracery, however, will not appear pure grey, but tinged with a colour complementary to that of the ground—that is, reddish. We can, of course, substitute for the green any other bright colour, and it will al-

ways be found that the grey is more or less tinged with the complementary hue. As black is really a dark grey, we should expect to find it also assuming to some extent a colour complementary to that of the ground ; and this is indeed the case, though the effect is not quite so marked as with a grey of medium depth. Chevreul, in his great work on the simultaneous contrast of colours, relates an anecdote which illustrates the matter now under consideration. Plain red, violet-blue, and blue woven stuffs were given by certain dealers to manufacturers, with the request that they should ornament them with black patterns. When the goods were returned, the dealers complained that the patterns were not black, maintaining that those traced on the red stuffs were green, on the violet dark-greenish yellow, and on the blue copper-coloured. Chevreul covered the ground with white paper in such a way as to expose only the pattern, when it was found that its colour was truly black, and the effects which had been observed were entirely due to contrast. The remedy in such cases is not to employ pure black, but to give it a tint a little like that of the coloured ground, taking care to make it just strong enough to balance the hue generated by contrast. If we substitute a white pattern for the black, something of this same effect can often be observed, but it is less marked than with grey or black. In cases like those now under consideration the contrast is stronger when the coloured surface is bright and intense or saturated in hue. The effect is also increased by entirely surrounding the second colour with the first ; the circumscribing colour ought also to be considerably larger than its companion. When these conditions are observed, the effect of contrast is generally noticeable only on the smaller surface, the larger one being scarcely affected.

When, on the other hand, the two coloured surfaces are about equal in extent, then both suffer change. If it is desired to produce a strong effect of contrast, the coloured surfaces must be placed as near each other as possible.

This is beautifully illustrated in one of the methods employed by Chevreul in studying the laws of contrast. Two coloured strips were placed side by side in contact, as shown in Fig. 117, duplicate strips being arranged in the field of

FIG. 117.—Arrangement to show the Effects of Simultaneous Contrast, half size.

view at some distance from each other. The tints of the two central strips were both altered ; those placed at a greater distance apart suffered no change. In the experiment represented in Fig. 117 the central ultramarine by contrast is made to appear more violet in hue, the central cyan-blue more greenish ; the colour of the outlying strips is scarcely affected. In this experiment we have an application of the rule above given for determining the changes which colours experience under the influence of contrast. The rule is quite simple ; its application, however, involves a knowledge of the colours which are complementary to each other, as well as of the effects produced by mixing together masses of coloured light. According to our rule, when two coloured surfaces are placed in contiguity, each is changed as though it had been mixed to some extent with the complementary colour of the other. In the example before us the ultramarine becomes more of a violet-blue,

because it is mixed, or seems to be mixed, with the complementary colour of cyan-blue—that is, with orange. The cyan-blue appears more greenish, because it is virtually mixed with greenish-yellow, which is the complementary colour of ultramarine. As it requires a little consideration to predict the changes which colours undergo through contrast, we give below a table containing the most important cases :

Pairs of Colours.		Change due to Contrast.
{ Red.....................	Becomes more purplish.
Orange.....................	"	" yellowish.
{ Red.....................	"	" purplish.
Yellow.....................	"	" greenish.
{ Red.....................	"	" brilliant.
Blue-green.....................	"	" brilliant.
{ Red.....................	"	" orange-red.
Blue.....................	"	" greenish.
{ Red.....................	"	" orange-red.
Violet.....................	"	" bluish.
{ Orange.....................	"	" red-orange.
Yellow.....................	"	" greenish-yellow.
{ Orange.....................	"	" red-orange.
Green.....................	"	" bluish-green.
{ Orange.....................	"	" brilliant.
Cyan-blue.....................	"	" brilliant.
{ Orange.....................	"	" yellowish.
Violet.....................	"	" bluish.
{ Yellow.....................	"	" orange-yellow.
Green.....................	"	" bluish-green.
{ Yellow.....................	"	" orange-yellow.
Cyan-blue.....................	"	" blue.
{ Yellow.....................	"	" brilliant.
Ultramarine-blue.....................	"	" brilliant.
{ Green.....................	"	" yellowish-green.
Blue.....................	"	" purplish.
{ Green.....................	"	" yellowish-green.
Violet.....................	"	" purplish.
{ Greenish-yellow.....................	"	" brilliant.
Violet.....................	"	" brilliant.
{ Blue.....................	"	" greenish.
Violet.....................	"	" purplish.

It is easy and instructive to study the changes produced by contrast with the aid of a chromatic circle, Fig. 118, and it

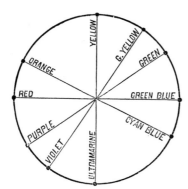

FIG. 118.—Chromatic Circle.

will be found that alterations in colour produced by contrast obey a very simple law: When any two colours of the chromatic circle are brought into competition or contrasted, the effect produced is apparently to move them both farther apart. In the case, for example, of orange and yellow, the orange is moved toward the red, and assumes the appearance of reddish-orange; the yellow moves toward the green, and appears for the time to be greenish-yellow. Colours which are complementary are already as far apart in the chromatic circle as possible; hence they are not changed in hue, but merely appear more brilliant and saturated. This is indeed the effect which a strict application of our rule leads to: the two colours are to be moved farther apart; they are already situated on the opposite extremities of a diameter of the circle, and, if they are to recede still farther from each other, they can accomplish this in no other way than by moving outside of the circumference of the circle; but this corresponds, as explained in the previous chapter, to an increase of saturation. If the

experiments indicated in the table are carefully repeated, it will be found that all the pairs of colours there enumerated are not equally affected by contrast. The *changes* of tint are greatest with the colours which are situated nearest to each other in the chromatic circle, and much less with those at a distance. Thus both red and yellow are much changed by contrast, the red becoming purplish, the yellow greenish; while red with cyan-blue or blue is much less affected in the matter of displacement or change of hue. On the other hand, the colours which are distant from each other in the chromatic circle, while suffering but slight changes in hue, are made to appear more brilliant and saturated; that is, they are virtually moved somewhat outside of the circle, the maximum effect taking place with colours which are complementary.

Colours which are identical are affected by contrast in exactly the opposite way from those which are complementary; that is, they are made to appear duller and less saturated. The author finds that these and other effects of contrast can be studied with great advantage by the aid of two identical chromatic circles laid down on paper. One set of these lines should be traced on a sheet of transparent paper, which is afterward to be placed over the companion circle. The use of these circles will best be made evident with the aid of an example. Let us suppose that we wish to ascertain with their aid the effect produced by red, as far as contrast goes, on all the other colours, and also on red itself. We place the transparent circle on its companion, so that the two drawings may coincide in position, and we then move the upper circle along the diameter joining red and green-blue some little distance, so that the two circles no longer have the same common centre. We then transfer the points marked red, orange, yellow, etc., on the upper circle, by pricking with a pin, to the lower circle, and these pin-marks on the lower circle will indicate the changes produced on all the colours by competition with red. Fig.

119 gives the result. The stars on the dotted circle represent the new positions of the different colours when contrasted with red. If we examine them we find that red when contrasted with greenish-blue causes this last colour to move away from the centre of the circle in a straight line; hence, as the new point is on the same diameter, but farther from the centre, we know that the greenish-blue is

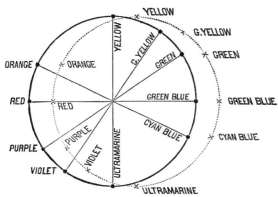

Fig. 119.—Chromatic Circle displaced by Contrast, showing the effects produced by the red on the other colours.

not made more or less blue or green, but is simply caused to appear more saturated or brilliant. The new point for the red lies also on the same diameter, but is nearer to the centre of the circle; that is, the colour remains red, but appears duller or less saturated. Experience confirms this. If a considerable number of pieces of red cloth, for example, are examined in succession, the last one will appear duller and inferior in brilliancy to the others, but it will still appear red. Proceeding with the examination of the effects produced on the other colours, we find that orange has been moved toward yellow, and also toward the centre of the circle; hence our diagram tells us that red, when put into competition with orange, causes the latter to appear

more yellowish and at the same time less intense. Advancing along the circumference of the circle, our diagram informs us that yellow is not much affected in the matter of saturation or intensity, but is simply made to appear more greenish. The two circles during superposition cut each other near the position of yellow; from this point onward the effect changes as far as intensity or saturation is concerned, the greenish-yellow being moved decidedly outside of the original circle, as well as toward the green; it is made therefore, by contrast with red, to appear more brilliant as well as more greenish. Green is made to appear somewhat bluish, and more brilliant. Greenish-blue has been considered. Cyan-blue is made to appear slightly more greenish as well as much more brilliant; the same is true of blue, though its increase in brilliancy by contrast with red is rather less than in the case with cyan-blue. Violet has its hue considerably altered toward blue; its saturation is diminished. Purple is made to look more violet, and is much diminished in saturation. If we wish to study the effects produced on the colours of the chromatic circle by contrasting them with yellow, we have of course merely to displace the upper circle along the line joining yellow and its complement ultramarine-blue, and then proceed as before. The proper amount of displacement will of course not be very large, and can be approximately determined by experiment; the upper circle, namely, is to be moved, so that the colours situated on either side of the points where the circles cut each other shall, in the diagram, Fig. 118, be made to suffer changes of *saturation* corresponding to the results of actual experiment.

It is quite evident that this contrast-diagram will furnish correct results only on condition that the colours in it are properly arranged; if the angular positions of the colours are laid down falsely, the results, in the matter of increase or diminution of brilliancy or saturation, will also be false. The author has made many experiments to settle

Fig. 120.—Contrast-Diagram according to O. N. Rood.

this question, and in Fig. 120 gives his result in the form of a diagram ; the same result is given below in the form of a table :

TABLE SHOWING THE DISTANCES OF THE COLOURS FROM EACH OTHER IN THE CONTRAST-CIRCLE, ACCORDING TO O. N. R.

	Angular Distances.
Pure red to vermilion	6°
Vermilion to red lead	10°
Red lead to orange	9°
Orange to orange-yellow	35°
Orange-yellow to yellow	28°
Yellow to greenish-yellow	23°
Greenish-yellow to yellowish-green	13°
Yellowish-green to green	22°

Green to emerald-green	10°
Emerald-green to very greenish blue, or to complement of carmine	18°

The hues of the papers employed in these experiments were determined with some degree of accuracy by comparing them with a normal spectrum nearly six times as long as that furnished by a single flint-glass prism, and at the same time brilliant and pure. (See Chapter III.) The following table gives the positions of these coloured papers in a normal spectrum, containing from A to H 1,000 equal parts ; the corresponding wave-lengths are also given :

Coloured Papers.	Position in Normal Spectrum.	Wave-length in $\frac{1}{1000000}$ mm.
Spectral red (vermilion washed with carmine)	285	6562
Vermilion (English)	387	6290
Red lead	422	6061
Orange	448	6000
Yellow (pale chrome)	488	5820
Greenish-yellow	535	5649
Yellow-green	552	5587
Green	600	5411
Emerald-green	648	5236
Cyan-blue 2	715	4991
Ultramarine, natural	785	4735
Ultramarine, artificial	857	4472
Violet ("Hoffmann's violet B. B.")	Rather more reddish than any violet in the spectrum.	

From the foregoing, then, it is evident in general that the effect of contrast may be helpful or harmful to colours : by it they may be made to look more beautiful and precious, or they may damage each other, and then appear dull, pale, or even dirty. When the apparent saturation is increased, we have the first effect ; the second, when it is diminished. Our diagram, Fig. 119, shows that the satura-

(27)

tion is diminished when the contrasting colours are situated near each other in the chromatic circle, and increased when the reverse is true. It might be supposed that we could easily overcome the damaging effects of harmful contrast by simply making the colours themselves from the start somewhat more brilliant ; this, however, is far from being true. The pleasure due to helpful contrast is not merely owing to the fact that the colours appear brilliant or saturated, but that they have been so disposed, and provided with such companions, that they are made to glow with *more* than their natural brilliancy. Then they strike us as precious and delicious, and this is true even when the actual tints are such as we would call poor or dull in isolation. From this it follows that paintings, made up almost entirely of tints that by themselves seem modest and far from brilliant, often strike us as being rich and gorgeous in colour ; while, on the other hand, the most gaudy colours can easily be arranged so as to produce a depressing effect on the beholder. We shall see hereafter that, in making chromatic compositions for decorative purposes or for paintings, artists of all times have necessarily been controlled to a considerable extent by the laws of contrast, which they have instinctively obeyed, just as children in walking and leaping respect the law of gravitation, though unconscious of its existence.

The phenomena of contrast, as exhibited by colours which are intense, pure, and brilliant, are to be explained to a considerable extent by the fatigue of the nerves, as set forth in the early part of the present chapter. The changes in colour and saturation become particularly conspicuous after somewhat prolonged observation, and are often attended with a peculiar soft glimmering, which seems to float over the surfaces, and, in the case of colours that are far apart in the chromatic circle, to lend them a lustrous appearance. Still, upon the whole, the effects of contrast with brilliant colours are often not strongly marked

at first glance, from the circumstance that the colours, by virtue of their actual intensity and strength, are able to resist these changes, and it often requires a practised eye to detect them with certainty. The case is quite otherwise with colours which are more or less pale or dark—that is, which are deficient in saturation or luminosity, or both. Here the original sensation produced on the eye is comparatively feeble, and it is hence more readily modified by contrast. In these cases the fatigue of the nerves of the retina plays but a very subordinate part, as we recognize the effects of contrast at the first glance. We have to deal here with what is known as simultaneous contrast, the effects taking place when the two surfaces are as far as possible regarded simultaneously. In the case of simultaneous contrast the changes are due mainly to fluctuations of the judgment of the observer, but little to the fatigue of the retinal nerves.

We carry in ourselves no standard by which we can measure the saturation of colour or its exact place in the chromatic scale ; hence, if we have no undoubted *external* standard at hand with which to compare our colours, we are easily deceived. A slip of paper of a pale but very decided blue-green hue was placed on a sheet of paper of the same general tint, but somewhat darker and more intense or saturated in hue. The small slip now appeared pure grey, and by no effort of the reason or imagination could it be made to look otherwise. In this experiment no undoubted pure grey was present in the field of view for comparison, and in point of fact the small slip did actually approach a pure grey in hue more nearly than the large sheet ; hence the eye instantly accepted it for pure grey. The matter did not, however, stop here. A slip of pure grey paper was now brought into the same green field, but, instead of serving as a standard to correct the illusion, it assumed at once the appearance of a *reddish*-grey. The pure grey really did approach reddish-grey more than the

green field surrounding it, and hence was accepted for this tint. The same pale blue-green slip, when placed on a pale-reddish ground, assumed a stronger blue-green hue than when on a white ground. In the first of these experiments we have an illustration of harmful and in the second of helpful simultaneous contrast. The result in both cases coincided with that which successive contrast would have produced under similar circumstances.

It has been stated above that the effects produced by simultaneous contrast are due not to retinal fatigue, but to deception of the judgment ; now, as the effects of simultaneous contrast are identical in kind with those generated by

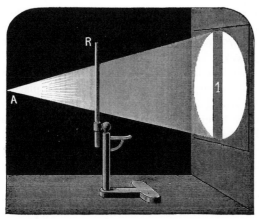

Fig. 121.—Shadow of Rod in Darkened Room.

successive contrast, it is evident that the statement needs some proof. This can be furnished with the aid of a beautiful experiment with coloured shadows. In making this experiment we allow white daylight to enter a darkened room through an aperture, A, arranged in a window, as indicated in Fig. 121. At R we set up a rod, and allow its shadow to fall on a sheet of white cardboard, or on the

white wall of the room. It is evident now that the whole of the cardboard will be illuminated with white light, except those portions occupied by the shadow 1. We then light the candle at C, Fig. 122 ; its light will also fall on

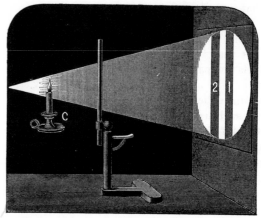

Fig. 122.—Shadows of Rod, using Daylight and Candle-light.

the cardboard screen, and will then cast the shadow 2 ; that is, the candle-light will illuminate all parts of the screen except those occupied by the shadow 2 ; this portion will be illuminated with pure white light. Instead, however, of appearing to the eye white, the shadow 2 will seem to be coloured decidedly *blue*. For the production of the most powerful effect, it is desirable that the shadows should have the same depth, which can be effected by regulating the size of the aperture admitting daylight. Now, although the shadow cast by the candle is actually pure white, yet, by contrast with the surrounding orange-yellow ground, it is made to appear decidedly blue. So strong is the illusion that, even after the causes which gave rise to it have disappeared, it still persists, as can be shown by the following experiment of Helmholtz : While the coloured shadows are

falling on the screen, they are to be viewed through a blackened tube of cardboard, held in such a way that the observer has both the shadows in his field of view; the appearance then will be like that represented in Fig. 123.

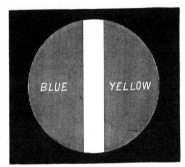

FIG. 123.—Blue and Yellow Shadows viewed through a Tube.

After the blue shadow has developed itself in full intensity, the tube is to be moved to the left, so that the blue shadow may fill the whole field. The tube being held steadily in the new position, the shadow will still continue to appear blue instead of white, even although the exciting cause, viz., the orange-yellow candle-light, is no longer acting on the eye. The candle may be blown out, but the surface will still appear blue as long as the eye is at the tube. On removing the tube, the illusion instantly vanishes, and it is perceived that the colour of the surface is identical with that of the rest of the screen, which is at once recognized as white. In a case like this the fatigue of the retinal elements can play no part, as the illusion persists during a far longer period of time than is necessary for their complete rest; we must hence attribute the result to a deception of the judgment. Expressing this in the language of Young's theory, we say that the sensation of white is produced when the three sets of nerves, red, green, and violet, are

stimulated to about the same extent; but that nevertheless, as we have in ourselves no means of judging with certainty about this equality of stimulation, we may under certain circumstances be induced to accept an unequal for an equal stimulation, or the reverse. In the experiment with the coloured shadows we had before us in the shadow due to the candle-flame an equal stimulation, which by contrast we were in the first instance induced to accept as unequal, and the judgment afterward obstinately persisted in the error till it was corrected and took a new departure.

This experiment may be modified and extended by the use of coloured glasses instead of a candle-flame. The window is to be provided with two apertures, one of which is to be covered with a piece of stained glass, through which sunshine will be admitted to the darkened room; the other aperture will admit white light, as before. If red glass be employed, the colour of the shadows will appear red and greenish-blue. In each case the shadows will assume complementary colours.

The effects of simultaneous contrast can also be studied with the aid of a contrivance of Ragona Scina. Two sheets of white cardboard are attached to a couple of boards fastened together at a right angle, as indicated in Fig. 124. Between the boards a plate of rather deeply coloured glass, G, is to be held in the manner shown in the figure, so that it makes, with the vertical and horizontal cardboards, an angle of about 45°. If the eye is placed at E, two masses of light will be sent to it. From the vertical cardboard white light will start, and, after being reflected on the glass plate G, will reach the eye. This light will be white, or almost entirely white, even after suffering reflection, owing to the circumstance that, with a deeply coloured plate of glass, the reflection takes place almost entirely from the upper surface, or from that turned toward the light. The second mass of light will proceed from the horizontal plate H: originally of course it was white light, but on its way

to the eye it traverses the glass plate, and becomes coloured by absorption. If the glass plate is red, this light when it reaches the eye will of course have the same colour; consequently the first result is that we have presented to the eye

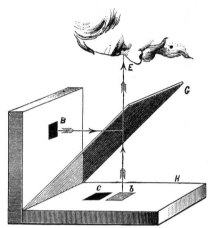

FIG. 124.—Apparatus of Ragona Scina for Contrast.

a mixture of red with white light, which will give the observer the idea that he is looking at an horizontal, square field of a somewhat pale reddish tint. If now a small black square be attached to the vertical cardboard at B, of course no white light can come to the eye from this portion of the cardboard, and the image of this spot will seem to the eye to be at *b*, on the horizontal board under the eye. Under ordinary circumstances this image would appear black; in point of fact, however, in this case it appears deep red, owing to the red light transmitted by the plate of glass. Thus far the arrangement amounts to a device for presenting to the eye a mixture of red with white light, the white light being absent at a certain spot, which consequently appears of a deeper red. A similar black square is now to be placed on the horizontal board at *c*; it will of

course prevent the light from the place it covers from reaching either the red glass or the eye, and under ordinary circumstances would be perceived simply as a square black spot. Owing, however, to the fact that the upper surface of the glass plate is reflecting white light to the eye, it really appears as a grey spot. The final result is, that we present to the eye at E a picture like that indicated by Fig. 125; that is, on a pale-red ground we have a spot which is pure grey, and near it one which is deep red.

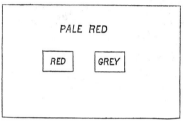

FIG. 125.—Colours that are really presented to the eye in the experiment of Ragona Scina.

Owing to contrast, however, the appearance is different: instead of a grey spot, we see one strongly coloured green-blue (Fig. 126). This effect is partly due to contrast with

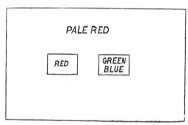

FIG. 126.—Colours that are apparently presented to the eye.

the pale red of the ground, but still more to the presence of the deep-red spot. This latter we can remove by taking away the black square B, which diminishes the effect con-

siderably. But now comes the most curious part of this experiment : If we select a square of grey paper which has the same color with the grey square seen in the apparatus arranged as in Fig. 124 (apart from effects of contrast), and place it over the glass plate and near the other two images, it will not be affected in colour, or only to a slight extent. In point of fact, we now have, side by side, on the same field, two grey squares quite identical in actual colour, but one appears by contrast blue-green, while the other is not affected, but is perceived by the eye as being simply a square of grey paper. As soon, however, as the observer recognizes the fact that these two squares really have the same grey colour, the illusion instantly vanishes, and both of them remain persistently grey. It is evident that in this case, as with the coloured shadows, the judgment is at fault rather than the retinal nerves ; for, as soon as an opportunity offers, it corrects itself and takes a new departure. The illusion in this case, as well as with the coloured shadows, is produced quite independently of the knowledge of the observer, who may indeed be a trained physicist, minutely acquainted with the exact facts of the case, and with all the details employed in producing the deception, and still find himself quite unable to escape from its enthrallment.

The simple experiments of H. Mayer are less troublesome than those just described, and at the same time highly instructive. A small strip of grey paper is placed on a sheet of green paper, as indicated in Fig. 127 ; it will be found that the tint of the grey paper scarcely changes, unless the experimenter sits and stares at the combination for some time. A sheet of thin semi-transparent white paper is now to be placed over the whole, when it will instantly be perceived that the colour of the small slip has been converted by contrast into a pale red. Persons seeing this illusion for the first time are always much astonished. Here we have an experiment showing that the contrast

produced by strong, saturated tints is much feebler than with tints which are pale or mixed with much white light ; for, by placing tissue paper over the green sheet, the colour of the latter is extraordinarily weakened and mixed with a

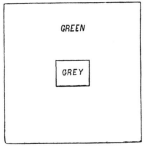

FIG. 127.—Green and Grey Papers, for Experiment on Contrast ; one-fourth size.

large quantity of white light. In this experiment it often happens that the red, which is due to contrast alone, seems actually stronger than the green ground itself. If, instead of using a slip of grey paper, we employ one of black, the contrast is less marked, and still less with one of white. It is scarcely necessary to add that, if red paper is employed, the small grey slip becomes tinted by contrast with the complementary colour, i. e., greenish-blue ; the same is true with the other colours.

By preparing with Indian ink a series of slips of grey paper, ranging from pure white to black, an interesting series of observations can be made on the conditions most favourable for the production of strong contrast-colours. The strongest contrast will be produced in the case of red, orange, and yellow, when the grey slip is a little darker than the colour on which it is placed, the reverse being true of green, blue, violet, and purple ; in every case the contrast is weaker if the grey slip is much lighter or much darker than the ground. We must expect then, in painting, to find that neutral grey will be more altered by pale

tints of red, orange, or yellow, which are slightly lighter than itself, and that the grey will be less altered by these colours when differing considerably from it in luminosity. An analogous conclusion with regard to green, blue, violet, and purple can also be drawn; these colours should be darker than the grey slip. Saturated or intense colours in a painting have less effect on white or grey than colours that are pale. This was shown in the preliminary experiment, where grey was placed on a ground of strong colour. In repeating these experiments, it will be noticed that the effect of contrast is stronger with green, blue, and violet than with red, orange, or yellow; that is to say, it is stronger with the cold than with the warm colours. If now we reverse our mode of proceeding, and place a small coloured slip on a grey ground, and cover the whole with tissue paper, it will be difficult even with a green slip to observe any effect of contrast. With a green slip, one sometimes imagines that the white sheet looks slightly pinkish or purplish for an instant, but the effect is quite uncertain. This is another illustration of the fact that, for the production of strong effects of contrast, it is necessary that the active colour should have a surface considerably larger than the one to be acted on; the former ought also, if possible, to surround the latter. There is, however, a limit beyond which this can not be carried. If the smaller field is reduced too much in size, it is liable to melt to a certain extent into the larger field of colour, in which case we obtain, not the effect due to contrast, but that produced by a mixture in the eye of the two colours; this is indeed one method employed by artists for the mixing of their colours.

Leaving now the contrast between pale colours and pure grey, we pause to consider for a moment the contrast of pale colours with each other. The laws governing this species of contrast have already been explained in detail in an earlier portion of the present chapter, and a construction

has been given by which the reader can study the differences produced in hue and saturation. To this it may now be added that, where pale tints are used in juxtaposition, the phenomena are those of simultaneous contrast, the retinal elements experiencing scarcely any fatigue; hence the effects are due to deceptions of the judgment, and occur instantly. They are more marked than with intense or saturated colours, and the effects produced even much more surprising. These effects are heightened if the contrasted colours have about the same degree of luminosity, or differ in the same manner as in the spectrum; that is, if the warm colours are selected so as to be rather more luminous than those that are cold. In Chapter III. the reader will find a table showing the relative luminosity of the different colours of the spectrum, and, what is still more to our purpose, another giving the relative luminosity of the different components of white light.

We must next examine the effects that are produced by contrasting colours that differ in luminosity or in saturation. If the two colours are identical except in the matter of saturation, it will be found that the one which is more saturated will gain in intensity, while its pale rival will appear still paler. A slip of paper painted with a somewhat pale red, when placed on a vermilion ground, appears still paler, and may actually be made to look white. If a *still paler* slip be used, it may even become tinged greenish-blue, its colour being in this case actually reversed by the effect of contrast. With the aid of the two movable chromatic circles shown in Fig. 119, it is easy to trace these changes theoretically. As a pale colour, or one mixed with much white, already lies near the centre of the upper circle,* a small displacement carries it to the centre, that is, makes it appear white; or it may even transport it beyond, and cause it to assume the complementary colour. When

* See Chapter XIV.

the colours differ in luminosity, analogous effects are observed. A dull-red slip was placed on a vermilion ground; the effect was as though a quantity of grey had been added to the slip; it looked more dingy and somewhat blackish. Another slip still darker and containing less red, when placed on the same ground, looked as if it were tinged with olive-green; a still darker slip, with still less red colour, treated in the same way, looked black with a tinge of blue; when, however, this last slip was placed on a white ground, or compared with true black, it was seen that its colour was far from black. The general result of contrasting colours which differ much in strength, then, is that the feebler one appears either more whitish or greyish, or assumes the complementary tint; the stronger one, on the other hand, appears still more intense. If the strong and weak colours are complementary to each other, then each of them gains in intensity and appears purer, this gain seeming to be greater in the case of the pale tint. From this it follows that, while the juxtaposition of strong with feeble colours usually injures or greatly alters the latter, colours that are complementary furnish an exception, the reason of which is evident at the first glance.

When the pale or dark colours are not complementary to their more intense or brilliant rivals, they undergo the same changes indicated in the table on page 245, the changes in the case of the dull or pale colours being considerably greater. In proportion as the colours are distant from each other in the chromatic circle do they gain in saturation and beauty; while as they approach their character is altered, and they are apt to look very pale, or, in the case of the dark colours, blackish or dirty. This is particularly so when the brilliant colour is large in surface and surrounds the darker one; with reversed conditions the effect is not so much felt. Thus, a somewhat dull red near vermilion no longer looks red, but brown; a dull orange tint on the same ground looks like a yellowish-brown.

It might be supposed from what has preceded that colours would enrich each other only when separated by a large interval in the chromatic circle; and from a purely physiological point of view this is indeed true. Still, there are other influences of a more spiritual character at work, which modify and sometimes even reverse this lower law. Thus, the presence of paler colour in a painting near that which is richer often passes unperceived, simply making the impression of a higher degree of illumination. We recognize the representation of a flood of light, and delight in it, without finding fault with the pale tints, if only they are laid with decision and knowledge. Again, pale colour we delight in as representing the distance of a landscape; the pale greenish-greys, bluish-greys, and faint tints of purple which make it up, we never think of putting into envious competition with the rich intense colours of the foreground, but enjoy each separately, and rejoice in the effect of atmosphere and distance, which neither kind of colour alone by itself could adequately render. That is to say, for the sake of light and atmosphere or distance, we gladly sacrifice a large portion of the powerful tints at our disposal, and consider ourselves gainers. The same is also true in another direction: we are ready to make the same sacrifice for the sake of avoiding monotony and gaining variety, provided only we can justify the act by a good reason. Cases of this kind often occur in large masses of foliage, which, if of the same general colour, are apt in a painting to look monotonous and dull, unless great labour is bestowed in rendering the light and shade and the small differences of tint which actually exist in nature. Under such circumstances the observer feels a certain relief at the presence of a few groups of foliage which are decidedly paler in colour than the surrounding masses, provided only there is a good excuse for their introduction. Willow-trees agitated by wind, and showing the under sides of their leaves, which are of a pale-greenish hue, offer a familiar example.

Again, the mere contrast of dark or dull tints enhances the colour and luminosity of those that are bright, and the observer receives the impression that he is gazing at a mass of gay and beautiful colouring, scarcely noticing the presence of the much larger quantity of tints that are darkened by being in deep shade. These darkened shade-tints are usually not variations of the same hue as the brighter tints, but are more bluish ; so that, technically, the combinations would often present instances of harmful contrast, were it not for the fact that the bright and dull tints do not belong even to the same chromatic circle, but to circles situated in different planes, as explained in the previous chapter. Putting this into more ordinary language, we should say simply that the strong contrast of light and shade masked such effects of harmful colour-contrast as were present. There is, however, another case where we are not so indifferent or lenient. Where two objects are placed near each other in a painting, and there is good reason why both should display the same colour with equal intensity, if one is painted with rich colour, the other with a pale or dark shade of the same colour, then the latter will look either washed out or dirty, and a bad effect will be produced. As a familiar illustration of this kind of effect, we may allude to the use in dress of two widely differing shades of ribbon, which have still the same general colour.

There is a still more general reason upon which the pleasure that we experience from contrast depends. After gazing at large surfaces filled with many varieties of warm colour, skillfully blended, we feel a peculiar delight in meeting a few mildly contrasting tints ; they prevent us from being cloyed with all the wealth of rich colouring so lavishly displayed, and their faint contradiction makes us doubly enjoy the richer portions of the painting. So also when the picture is mainly made up of cool, bluish tints : it is then extraordinarily strengthened and brightened by a few touches of warm colour. Precisely the same idea

holds good in drawings destitute of colour, and made up merely of lines : if the drawing is composed mainly of soft flowing curves, a few slanting straight lines across them seem delicious ; or, to take a parallel case from another department of art, in a discourse which is mainly grave in tone the introduction of a few slight touches of humour brightens and warms the audience most pleasantly. If there is about an equal quantity of gay and sombre tints, the effect is less good, becoming particularly bad when the composition is divided up into many alternate groups of gay and pale or sombre colours, impartially distributed.

Before concluding this chapter, it is necessary to add a few words with regard to the simple contrast of light and shade, that is, where all the elements are comprised by white, black, and intermediate shades of grey. As might be expected from what has preceded, when a light grey is

FIG. 128.—Black and White Disk for Experiment on Contrast.

FIG. 129.—Showing the result when disk, Fig. 128, is set into rapid rotation.

placed near a darker grey, the light shade appears still lighter, the dark shade still darker. This can be beautifully shown with the aid of our very convenient revolving disks. We take a black and white disk painted as represented in Fig. 128. When this disk is set in rotation, it will, on account of the mixture of the black and white, produce a series of grey rings, growing darker as we proceed from

the circumference toward the centre. Each ring, from the circumstances of the case, will as a matter of fact have an absolutely uniform shade of grey, but nevertheless it will not appear so to the observer. The rings will appear to him not uniform, but shaded, the lightest shade being always turned inward toward the centre, as roughly represented in Fig. 129. Where a ring comes in contact with one that is lighter than itself, it is made to look darker ; with one darker than itself, to look lighter. The same effect can be observed by painting a series of pieces of paper with different flat tints of grey, and then arranging them to correspond with the disk experiment ; they will present an appearance like that indicated by Fig. 130. It is hardly

Fig. 130.—Slips of grey paper made to appear shaded by contrast.

necessary to add that in light-and-shade drawings, as well as in nature, appearances of this kind, more or less modified, are of constant occurrence. One of the most common cases is where range after range of mountains rise behind one another, the lower portions of the distant ranges appearing lighter than the upper outlines. During rain, ranges of hills often exhibit this phenomenon with astonishing distinctness. Even when the light and dark tints are at quite a distance from each other, the phenomena of contrast present themselves if there is much difference in the depth of

the two sets of shades. It is a very common experience that the sky of a landscape in a drawing turns out too pale after the rest of the drawing is completed. Contrasted with the white paper of the unfinished sketch, it may look quite right ; but, after the deeper tones of the distance and foreground are added, may become quite insignificant. Again, a few decidedly black touches in a drawing will often by contrast lighten up portions that had previously seemed considerably too dark ; or a few touches of pure white will apparently darken spaces that had seemed pale and weak. In each case the observer is furnished by external means with a standard for measuring the depth of the shade, and induced to use it rather than his memory. By the skillful employment of contrast, drawings in light and shade can be made to appear luminous and brilliant, or rich and deep ; neglect of this element produces tameness and feebleness. The contrast of light with dark shades is not inferior in power to that of warm with cool tints ; and, in point of fact, the contrast of white with black is the strongest case of contrast possible. We have on the one hand the presence of all the colours, on the other their total absence. Hence, as has been noticed before, the contrast that takes place between light and shade will sometimes mask or even reverse that which occurs with different colours. We can perhaps better tolerate a shortcoming in the matter of colour-contrast than in that of light and shade ; if the latter is right and powerful, we forgive a limited amount of inferiority in the former, merely remarking that the work is rather slight or pale in colour, but not on that account pronouncing a verdict of total condemnation. On the other hand, if the colour as such is right, but the depth of the different tints mostly defective, then the whole is spoiled, and we contemplate the tints, lovely enough in isolation, with no satisfaction. We forgive, then, a partial denial of the truths of colour more easily than those of light and shade, which probably is a result of the nature of the opti-

cal education of the race. For the human race, thus far, light and shade has been the all-important element in the recognition of external objects; colour has played only a subordinate part, and has been rather a source of pleasure than of positive utility.

All that has been said with regard to the contrasts of white, black, and grey, with slight modification, applies to any single colour taken by itself; for instance, to drawings executed in one colour only, such as blue or brown. From this it results that every colour is capable of exhibiting two kinds of contrast, viz., that involved by competition with other colours and that of mere light and shade.

The contrast of white, black, and grey with the series of positive colours remains to be noticed. Taking up these in order, we find that red when placed on a white ground appears darker and rather more intense in hue; on a black ground it becomes tinted somewhat orange-red, and looks of course more luminous. Both these effects are probably due ultimately to mere contrast of light and shade; the white ground makes the red by contrast look darker. But we are accustomed to see red when it is darkened recede from orange and approach pure red, or even perhaps to become somewhat purplish; hence it appears so in this case; it is an instance of expectant attention. When red is placed on a black ground, it is made by contrast to look more luminous; but we are accustomed to see luminous red become tinted with an orange hue; hence the result. Red on grey grounds of various depths undergoes modifications corresponding to those just mentioned. Pale red, i. e., red mixed with much white, on a white ground, gains in intensity of colour; on a black or dark-grey ground it loses intensity, and approximates to pure white in appearance. Here the contrast of light and shade is so strong as to cause the colour to pass almost unperceived; or we may say pale red really does approach much nearer to pure white than black, and hence is at last accepted for it. Dark, dull red

on a white ground may be mistaken for brown; on a black ground it appears more luminous and more red. Orange on a white ground looks darker and more reddish, on a black ground more luminous and yellow. The other effects correspond with those described in the case of red. Yellow on a white ground appears darker and more greenish than on a black ground; in the latter case it is particularly brilliant, and the black also looks well, taking on a bluish tint. Dark yellow on a white ground looks brown or greenish-brown; on a black ground its colour is displayed to more advantage. Pale yellow on a white ground is apt to look greenish, on a black ground to appear whitish. Yellow and grey or black constitute a pleasant combination, of which extensive use has been made in nature and art. Green on a white ground looks deeper and richer, on a black ground somewhat paler; by contrast the black is made to look somewhat reddish or rusty. Green causes grey to appear reddish; the effect is particularly marked when the grey has about the same luminosity with the green, also when both are in the shade. Cyan-blue on white appears darker and perhaps more greenish than on black. Blue on white appears dark and rich, but shows no tendency to green; on black, by contrast, it becomes more luminous. The same is true with blue on grey; the latter acquires a somewhat yellowish or rusty hue. The action with violet is similar to that of blue.

From the foregoing it is evident that the contrast of black, white, and grey with the colours depends mainly on an apparent increase or diminution of their luminosity, whereby in most cases their apparent hue is affected owing to association. In the case of the colder colours, the tint of the grey or black ground is affected, and shows a tendency toward a hue complementary to the colour employed. We associate grey with blueness, and where the effect is such as contradicts this habitual association it is disagreeable; on the other hand, grey with yellow forms

an agreeable contrast, as the yellow tends to make the grey look more bluish, and thus corrects any yellowish or rusty appearance connected with it. It is claimed in some works on colour that the complementary tints furnished by the pure grey react on and strengthen the colours which call them forth. An eye which is tired by gazing at green is indeed rested by looking at its complement, i. e., at a mixture of red and violet, and afterward will see the green with more vividness; but it is difficult to understand how the presentation of red, violet, and green, or, what is the same thing, grey light, can materially refresh the eye, or restore its temporarily exhausted power. In the case of pale tints, an effect of this character does indeed seem to take place, but we must attribute it rather to an act of judgment than to a physiological cause.

CHAPTER XVI.

ON THE SMALL INTERVAL AND ON GRADATION.

IN the preceding chapter we have seen that, when two colours which are nearly identical are contrasted, each is made to appear less intense or saturated : red with orange-red, yellow with orange-yellow, cyan-blue with blue, are examples of such combinations. From this it might be supposed that, in chromatic compositions, it would not be allowable to place colours thus nearly related in close juxtaposition. It is, however, found in practice that colours which are distant from each other in the chromatic circle by a *small interval* can be associated without detriment under certain conditions. If the two colours express a variation in the luminosity of one and the same coloured surface, they do not come into hurtful competition, and we receive the impression of a single coloured surface, more highly illuminated in certain portions. The scarlet coat of a soldier when shaded appears red ; the sunlit portion is orange-red. Grass in the sunshine acquires a yellowish-green hue ; in the shade its colour is more bluish. But neither of these cases produces on us a disagreeable effect, for we regard them as the natural consequences of the kind of illumination to which these objects are exposed. The effect is not disagreeable even in mere ornamental painting, if it is seen that the two tints are intended to express different degrees of luminosity of the same constituent of the design, even though this be only arabesque tracery. From this explanation it follows that the two contiguous tints should

have their luminosities arranged so as to correspond to nature; otherwise a contradictory effect would be produced. The following table gives a series of small intervals, arranged properly as to luminosity; and it will be seen to correspond to the relative luminosities of the colours of the spectrum, or of the colours which taken together make up white light (see Chapter III.) :

TABLE OF SMALL INTERVALS.

Darker.	Lighter.
Red	Orange-red.
Orange-red	Orange.
Orange	Orange-yellow.
Orange-yellow	Yellow.
Yellowish-green	Greenish-yellow.
Green	Yellowish-green.
Cyan-blue	Green.
Blue	Cyan-blue.
Ultramarine-blue	Blue.
Violet	Purple.
Purple	Red.

It will be noticed that the colours under the heading "Darker" are really the shade-tints of the series opposite them, and the difference may often be greater than that indicated in the table. One of the commonest of these intervals is that of yellow deepening into orange-yellow. In sunsets yellow scarcely occurs without undergoing a change of this kind; it is almost the rule with yellow flowers; and even the pale, broken, subdued yellowish-browns of many natural objects manifest the same tendency. The relations of greenish-yellow, etc., to green are shown beautifully by foliage under sunlight, while the interval of cyan-blue to blue or to ultramarine-blue is displayed on the grandest scale by the sky. In brilliant sunsets the first and last pair of intervals are of constant occurrence; in fact, we can scarcely think of a sunset without calling up in imagination

red and purple. The interval greenish-yellow and yellow is not included in the list; it is perhaps less easy to tolerate than any of the others; we like to see yellow luminous or rich, that is, passing into orange; but, when it begins to become decidedly greenish, we hesitate, unless there is some good reason for accepting it. When the small interval is used, and the two tints are put more or less into competition by belonging to different surfaces, the effect is less good, unless it is accounted for by the nature of the illumination, or in some other equally satisfactory way.

Much of the above applies to the case where the colours pass into each other by gentle and insensible gradations, so that the observer is quite at a loss to say where one ends and the other begins. Here, as before, colours which are nearly related, or separated only by a small interval, blend harmoniously into each other and produce a good effect. The reason of this is again found mainly in our preconceived ideas of the changes which coloured surfaces undergo when more or less strongly illuminated. If the colours are quite distant from each other in the chromatic circle, a rapid transition from one to the other, by blending, produces always a strange and often a disagreeable effect. A yellow surface distinctly opposed or contrasted to a blue surface often gives a good effect; but, if it passes by a series of quick gradations into blue, the effect is bad; it is as though it tried to assert at the same time that it was warm and luminous as well as cold and dark. In the case of the sky, it is true that we have, toward sunset, the yellow portions blending below into orange and red, and above, by a long and slow series of gradations, into blue; but the distance between the blue and yellow is large, and they are separated by a series of neutral tints, and we think of the whole as an effect produced by apparent nearness or distance from the sun. Even in a case like this, many artists prefer not to include in their paintings too much of the upper blue, and thus are able to give more decided expres-

sion to the warmth and brightness of the sky. When we
see in nature a field of grass gradually growing decidedly
red, we think of clover as the excuse, without, nevertheless,
being particularly edified by its presence. In some moun-
tain lakes, such as the Königssee, we find the blue-green
water actually passing in some places by rather quick gra-
dations into a purplish-red. The rapid transition into this
almost complementary hue produces an effect which seems
strange and almost incredible to those who for the first time
behold it. When the cause is recognized, we learn to look
upon the purple patches as marking the shallower water,
and, having accepted the effect as reasonable, we soon find
ourselves enchanted by it, and always remember it for its
strange beauty.

When two colours differing considerably, not only in
hue but in saturation, or simply in the latter respect, blend
rapidly into each other on the same surface, we always
require a reason for the change of tint ; and, if none is fur-
nished, the effect is apt to appear absurd, and resemble
somewhat the case of a man who at one moment is calm
and cool, and the next, without obvious reason, tender and
pathetic. When we find the cool grey or greyish-brown
tones on the surface of a cliff suddenly becoming rose-
tinted, we require an explanation of the change, and are
quite satisfied if told that the top of the cliff is still illumi-
nated by the sinking sun ; if, however, it is midday, we are
forced to think of red veins of some foreign substance dis-
seminated through the sober rock, and wonder what it can
possibly be, and wish it were away. All this forms one of
the minor reasons why painters like to keep their tints to-
gether in large masses, the bright warm colours in one
place, the cool pale tints in another.

One of the most important characteristics of colour in
nature is the endless, almost infinite gradations which al-
ways accompany it. It is impossible to escape from the
delicate changes which the colour of all natural objects un-

dergoes, owing to the way the light strikes them, without
taking all the precautions necessary for an experiment in a
physical laboratory. Even if the surface employed be
white and flat, still some portions of it are sure to be more
highly illuminated than others, and hence to appear a little
more yellowish or less greyish ; and, besides this source of
change, it is receiving coloured light from all coloured ob-
jects near it, and reflecting it variously from its different
portions. If a painter represents a sheet of paper in a pic-
ture by a uniform white or grey patch, it will seem quite
wrong, and can not be made to look right till it is covered
by delicate gradations of light and shade and colour. We
are in the habit of thinking of a sheet of paper as being
quite uniform in tint, and yet instantly reject as insufficient
such a representation of it. In this matter our unconscious
education is enormously in advance of our conscious ; our
memory of sensations is immense, our recollections of the
causes that produce them utterly insignificant ; and we do
not remember the causes mainly because we never knew
them. It is one of the tasks of the artist to ascertain the
causes that give rise to the highly complex sensations which
he experiences, even in so simple a case as that just consid-
ered. From this it follows that his knowledge of the ele-
ments that go to make up chromatic sensations is very vast
compared with that of ordinary persons ; on the other
hand, his recollection of mere chromatic sensations may or
may not be more extensive than theirs. Hence it follows
that it requires long training to acquire the power of con-
sciously tracing fainter gradations of colour, though much
of the pleasure experienced by their passive reception can
be enjoyed without previous labour.

These ever-present gentle changes of colour in all natu-
ral objects give to the mind a sense of the richness and
vastness of the resources of Nature ; there is always some-
thing more to see, some new evanescent series of delicate
tints to trace ; and, even where there is no conscious study

of colour, it still produces its effect on the mind of the be-holder, giving him a sense of the fullness of Nature, and a dim perception of the infinite series of gentle changes by which she constantly varies the aspects of the commonest objects. This orderly succession of tints, gently blending into one another, is one of the greatest sources of beauty that we are acquainted with, and the best artists constantly strive to introduce more and more of this element into their works, relying for their triumphs far more on gradation than on contrast. The greatest effects in oratory are also produced by corresponding means; it is the modulation of the tone and thought, far more than sharp contrasts, that is effective in deeply moving audiences. We are very sensi-tive to the matter of modulation even in ordinary speech, and instantly form a general judgment with regard to the degree of cultivation and refinement of a stranger from the mode in which a few words are pronounced. All this has its parallel in the use of colour, not only in painting, but also in decoration. Ruskin, speaking of gradation of col-our, says: " You will find in practice that brilliancy of hue and vigor of light, and even the aspect of transparency in shade, are essentially dependent on this character alone; hardness, coldness, and opacity resulting far more from *equality* of colour than from nature of colour." In another place the same author, in giving advice to a beginner, says: " And it does not matter how small the touch of colour may be, though not larger than the smallest pin's head, if one part of it is not darker than the rest, it is a bad touch; for it is not merely because the natural fact is so that your col-our should be gradated; the preciousness and pleasantness of colour depends more on this than on any other of its qualities, for gradation is to colours just what curvature is to lines, both being felt to be beautiful by the pure instinct of every human mind, and both, considered as types, ex-pressing the law of gradual change and progress in the human soul itself. What the difference is in mere beauty

between a gradated and ungradated colour may be seen easily by laying an even tint of rose-colour on paper and putting a rose-leaf beside it. The victorious beauty of the rose as compared with other flowers depends wholly on the delicacy and quantity of its colour-gradations, all other flowers being either less rich in gradation, not having so many folds of leaf, or less tender, being patched and veined instead of flushed." *

All the great colourists have been deeply permeated by a sentiment of this kind, and their works, when viewed from the intended distance, are tremulous with changing tints—with tints that literally seem to change under the eye, so that it is often impossible for the copyist to say exactly what they are, his mixtures never seeming to be quite right, alter them as he will. Among modern land-scape paintings, those of Turner are famous for their end-less quantity of gradation, and the same is true even of his water-colour drawings. The perfect blending of colours, for example, in the sky, or in our best representations of it, produces an effect of wonderful softness and beauty, the tints melting into each other with a liquid smoothness for which we can find no other parallel. The absolutely per-fect gradation and softness of the sky well expresses its qualities as a gas, impalpable, evanescent, boundless.

There is, however, another lower degree of gradation which has a peculiar charm of its own, and is very precious in art and nature. The effect referred to takes place when different colours are placed side by side in lines or dots, and then viewed at such a distance that the blending is more or less accomplished by the eye of the beholder. Under these circumstances the tints mix on the retina, and produce new colours, which are identical with those that

* " Elements of Drawing," by J. Ruskin. The distinguished artist Samuel Colman once remarked to the writer, that this book not only con-tained more that was useful to the student of art than any previous work, but that it contained more than all of them put together.

are obtained by the method of revolving disks. (See Chapter X.) If the coloured lines or dots are quite distant from the eye, the mixture is of course perfect, and presents nothing remarkable in its appearance; but before this distance is reached there is a stage in which the colours are blended, though somewhat imperfectly, so that the surface seems to flicker or glimmer—an effect that no doubt arises from a faint perception from time to time of its constituents. This communicates a soft and peculiar brilliancy to the surface, and gives it a certain appearance of transparency; we seem to see into it and below it. Dove's theory of lustre has perhaps some bearing on this well-known phenomenon. According to Dove, when two masses of light simultaneously act on the eyes, lustre is perceived, provided we are in any way made conscious that there are actually *two* masses of light. On a polished varnished table we see the surface by means of its imperfections, scratches, dust, etc., and then besides have presented to us another mass of light which is regularly reflected from the surface; the table looks to us lustrous. The author, and afterward Dove in a different way, succeeded in producing this lustrous appearance when only a single eye was employed, that is, without the aid of binocular vision.* In the case before us, the images of the colour-dots are more or less superimposed on the retina, and consequently seen one through the other; and at the right distance there is some perception of a lack of uniformity, the degree of blending varying from time to time. According to Dove's theory, we have here the conditions necessary for the production of more or less soft brilliancy. With bright complementary colours the maximum degree of lustre is obtained; when the colours are near each other in the chromatic circle, or dull or pale, the effect is not marked, but exists to the extent of making the surface appear somewhat transparent. When the two colours are replaced simply by black and white,

* "American Journal of Science and Arts," May, 1861.

the same lustrous appearance is still produced. Sir David Brewster has described an experiment which has some bearing on these matters. If a wall-paper is selected with a pattern which repeats itself at intervals of a few inches, it is possible, after some practice, so to arrange the eyes as to cause the adjacent and corresponding portions to seem to coalesce and form a new picture, which will in most respects be identical with that obtained by ordinary vision. This new picture will not seem to be at the same distance from the eye as the real objects, and will move with each slight motion of the head; but what concerns us more is, that it has a certain appearance of transparency and beauty not found in the original. In this experiment two slightly dissimilar masses of light are presented to the two eyes, and the result is an appearance of transparency, using this word in its artistic sense.

But to return: the result of this imperfect blending of colours or of black and white by the eye is to communicate to the surface an appearance of clearness, and to remove any idea of hardness or chalkiness; it is so familiar to us that we accept it as quite natural, and only become conscious of its charm when it is withdrawn. As an example in nature, we have the somewhat distant sea under a bright-blue sky: the waves will be mainly green, the spaces between them blue; these colours then blend into a sparkling greenish-blue, which can not be imitated with a simple mixed pigment. Also in grasses viewed at some distance, the yellowish-green, bluish-green, reddish, purplish, and brown tints, and the glancing lights, blend more or less together, and produce an effect which can not be reproduced by a single sweep of the brush. The more distant foliage of trees on hillsides shows something of this kind; and it does not appear to be entirely absent even from the dust on a traveled road, the minute sparkling grains of sand still producing some action on the eye after they can no longer be distinguished individually.

In fresco-painting, and in scene-painting for the theatre, most extensive use is made of this principle: at the right distance adjacent tints blend, and what near at hand seemed a mass of purposeless daubs becomes an effective picture. This same method of mixing colours on the retina of the observer is also used more or less in oil painting with excellent effect; it lends to them a magical charm, the tints seeming purer and more varying; the very fact that the appearance of the painting changes somewhat according as the observer advances or retires from it being an advantage, communicating to it, as we might say, a certain kind of life. Oil paintings in which this principle is not employed labour under one quite demonstrable disadvantage: as the observer retires adjacent tints blend, whether it was the intention of the artist or not; and if this has not been calculated for, a new and inferior effect is pretty sure to be produced. In water-colour drawings the same mode of working is constantly employed under the form of stippling, more or less formal; and with its aid certain results of transparency and richness can be attained, which otherwise would be out of the reach of the artist. If the stippling is formal and quite evident, it is apt to give a mechanical look to a drawing, which is not particularly pleasant; but properly used, it has great value, and readily lends itself to the expression of form. To descend several steps lower, we find the designers of wall-papers and carpets employing this mode of mixing colours and producing their gradations. In cashmere shawls the same principle is developed and pushed to a great extent, and much of their beauty is dependent on it. Finally, in etchings, engravings, and pen-and-ink drawings, we have other examples of its application; their clearness, transparency, and sparkling effect being mainly due to the somewhat imperfect blending of the black and white lines. This effect can best be perceived by comparing them with lithographs, or, better still, with Indian ink or sepia drawings. The sky-like softness of the last two is very lovely, and, in

some respects, very true to nature; but if in them the line manner is entirely avoided, they are a little apt to show a lack of transparency in the deeper masses of shade, and to look heavy or dull. This result is avoided by purposely introducing a certain amount of line-drawing, either with the pen or a small brush. We have in nature a great variety of appearances, and the various methods of art are calculated to represent one or the other of them more or less perfectly; but there is no single kind of art manipulation which will deal equally well with all.

Finally, it is to be remarked that when colour is used simply for ornamental purposes, blending or gradation becomes of subordinate importance. This is the case, for exmaple, where the design is worked out solely in flat tints. Work of this kind, where the fancy is not allowed to interfere much with the general correctness of the drawing or colour, forms one of the first steps by which painting gradually passes over into pure ornamental design. We have here colours arranged in harmonious masses, bounded by sharp outlines, often definitely traced in black, and are pleased with them, and with the beautiful, correct outlines. All gradation and blending of colours is abolished, and this fact alone announces to us, in an emphatic way, that the design makes no pretension to realistic representation; we are pleased with the colours and outlines, and are rather surprised to find how much can be accomplished by them; and if gold is introduced in the background or draperies, its presence only adds to the general effect. By insensible changes the figures of men and animals, etc., become more conventional or grotesque, as in heraldry, until finally there is no attempt made to portray any particular natural object. *Suggestions* are taken from objects in nature, which are used in much the same way as by musical composers. The intention, however, is the production of a beautiful design which shall serve to ornament something else, as a woven stuff, a vase, or the wall of a building. As gradation is

one of our most efficient modes of giving work in colour a thoroughly realistic appearance, it evidently can not be much employed in ornament, where it is an object to avoid any imputation of intentional realism.

In closing this chapter it may be well to allude to a singular effect often produced by insensible gradation on natural objects, or on their representations in paintings. We have seen that a coloured surface having a well-defined shape, when placed on a grey ground, is capable through contrast of causing the ground to appear of the complementary colour. For example, a grey square or a green ground will appear as though tinted with rose-colour. If, however, the green passes into the grey by insensible gradations, the matter may be so arranged that a small amount of green causes the whole surface to appear green, when most of it really is grey. This effect is often seen on rocks partially covered with green moss: a few small patches on the side exposed to the light will have a bright-green hue; some of the surface in the shade will be tinted dark green, this colour passing gently into brown or grey, with here and there a few quite small touches of olive-green. Three fourths of the surface of the shaded side of the rock will then be really grey or brown, but nevertheless the whole will appear to be dark green. Another very common example is furnished by the foliage of trees standing so that the sun appears to be over them. Under these circumstances their tops and sides catch the sunbeams and appear of a bright yellowish-green; the rest of the tree is in the shade, and appears at first sight of a darker green, and is always so painted by beginners. If, however, the colour is examined through an aperture about the size of a pea, cut in a piece of white cardboard, it will be found that the real colour is a somewhat greenish grey. On retiring farther from the tree, this colour of its shady side will often change to a pure grey, yet to a casual observer it will still appear green. Quite wonderful effects have been obtained by

some artists from the recognition of the principle here involved; their calm resignation of every trace of local colouring, and acceptance in its place of some kind of grey, imparting to their pictures a high degree of aërial perspective and of apparent luminosity.

Spectral red with yellow gives an inferior combination.
Spectral red with red lead gives a bad combination.
Spectral red with violet gives a bad combination.

If gold be substituted for the yellow pigment, the combination becomes excellent. Red and yellow also make a better combination when the red inclines to purple and the yellow to greenish-yellow. The combination red and yellow is also improved by darkening the yellow or both colours ; this causes the yellow to appear like a soft olive-green (R.). The combination red and green is also improved by darkening both colours, or the green alone (R.).

Vermilion with blue gives an excellent combination.
Vermilion with cyan-blue gives an excellent combination.
Vermilion with green gives an inferior combination.
Vermilion with yellow gives an inferior combination.
Vermilion with violet gives a bad combination.

Vermilion and gold furnish an excellent combination. The combination vermilion and yellow is improved somewhat by darkening the yellow ; if it is considerably darkened, it tells as a soft olive-green (R.). Vermilion and green are better when the green or both colours are much darkened (R.).

Red lead with blue gives an excellent combination.
Red lead with cyan-blue gives an excellent combination.
Red lead with blue-green gives a strong but disagreeable combination.
Red lead with yellowish-green gives a tolerably good combination.
Red lead with yellow gives quite a good combination.
Red lead with orange gives quite a good combination.

The combination red lead and bluish-green is improved by darkening the green or both the colours (R.). Red lead gives a better combination with a yellow having a corresponding intensity or saturation ; if the yellow is too bright, the effect is inferior (R.). The combination red lead and yellow is much better than red and orange. The last two

13

CHAPTER XVII.

ON THE COMBINATION OF COLOURS IN PAIRS AND TRIADS.

IN the previous portions of this work we have dealt with facts that are capable of more or less rigorous demonstration ; but we now encounter a great series of problems that can not be solved by the methods of the laboratory, or by the aid of a strictly logical process. Why a certain combination of colours pleases us, or why we are left cold or even somewhat shocked by another arrangement, are questions for which we can not always frame answers that are satisfactory even to ourselves. There is no doubt that helpful and harmful contrast have a very great influence on our decision, as will hereafter be pointed out ; but besides this, we are sometimes influenced by obscure and even unknown considerations. Among these may perhaps be found inherited tendencies to like or dislike certain combinations or even colours ; influence of the general colour-atmosphere by which we are surrounded ; training ; and also a more or less delicate nervous susceptibility.

The author gives below, in the form of tables, some of the results furnished by experience, and takes pleasure in acknowledging his indebtedness to Brücke and to Chevreul for much of the information contained in them.

Spectral red * with blue gives its best combination.
Spectral red with green gives a strong but rather hard combination.

* A red between carmine and vermilion.

combinations given in the table are of course cases where the small interval is employed. (See Chapter XVI.)

Orange with cyan-blue gives a good and strong combination.
Orange with ultramarine gives a good and strong combination.
Orange with green gives a good combination.
Orange with violet gives a moderately good combination.

Orange-yellow with ultramarine gives its best combination.
Orange-yellow with cyan-blue gives not quite so good a combination.
Orange-yellow with violet gives a good combination.
Orange-yellow with purple gives a good combination.
Orange-yellow with purple-red gives an inferior combination.
Orange-yellow with spectral red gives an inferior combination.
Orange-yellow with sea-green gives a bad combination.

Yellow with violet gives its best combinations.
Yellow with purple-red gives good combinations.
Yellow with purple gives good combinations.
Yellow with spectral red gives inferior combinations.
Yellow with blue, inferior to orange-yellow and blue.
Yellow with blue-green gives one of the worst possible combinations.
Yellow with green gives bad combinations.

The combination yellow and spectral red is improved by darkening the yellow (R.). Blue-green and yellow, both much darkened, give a better combination (R.). According to Chevreul, yellow gives with green a good and lively combination ; to this the author can not agree, although it is true that the effect is improved by darkening the yellow considerably. Chrome-yellow and emerald-green give combinations that are not bad when both the colours are very much darkened (R.).

Greenish-yellow with violet gives its best combinations.
Greenish-yellow with purple gives good combinations.
Greenish-yellow with purplish-red gives good combinations.
Greenish-yellow with vermilion gives strong but hard combinations.
Greenish-yellow with spectral red gives strong but hard combinations
Greenish-yellow with red lead gives tolerably good combinations.

Greenish-yellow with orange-yellow gives bad combinations.
Greenish-yellow with cyan-blue gives bad combinations.
Greenish-yellow with ultramarine gives a somewhat better combination.

The combination greenish-yellow and orange-yellow is improved by darkening the latter colour, which then appears brownish (R.). Greenish-yellow and cyan-blue make a better combination when the blue is darkened (R.).

Grass-green with violet gives good but difficult combinations.
Grass-green with purple-violet gives good but difficult combinations.
Grass-green with rose gives combinations of doubtful value.
Grass-green with carmine gives combinations of doubtful value.
Grass-green with pink gives combinations of doubtful value.
Grass-green with blue gives combinations of doubtful value.

The value of the last four combinations is a disputed matter. The combination green and carmine is improved by darkening both colours considerably (R.). The combination green and blue becomes better as the green inclines to yellow and the blue to violet (R.). The combination green and violet, according to Chevreul, is better when the paler hues of these colours are employed.

Emerald-green with violet gives strong but hard combinations.
Emerald-green with purple gives strong but hard combinations.
Emerald-green with red gives strong but hard combinations.
Emerald-green with orange gives strong but hard combinations.
Emerald-green with yellow gives bad combinations.

All these combinations are very difficult to handle. Emerald-green and yellow, when both are much darkened, furnish somewhat better combinations (R.).

Sea-green with vermilion gives good combinations.
Sea-green with red lead gives good combinations.
Sea-green with violet gives good combinations.
Sea-green with purple-violet gives tolerably good combinations.
Sea-green with purple-red gives, simply as pairs, poor combinations.

Sea-green with carmine gives, simply as pairs, poor combinations.
Sea-green with blue gives bad combinations.
Sea-green with yellow gives bad combinations.

The surface of the green should be much larger than that of the vermilion or red lead.

Cyan-blue with chrome-yellow gives moderate combinations.
Cyan-blue with Naples-yellow gives good combinations.
Cyan-blue with straw-yellow gives good combinations.
Cyan-blue with carmine (light tones) gives good combinations.
Cyan-blue with violet gives poor combinations.
Cyan-blue with purple-violet gives poor combinations.
Cyan-blue with ultramarine gives good combinations (small interval).

The combinations of cyan-blue with violet and purple-violet are not good, except in fine materials and light tones.

Ultramarine with carmine gives poorer combinations than cyan-blue.
Ultramarine with purple-red gives poorer combinations than cyan-blue.
Ultramarine with violet gives, simply as pairs, poor combinations.

Violet with purple gives poor combinations if extended beyond the small interval.
Violet with carmine gives poor combinations.

In studying the effects produced by colours in combination, it is of course important to exclude as far as possible all extraneous causes that might influence or confuse the judgment. Hence the colours under examination should be disposed in very simple patterns, as the employment of beautiful form or good composition might easily become a means of leading the student to accept, as good, combinations that owed their beauty to something besides mere colour. For the same reason, gradation and good light-and-shade effect should in such examinations be avoided; for these, as well as good composition, are means of concealing to some extent the poverty of a colour-combination. For a similar reason the materials employed in such experi-

ments should not be too fine. Almost any colour-combination worked out in stained glass appears pretty good, owing to the brilliancy of the coloured light. This is one reason why the patterns in a kaleidoscope have been of so little value in decorative art; for, when the colours are most carefully imitated in coarser materials, they are apt not only to lose their brilliancy, but even sometimes to appear dull or dirty from the effects of harmful contrast, which did not make itself felt before. To a less degree this applies also to silk; many colour-combinations worked out in this material are tolerable on account of its high reflecting power, while the same colours, if transferred to wool or cotton, appear poor enough.

In forming a judgment as to the value of combinations of colour, we should also be cautious in basing our conclusions even on observations made directly from nature itself; for here our judgment is liable to be warped by the presence of beautiful form, good composition, exquisite gradation, and high luminosity. Green and blue, for example, make a poor combination, and yet it is one constantly occurring in nature, as in the case where the blue sky is seen through green foliage. This effect is often very good, but a careful examination will show that, in most cases, blue and green do not really come in contact; for if the sunlight penetrates the leaves in contact with the sky, they no longer look green, but greenish-yellow, and this colour makes a tolerable combination, particularly with ultramarine-blue. Generally, however, the leaves actually in contact with the sky are in the shade, or at least do not send bright light to the eye, and we have really greenish-grey or brownish-green combined with the blue of the sky. When green actually does fairly touch the blue of the sky, as with a forest of young trees growing thickly, the green is usually far darker than the blue sky, as may be seen by closing the eyes partially. Here the combination is helped somewhat by light-and-shade contrast; but when, owing to

any cause, the blue of the sky is darkened till it approximates in luminosity to the green of the foliage, then the colour-combination is felt by an artist to be bad. The forms of trees are so beautiful, the variety, the gradation they exhibit so endless, the associations called up by them so agreeable, that we are apt to deceive ourselves about this colour-combination ; but when an attempt is made to transfer it to canvas, we become painfully sensible of the fact that Nature sometimes delights in working out beautiful effects with colours that are of very doubtful value, cunningly hiding their poverty with devices that often are not easy to discover or to imitate.

There are several causes that may render a combination of two colours bad. Prominent among them we find the matter of contrast : the colours may look dull and poor on account of harmful contrast, or may on the other hand appear hard and harsh from an excess of helpful contrast. The author has placed in the form of a diagram the results of his observations on the effects of contrast in diminishing or increasing the saturation or brilliancy of colours. This diagram (Fig. 131) and its use are explained in Chapter XV., and at present we merely remind the reader that colours less than 80° or 90° apart suffer from harmful contrast, while those more distant help each other. In the case of colours that are about 80° apart, the matter remains a little doubtful ; the two colours may help each other somewhat, or the reverse may be true. On comparing this diagram with the results furnished by experience and given in the preceding tables, it will be found that in good combinations the two colours are always more than 90° apart, so that the effect of contrast is mutually helpful. Thus, red furnishes good combinations with blue and cyan-blue, which are considerably more than 90° distant from it ; while the combination with artificial ultramarine, which is nearer, is inferior, and that with violet bad. It does not follow, however, that the colours in the diagram which are

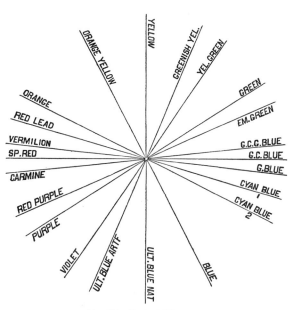

Fig. 131.—Contrast Diagram.

situated farthest apart always make the best combinations ; for, if this were the case, the best combinations would be simply the complementary pairs, which in the diagram are placed at the greatest distance from each other, viz., opposite. But some of the complementary colours are quite harsh from excessive contrast ; for example, red and its complement green-blue, also purple and its complement green. Of all the complementary pairs, according to Brücke, these are least employed in art, as the harshness with them is at a maximum. Now we can divide the colour-diagram, Fig. 131, into two halves by a line drawn from yellowish-green to violet, and the left-hand half will contain the warm colours, the right-hand the cold. After doing this, we find that red and green-blue, or purple and green, are not only complementary, but also situated at or

near the positions, if we may so express it, of the greatest warmth and coldness; hence, owing to a double reason, the contrast becomes excessive, and the combination harsh. According to the same authority, the complementary colours most in use are ultramarine and yellow, blue and orange-yellow, or cyan-blue and orange; then follow violet and greenish-yellow. In these cases, the complementary pairs are situated at some distance from the centres of warmth and coldness, being in fact either on or not far from the dividing line, which prevents excessive contrast and the consequent hardness complained of in the examples first cited. It may here be remarked that colours which are truly complementary often appear better than those which only approximate to this condition; vermilion and red lead, with their complements green-blue and greenish-blue, do not furnish such offensive combinations as are obtained when green is substituted for the true complementary hue.

The complementary colours are very valuable when the artist is obliged to work with dark, dull, or pale colours, and still is desirous of obtaining a strong or brilliant effect. The fact that the colours are dull or pale or greyish prevents much possibility of harshness; and the use of complementary hues excludes all risk of the brilliancy of the tints being damaged by harmful contrast. In general, the lower we go in the scale, and the more our colours approximate to black, brown, or grey, the more freely can we employ complementary hues without producing harshness; and even those objectionable pairs, red and green-blue, purple and green, if sufficiently darkened, become agreeable.

It has been stated above that in good combinations the colours are always a considerable distance apart in the chromatic circle. This, however, does not exclude the class of combinations mentioned in Chapter XVI., where it was shown that any two colours differing but slightly produce

a more or less pleasant effect; this is the case of the *small* interval, which at present we are not considering.

Now, although in good combinations the colours are rather far apart in the chromatic circle, it does not follow that all colours that are far apart make good combinations. When green, emerald-green, or bluish-green enters into a combination, it is apt to produce a harsh effect if the green is at all decided or covers much space. The enormous difficulty of managing full greens or bluish-greens is perfectly well understood by artists, and many of them avoid their use as far as possible. The presence in a picture of a very moderate amount of a colour approaching bluish-green or emerald-green excites in most persons a feeling of disgust, and causes a work otherwise good to appear cold and hard—very cold and hard. Corresponding to this, most artists seem to be of the opinion that the pigment known as emerald-green is more intense and saturated than any of the other colours used by them. From a purely optical point of view this would seem hardly to be the case: emerald-green reflects more white light mixed with its coloured rays than vermilion, and its luminosity is not out of proportion to those of vermilion or ultramarine-blue, if we adopt as our standard the luminosities of the corresponding colours in the spectrum. Hence we must seek elsewhere for the reason of its unusually intense action. The author is disposed to attribute this well-known intolerance of all full greens to the fact that green light exhausts the nervous power of the eye sooner than light of any other colour. This exhaustion is proved by the observation that the after-pictures, or accidental colours, are more vivid with green than with the other colours. (See Chapter VIII.) Now, as a general thing, very strong sensations are offensive when freely interspersed among those that are weaker; thus Helmholtz has shown that discord in music is due to the presence of "beats," which are merely rapid alternations of sound and silence following each other at such

intervals as to allow the sensitiveness of the ear to remain at a maximum, and hence producing disagreeably intense sensations which offend. Quite analogous to this is the action of a flickering light, which is both disagreeable and hurtful to the eye. This general principle, as it seems to the author, applies also to the matter now in hand : a green which optically may be the equivalent of a red, yellow, blue, or violet, nevertheless produces on the nerves of the eye a more powerful and exhausting sensation than these colours, and hence is out of harmony with them, or discordant. Besides this, and apart from these considerations, green is not a colour suggestive of light or warmth, but is what artists call cold ; the peculiar action above alluded to renders it intense as well as cold, and consequently painters are only able to employ it with a most cautious hand. Yellow conveys the idea of light, red that of warmth : if too much of either is present in a painting, the general effect is of course impaired ; but by a small over-dose of green, the picture is killed.

The colour which next to green acts most powerfully on the nerves of the eye is violet ; after that follows blue-violet (artificial ultramarine-blue). It so happens that, among the pigments at the disposal of the painter or decorator, violet has only a set of dull representatives ; hence it is not quite so easy to transgress in this direction as with green, for to obtain a violet which is at all the optical equivalent of vermilion or emerald-green, it is necessary to use some of the aniline colours. Blue-violet or artificial ultramarine-blue easily gives rise to cold and hard combinations, and large surfaces of it are apt to appear disagreeable if the hue is at all intense. Skies painted with blues that are too intense are easily ruined, and misjudgments in this direction are not entirely confined to the work of beginners or amateurs.

When the colours are arranged according to the order in which they exhaust the nervous power of the eye, it is found that green heads the list ; violet, blue-violet, and blue follow ; then come red and orange, and last of all yellow. This is also about the order in which we are able to enjoy (or tolerate) positive colour in a painting ; large masses of yellowish hues being often recognized only as communicating luminosity, while hues of orange or red-orange, darkened, are called brown, and considered as scarcely more positive than warm greys. From this it by no means follows that the introduction of large masses of positive green into paintings is always to be avoided ; it is not advisable, unless it can be accomplished *successfully*, and without injury to the work as a chromatic composition. The ability to solve this problem in a brilliant manner is one of the signs which indicate an accomplished colourist ; and, when the green is combined with blue, the task becomes still more difficult and success more praiseworthy. On the other hand, the handling of combinations of dull yellow, brown, grey, or bluish-grey is much easier, and, in fact, constitutes the first step by which beginners should approach more positive colour.

As stated above, hurtful contrast is one of the commonest reasons that render combinations of colour bad : as examples, we have orange and carmine, yellow and yellowish-green, green and cyan-blue. All the colours in the contrast-diagram, Fig. 131, that are less than 80° or 90° apart are more or less under the dominion of harmful contrast. These effects become still more pronounced when the colours have luminosities decidedly differing from those found in the spectrum, where yellow is the brightest and violet the darkest. (See Chapter III.) There are various modes of mitigating to a considerable extent the effects of hurtful contrast : a common one is to make one of the contending colours darker than its rival, or to assign to it a much smaller field ; a third colour situated at a considerable distance in the chromatic circle is also sometimes added. Thus, for example, yellow and yellowish-green are im-

proved by adding to the combination a small quantity of violet or purplish-violet ; green and cyan-blue in the same way are helped by the addition of purple or orange. Harmful contrast in the matter of colour may also sometimes be concealed by strong light-and-shade effect, or by a large amount of gradation, which tends to enable all colours to maintain themselves against its influences ; beauty and variety of form also to some extent mask its effects. It may be added that apparent truth to nature sometimes causes harmful contrast to be overlooked or pardoned ; on the other hand, soiled or impure-looking tints, contradiction of nature either in colour or form, and indecision of handling, all are causes that intensify its action.

A combination may also be poor because the actual intensities of the two colours differ too much, although their position in the chromatic circle is advantageous ; thus, for example, the introduction of a quantity of chrome-yellow into a design produces harsh effects, which would be avoided by the use of the more modest yellow ochre. When this trouble exists in a high degree, the offending colour usually catches the eye of the observer at first glance, and before any of the other colours are fairly seen. A delicate colour-emphasis is by no means easy of attainment, and its lack produces on a chromatic composition effects quite analogous to the want of the corresponding quality in speaking or reading.

A combination may also be poor because it contains no decided representative of the warm colours, including under this term yellow and purple and the colours situated between them. There is reason to believe that the warm colours actually preponderate in the most attractive and brilliant chromatic compositions ; however this may be, it is certain that compositions founded almost exclusively on the colder colours, such as yellowish-green, green, blue, and violet, appear poor, and are apt to arouse in the mind of the beholder a feeling of more or less dissatisfaction. The

general preference for warm colour is somewhat analogous to that displayed for articles of food that have a tendency rather to sweetness than the reverse ; but, however interesting an inquiry as to the causes which during past ages have brought about this result might be, it evidently would not help us much in our present studies ; we are obliged to accept the fact, and make as good use of it as our skill and feeling for colour permit.

Thus far we have considered the effects that are produced when the colours are used in pairs ; they may, however, also be employed in triads. The studies that we have made with the contrast-diagram, Fig. 130, render it easy for us to select a series of triads that are free from the defect of hurtful contrast ; for this will be the case with all colours that are equally distant from each other in the diagram, or are separated by an angle of 120° ; and, when we examine the triads that have been most employed by artists and decorators, we find that this principle has actually been more or less closely observed. The triads that have been most extensively used are :

> Spectral red, yellow, blue ;
> Purple-red, yellow, cyan-blue ;
> Orange, green, violet ;
> Orange, green, purple-violet.

In the second triad the colours are almost exactly 120° apart ; in the first the yellow is a little less than 90° from the red, and in fact forms with it a doubtful combination, which is only rendered good by the presence of the blue. In the third triad the orange and violet are about 90° apart, but are nearly equally distant from the green, and form, both of them, a good combination with it.

In the selection of colours for these triads a second principle also seems to have guided the choice of artists : there is an evident wish in each case that two out of the three should be *warm* colours, and in two of the triads the matter

of contrast has been somewhat sacrificed for the further-ance of this end. The desire to satisfy both these condi-tions of course greatly limits the number of triads, as an examination of the contrast-diagram shows ; and, in point of fact, in certain inferior triads which have been employed, one or both of these principles have necessarily to a consid-erable extent been neglected.

Carmine, yellow, and green

was, according to Brücke, a triad much used during the middle ages, though to us the combination is apt to appear somewhat hard and unrefined. Here we have two warm colours, but the matter of contrast is also twice sacrificed ; that is, slightly in the case of the carmine and yellow, and more with the yellow and green.

Orange-yellow, violet, and bluish-green

is an example of a combination which is poor not from defect of contrast, but because it contains two cold colours, one of them being the coldest in the chromatic circle.

Vermilion, green, and violet-blue

is a triad which has been extensively used in some of the Italian schools. At first sight we have here apparently two cold colours ; but, as the green was olive-green, the com-bination really amounts to

Vermilion, dark greenish-yellow, and violet-blue,

and corresponds in principle with those above given.

In the employment of any of these triads in painting or in ornament, the artist can, of course, vary the hue of the three colours through the small interval without destroying the definite character of the chromatic composition ; and even small quantities of foreign colours can also be added. When, however, they begin to assume importance in the combination, they destroy its peculiar character. White or grey can be introduced, and is often used with a happy effect, particularly in the triads

Orange, green, violet ;
Purple-red, yellow, cyan-blue.

It is perhaps hardly necessary to dwell on the advan-tages of studying the relations of colours to each other by the use of pairs and triads, before more complicated arrange-ments are attempted. Many of the pairs furnish opportuni-ties for the construction of beautiful chromatic composi-tions, and the practical study of colour in pairs and triads can not be too strongly urged. In constructing a chromatic composition, it is also of the first importance to determine at the outset what the leading elements are to be ; after this has been done, it will be comparatively easy to see what variations are allowable, and what are excluded. The most impressive and beautiful compositions are by no means those that contain the most colours ; far more can be at-tained by the use of a very few colours, properly selected, varied, and repeated in different shades, from the most luminous to the darkest.

We have now examined to some extent the good and the poor combinations of colour, and it may be as well to add a word with regard to the balance of colour ; for it is desir-able that we should be able not only to select our colours properly, but also to provide them in quantities suitable for the production of the best effect. It has been a common opinion among English writers on colour, that the best result is attained by arranging the relative areas of the colours in a chromatic composition in such a way that a neutral grey would result if they all were mixed together. It is quite true that, if the colours were portioned out in this manner, there would be a balance of colour in an op-tical sense, though how far balance in an æsthetic sense would be attained is quite another question. Field in his " Chromatics " has given certain rules for obtaining an op-tical balance, and assumes that optical and æsthetic balance are one and the same thing. For example, he states that if

we take red, yellow, and blue, of corresponding intensities, then 5 parts of red, 3 parts of yellow, and 8 of blue will neutralize each other in a mixture, and produce grey; also, 8 parts of orange with 11 of green and 13 of purple will produce the same result; likewise 19 parts of citrine ("compound of orange and green"), 21 parts of russet ("orange and purple"), and 24 parts of a mixture of olive-green and purple. These rules are based on the supposition that red, yellow, and blue are fundamental colour-sensations, and when mixed produce white, though, as we have seen in Chapter IX., this is quite the reverse of being true. In a mixture of red, yellow, and blue, the yellow neutralizes the blue, since these colours are complementary, and the superfluous red strongly tinges this grey or white light, which then appears decidedly reddish. Field's actual experiments on mixing colours were made by transmitting white light through hollow glass wedges filled with coloured liquids; but it is, as we have seen in Chapter X., impossible in this way to mix masses of coloured light. For example, the light which passes through a yellow and a blue wedge placed in contact is merely that which is not absorbed by either wedge, or which both the wedges allow to pass. Both wedges allow green light to pass, and stop almost all the other rays; but from this it is not allowable to draw, as Field did, the inference that yellow light and blue light make green light when mixed, since we know with the utmost certainty that these two kinds of coloured light make grey or white light. Field's method gave entirely false results, and his conclusions based on them, including his so-called "chromatic equivalents," have therefore for us neither value nor meaning.

We return now to the proposition that the best effect is produced when the colours in a design are present in such proportions that a complete mixture of them would produce a neutral grey. It is very easy with our present knowledge to ascertain what areas we must assign to two

or more coloured surfaces in order to realize this effect. It is only necessary to combine, according to Maxwell's method, rotating disks which are painted with the pigments that are to be used in the chromatic composition. Let us examine this matter with the aid of a few actual examples. Taking the first of the triads, spectral red, yellow, and blue, we find that it is not possible to mix the colours in such proportions as to obtain a neutral grey; the yellow and blue neutralize each other, and the red then colours the mixture reddish. The same is true of the triad carmine, green, yellow: the mixture will be orange, yellowish, or greenish-yellow, according to the proportions. In the case of the two triads, purple-red, yellow, cyan-blue; and orange, green, violet, neutralization can be produced by mixture; and, when the colours are thus arranged, the result is more pleasing in the first than in the second case. If we take triads not much used in art, we meet with similar results; for example, vermilion, green, ultramarine-blue, when combined in such proportions as to furnish a grey, give a very unpleasing result, the cold colours being greatly in excess. But it is needless to multiply examples, as the reader can easily make these experiments for himself. If we examine the areas and intensities of the colours in the works of good colourists, we shall find that they are generally not such as to produce neutrality when the colours are mixed; that, on the contrary, as in most of the above experiments, there is always an excess of some positive colour. The presence of this excess gives a particular character to the composition, which will vary with the hue which is thus emphasized. Hence we see that this problem of the proper balance of colour is one which can not be solved exactly by any set of rules, but must be left to the feeling and judgment of the artist.

Attempts have been made from time to time to build up theories of colour based on analogies drawn from sound. The sensation of sound, however, is more particularly connected with time, that of sight with space; and these facts

necessitate a fundamental difference in the organs devoted to the reception of sound-waves and of light-waves; and, on account of this difference between the eye and the ear, all such musical theories are quite worthless. Thus, our perception for colour does not even extend over one octave, while in music seven octaves are employed. When two musical sounds are mingled, we have accord or discord, and the ear of a practised musician can recognize the separate notes that are struck; but, when two masses of coloured light are mingled, a new colour is produced, in which the original constituents can not be recognized even by the eye of a painter. Thus, red and green light when mixed furnish yellow light; and this yellow is in no way to be distinguished from the yellow light of the spectrum, except that it is somewhat paler and looks as though it had been mixed with a certain amount of white light. Again, in music the *intervals* are definite and easily recognized relations, as, for example, that of the fundamental with its fifth or octave; we can calculate the corresponding intervals for coloured light, but they can not be accurately recognized even by the most skillful painter. In painting we are constantly obliged to advance from one colour to another by insensible steps, but a proceeding like this in music gives rise to sounds that are ludicrous. These facts, which are susceptible of the most rigid proof, may suffice to show that a fundamental difference exists between the sensations of vision and hearing, and that any theory of colour based on our musical experience must rest on fancy rather than fact.

CHAPTER XVIII.

ON THE USE OF COLOUR IN PAINTING AND DECORATION.

THE power to perceive colour is not one of the most indispensable endowments of our race; deprived of its possession, we should be able not only to exist, but even to attain a high state of intellectual and æsthetic cultivation. Eyes gifted merely with a sense for light and shade would answer quite well for most practical purposes, and they would still reveal to us in the material universe an amount of beauty far transcending our capacity for reception. "But over and above this we have received yet one more gift, something not quite necessary, a benediction as it were, in our sense for and enjoyment of colour."* It is hardly fair to say that without this gift nature would have appeared to us cold and bare; still, we should have lost the enjoyment of the vast variety of pleasant and refined sensations produced by colour as such and by colour-combinations; the magical drapery which is thus cast over the visible world would have given place merely to the simpler and more logical gradations of light and shade. The love of colour is a part of our constitution as much as the love of music; it develops itself early in childhood, and we see it exhibited by savage as well as cultivated races. We find the love of colour manifesting and making itself felt in the strangest places; even the most profound mathematicians

* From an address by Professor Stephen Alexander.

are never weary of studying the colours of polarized light, and there can be no doubt that the attractive power of colour has contributed largely to swell the mathematical literature of this subject. The solar spectrum with its gorgeous tints was for many years before the discoveries of Kirchhoff and Bunsen a favourite, almost a beloved, subject of study with physicists; the great reward of this devotion was withheld for nearly half a century; divested of its colour-charm, attracting less study, the spectrum might still have remained an enigma for another hundred years.

(35) Colour is less important than form, but casts over it a peculiar charm. If form is wrongly seen or falsely represented, we feel as though "the foundations were shaken"; if the colour is bad, we are simply disgusted. Colour does not assist in developing form; it ornaments and at the same time slightly disguises it: we are content to miss some of the modeling of a beautiful face for the sake of the colour-gradations which adorn and enliven it.

The aims of painting and decorative art are quite divergent, and as a logical consequence it results that the use made by them of colour is essentially different. The object of painting is the production, by the use of colour, of more or less perfect representations of natural objects. These attempts are always made in a serious spirit; that is, they are always accompanied by some earnest effort at realization. If the work is done directly from nature, and is at the same time elaborate, it will consist of an attempt to represent, not all the facts presented by the scene, but only certain classes of facts, namely, such as are considered by the artist most important or most pictorial, or to harmonize best with each other. If it is a mere sketch, it will include not nearly so many facts; and finally, if it is merely a rough colour-note, it will contain perhaps only a few suggestions belonging to a single class. But in all this apparently careless and rough work the painter really deals with form, light and shade, and colour, in a serious spirit, the conven-

tionalisms that are introduced being necessitated by lack of time or by choice of certain classes of facts to the exclusion of others. The same is true of imaginative painting: the form, light and shade, and colour are such as might exist or might be imagined to exist; our fundamental notions about these matters are not flatly contradicted. From this it follows that the painter is to a considerable extent restricted in the choice of his tints; he must mainly use the pale unsaturated colours of nature, and must often employ colour-combinations that would be rejected by the decorator. Unlike the latter, he makes enormous use of gradation in light and shade and in colour; labours to express distance, and strives to carry the eye beneath the surface of his pigments; is delighted to hide as it were his very colour, and to leave the observer in doubt as to its nature.

In decorative art, on the other hand, the main object is to beautify a surface by the use of colour rather than to give a representation of the facts of nature. Rich and intense colours are often selected, and their effect is heightened by the free use of gold and silver or white and black; combinations are chosen for their beauty and effectiveness, and no serious effort is made to lead the eye under the surface. Accurate representations of natural objects are avoided; conventional substitutes are used; they serve to give variety and furnish an excuse for the introduction of colour, which should be beautiful in itself apart from any reference to the object represented. Accurate, realistic representations of natural objects mark the decline and decay of decorative art. A painting is a representation of something which is not present; an ornamented surface is essentially not a representation of a beautiful absent object, but is the beautiful object itself; and we dislike to see it forsaking its childlike independence and attempting at the same time both to be and to represent something beautiful. Again, ornamental colour is used for the production of a result which is delightful, while in painting the aim of the

artist may be to represent sorrow, or even a tragic effect. From all this it follows that the ornamenter enjoys an amount of freedom in the original construction of his chromatic composition which is denied to the painter, who is compelled by profession to treat nature with at least a fair degree of seeming respect. The general structure of the colour-composition, however, being once determined, the fancy and poetic feeling even of the decorator are compelled to play within limits more narrow than would be supposed by the casual observer. It is not artistic or scientific rules that hedge up the path, but his own taste and feeling for colour, and the desire to obtain the best result possible under the given conditions. In point of fact, colour can only be used successfully by those who love it for its own sake apart from form, and who have a distinctly developed colour-talent or -faculty; training or the observance of rules will not supply or conceal the absence of this capacity in any individual case, however much they may do for the gradual colour-education of the race.

From the foregoing it is evident that the positions occupied by colour in decoration and in painting are essentially different, colour being used in the latter primarily as the means of accomplishing an end, while in decoration it constitutes to a much greater degree the end itself. The links which connect decoration with painting are very numerous, and the mode of employing colour varies considerably according as we deal with pure decoration, or with one of the stages where it begins to merge into painting.

The simplest form of colour-decoration is found in those cases where surfaces are enlivened with a uniform layer of colour for the purpose of rendering their appearance more attractive: thus woven stuffs are dyed with uniform hues, more or less bright; buildings are painted with various sober tints; articles of furniture and their coverings are treated in a similar manner.

The use of several colours upon the same surface gives rise to a more complicated species of ornamentation. In its very simplest form we have merely bands of colour, or geometrical patterns made of squares, triangles, or hexagons. Here the artist has the maximum amount of freedom in the choice of colour, the surfaces over which it is spread being of the same form and size, and hence of the same degree of importance. In such cases the chromatic composition depends entirely on the taste and fancy of the decorator, who is much less restricted in his selection than with surfaces which from the start are unequal in size, and hence vary in importance. After these simplest of all patterns follow those that are more complicated, such as arabesques, fanciful arrangements of straight and curved lines, or mere suggestions taken from leaves, flowers, feathers, and other objects. Even in these, the choice of the colours is not necessarily influenced by the actual colours of the objects represented, but is regulated by artistic motives, so that the true colours of objects are often replaced even by silver or gold. Advancing a step, we have natural objects, leaves, flowers, figures of men or animals, used as ornaments, but treated in a conventional manner, some attention, however, being paid to their natural or local colours, as well as to their actual forms. In such compositions the use of gold or silver as background or as tracery, also the constant employment of contours more or less decided, the absence of shadows, and the frank disregard of local colour where it does not suit the artist, all emphasize the fact that nothing beyond decoration is intended. Up to this point the artist is still guided in his choice of hues by the wish of making a chromatic composition that shall be beautiful in its soft subdued tints, or brilliant and gorgeous with its rich display of colours; hence intense and saturated hues are often arranged in such a way as to appear by contrast still more brilliant; gold and silver, black and white, add to the effect; but no attempt is made to imitate nature

in a realistic sense. When, however, we go some steps further, and undertake to reproduce natural objects in a serious spirit, the whole matter is entirely changed ; when we see groups of flowers accurately drawn in their natural colours, correct representations of animals or of the human form, complete landscapes or views of cities, we can be certain that we have left the region of true ornamentation and entered another which is quite different. A great part of our modern European decoration is really painting—misapplied.

We return now to a brief consideration of monochromy, or decoration in a single colour. In order to avoid the monotony attendant on the use of a uniform surface of colour, lighter and darker shades of the same hue are very often employed. These not only give more variety, but serve also as a means of introducing various ornamental forms, such as borders, centre-pieces, etc. Monochromy is advantageously employed when it is desired, on the one hand, to avoid the brilliancy attendant on the introduction of several distinct colours, and on the other the dullness consequent on the exclusive use of a single tone. It is much used in wall-painting, also in woven stuffs intended for articles of dress or for covering furniture, and for many other purposes.

In monochromatic designs the small interval is very frequently employed : for example, in using red, the artist will employ for the lighter shades a red that is slightly more orange than the general ground ; for the darker, one that is rather more purplish. In this use of the small interval, regard is to be had to the hues which colour assumes under different degrees of illumination ; this matter is fully explained in Chapter XVII. Monochromatic designs can furthermore be enlivened by ornamenting them with gold, either alone or in connection with a small amount of positive colour. The use of black and white is, however, best avoided, as it furnishes occasion for the production of

contrast-colours which interfere with the general effect. (See chapter on Contrast.)

In polychromy a number of distinct colours are employed simultaneously, with or without gold and silver, white and black. The laws which guide the selection of colours in this kind of ornamentation have already been considered in Chapter XVII. Saturated and intense colours are often used to cover only the smaller surfaces ; they are then balanced or contrasted with colours of less intensity spread over proportionately larger surfaces. In purely decorative polychromy we deal mainly with rich and beautiful arrangements of colour disposed in fanciful forms ; natural objects, if introduced at all, being treated conventionally. In the composition of such designs, however, the artist is controlled to a considerable extent by the shape and size of the spaces which the colours are destined to occupy; the large masses of the composition in the best polychromy being worked out in colours of proper intensity, which make by themselves a broad design, over which again smaller designs are wrought out in the same and in different colours. As remarked by Owen Jones,* "The secret of success is the production of a broad general effect by the repetition of a few simple elements, variety being sought rather in the arrangement of the several portions of the design than in the multiplication of varied forms."

In the best polychromy great use is made of outlines or contours ; they are employed to separate ornaments from the ground on which they are placed, particularly when the two do not differ greatly in colour. Colours that differ considerably are prevented by contours, on the other hand, from melting into each other and thus giving rise to mixture tints ; in other words, each colour is made by the separating outline to retain its proper position. Contours when used for this purpose may be light or dark coloured,

* "Grammar of Ornament," London, 1856.

14

or even black. If the ornament is lighter than the ground, the contour is made still lighter; if darker, the contour will be still darker. In the best decoration the figures of men and animals, when introduced, are surrounded with decided contours which emphasize the fact that realistic representation is not intended. Contours are also made white or golden; they then become an independent part of the ornamentation. Contours consisting of several lines of gold and silver, white and black, are often used to separate colours that do not harmonize particularly well together, though, considered in a large way, they may still belong in the compositions. These pronounced contours are never intended to disappear when viewed at a distance, but form a new ornamental element; hence their shapes will often vary more or less from the form of the spaces which they enclose.

In the richest polychromy the designs are mainly worked out in intense or saturated colours, along with gold and silver, white and black. Dark and pale tints are not much employed as such, but are produced by black or white tracery on the coloured grounds. Corresponding to this, variations of the dominant colours are effected, not by the introduction of new tints, but by placing small quantities of pure colour on a differently coloured ground; the two colours then blend on the retina of the observer and give rise to the desired hue. For example, in a richly ornamented table-cover from Cairo, the writer noticed that the use of a fine tracery of white on a blue ground gave rise to the appearance of a lighter blue, which persisted at a distance; in the border a pure red was made to appear orange-red by a tracery of yellow; in other portions, small red and white ornaments on a blue ground produced at a distance the effect of a light violet tint.

In the superb decoration of the Alhambra, the colours employed on the stucco work are red, blue, and gold; purple, orange, and green are found only in the mosaic dados.

The colours are either directly separated by narrow white lines, or indirectly by the shadows due to the projecting portions of the ornamentation. Masses of colour are never allowed to come into contact. The blue and gold are often, however, interwoven purposely, so as to produce at a distance a soft violet hue; on this ground designs are traced in gold and red, the gold figures being much larger than the red; or, on the same ground sometimes, will be found figures in white with small touches of red. The principle for the production of new colours above mentioned is constantly employed: blue and white blend to a light blue; blue, white, and red furnish a light violet or purple hue; while red and gold mingle to a rich, subdued orange. Sometimes in these designs the gold greatly predominates, as in the "Hall of the Ambassadors" or in the "Court of the Lions"; here we find a mass of wonderful gold tracery, with only small portions of red and blue imbedded in it. On the dados the mosaic designs are often worked out in red-purple, green, orange-yellow, and a dark blue of but slight intensity, the ground being grey. Narrow contours of white separate the colours from the ground. To this series light blue is sometimes added, or we find combinations of orange-yellow, dark blue, and green or purple; dark blue and orange-yellow; or simply orange-yellow and small spaces of dark blue, the grounds in all these cases being of a medium grey. The general effect of the colour of the mosaics is cool and somewhat thin; it rests the eye which has gazed on the magnificent displays placed above, or prepares it by the contrast for new enjoyment.

True polychromy has not been very successfully cultivated in Europe since the time of the Renaissance, painting having to a great extent usurped its place. Hence in modern times we find not only our porcelain, carpets, window-shades, but the walls themselves and whatever else it may be possible to decorate, covered with groups of flowers, figures, or landscapes, architectural views, copies of cele-

brated paintings—all executed with as much pretended truth to nature as the purchaser is able or willing to reward. It is hardly necessary to add that the taste which produces or demands such false decoration, while it may have much to excuse, has but little to recommend it; and it is not to be expected that any general improvement can be effected till the public at large learns better to distinguish between genuine decoration and genuine painting.

In decorative art the element of colour is more important than that of form: it is essential that the lines should be graceful and show fancy or even poetic feeling; but we do not demand, or even desire, that they should be expressive of form in a realistic sense. Just the reverse is true in painting: here, colour is subordinate to form. Nevertheless, its importance still remains very great, and it is trifling to attempt to adorn with colour that which is really only a light-and-shade drawing. The chromatic compositions of a painting should from the start receive the most careful and loving attention; otherwise it is better to work in simple black and white.

The links which connect designs in mere light and shade with works in colour run about as follows: We have, as the first step, pictures executed essentially in one tint, but with endless small modifications. In this way a peculiar luminous glow is introduced which is never exhibited by designs executed solely in black and white, or indeed in any one tint. As examples of this kind of work we may mention drawings in sepia or bistre, in which the tint is varied by the introduction here and there of different quantities of some other brown having a reddish, yellowish, or orange hue. In the next stage the design is worked out essentially in bluish and brownish tints. If a landscape, the distance and much of the sky will be greyish-blue; the foreground, on the other hand, a rich warm brown, with here and there a few touches of more positive color. The blue of the dis-

tance will be variously modified, having often a greenish hue, and being replaced in the more highly illuminated portions by a yellowish tint. No real attempt will be made to render correctly the natural colours of the objects depicted, except as they happen to fall in with the system adopted. By this mode of working, distance and luminosity can be represented far more effectively than by the mere use of black and white. Designs of this kind merge by insensible degrees into others, where the strong browns of the foreground vanish, and are replaced by a set of tints which, though not very positive, yet represent the actual colours of the scene somewhat more truly. The rather uniform bluish-grey of the distance, also, is exchanged for a greater variety of cool bluish tints, and faint violet and purple hues begin to mingle with the other colours. The yellows and orange-yellows become more pronounced, but decided greens are not admitted except in small touches, and as the local colour requires it; large masses also of any other strong colours that happen to be present in the scene will be suggested rather than represented. In designs of this kind there is a good deal of room for the interchange and play of different hues, and they make at first sight the impression of being veritable works in colour. Many of Turner's earlier drawings were executed in accordance with these methods, which allow the student gradually to encounter and overcome the difficulties of colour. The substitution of paler tints for the real colours of the scene, and particularly the exclusion of green, a colour always difficult to manage, diminish the possibilities of entanglement in harsh or bad combinations of colour, and render more easy the attainment of harmony. This mode of using colour is of course conventional, and pictures of this kind are not to be regarded as executed in colour, in the full sense of the word. Among genuine works in colour, the simplest are those painted essentially with a single pair of colours, variously modified or combined with grey; colours widely separated in the chro-

matic circle from the selected pair being admitted only in small masses or subdued tones. After these follow chromatic compositions in which three colours with their modifications are systematically employed in the same manner, to the exclusion as far as possible of all others. The character of these compositions will again vary according as the light illuminating the scene in nature is supposed to be white or coloured. If yellowish, the blue and violet hues will be more or less suppressed, the greens more yellowish, while the red, orange, and yellow tints will gain in intensity. Just the reverse will occur under a bluish illumination. The practice of employing an illumination of one dominant colour, which spreads itself over the whole picture, modifying all the tints, is very common among artists, and has often been successfully used for the production of impressive effects.

Good colour depends greatly on what may be called the chromatic composition of the picture. The plan for this should be most carefully considered and worked out beforehand, even with reference to minor details; the colours should be selected and arranged so that they all help each other either by sympathy or by contrast—so that no one could be altered or spared without sensibly impairing the general effect. No rules will enable a painter coldly to construct chromatic compositions of this character; the constant study of colour in nature and in the works of great colourists will do much, but even more important still is the possession of a natural feeling for what may be called the poetry of colour, which leads the artist almost instinctively to seize on colour-melodies as they occur in nature, and afterward to reproduce them on canvas, with such additions or modifications as his feeling for colour impels him to make. Thus it is often advisable to deepen nature's colours somewhat, as in the case of the pale-tinted greys of a distance, or in the mere suggestions of colour often presented by flesh. In this process the proportions of the coloured and

white light of nature are somewhat altered, and the coloured element made more prominent. On the other hand, all the colours may be made paler and more greyish than those of nature; yet if they retain their proper relations, if all are correspondingly affected, the harmony will not be disturbed, and a design of this character will still be, from a chromatic point of view, logical. If the cold hues, the greens and blues, are allowed to stand in full strength, while the warm colours, red, orange, and yellow, are weakened, a particularly bad effect is produced.

Good colour, then, depends primarily on the chromatic compositions; next in importance on the drawing, including under this term outline and light and shade. The want of good, decided, and approximately accurate drawing is one of the most common causes that ruin the colour of paintings. Powerful drawing adds enormously to the value of the tints in a coloured work when they are at all delicate, or when the combination contains doubtful or poor colour-contrasts, which in point of fact is a case common enough in nature. Here the artist is obliged either to reject the material furnished by nature, or to treat it in nature's own way; that is, the drawing must be excellent and the gradation endless. Poor or bad combinations of colour are almost converted into good combinations by sufficient gradation. When all the tints are pale, as in distances, it is almost impossible to cause them to appear luminous or brilliant without the aid of delicate and accurate drawing. There is still another way in which the drawing influences the colour: perfectly clear, clean tints can be used, and will look well, where the same colours in a slightly soiled or dirty condition would be quite inadmissible. This results from the circumstance that helpful contrast is favoured by clean, even tints, while harmful contrast is strengthened by a dirty or spotty condition of the pigments. This is peculiarly true when the colours are not very positive, or are low in the scale; the tints, if not clear and decided, instantly lose all

value and become a blemish. To insure this desirable appearance, called by artists purity, the colours must be laid on rapidly and with decision, and not afterward gradually corrected ; but to do this requires the hand of an accomplished draughtsman.

The advance from drawing to painting should be gradual, and no serious attempts in colour should be made till the student has attained undoubted proficiency in outline and in light and shade. Amateurs almost universally abandon black and white for colour at a very early stage, and this circumstance alone precludes all chance of progress. The stage of advancement can, however, be very easily ascertained. Thus, for example, if the student can not execute a perfectly satisfactory study of any class of subjects in outline with slight shade, then there is no use in trying full light and shade ; if it is impossible for him to draw the objects in full light and shade in a rather masterly way, then there is no use in attempting colour. The method employed by Turner of gradually effecting the transition from black and white to colour has been just described, and is worthy of the most careful study. In making the first essays at colour, it is advantageous to execute careful studies of the scene in full light and shade, but to note down the colours only in writing and in the memory. Afterward, from these notes and the black and white drawing, a colour-sketch may be attempted, *away* from the scene. By this means fluctuations of judgment about the colours and their relations are avoided, and, though the painting may be all wrong, it has at least a chance of being executed on one plan, and its frank errors can afterward be ascertained. Beginners when working in the presence of nature are apt to keep constantly altering the plan of the chromatic composition, in the hope that it will at last come right, and thus waste much time. Artists under similar circumstances deliberately make up their minds beforehand what colour-facts they will take, what

view of the problem they will adopt, and adhere to this decision unflinchingly.

After some progress has been made, the colour-sketches that are attempted directly from nature should be simple and executed with reference to *colour*, the element of form being kept quite subordinate. The very natural desire to make something that will afterward look like a picture is to be suppressed, and the work performed rather with an eye to the remote future. Beginners always neglect the large relations of light and shade and colour, dwelling on those that are small ; whereas the aim of the true artist is the production of a broad general effect by the use of a few masses of colour, properly interchanged and contrasted, variety being gained not so much by the introduction of new colours as by the repetition of the main chords. Various modes of contending with this evil have been suggested. One of the simplest is making the colour-sketches so small that there is hardly room for anything but the main masses of colour, the use of small brushes meanwhile being avoided. Corresponding to this, it is frequently found that if a picture by a beginner is actually cut up into two or more parts, the fragments thus produced are better in the matter of chromatic composition than the original.

There are several other stumbling-blocks that are encountered with much regularity by those who make their first essays in colour. One of the most important is the tendency to employ in the painting colours that are vastly more intense than those displayed by nature. The colours of nature are usually pale and low in intensity, even when they make upon the beholder just the reverse impression ; and a practical knowledge of this fact is not to be immediately attained. Distant fields, for instance, often appear to be of a rather intense green hue, when the colour *actually* presented to the eye may be scarcely more than a grey having in it a faint tinge of green. The actual colours

exhibited by different parts of a landscape may be advantageously studied by isolating them, according to a suggestion of Ruskin, with the aid of a small aperture, half an inch square, in a piece of white cardboard, held at arm's length. By this simple proceeding the student can convince himself of the true nature of the tints composing a scene, for when thus isolated they are not heightened by contrast. With such square patches of colour, the judgment is not so much affected by the *memory* of the hues which the objects exhibit at short distances, or by what artists call their local colour. The local colour of grass is green, but if placed at a distance it may display a great variety of pale tints, scarcely even greenish ; yet owing to the action of the memory the distant grass still suggests, not the idea of a variety of pale delicate greys, but of its local colour, green. The illustration is very old, but the principle applies not only to the greens, but to all colours : all will be altered by distance, by the brightness of the illumination or by its colour. The hues of all objects are also greatly affected by their surroundings, as explained in the chapter on contrast ; and this is another source of perplexity and confusion to the beginner, who is constantly led astray by appearances due to this cause. The extent of the difficulty can be appreciated when we remember that contrast affects not only the intensity of the colour, but its position in the chromatic circle, and also its apparent luminosity, and is particularly lively in the case of the pale colours of nature. It is as well to meet this difficulty fairly face to face, and, instead of spending all the disposable time in endeavoring to solve the riddles of contrast presented by nature, to reverse the process, and occasionally to construct in the studio simple chromatic compositions founded on the known laws of contrast, and thus study its effects by experiment as well as by observation.

The appearance of colour, as has been explained in another chapter, depends also greatly on gradation ; colour

which is uniform appearing hard and disagreeable, while the same tint when gently varied becomes pleasing as well as truer to nature. Gradation of colour is almost universal in nature, and a considerable part of the education of the student consists in its study and practice. The uneducated eye feels the effect of gradation in nature and in a painting, but is quite unable to trace the delicate play of colour and light and shade on which it depends. Skill in the use of gradation gives the artist great power to manage large masses of nearly uniform colour, and an astonishing mastery over colour-combinations which inherently are of doubtful value.

The enormous influence of good, decided drawing has already been alluded to, but we return again to the matter for a moment, to insist on the added lustre which all the tints of a painting acquire when connected with good, well wrought-out light-and-shade effect. The beginner can most easily convince himself of the great influence which the light-and-shade effect exercises on the colour, by copying the engraving of some simple subject by a master in such colours as may seem most appropriate, and then comparing the coloring thus obtained with that of his own original designs. The selection of pigments in both cases is by the same hand, but it will be found that the masterly light and shade has given a value even to the colours, which without this little plagiarism they would not have possessed.

In painting, the selection of subjects on account of their chromatic qualities is a very important element of success. It is only by experience that artists gradually learn better and better how to select their subjects, and the mistakes of beginners in this respect are often a source of prolonged discouragement. Subjects which contain much green are invariably difficult to manage, and should as far as possible be avoided in the earlier stages ; green fields, green trees, green mountains, all need great skill if the colour is rendered with any approach to fullness. This is the reason

that the older landscapists lowered the colour of their trees to a dull olive-green, and even to brown. Combinations of green, blue, and grey or white are very common in nature, but difficult to handle, and necessitate the use of an unusual amount of gradation. From a chromatic point of view the combination is poor ; as seen in nature, we do not value it less on that account, perhaps more. It is delightful to see how much can be accomplished with elements of such doubtful value. Again, effects which are much dependent for beauty on very high degrees of luminosity are difficult, for their pale colours, when transferred to canvas and robbed of their natural luminosity, are apt to appear tame enough. In the same category we must place distances, with their excessively pale, delicate tints. The colouring in nature seems very brilliant, but in point of fact the effect is produced partly by mere luminosity, and partly by the aid of tints differing so slightly from each other and from grey that the problem of imitation, either literal or free, is not at all easy.

We might go on in this way adding to the catalogue of art difficulties, but perhaps it will be asked, What subjects are easy ? The truthful answer is simply, that all are difficult if even a moderate degree of excellence is demanded. The painter who wishes to excel in colour devotes his life to this object, and is constantly accumulating studies and sketches from nature of all kinds of subjects, some quite elaborate, others with less detail, many mere colour-notes. Quite often beautiful effects of colour in nature last only a few minutes ; these will be treasured in the memory and transferred to paper or canvas the next day, the sketch being completed only far enough to fix the facts in the memory of the artist. Many experimental sketches will be made, not directly from nature, but with a view, as it were, of guessing at the elements on which certain difficult or evanescent chromatic effects depend, and also for the purpose of ascertaining their relations to mere light and shade.

This varied work in colour will be accompanied by constant practice in black and white for light and shade, and in outline for form, since bad drawing is ruinous to colour. All the while there will be more or less anxious study of the works of good colourists, ancient and modern ; and this work will be pushed on month after month with patient energy, till, after a score of years or so, the student finally, if gifted, blossoms out into a colourist.

HERING has lately proposed a theory of colour which is quite different from that of Young. According to the new theory, the retina is provided with three visual substances, and the fundamental sensations are not three but six

Black and White.
Red and Green.
Blue and Yellow.

Each of these three pairs corresponds to an assimilation or diassimilation process in one of the visual substances; thus red light acts on the red-green substance in exactly the opposite way from green light, and when both kinds of light are present in suitable proportions a balance is effected, and both sensations, red and green, vanish.

Furthermore, according to this theory, all the colours of the spectrum also affect the black and white substance in the same way that white light does; for example, red light affects the red-green substance and produces the sensation of red, but it also acts on the white-black substance, and the sensation of red is mingled with that of white—to a large degree. Consequently, according to this theory, the white which is produced by mixtures of red and green light. ought to have a less intensity than the sum of the separate components; but according to the experiments of the author this is not the case.* For further details the reader is referred to the original paper, "Lehre vom Lichtsinne," Vienna, 1878.

In 1876 F. Boll discovered that the retina contained a red or purple substance that quickly disappeared on exposure to light. Boll and Kühne have both studied the effect of monochromatic light on this coloured substance, and it was found that red light intensified the hue at first and afterward caused it to fade slowly. The action of yellow light was slow; green, blue, and violet light acted more quickly. On observations of this charac-

* "American Journal of Science and Arts," October, 1877.

ter Kühne has constructed a theory of vision. He supposes that the waves of light give rise in the retina to different compounds according to their length, and thus produce the different colour-sensations. If three such compounds are thus produced, giving rise to the sensations red, green, and violet, then this new theory is identical with that of Young; if there are five such compounds, furnishing the sensations red, yellow, green, blue, violet, then the apparatus for yellow and blue has been duplicated in the retina, since it can be shown that a mixture of the sensations red and green gives that of yellow, a mixture of green and violet that of blue. Good reasons can also be adduced to render probable the idea that yellow and blue are not fundamental sensations, but mixtures (compare the observations of Bezold in Chapter XII.). For additional information the reader is referred to the papers of Kühne published in the " Verhandlungen des Naturhistorische-medicinischen Vereins zu Heidelberg, 1877-'79."

INDEX.

THE END.